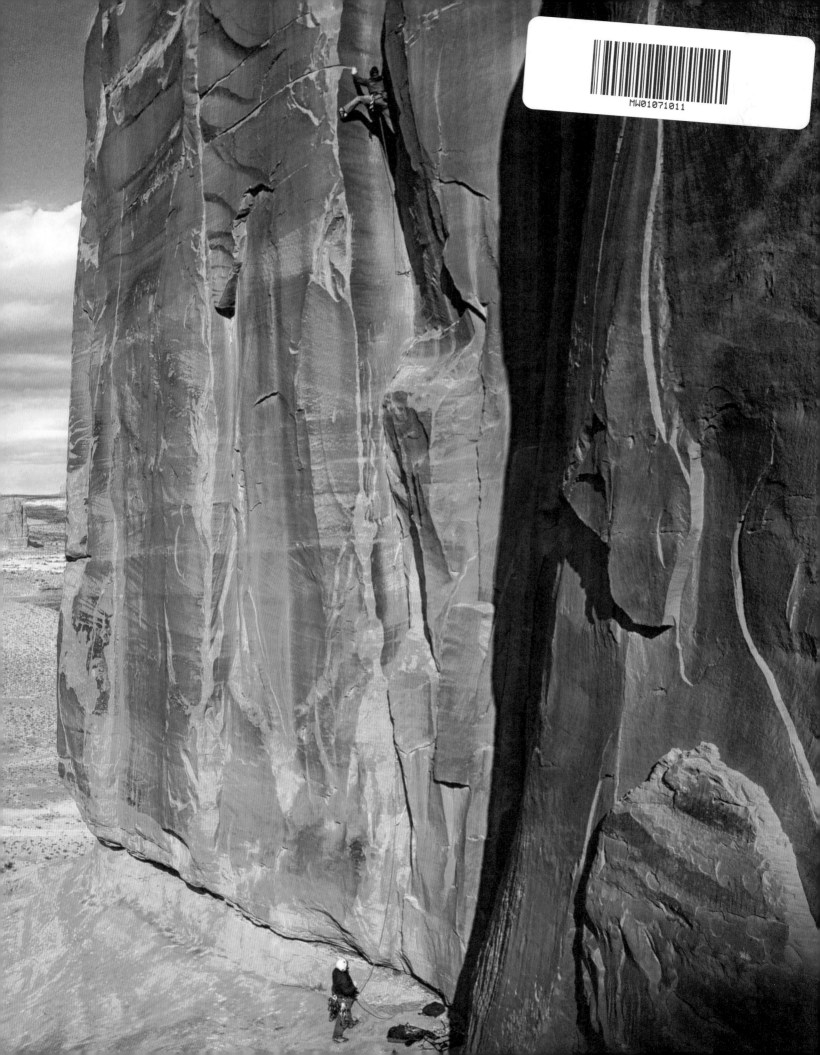

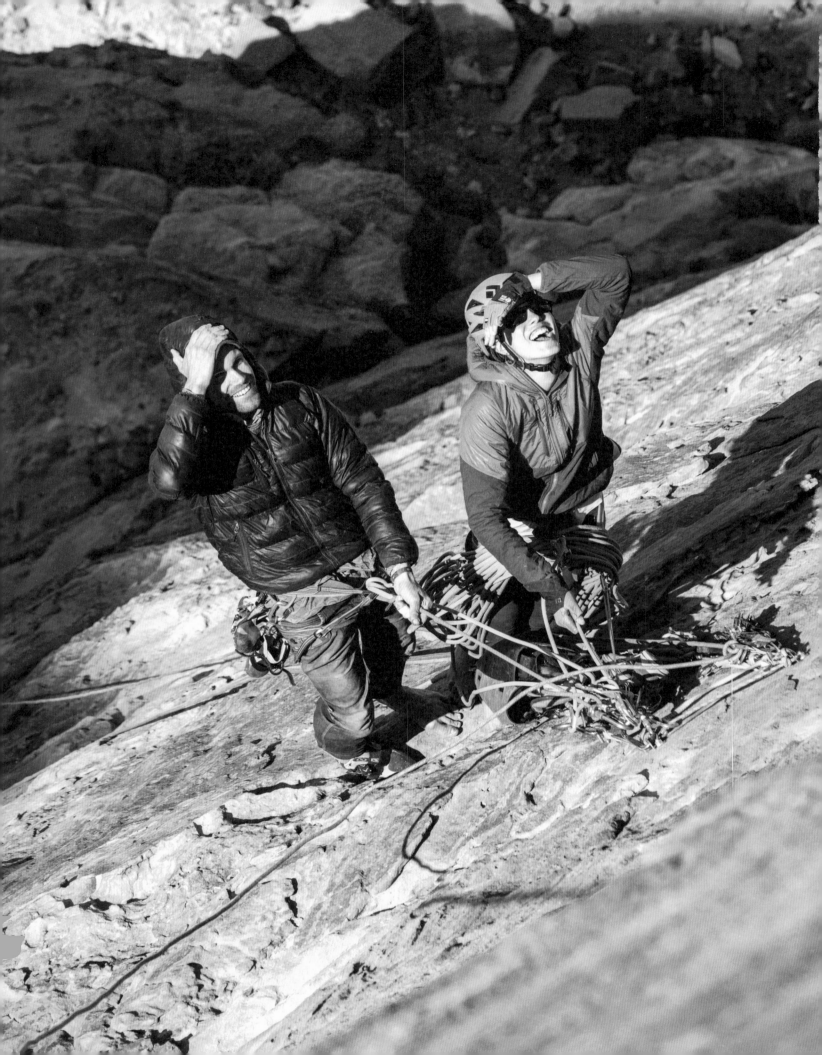

CLIFFHANGER

New Climbing Culture & Adventures

gestalten

CONTENTS

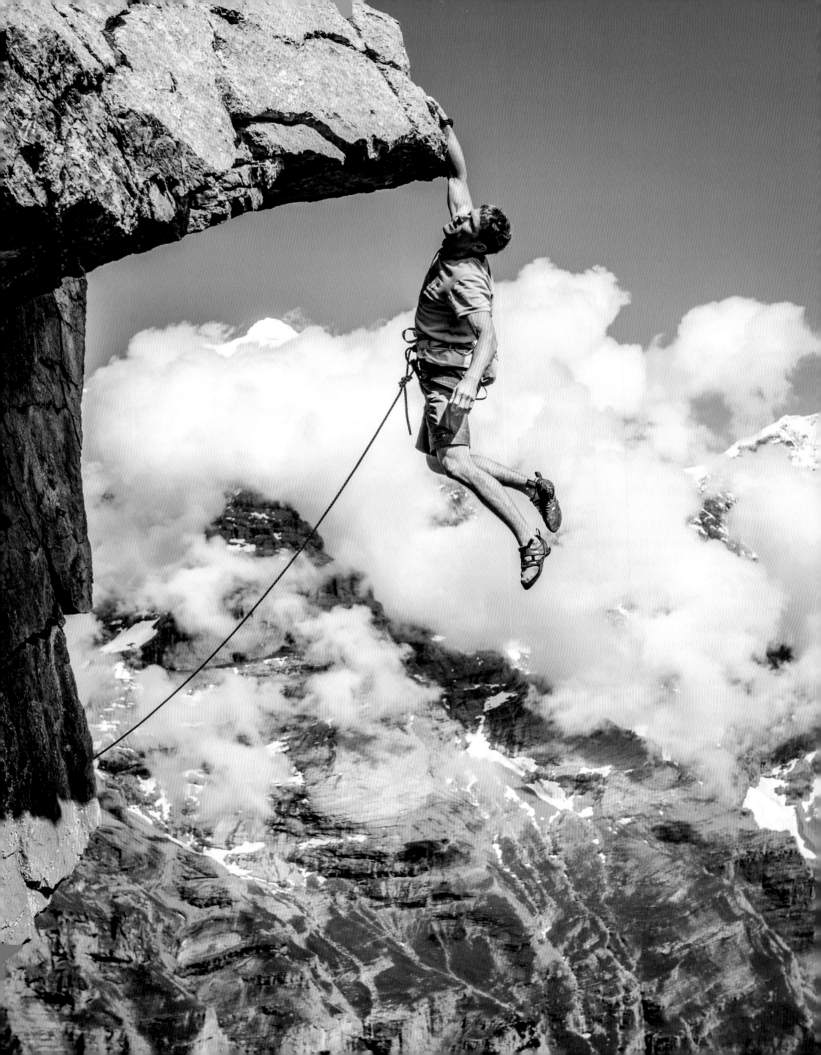

THE RISE OF CLIMBING

by Julie Ellison

The word "climbing" used to conjure up the image of a helmet-clad person covered in brightly colored clothes with mountain boots and sharp, pointy tools desperately clawing up a snow-covered peak, or a muscled person hanging off the side of a steep rock face with a dizzying amount of air under their feet. Being a "climber" meant being part of a small, elite club where all the members seemed crazy and all the objectives seemed impossible. But since the early 2000s, climbing has spread beyond this niche of a select few and become accessible to anyone and everyone. It's no longer a mysterious and little-understood pastime. It has now trickled into the mainstream as an internationally recognized sport, a global fitness trend, and an all-consuming lifestyle. From indoor climbing gyms to hundreds of thousands of routes on real rock, climbing continues to grow—without showing any signs of slowing down.

Climbing has undoubtedly existed in some form or another for hundreds of thousands of years—humans have been ascending peaks and mountains for as long as both have been around. But modern rock climbing only came about in the mid-20th century, as an offshoot of mountaineering. Summiting mountains was considered a noble pursuit, but when weather was bad or time was limited, mountaineers would climb shorter rock faces and boulders for training. Eventually climbers stopped taking the fitness and skills gained on these smaller rock features to the big mountains, and climbing these smaller objectives became the main attraction. Those early pioneers could not have imagined where climbing would go in a few short decades. Thousands of climbing gyms dot the globe, the highest difficulty level in outdoor climbs are 9A/V17 and 9c/5.15d, a climbing film won an Oscar, and now climbing is in the Olympics—arguably the highest achievement for any athletic endeavor. There are climbing-centric careers, stores, gyms, manufacturers, books, movies, magazines, festivals, schools, organizations, nonprofits, podcasts, apps, and social media feeds—an entire industry based on climbing.

And climbing has exploded for good reason—well, many good reasons. Climbing is FUN. Difficult movement sequences offer a physical and mental challenge, and improvement happens on a regular basis. There is a problem-solving component, as well as a strength component, and if you do it enough, you will develop a muscled physique to boot. Climbing can be done alone, or with friends, at the local indoor spot for a few hours, or thousands of miles from the nearest town, surrounded by only a glacier and polar bears for a few months. Objectives range from 10-foot-tall (three-meter-tall) boulders to 26,000-foot (8,000-meter) peaks. There are so many different types of climbing that you can pick one and specialize in that, or try to master them all. And the challenges are endless. Tick your proudest send ever, and there are seemingly infinite other routes, problems, and peaks to send. If you want to see how strong and powerful you can get, try bouldering or sport climbing. If you just want to focus on overall fitness, visit the local climbing gym a few times a week. If you like the cerebral task of figuring out puzzles and controlling your fear, trad climbing is for you. If you prefer huge undertakings that require manual labor and a touch of suffering, then you might be a big waller or alpinist at heart. It is all climbing, and it is all awesome.

One tradition that has carried on from the earliest days of the sport is the fact that climbing is more than just a hobby or a way to fill one's time. Climbing is also a lifestyle and a way to travel and experience the world. Committed climbers base their whole lives around the sport, chasing seasons and "climbing temps" in beautiful destinations near and far. All our vacations turn into climbing trips, and our social circles are entirely climbers. Many climbers even move →

→ into their vehicles to save money on housing and live a simpler, more frugal lifestyle that allows them to climb more and work less. We eat, sleep, train, and live for climbing.

While one book could not possibly cover all these things—and still be light enough to pick up—this book aims to give you an overview of this worldwide phenomenon. By highlighting people, places, history, culture, technique, ethics, and other interesting topics, we will take an in-depth look at some of the most notable aspects of this fascinating activity. We lay out the basics and history of each of the major disciplines: bouldering, sport climbing, trad climbing, and alpinism, as well as 15 of the world's best destinations, from China's Getu Valley to Jordan's Wadi Rum to Indian Creek in the United States. We offer an exhaustive look into the life of a mountain guide, explain how the complex discipline of big wall climbing works, and describe the incredible growth of paraclimbing, as well as the downsides of climbing's popularity. There are profiles of a dozen of the world's leading climbers, including one family of four that among its members has multiple world championships, 9b/5.15b and 8C+/V16 ascents, and a ticket to the Olympics. Whether you are a longtime, dedicated climber or someone who has never climbed, you will find the following stories a balance of educational, informative, and entertaining. Throw in the breathtaking imagery of climbing incorporated into an aesthetic design, and everyone will enjoy flipping through the following pages to see what a life in the vertical is all about.

JULIE ELLISON has been writing, shooting, and editing stories about climbing and the outdoors for more than a decade. She was Climbing *magazine's first female editor in chief, and now works as a freelance writer, photographer, and filmmaker. With a genuine documentary style, she uses adventure as a way to experience the world and help the people in it. Through the lens of climbing, she's documented the refugee crisis in the Mediterranean, a climbing camp for cancer survivors, a transgender climber's ground-breaking journey, and seeing death firsthand in Mexico.*

For four years, Julie lived in a van named Betsy, chasing interesting stories, dry rock, and good climbing conditions across the United States, all with her pit bull Lizzie by her side. In fall 2016, she and two colleagues formed Never Not Collective, a women's production company that seeks to tell the stories of everyday people doing great things, brave things, things that are challenging, engaging, and gratifying—regardless of "success." In January 2020, Never Not Collective premiered their first major film project: Pretty Strong, *a feature-length movie that puts women climbers front and center. As the first film of its kind,* Pretty Strong *is a climbing film about women, by women, and for everyone.*

Now Julie lives in the mountains of southeastern Idaho, where she plays in the Tetons half the year and travels for climbing and work the other half. See more of Julie's work on her website www.julieellison.com, and check out Never Not Collective and Pretty Strong *at www.nevernotcollective.com.*

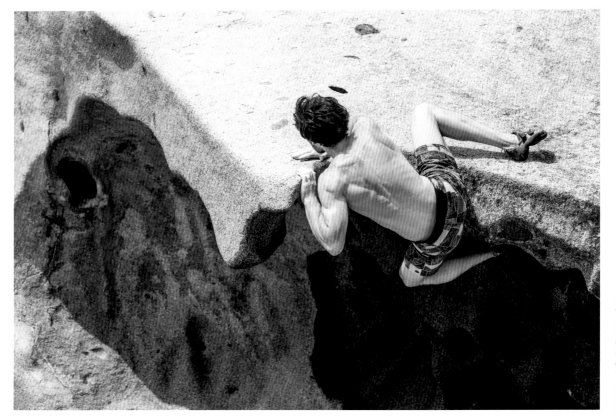

→ *Right page* The co-editor Julie Ellison on her way to sending one of her favorite trad routes of all-time: *Exasperator* (5.10c/6b) in Squamish, Canada. ← *Left* The oceanside bouldering of Virgin Gorda offers a perfect combination of beach vacation and climbing trip. →→ *Following spread* The striking sandstone of Waterval Boven, South Africa, is home to plenty of world-class climbing.

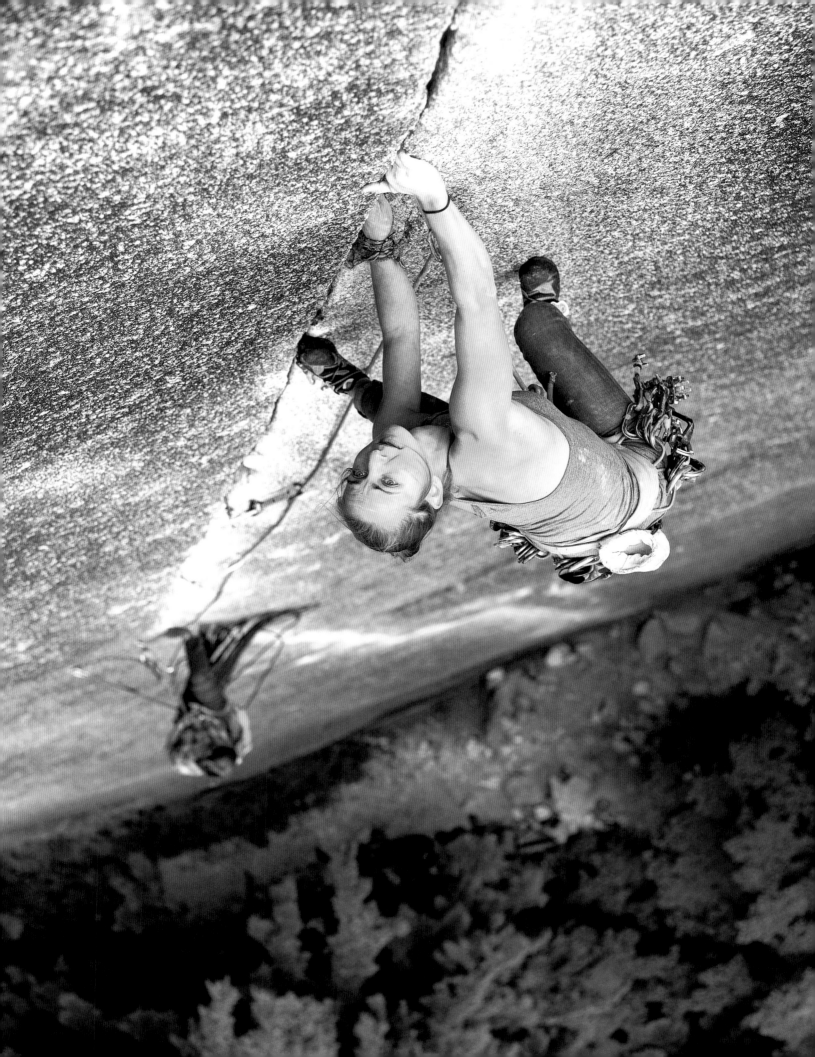

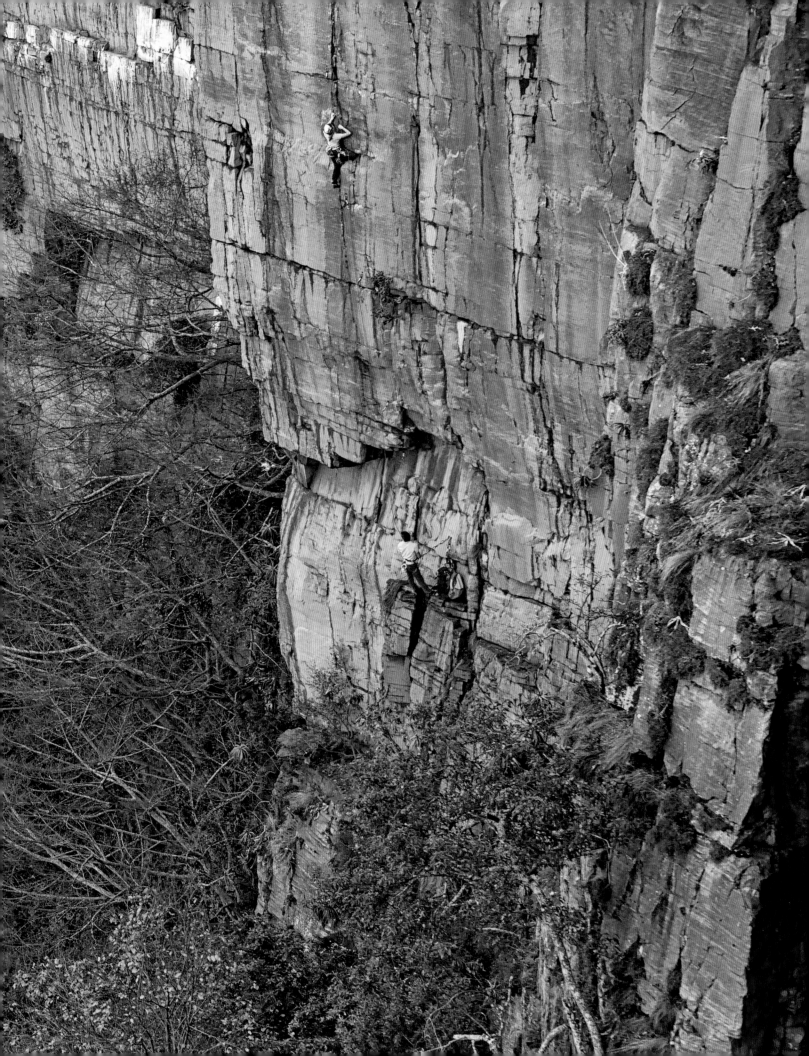

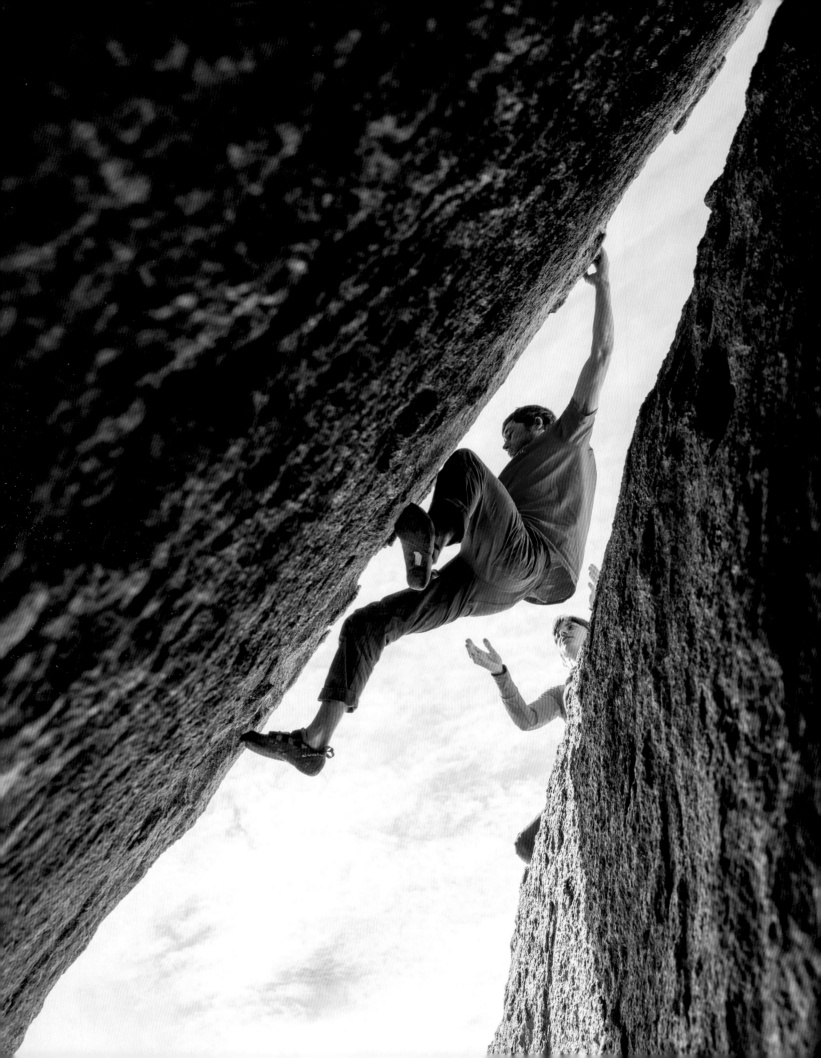

UNDERSTANDING THE LINGO

Listening to climbers speak to each other is like listening to a foreign language from a country where you spent a few weeks on holiday—10 years ago. A handful of words sound familiar, but the context in which they are used is totally baffling. The vocabulary ranges from everyday words that take on a whole new meaning in the vertical realm—send, jug, project—to words that are only used by climbers—gaston, sidepull, onsight. Few sports have a language as esoteric as climbing, but learn the lingo and you will find yourself sprinkling this verbiage into otherwise normal human-speak.

ARÊTE
A rock feature where two faces meet and form a protruding apex.

BETA
Generally this just means information. It can be about anything related to a climb or an area, but more specifically, it refers to the moves required to do a particular route or problem. Climbers often share "beta" to help each other send.

CRIMP
A small hold that the fingers must compress tightly around.

CRUX
The hardest part of any problem or route.

FLAG
When the climber removes a foot from a hold in order to make a move that requires balance.

FLASH
Sending a climb on the first attempt, with prior knowledge of the route.

GASTON
A hold that must be grabbed with the thumb pointing down and the wrist and elbow angled out away from the body, pressing outward toward the elbow; named for French climber Gaston Rébuffat.

HEEL HOOK
A move where climbers hook their heels around a hold.

JUG
A massive hold that the whole hand fits around, like a milk jug.

MULTIPITCH
A route that requires multiple rope lengths to ascend, as opposed to "single-pitch," where the climber goes up one rope length and comes down to the ground.

ONSIGHT
Sending a climb on the first attempt, without prior knowledge of the route, meaning the climber has not seen photos or gotten information from other climbers.

PEBBLE-WRESTLING
Another term for bouldering.

PROBLEM
A short climb done when bouldering.

PROJECT
A route or problem that the climber has been practicing/rehearsing (called projecting) in order to do successfully.

PUMP
Climbers are feeling "pumped" when they cannot hold on to the rock any more; typically, it is a burning feeling felt in the forearms.

ROUTE
A longer climb done in any of the roped styles of climbing.

SEND
When climbers "send" a climb, they have done it from bottom to top without falling.

SIDEPULL
A hold that is grabbed sideways, with thumb pointing up and wrist angling toward the body.

TOE HOOK
A move where climbers hook their toes around a hold.

UNDERCLING
A hold that is grabbed from underneath, with the palm and wrist pointing upward.

← *Left page* Figuring out beta on *The Fall Guy* (7C/V9), a highball boulder that has a potentially back-breaking fall on top of another boulder, located in the Buttermilks of California.

BOULDERING

THE INFAMOUS PAST, TRENDY PRESENT, AND HOPEFUL FUTURE OF THIS SIMPLE AND SOCIAL FORM OF CLIMBING

Look at the overwhelming popularity of bouldering today, and it can be hard to believe that this rope-less discipline of climbing almost wasn't anything at all. The early years of bouldering were unremarkable, with most practitioners using it as "practice climbing" for longer rock climbs. Climbers didn't need a rope, a partner, or a lot of time to ascend short cliff bands and boulders, and it distilled the practice of climbing into the purest form of moving over rock. This necessitated better gear and eventually led to the introduction of chalk and modern climbing shoes. Bouldering was seen as a great way to train movement technique and get strong without getting too high off the ground, but it wasn't seen as a respected pursuit on its own.

In the 18th and 19th centuries, any human with vertical aspirations was consumed by the idea of standing on summits and conquering the great peaks of the world. Mountaineering was de rigueur, and climbing anything smaller than an actual mountain was considered insignificant (if it was considered at all). It seems inevitable that passionate mountaineers would scramble around on boulders and small rock outcrops, but at the time it wasn't deemed notable enough for documentation, and thus we have none. By the late 1800s, rock climbing, which had become a

necessity for harder alpine objectives, had diverged from mountaineering as a standalone pursuit. Now climbers were seeking out shorter rock faces and stone spires, using ropes and specialized gear to ascend them. The sport of rock climbing required knowledge of technical rope systems, strength, endurance, mental fortitude, and courage, which all took years to develop. Climbers started to use short cliff lines and freestanding boulders as a way to practice their skills closer to the ground. As one of the first documented boulderers, English climber Oscar Eckenstein used boulders in the United Kingdom to prepare for his numerous alpine expeditions in the late 1800s. Around the same time, British climbers introduced the terms "bouldering" and "problem" into the climbing vernacular. Simultaneously, French alpinists were using the boulder-filled forests of Fontainebleau, France, as their training ground for the Alps. In the 1930s, Pierre Allain, a French alpinist, and other climbers went to Fontainebleau to practice for bigger mountains. Eventually, they developed an affinity for bouldering beyond just its training capabilities. These climbers, known as the "Bleausards," heralded the notion that bouldering was a worthy form of climbing in its own right. For the delicate footwork required by Fontainebleau's sculpted sandstone, Allain experimented

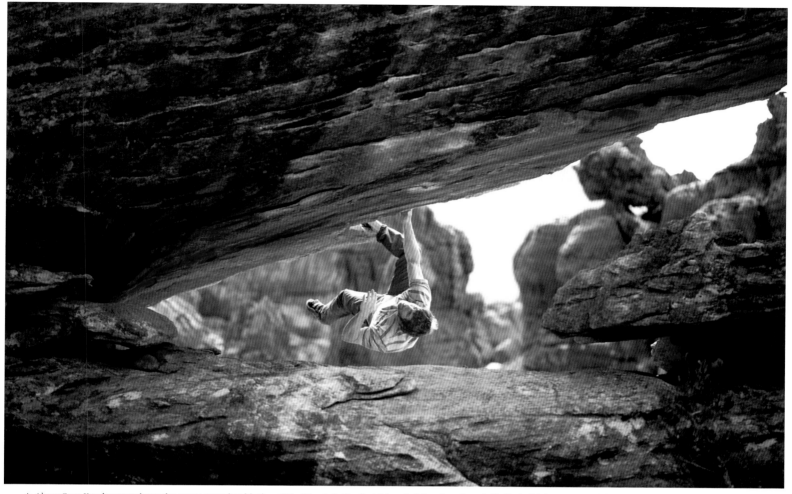

↑ *Above* Greg Kerzhner explores the super-steep bouldering of Rocklands in South Africa. ↓ *Below* Jess Campbell climbs high over a creek in a boulder-filled canyon in Jordan.

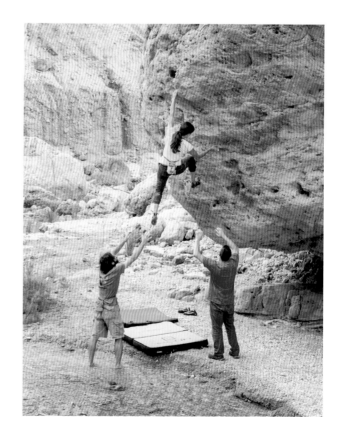

with rubber-soled shoes that were softer, unlike the heavy and hard boots used by mountaineers. This would become the foundation of modern rock shoes.

While the freestanding boulders provided interesting and challenging movement, their short stature was un-impressive to the larger climbing community. Formations like the massive glaciated peak of Mont Blanc in the Alps and the clean, solid rock of Yosemite's Half Dome warranted time, bravery, hard work, and commitment to get to the top. Serious alpinists would leave Europe to travel thousands of miles to the far-flung Karakoram mountain range in Asia for massive objectives. The Bleausards didn't leave Fontainebleau, which was just south of Paris, for pocket-sized rocks. Bouldering still didn't measure up.

In the 1950s, a former American gymnast named John Gill started climbing, focusing on acrobatic moves on short climbs. Gill thought of bouldering as an extension of gymnastics, rather than hiking and mountaineering. He focused on the style and grace of movement, rather than pure difficulty. With his gymnastics background, Gill introduced chalk into the sport of climbing, which spread quickly. He also incorporated the idea of strength training outside of climbing itself, introducing one-arm pull-ups, muscle-ups, →

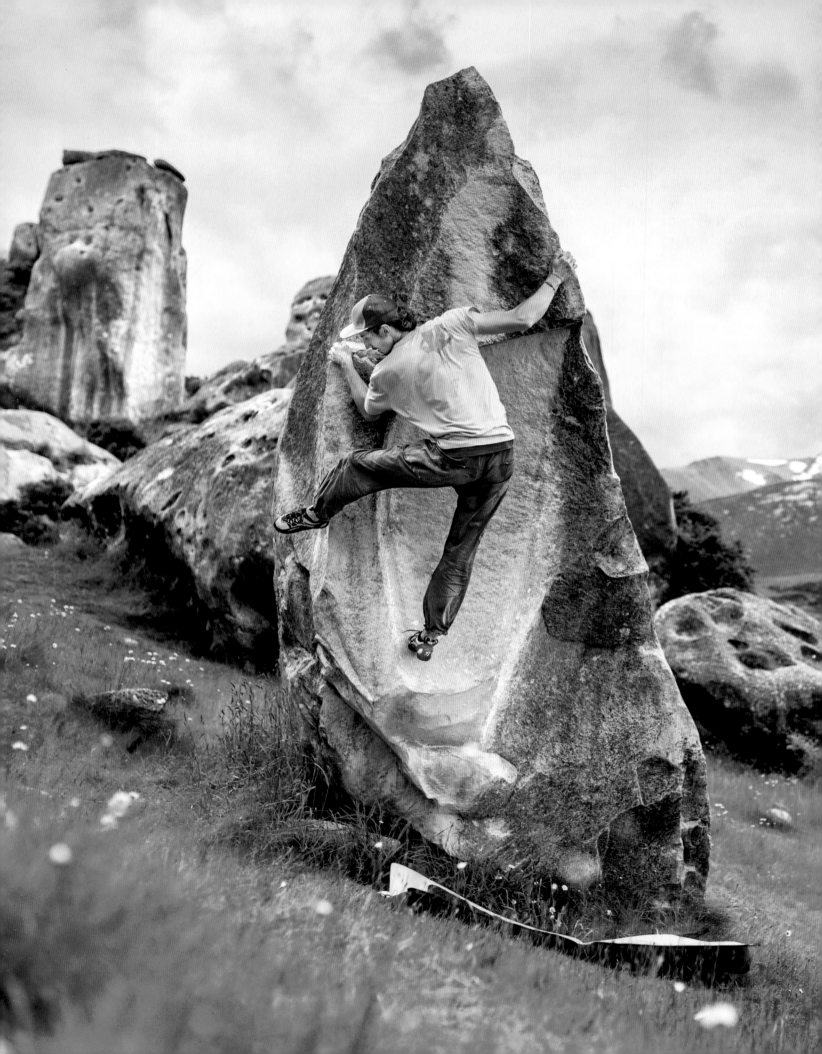

→ and front levers as exercises. Gill was also a proponent of dynamic movement, now known as a "dyno," where he would jump from one hold, his feet would leave the rock, he would catch the swing, and then bring his feet back into the wall in a smooth, controlled manner. Throughout the 1950s and '60s, Gill established boulder problems in the United States along with many other notable American climbers, like Pat Ament and Royal Robbins. Gill concentrated on bouldering and became its primary advocate. He is considered by many to be the "father of modern bouldering."

By the 1980s, bouldering had flourished, thanks in part to the invention of crash pads for protecting falls and indoor climbing walls for training year-round. The sport continued to grow. In the 1990s, American climber John "The Vermin" Sherman developed the V-scale while climbing in Hueco Tanks, Texas. It is a grading system for bouldering problems that is still used today. With the rise of the internet in the 2000s and social media in the 2010s, the visibility of bouldering through videos, blogs, and online guidebook resources has made it arguably the most popular form of climbing.

Travel to a popular bouldering destination like Bishop, California, in the winter or Squamish, Canada, in late summer, and you'll likely encounter dozens of people crowded around every boulder. The ground resembles a colorful sea of crash pads, with dogs wandering around, small children playing in the dirt, and all the requisite *stuff* strewn about. It's no wonder that bouldering has become so popular these days: it is freakin' FUN. The fear factor and risk potential are very low, and there are no complicated rope systems to →

TRAVEL TO A POPULAR BOULDERING DESTINATION AND YOU'LL LIKELY ENCOUNTER DOZENS OF PEOPLE CROWDED AROUND EVERY BOULDER. IT'S NO WONDER THAT BOULDERING HAS BECOME SO POPULAR THESE DAYS: IT IS FREAKIN' FUN.

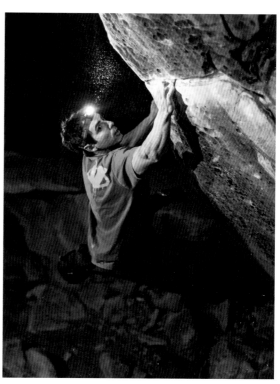

← *Left page* The boulders of New Zealand's Castle Hill offer tons of problems in a beautiful setting. ← *Left* Bouldering is a social form of climbing because it can be done in large groups and more time is spent on the ground with other climbers, spotting each other and sharing beta. ↑ *Above* Ronnie Dickson enjoys the cooler temps of nighttime in Joe's Valley, Utah. →→ *Following spread* Katie Lambert climbing *The Force* in Yosemite National Park.

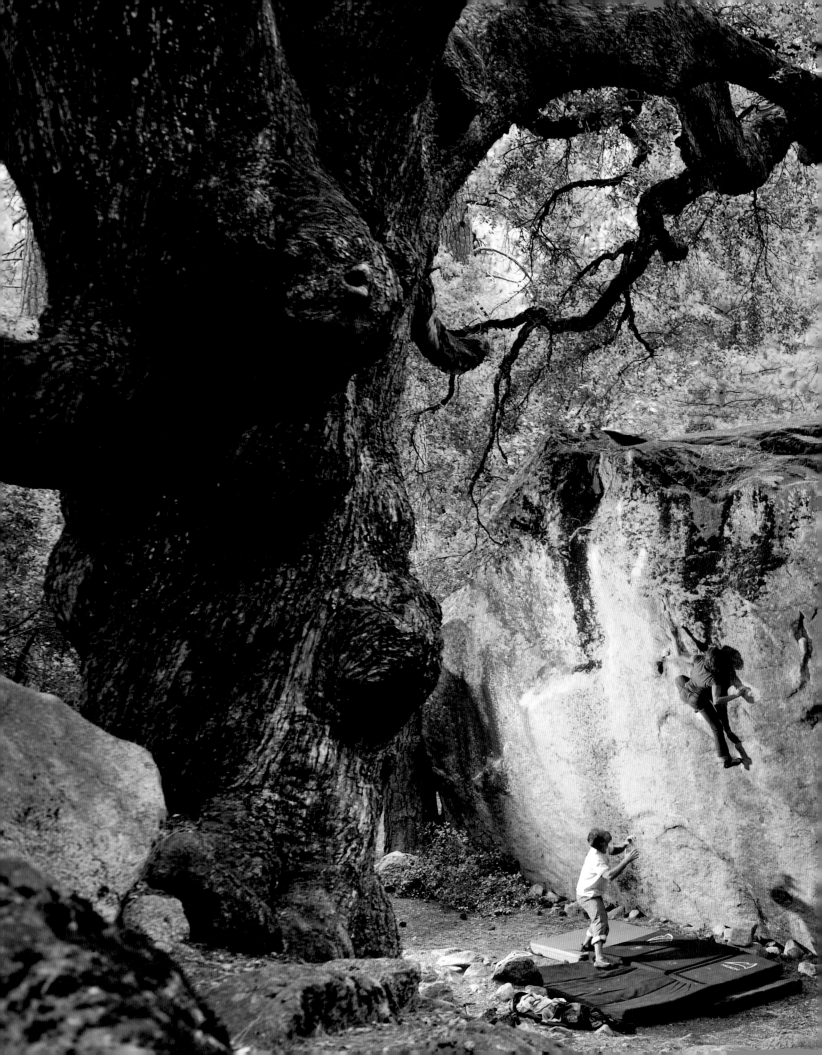

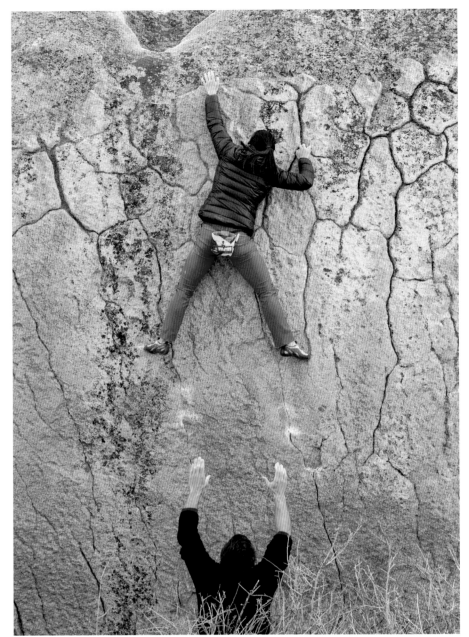

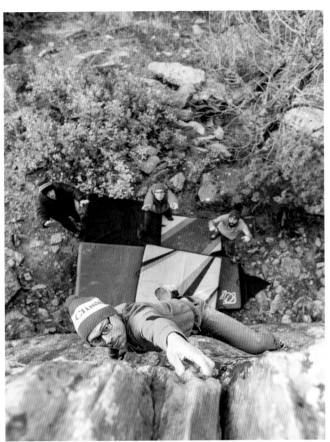

↑ *Top left* Bishop, California's Buttermilks bouldering area is known for its patina edges and aesthetic stone. ↑ *Top right* The taller the boulder, the more spotters you might need! → *Right page* Boulderers are all about their footwear: tight, downturned shoes are the name of the game. →→ *Following spread* Bouldering can take climbers to the most aesthetically beautiful settings, even without getting high off the ground.

→ learn. You don't need a lot of gear or technical training or a belayer; you can just put your shoes on and start climbing. It's also a super-social type of climbing, where you spend more time on the ground with friends than high up on the wall by yourself.

Because of its simplicity and social nature, bouldering is the perfect gateway drug to get people hooked on the sport of climbing. It has exploded in popularity in recent years, fueled partially by the exponential growth of climbing gyms and the resulting access to indoor bouldering. While the proliferation of bouldering is exciting, it can be problematic for the outdoor areas we love to visit. More people means more environmental impact. As we look toward the future, reducing our footprint in these areas should be celebrated the same as—if not more than—athletic achievement.

What started as a way to practice for "real climbing" has evolved into a unique sport with millions of participants, many of whom will never tie into a rope. Year after year, the boundaries have been pushed. The first V14/8B+ was climbed in 2000, the first V15/8C in 2005, and the first V16/8C+ in 2008. Ashima Shiraishi, who was 14 at the time, became the first female to climb V15/8C in March 2016, after sending *Horizon* in Japan. Two other women have climbed V15/8C: German climber Kaddi Lehmann and Japanese →

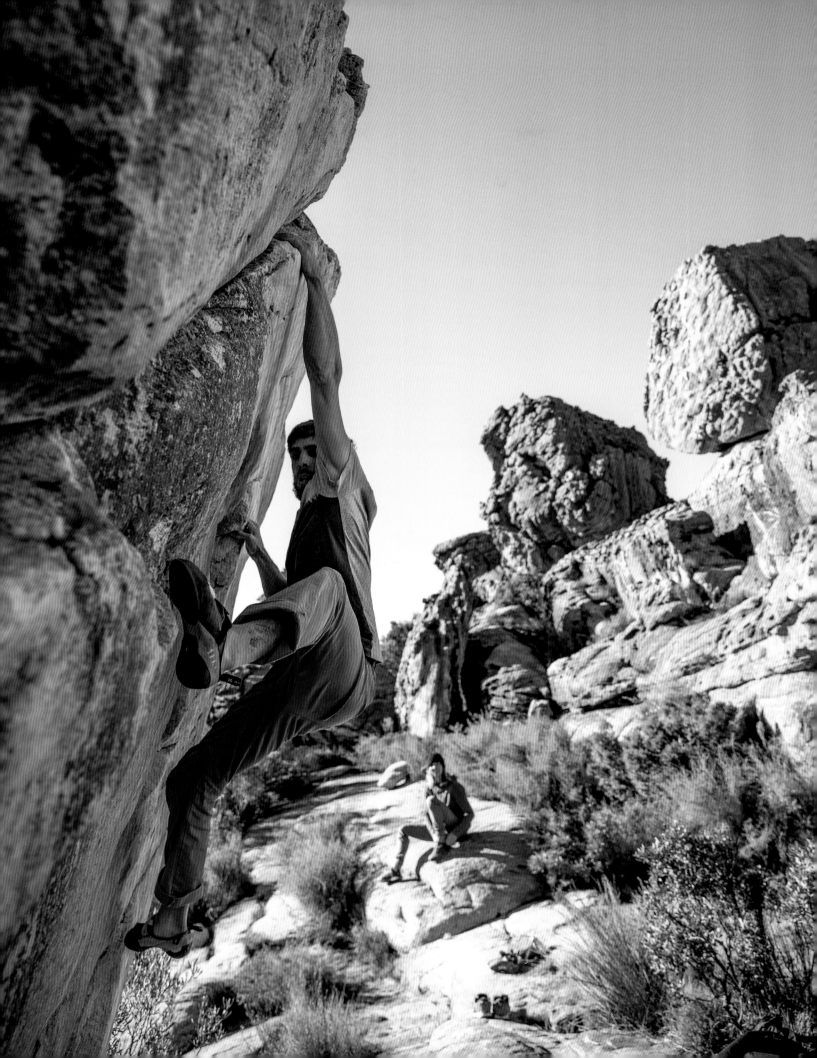

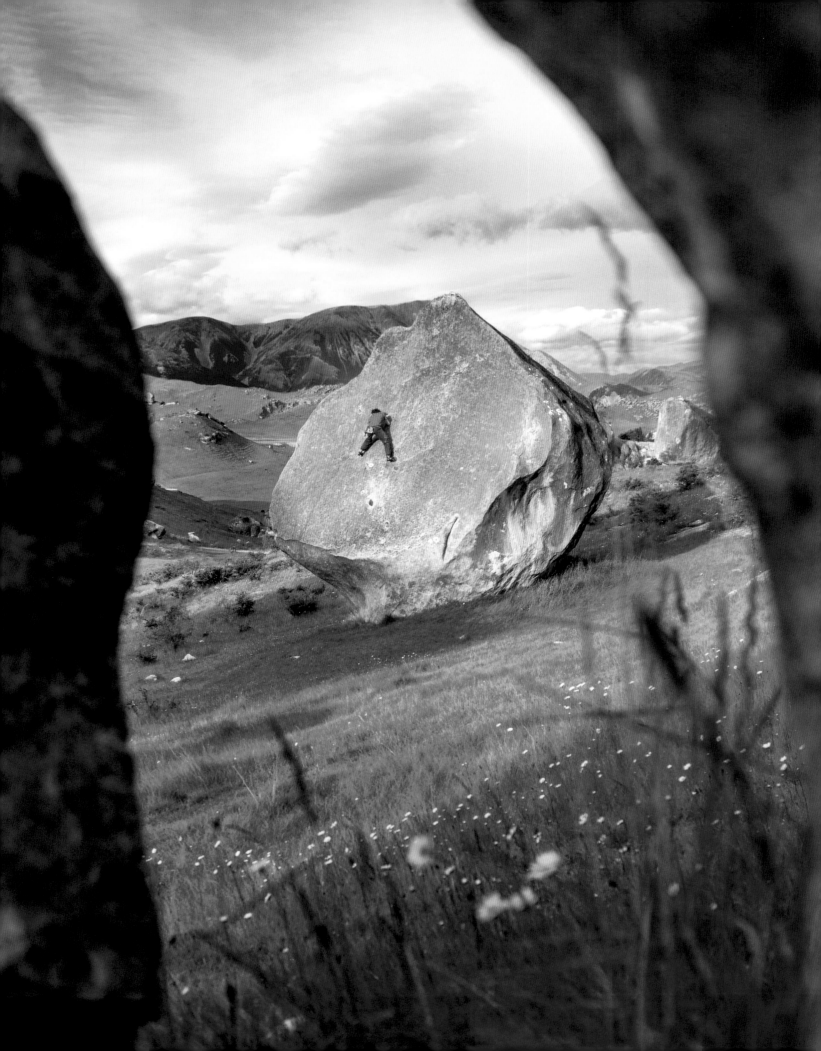

→ climber Mishka Ishi, in 2018 and 2019, respectively. At 13 years old, Ishi is also the youngest person to have climbed V15/8C. The current hardest boulder problems in the world are proposed 9A or V17. In October 2016, Nalle Hukkataival sent a four-year project in his home country of Finland, calling it *Burden of Dreams* and suggesting V17/9A as the first in the world of the grade. As climbers get stronger and the hardest climbs get repeated, only time will tell how far the next generation will take the sport of bouldering.

There are two main grade scales for bouldering, plus one historic. John Gill, the American climber who is considered the "father of modern bouldering," created the closed B-system (B1, B2, B3), which is no longer in use. B1 was measured against the highest level of trad climbing at the time, B2 was harder than B1 and considered "bouldering level," and B3 was a problem that had only been done by one person but attempted by others. Because of the closed system with only three categories, problems would change categories →

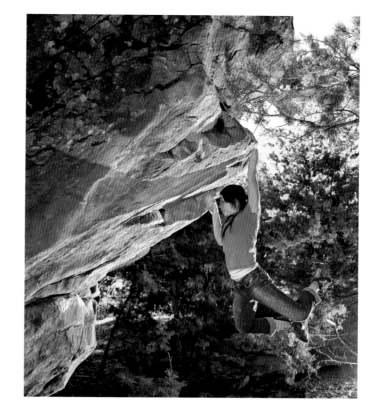

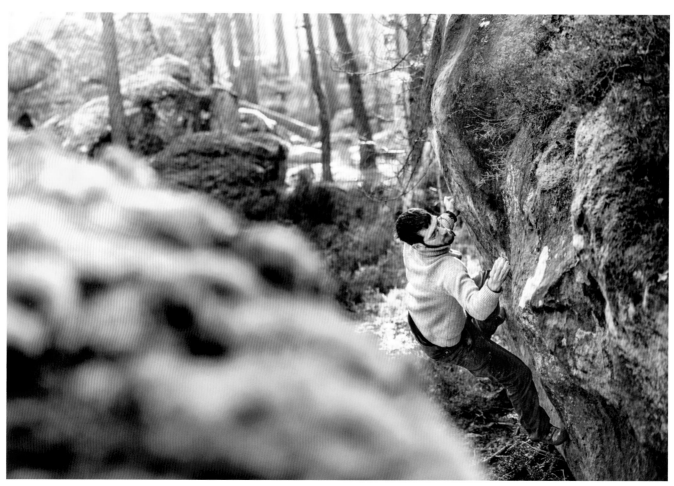

← *Left page* Typically crash pads are used for protection in a fall, but thick grass offers a slightly softer landing too. ↑ *Top* Bouldering requires powerful movements, so "foot cuts" are common, meaning a climber's feet come off and swing away from the rock. ↑ *Above* The magical forest of Fontainebleau, France, is thought to be the birthplace of bouldering.

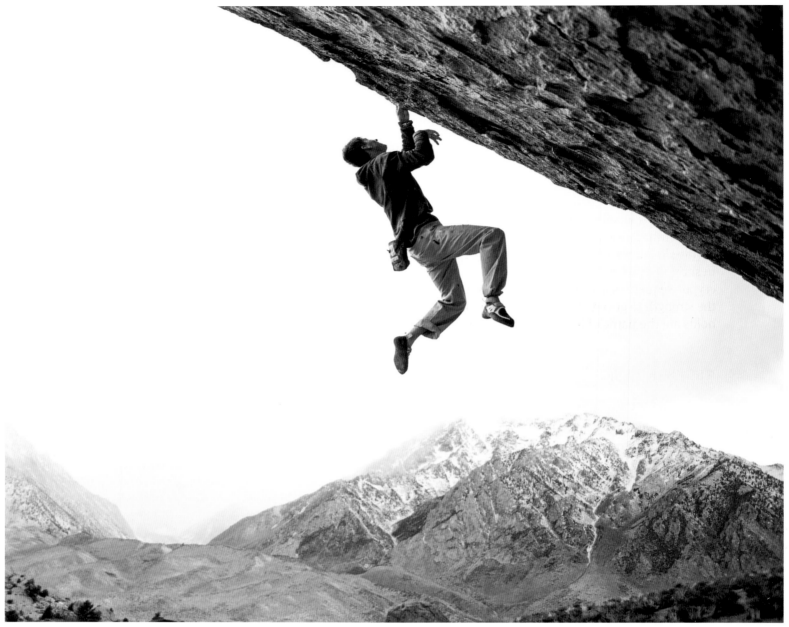

↑ *Above* The Buttermilks in Bishop, California, is a top bouldering destination in the United States and across the globe.

→ over time and the scale would shift as traditional climbing standards rose. For example, a B1 climbed in 1965 would be harder than a B1 climbed in 1959. As soon as a B3 problem was done by a second person, it would become a B2. Gill designed it this way in order to attract climbers who were interested in the physical and mental qualities of bouldering, not people who wanted to chase grades. However, Gill's system was never widely used and has been mostly phased out.

The two current systems are Fontainebleau grading and the V-scale. (Many other countries, such as Japan and the United Kingdom, have their own grading systems, but the Fontainebleau and V-scales are the most popular and widely used.) Fontainebleau grading is used mostly in Europe and anywhere outside the United States, and it was developed in—you guessed it—Fontainebleau. The

V-scale, so-called because of its creator's nickname, John "The Vermin" Sherman, was developed in the bouldering mecca of Hueco Tanks, Texas, in the 1990s. (See the chart on the opposite page for how each system is broken down and how the scales correlate to each other.) Both systems are open-ended, meaning that as the difficulty of boulder problems develop, new grades will be added to the system. Climbing grades in general are completely subjective, but they're a good starting point for describing difficulty. Often when people complete a boulder problem for the first time, they will suggest a grade. When other people complete the climb, they will agree with the grade or potentially suggest an easier or harder grade. After several people have done the problem and suggested grades, the problem will settle on what is considered a confirmed grade.

BOULDERING

Good to Know

WHAT SETS IT APART

Bouldering is all about doing unique, interesting moves that require maximum strength in short bursts. Figuring out the cryptic sequences and having the strength to grip really bad holds are the name of the game.

NECESSARY SKILLS

Falling and spotting techniques, or how to help other climbers land safely and not get injured.

FITNESS FOCUS

Finger strength, full-body strength, and a LOT of power.

ICONIC LOCATIONS

Fontainebleau, France; Bishop, U.S.; Squamish, Canada; Rocklands, South Africa; Magic Wood and Ticino, Switzerland; Hueco Tanks, U.S.

RATING SYSTEM

Hueco V-scale or French scale

NOTABLE FIRSTS

1930s Pierre Allain and the "Bleausards" start bouldering in Fontainebleau, just for the sake of bouldering itself, not just "practice climbing."

1950s John Gill specializes in bouldering and becomes the discipline's biggest advocate; he later introduces chalk to the sport.

1978 Ron Kauk sends *Midnight Lightning* (7B+/V8) in Yosemite's Camp 4, arguably the world's most iconic boulder problem.

1990s John "The Vermin" Sherman invents the V-scale grading system.

1999 The climbing film *Rampage* features Chris Sharma and helps launch the bouldering era.

2008 Christian Core climbs the first 8C+/V16, Gioia, in Varazze, Italy.

2012 Tomoko Ogawa climbs *Catharsis* in Shiobara, Japan, the first 8B+/V14 completed by a woman.

2016 Ashima Shiraishi becomes the first woman to climb 8C/V15: *Horizon*, Mount Hiei, Japan. She climbs a second 8C that same year: *Sleepy Rave*, Grampians, Australia.

2016 Nalle Hukkataival proposes the world's first 9A/V17, *Burden of Dreams*, in Lappnor, Finland.

2018 Charles Albert proposes the world's second 9A/V17, *No Kpote Only*, in Fontainebleau, France.

GRADE SCALES FOR BOULDERING

V-Scale and Fontainebleau Scale in comparison, from very easy (VB/1) to extreme (V17/9A); A, B, C as well as + refine the difficulty level.

Hueco V-Scale (USA)	Font Scale (Franz.)
VB	3
V0	4
V1	5
V2	5+
V3	6A/6A+
V4	6B/6B+
V5	6C/6C+
V6	7A
V7	7A+
V8	7B/7B+
V9	7B+/7C
V10	7C+
V11	8A
V12	8A+
V13	8B
V14	8B+
V15	8C
V16	8C+
V17	9A

EQUIPMENT: BOULDERING

One of the charming features of this ropeless style of climbing is how little gear you need to do it. Just grab some chalk, shoes, a crash pad, and go. Bouldering removes the stress and challenge of dealing with a bunch of equipment, distilling climbing down to the purest form of movement. However, because the equipment list is so minimal, it means each item in your collection is that much more crucial.

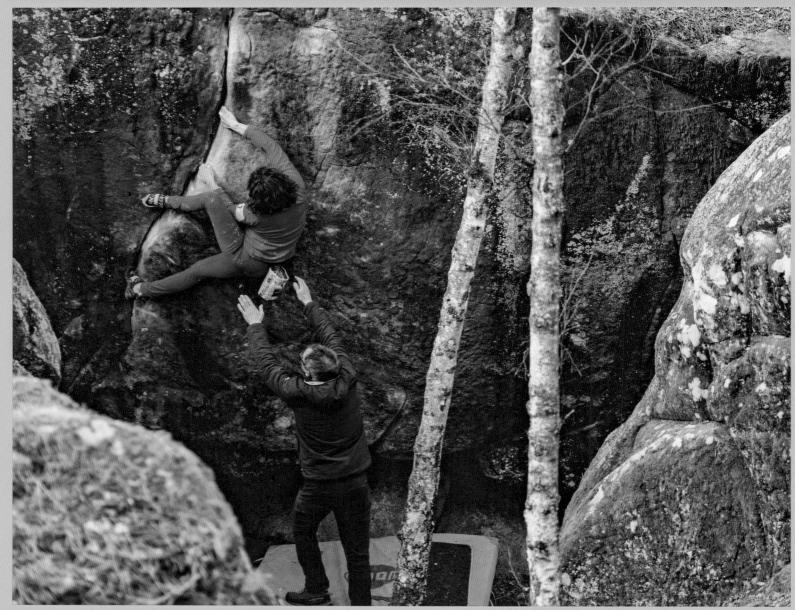

↑ *Above* Katie Lambert and Ben Ditto bouldering in Fontainebleau, France.

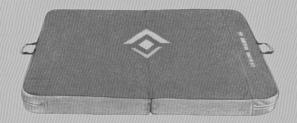

CRASH PAD

This foam mat is placed underneath a boulder problem so the climber lands on a soft, cushiony pad instead of the hard, unforgiving ground. Crash pads are usually 4 to 5 inches (10 to 12 centimeters) thick, with two different types of foam inside. Open-cell foam is the thicker layer in the middle that absorbs most of the fall and feels the squishiest. Closed-cell foam is the thinner layer on top (and on the bottom in some pads), and it is stiffer to disperse the force of a fall across a wider area. Crash pads fold up and have different carrying straps, including shoulder straps so they can be worn like a backpack.

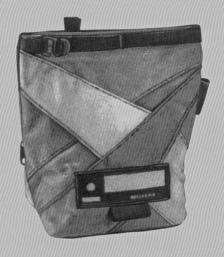

CHALK POT

Thanks to his background as a gymnast, American boulderer John Gill was the first person to use chalk for climbing in the 1950s. Composed of primarily magnesium carbonate, chalk acts as a drying agent to absorb sweat in the hands. A chalk pot is a container made of sewn fabric, with a flat bottom so it sits on the ground without tipping over. Typically it has pockets to hold tape or brushes, and boulderers will keep it out during a session so they can chalk up in between attempts.

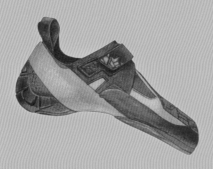

BOULDERING-SPECIFIC CLIMBING SHOES

The most important piece of gear for climbers are their climbing shoes, or rock shoes. They are tight fitting, with a sticky rubber sole that provides crucial grip. The tiny edges, divots, and nubbins used as footholds in bouldering are infamous for being horrible (read: hard to use), but the right climbing shoes can make all the difference. For the super-steep roofs and overhanging angles of bouldering, rock shoes are usually downturned, with an aggressive curve that mimics the foot's arch, and fitted very tight for aggressive performance. They can be Velcro, lace, or slip-on, with a formfitting heel that does not slip or slide.

BRUSH

Often boulder problems have the absolute smallest holds that seem impossible to hold on to, so every little bit of preparation helps. Chalk is important for drying a climber's hands, but too much chalk can actually have an adverse effect and reduce friction. Because bouldering involves a lot of attempts—grabbing the same teeny-tiny grips over and over and over—a brush can help keep the chalk on the holds to a minimum. There are a variety of brush sizes, shapes, and bristle types, but boar's hair brushes have very soft, fine bristles for the best performance.

FALLING FOR BOULDERING

Climbing at your absolute limit is usually 99 percent failure and 1 percent success, which means you are falling—a lot. The thing about bouldering falls is that each and every one is a ground fall, and terra firma can be quite unforgiving. From the beginning of bouldering, climbers would drag out carpets and mattresses to protect the landings. Many of them followed a simple ethos—do not fall—and would downclimb if moves became too difficult. Eventually the modern crash pad was developed, and bouldering grew in popularity because climbers could fall repeatedly without breaking an ankle. Like everything in climbing, falling is a skill that should be practiced in order to improve. Below are some basics on proper falling technique.

Do not try to stick the landing. The goal should not be to end up standing upright on two feet. Instead, boulderers should hit the pads feet first, knees bent, and let their bodies crumple under the force of the fall. Momentum will carry their bodies down to the pads.

Landing on your bum is a good thing—it is like a built-in crash pad.

Feet, knees, legs, and hips should be active and ready to absorb the force of a fall, but not so stiff that they do not give a little on impact.

Looking down at the landing can help put the climber's body in a favorable part of the landing zone.

Arms will naturally go out to the side as the climber falls, but they should be the last things to hit the pads. One of the most common injuries in bouldering is a sprained or broken wrist from a person's natural inclination to stick a hand out to stop a fall.

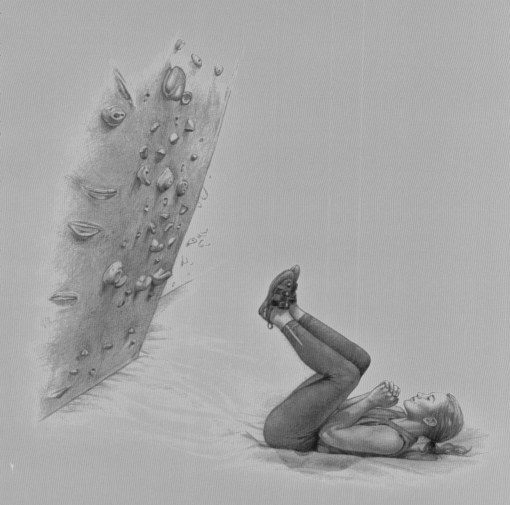

SPOTTING FOR BOULDERING

The best protection for bouldering is a soft, cushy crash pad to land on, but a spotter can be necessary to make that happen. The goal of spotting is to help a falling climber land on the crash pads. Usually one or more spotters stand slightly behind the climbers, watching them move, cheering them on, and remaining ready to help guide them onto the proper landing zone. While spotters are not always necessary, having people there looking out for you can provide extra confidence to try a hard move or go for it when you might otherwise want to back down.

Spotters should have an athletic stance, legs strong with knees and hips slightly bent, moving around as the climber moves on the boulder. If the climber falls, the spotters can squat to help absorb the force of the fall.

Arms are up with elbows bent and palms facing out, fingers and thumbs tucked tightly against each other (think spoons, not forks). This helps prevent a hand or wrist injury to the spotter.

Staying prepared for climbers to fall at any time until they are safely standing on top is key, as well as being aware of the hard sections where a fall is likely. If the climbers fall, the spotters will put their hands on the climbers' hips and forcefully push them in the direction of the pads.

Great spotters are also great at arranging pads into a solid landing zone. The best landing zones are a double layer of crash pads (more if the problem is high), with no major gaps or edges. Spotters might need to move pads if the climber traverses sideways, or if there are not enough pads to begin with.

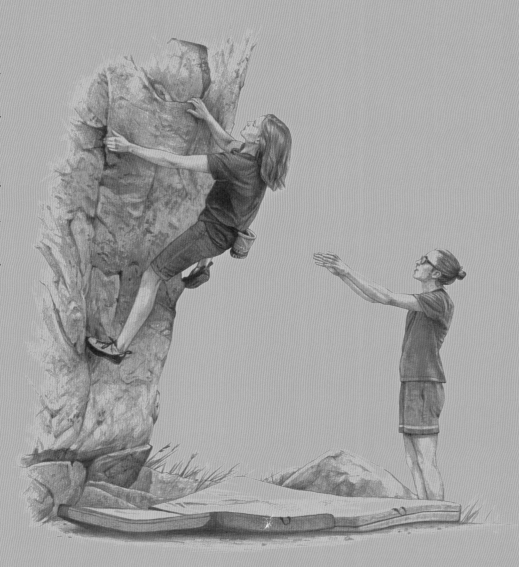

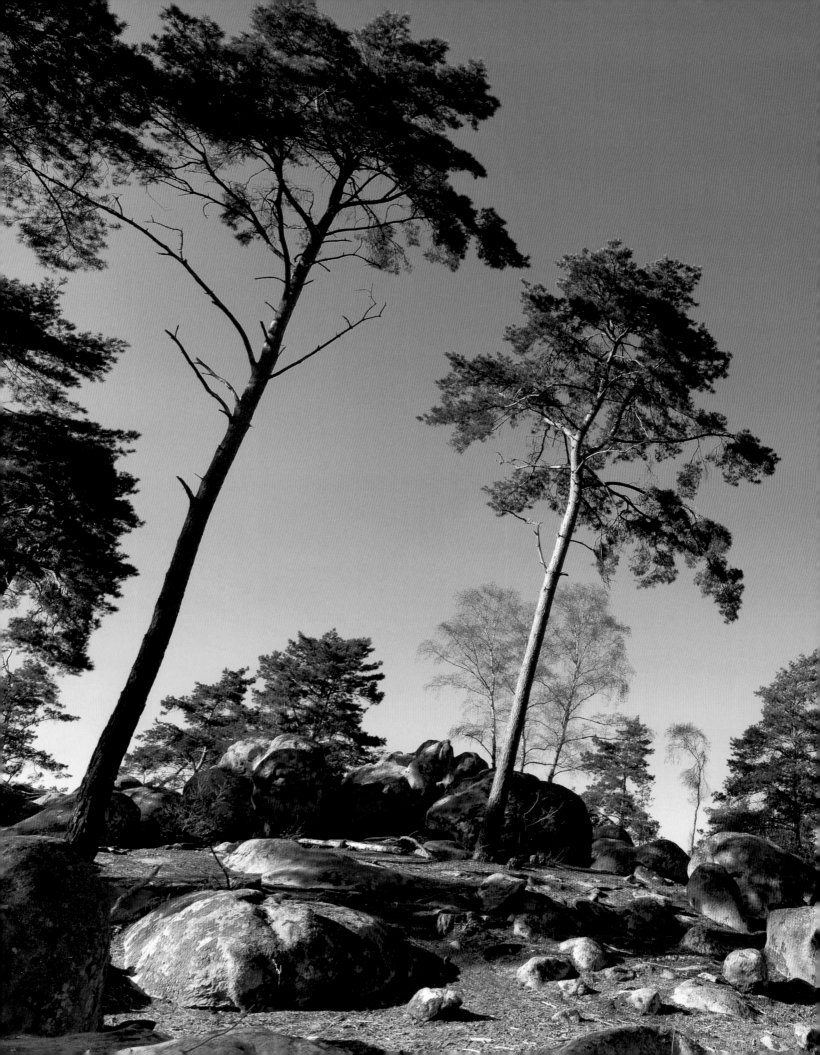

FONTAINEBLEAU

Île-de-France · France

With endless blocks in a beautiful French forest,
the birthplace of bouldering is still everyone's favorite
destination for pebble-wrestling.

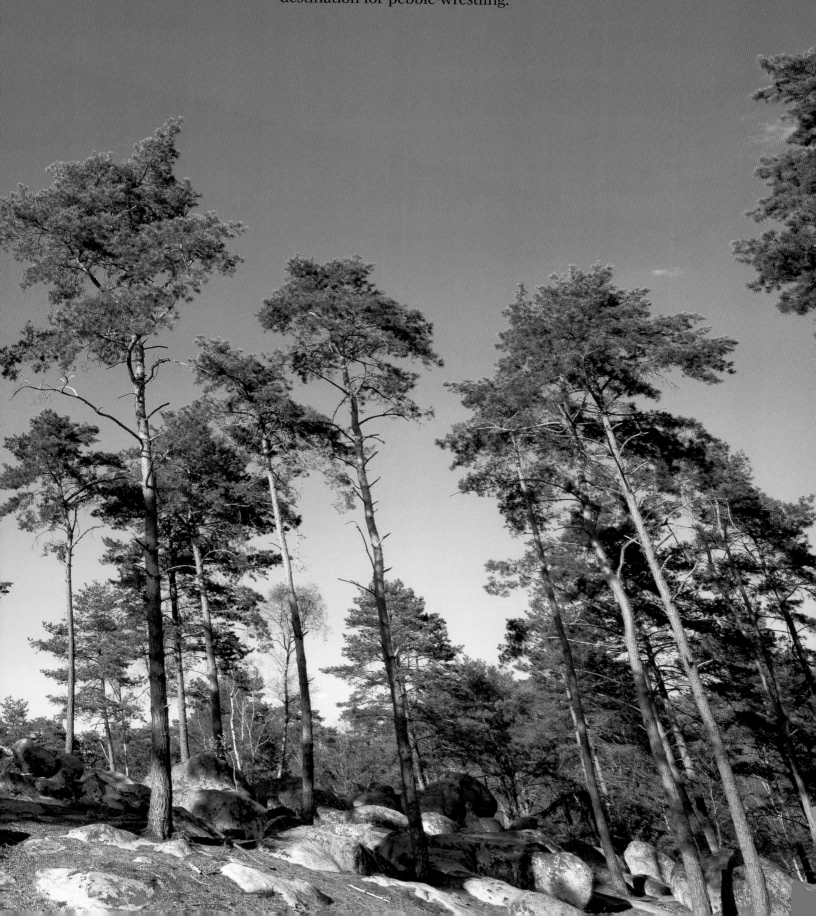

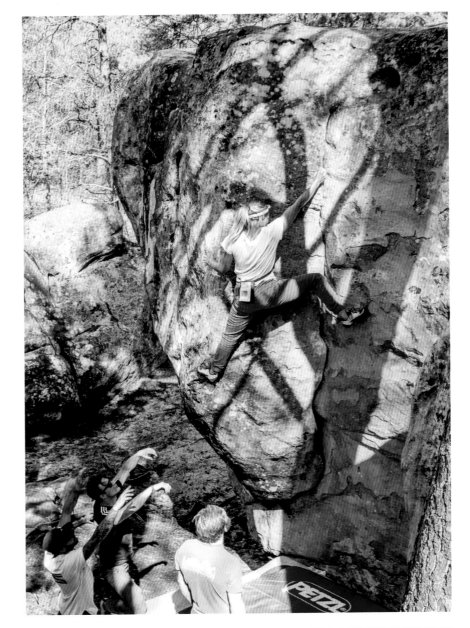

Not everything stands the test of time, but those things that do usually endure for good reason. Fontainebleau is no exception. This area in France, about 37 miles (60 kilometers) south of Paris, is a massive, sweeping forest that is dotted with thousands of medium-size boulders. Called "Font" by foreigners and simply "Bleau" by locals, the nearly 115 square miles (300 square kilometers) contain more than 20,000 individual boulder problems located primarily on *forêt domaniale,* or national forest, land. (Some of the areas are on private land.) Approaches are super-short (10 minutes or less) and totally flat. Grades range from V-easy to 9A/V17, the actual hardest grade in the world. Font is also where the commonly used grading system of the same name started, known as the Font scale. A short train ride from the City of Lights, plentiful *gîtes* to rent in the area, and the unbeatable French cuisine make Font a top destination for climbers all over the world. Most of the problems are only a dozen feet (a few meters) tall, and thanks to flat landings covered in sand and leaves, climbers can focus on the challenging movement, instead of committing to tall, scary top-outs.

Walking through the expanse of boulders, anyone can see the climbing potential of the sandstone blocks covered in crimps, jugs, *huecos,* pockets, slopers, arêtes, and cracks. This is why the *Club Alpin Français* (French Alpine Club) started going there in the late 1800s to practice and train for bigger mountain objectives in nearby Chamonix. Initially the alpinists were climbing in boots and spiked shoes before moving onto espadrilles, or moccasins with soles made of rope. Pierre Allain started coming to Font in 1930 and found that stiff mountain boots didn't work on the subtle divots and rounded slopers of Font. He started using sneakers that he reinforced with rubber on the sides. (His design would eventually lead to a climbing-specific shoe called the PA in 1947. Shoemaker Edmond Bourdonneau eventually bought Allain's business and created the EB, widely considered the first commercial climbing shoe.)

In 1934, he climbed the now-famous *Allain Angle,* a laser-cut 6-/V2 arête. Allain and his crew of "Bleausards," a group that included Robert Paragot, Lucien Bérardini, and René Ferlet, took their Font training to the big mountains of the Karakoram, Aconcagua, and the Aiguille du Dru. There were talented alpinists who were starting to see the light of bouldering as a standalone

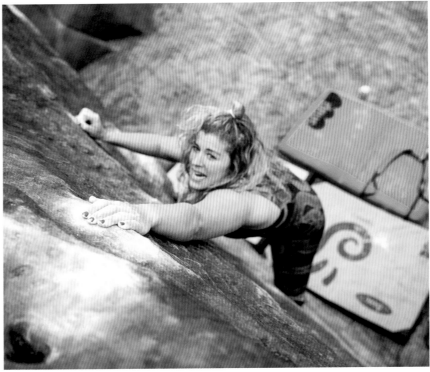

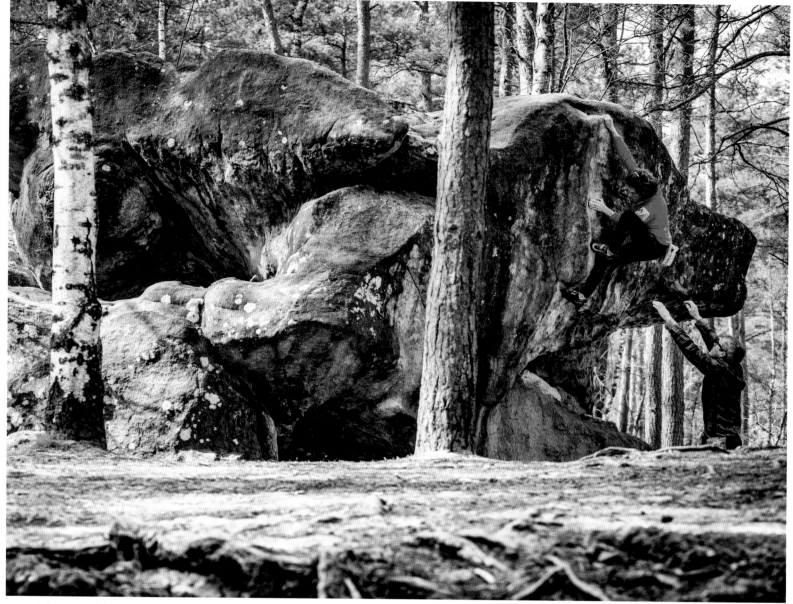

← *Left page top* Miriam Wallenius tackles a bouldering problem in Fontainebleau, which has boulders of all difficulty, angle, and height. ← *Left page bottom* Lou Gold goes for it on a problem on the red circuit at Roche aux Sabots, Fontainebleau. ↑ *Above* Katie Lambert finds the beta while her husband, Ben Ditto, spots. →→ *Following spread* Ben Ditto topping out a laser-cut block in Fontainebleau. →→ *Page 36* Fontainebleau boulders are known for slopers, or rounded climbing holds, that require a lot of friction and strength to grip.

pursuit, enjoying the challenge of intricate movement and difficult grips on these short blocks. The Bleausards became adept at figuring out the subtleties of movement demanded by the sculpted stone, relying on repetition to perfect the moves and falling on rugs or straw pads. In his 1947 book, *Alpinisme et Compétition,* Allain wrote, "If need be, we can try a given hard start twenty times in a row, learning thereby, with exactitude, the friction limits between rock and rubber. We can detect precise [sense] balancings, trust incredibly small holds and in this way acquire the qualities of a climber that are superior to those given by any other major school of rock climbing."

The first climbing map to Font appeared in 1945, and two years later, in 1947, Fred Bernick started creating circuits. Bernick would climb a problem, descend the boulder, and head straight to another problem, stringing a few dozen boulders together in this manner. This allowed him to create a high volume of problems in a short amount of time, dialing in technique and improving endurance to carry into the alpine. Bernick and other *Bleau* climbers painted colored dots and arrows at the starts of boulders, the former indicating the difficulty and the latter indicating which direction the problem goes. On the tops of the blocks, an arrow would indicate the direction of the next problem in the circuit. Today there are more than a hundred different circuits of varying difficulty and length; some are a few dozen problems, some are 100-plus problems. Whether you come for the unique circuits, the hard problems in a beautiful setting, or just the butter-filled food, walking through the forests of Font is like walking through the history of bouldering.

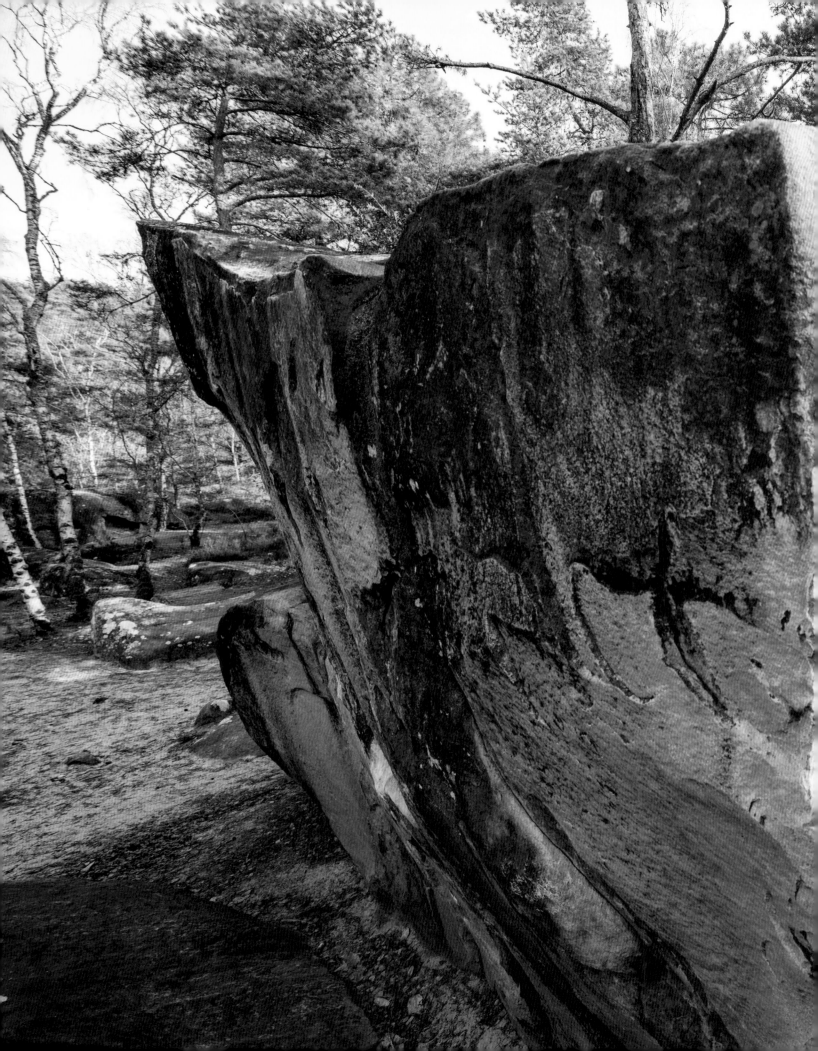

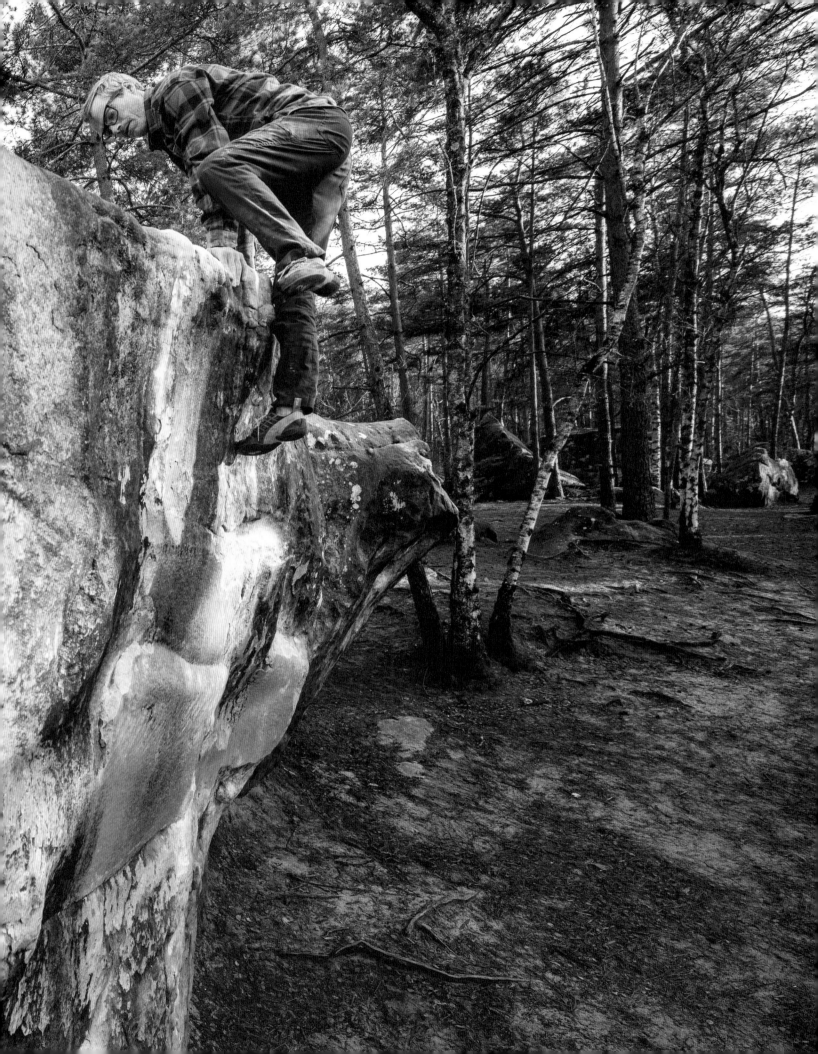

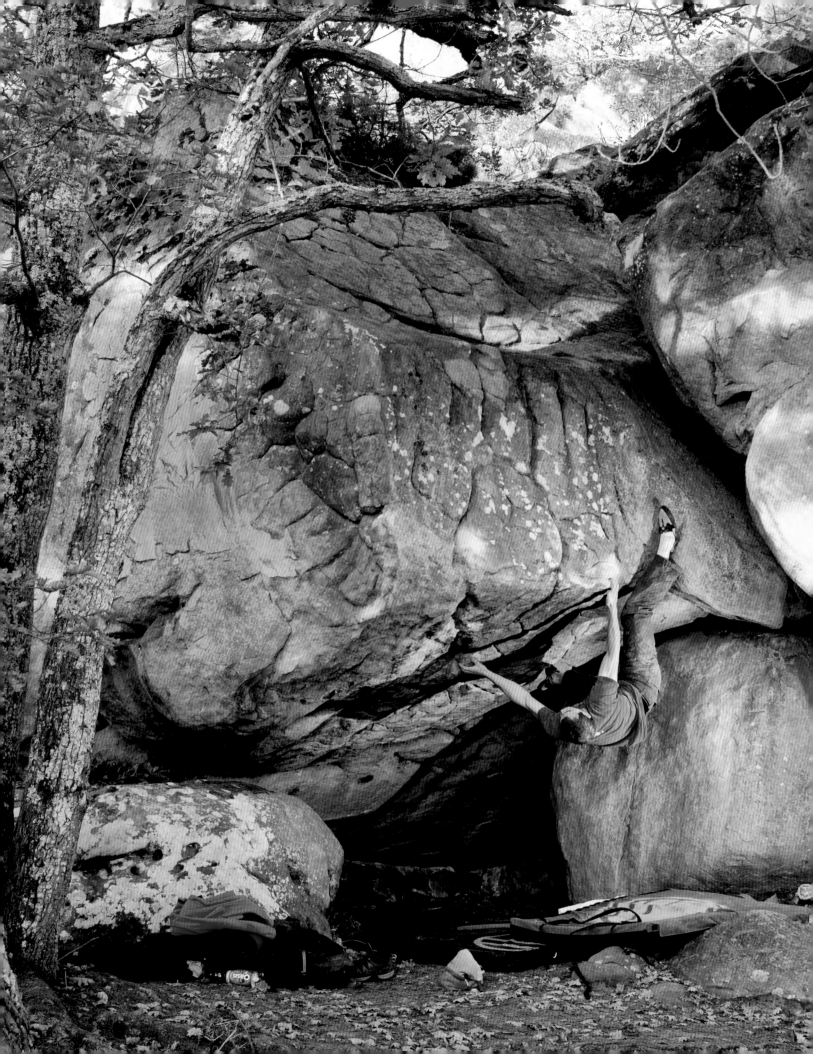

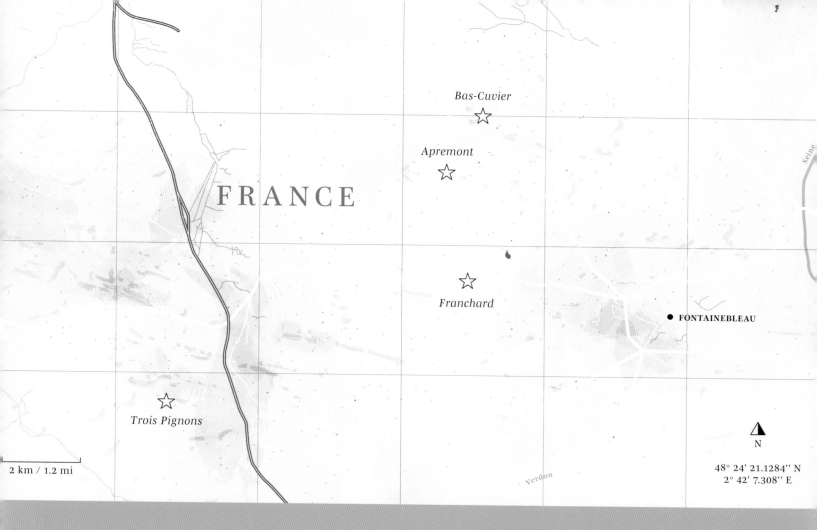

Bas-Cuvier
☆

Apremont
☆

FRANCE

Franchard
☆

● FONTAINEBLEAU

Trois Pignons
☆

2 km / 1.2 mi

Seine

Verdon

▲
N

48° 24' 21.1284'' N
2° 42' 7.308'' E

FONTAINEBLEAU

in a Nutshell

CLIMBING TYPE

Bouldering

PROTECTION

Crash pad

SEASON

Spring, fall, winter
(can be really cold)

WHERE TO STAY

Book a gîte, or small
vacation house.

ONE MORE THING

Font's popularity makes it very
susceptible to impact issues
from overuse. The areas are pro-
tected by the local and national
governments, but it's up to
climbers and other land users
to act responsibly while there.
Do research beforehand on
proper practices.

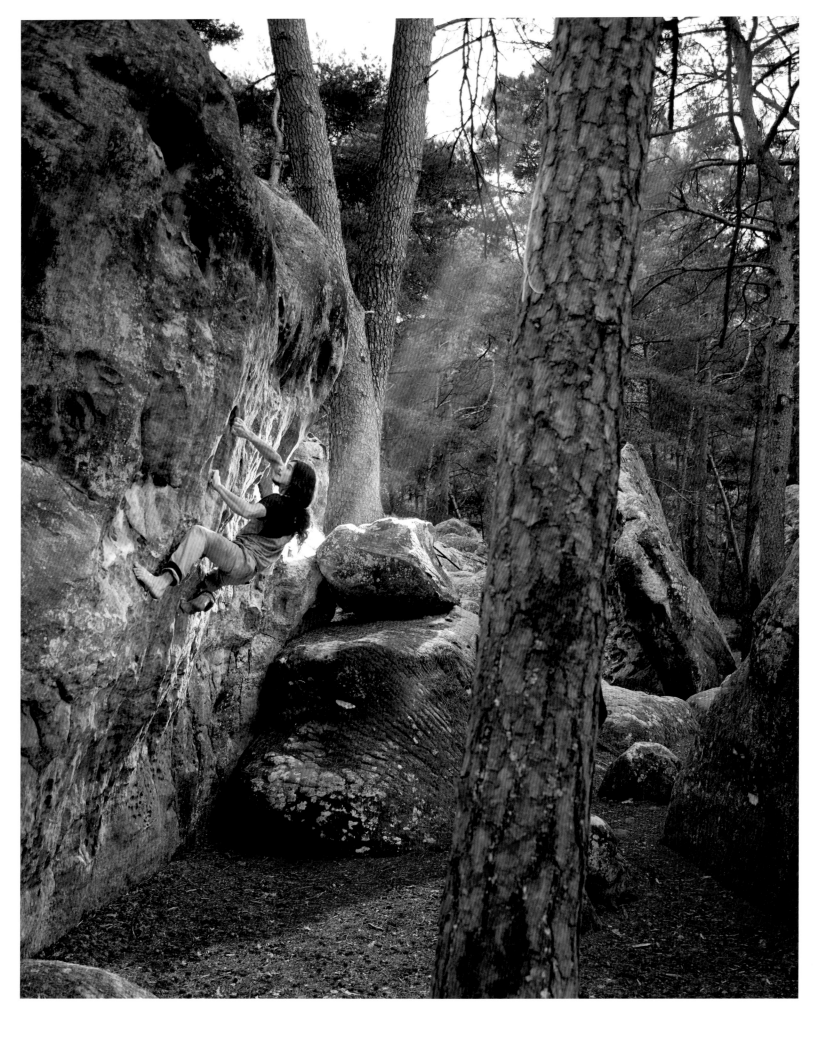

CHARLES ALBERT

THIS YOUNG FRENCH CLIMBER HAS BEEN
BOULDERING SINCE HE WAS A KID.
AT ONE POINT HE TOOK OFF HIS CLIMBING SHOES,
STARTED DOING WELL, AND
NEVER REALLY PUT THEM BACK ON.

The dexterity and strength of a climber's fingers make them perfect for adapting to the infinite holds of rock climbing. The knuckles of each joint bend at just the right angle, and the pads of each digit conform to the tiniest of nubs. Like a samurai prizes his katana, climbers value their hands and take meticulous care of the fickle skin on their palms and fingers. They chalk them for improved grip before climbing and rest them after a long session to heal and regrow skin. Watching Charles Albert climb in his notorious style—that is, barefoot—it might look like he has four hands.

Sitting below the sculpted sandstone in his home climbing area of Fontainebleau, France, Charles dips his hand in his chalk bag and pats the bottoms of his feet, rubbing the agent evenly over his toes and soles. When he steps onto the rock, he is immediately more reminiscent of a chimpanzee than a human rock climber, whose feet are typically covered in black-soled rock shoes. Each of Charles's toes has a bony protrusion at the knuckle, which are typically a sign of strengthened tendons and found on a climber's hands, and the digits articulate so delicately that they can wrap individually around divots and bumps in the rock. There is no better display of Charles's pedal superiority than on the slopey, pocked blocks of Font, where subtle footwork can be the true decider of success. Charles climbs without a crash pad below him, saying he likes climbing with the fear of the fall. "Climbing isn't just a number followed by a letter," he says. "You can do whatever you want, like climbing blindfolded, barefoot, downclimbing, and so on. Search for the flow in your moves. There are as many challenges out there as you can imagine."

Climbing barefoot is nothing new. Whether it is because of a lack of access or funds, or just by personal preference, climbers have done their sport without using modern →

→ sticky rubber climbing shoes. In the era of modern technology and equipment, Charles's choice to climb without shoes might at first appear to be a novelty, but the pure difficulty of his tick list refutes that. He has ticked multiple boulder problems in the 8C / V15 and 8C+ / V16 range, as well as doing the first ascent of a problem in January 2019 and proposing a grade of 9A / V17. All barefoot. The hardest problem he has done with shoes is 8A / V11.

"When you climb barefoot, you can use your toes to grab holds," he says. "It opens a lot of possibilities. Also it makes climbing more intuitive, because you can feel what you are standing on. That means you immediately get to know what you can and cannot do on a given climb." When he first started climbing without shoes, he says it was a little bit painful, and he quickly learned he had to go easy on heel hooks and toe hooks. In particular, the skin on the top of his foot is more fragile and rips easily, sometimes forcing him to take a week or more off to rest the skin and let it heal. But the more he climbed barefoot, the stronger his toes got. "I now can stand on edges I once thought were too small to stand on without a climbing shoe," he says.

His notable ascents have included *Monkey Wedding* (8C / V15) in Rocklands, South Africa; *Le Pied à Coulisse* (8C+ / V16) in Fontainebleau; and the first ascents of *La Révolutionnaire* (8C / V15), *La Révolutionnaire Extension* (8C+ / V16), and *Hypothèse Assis* (8C+ / V16), all in Fontainebleau. In January 2019, he got the first ascent of *No Kpote Only* in Font's Rocher Brûlé, suggesting it as the world's second 9A / V17. (In March 2019, Japanese climber Ryohei Kameyama made the second ascent of the line and used different beta, including a heel hook. He suggested it might be easier than the proposed grade of 9A / V17.) Despite the impressively high grades of these ascents, Charles cites his proudest ascent as *Duel*, a famous 8A / V11 slab in Font. "Because it is in the forest," he says, "it is the climb we considered impossible with no shoes."

Charles was a self-described quiet child, with the best grades in class even though he did not like school. "It was abnormal for me to make a mistake—I was competitive," he says. "I remember I was usually bored as a child. I wanted to play video games on the computer, but I had a time limit, then I was bored again." Weekdays were school, soccer, meals with his family, cartoons on TV, and reading comics before bed. On Saturday, he would play soccer with his classmates most days because "my father wanted me to do an activity outside school, so I did what every other kid was doing." On Sunday morning, they would go shopping at the local market with his mother, and when the weather was nice, they would go climbing as a family.

"I have always been climbing," Charles says. "My parents were climbing, so as an infant, I just mimicked them. My father still climbs. As I grew up, I wanted to climb more, so we went climbing more often, with my father. I've always liked climbing, and I've always been good at it." At the age of nine, he learned about the grading system and was able to climb 5A / V1 boulders easily. When he was 10, he stopped playing soccer and picked up archery, and his parents got

↑ *Above* Albert grew up climbing in the forest of Fontainebleau, and it remains one of his favorite climbing destinations. → *Right page top* Albert enjoys the "perfect angle" of *l'Angle Parfait* (7B / V8) in the Massif de la Dame Jouanne area. → *Right page bottom* Charles Albert shows the beta of a first ascent he did during the Blokuhaka climbing festival in Kerlouan, France. →→ *Following spread, left* Albert climbs a 7A / V6 in the Cuvier Est area of Font. →→ *Following spread, right* Climbing on a blank arête is all about finding a delicate balance between pushing with your feet and pulling with your hands, which Albert skillfully manages on this V8 / 7B boulder problem.

NOW HE LIVES IN THE WOODS MOST OF THE TIME AND FOCUSES ON CLIMBING, OCCASIONALLY TRAVELING TO OTHER NOTABLE CLIMBING AREAS TO "LOOK FOR A BOULDER I CAN SPEND A LOT OF TIME ON WITHOUT GETTING BORED."

divorced. He was told he was a genius at archery. As a child, he earned the nickname Mowgli because of his resemblance to Rudyard Kipling character, a human child raised by wolves in the jungles of India. With wild black hair hanging halfway down his back, Charles would soon resemble the barefoot, tree-climbing child in more than just appearance.

In 2012, a 14-year-old Charles went to the south of France with his older sister, his father, and his father's girlfriend. "There were some rocks to climb, and my father did not bring his climbing shoes, so he climbed barefoot," he says. "I tried it and thought it was inefficient. Next year, I was warming up barefoot, then trying hard boulders with shoes. A couple months later, my climbing shoes were too small, so I just stopped using them." Now he lives in the woods most of the time and focuses on climbing, occasionally traveling to other notable climbing areas to "look for a boulder I can spend a lot of time on without getting bored." While he says his future is somewhat uncertain, it will probably involve sending even harder problems—*pieds nus*.

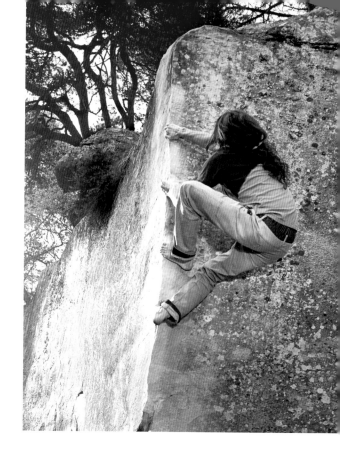

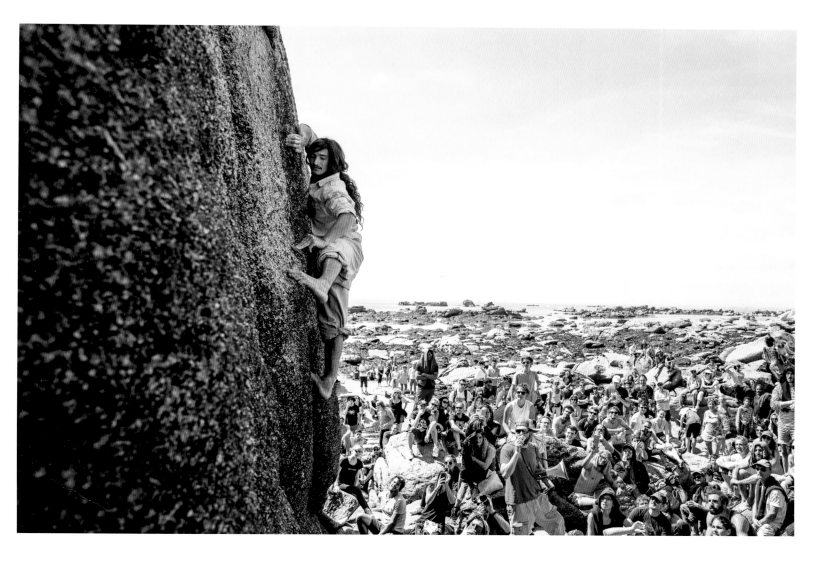

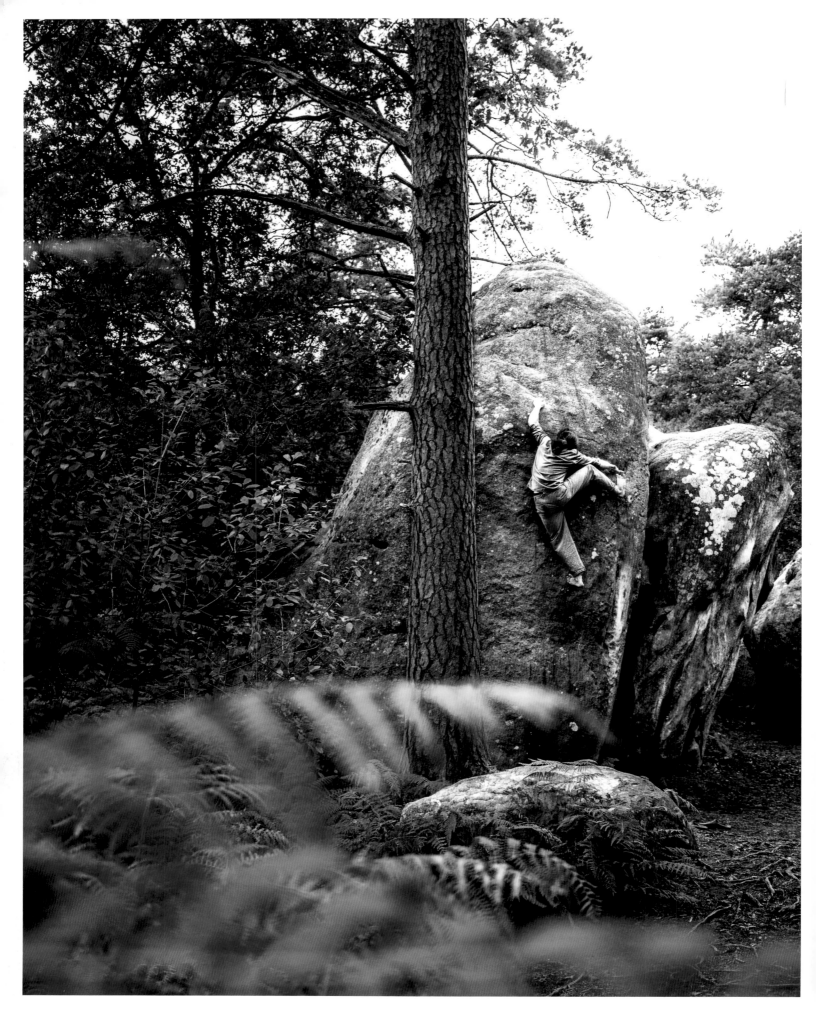

CHARLES ALBERT

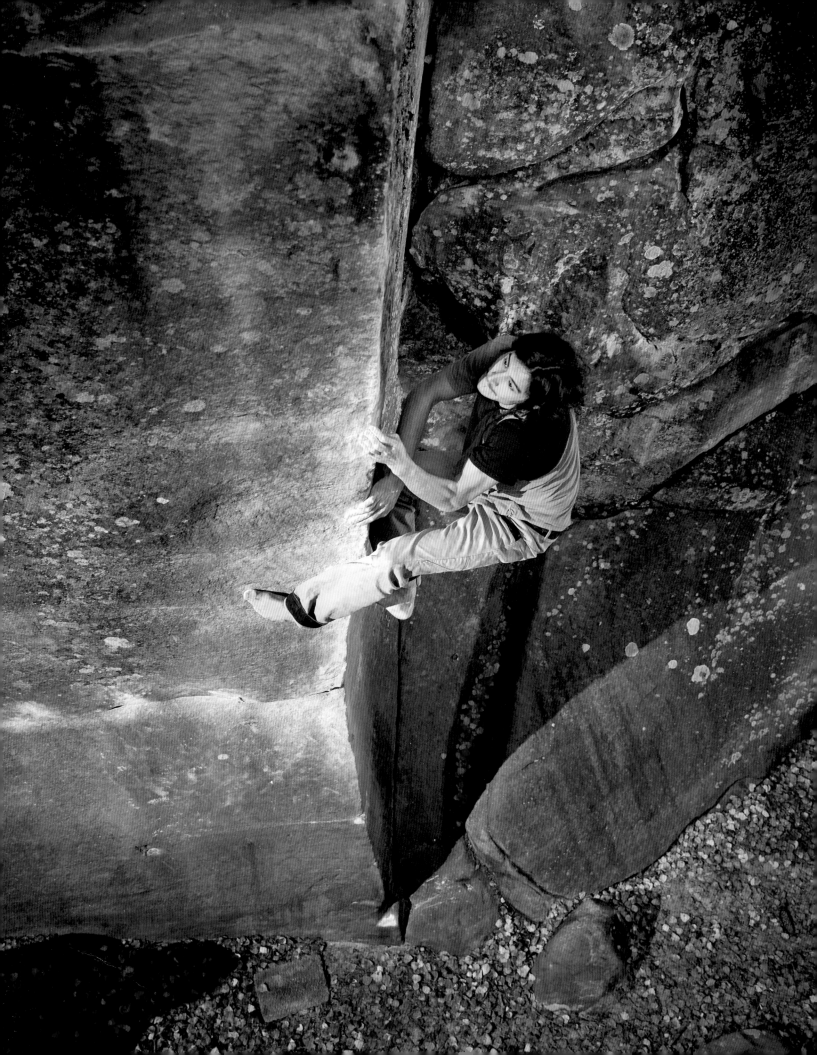

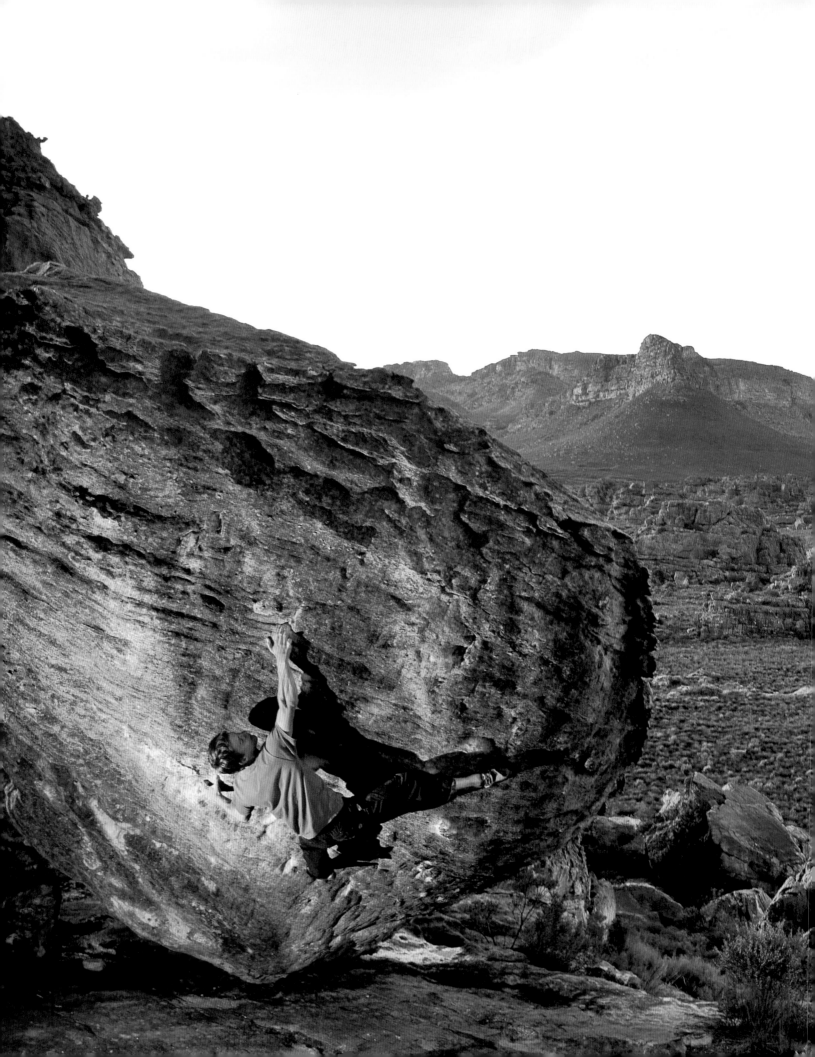

ROCKLANDS

Western Cape · South Africa

The quantity and quality of bouldering in this
South African gem are unsurpassed—more rocks that
are better than you can even imagine.

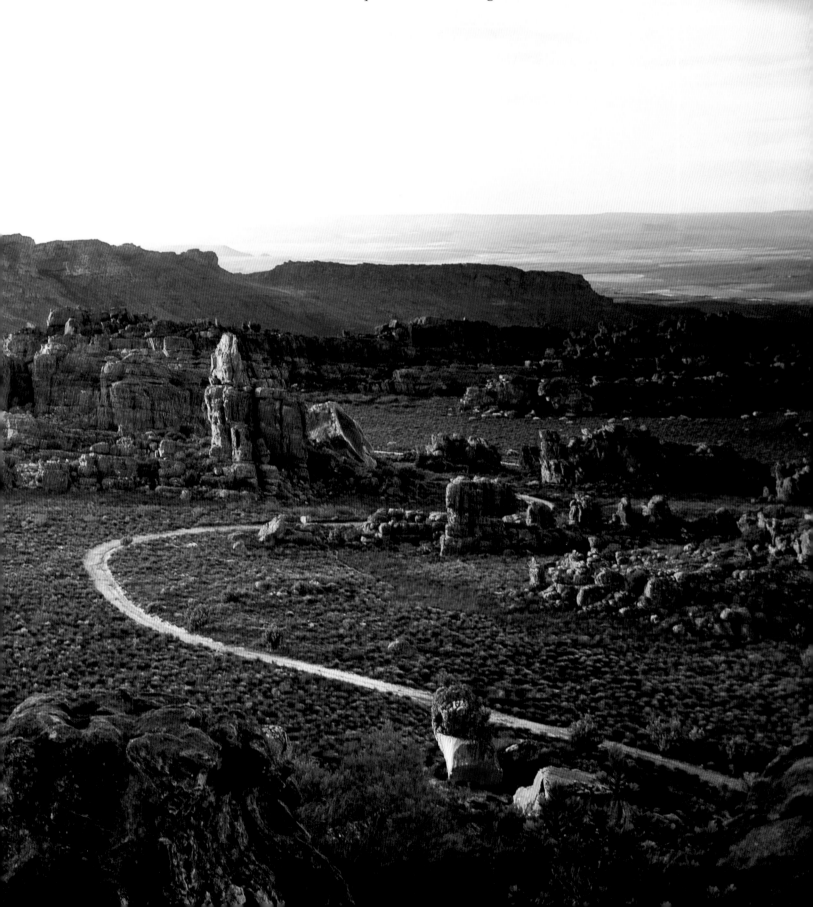

"If rock climbing is a distillation of mountaineering, then bouldering is grain alcohol." This quote from a 1996 video of bouldering in Rocklands perfectly sums up how the ropeless discipline fits into the bigger picture of climbing. When American Todd Skinner visited the Cederberg Mountains of South Africa in 1992 looking for sport climbs in the area, it was the overwhelming number of sandstone boulders at the bases of the cliffs that left him speechless. Skinner, who was from Wyoming, was known for making big wall free ascents throughout the United States and abroad, including the first free ascents of the *Salathé Wall* (8a / 5.13b) on Yosemite's El Capitan and the *Cowboy Direct* (7c+ / 5.13a) on the east face of Trango Tower in Pakistan's Karakoram Himalayas. The latter is the world's first grade 7 free climb, due to its length and commitment. In Rocklands, Skinner turned his attention to focusing on pure difficulty of movement, inviting his friend, Swiss boulderer Fred Nicole, to the area in the late 1990s to develop and put up problems. Nicole spent many consecutive summers (South African winters) in Rocklands and put up countless first ascents, many of which are the hardest problems in the area.

Probably the most aptly named climbing area in the world, Rocklands is just that: a vast—emphasis on the word vast—expanse of boulder fields. Three hours north of Cape Town, the hillsides are covered with orange-and-gray-streaked sandstone blocks located on a CapeNature conservation reserve, as well as numerous private properties. Due to the ever-increasing popularity of the area, a permit system has been put in place, where climbers must pay a small fee to climb each day. With more than 2,900 problems up to 8C+ / V16 spread out over 50-plus areas, climbers of all levels will find plenty to do. The style here favors gym climbers who are familiar with the overhanging walls and big holds that constitute the setting trend of modern plastic paradises. Much of the sandstone is featured and steep, with positive holds. This amounts to powerful climbing with lots of heel hooking, body tension, dynos, compression, and shoulder-intensive moves. Aim for strong shoulders and an even stronger core before a trip to Rocklands.

Since Nicole's heyday in the early 2000s, more and more of the world's elite boulderers gather in Rocklands every year. It has been the scene where bouldering boundaries have been pushed consistently, so much so that it is best understood as a list of dates and grades. In 1996, on his first trip to Rocklands, Nicole established a handful of 8A / V11 and 8A+ / V12 problems. In September 2000, he sent *Oliphant's Dawn*, an 8B+ / V14, followed by two 8C / V15 problems in 2002. (For reference, the world's first 8C / V15, *Dreamtime*, was climbed by Nicole in Cresciano, Switzerland in October 2000.) From 2003 to 2005, he established three more 8B+ / V14s and another 8C / V15. It wasn't until almost a decade later that young crushers showed up to repeat Nicole's hardest lines and establish some of their own. In 2014, a 13-year-old Ashima Shiraishi became the second female to climb 8B+ / V14 when she sent *Golden Shadow*. The next year, Isabelle Faus climbed *Amandla*, becoming the fifth woman to climb the 8B+ / V14 grade.

(It took Nicole four seasons to send the same problem.) Finnish climber Nalle Hukkataival is a notable developer of hard problems in Rocklands, with problems like *Livin' Large* and *The Finnish Line*—both highball problems considered 8C / V15—on his first-ascent résumé. Americans Daniel Woods and Paul Robinson have also established numerous 8C / V15 and 8B+ / V14 ascents in the area and repeated many of Nicole's original problems. With Rocklands now an epicenter of difficult bouldering, perhaps the closing line of Skinner's 1996 Rocklands video is more fitting today than it was then. "Success is fleeting," the narrator says. "The climber is compelled to move on to a more difficult problem. The top of the boulder is obviously not the goal. There are always easier routes than the one chosen."

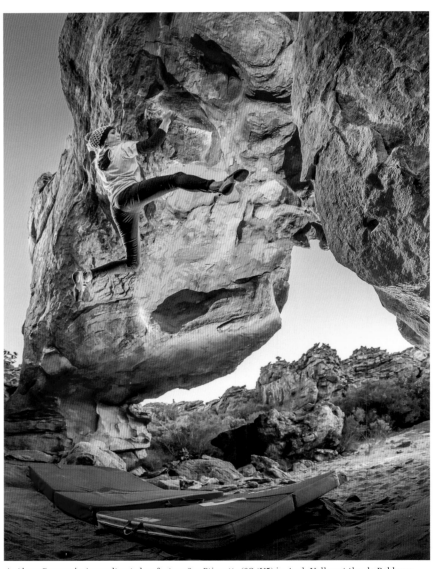

↑ *Above* Rannveig Aamodt cuts her feet on *Sex Etiquette* (6C / V5) in Arch Valley at the de Pakhuys area. → *Right page top* A climber figures out the heel hook beta on *The Rhino* (7B+ / V8), one of the most classic and aesthetically unique problems in all of Rocklands. → *Right page bottom* Maya Bushe hugs the very unique feature with an unmistakable silhouette known as *The Rhino* (7B+ / V8). →→ *Following spread* Nathan Welton gets high off the ground on *Creaking Heights* (6C / V6) in this bouldering paradise. →→ *Page 50* Lush valleys and orange rock in South Africa.

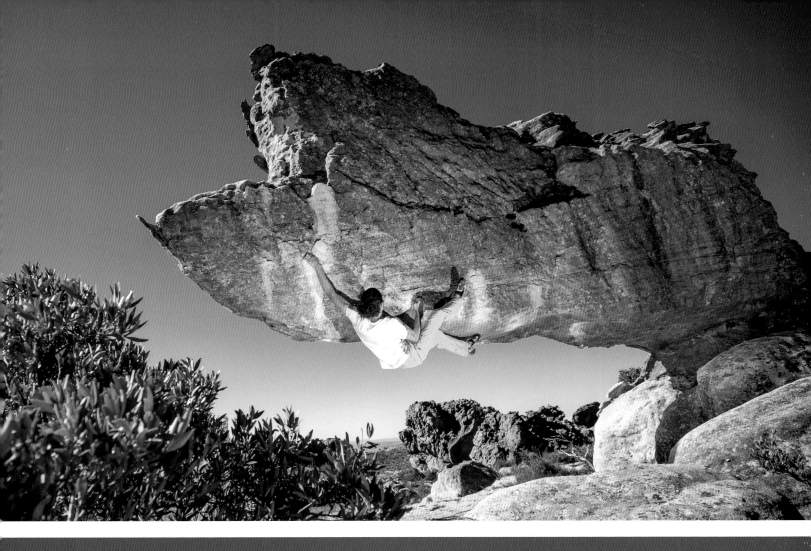
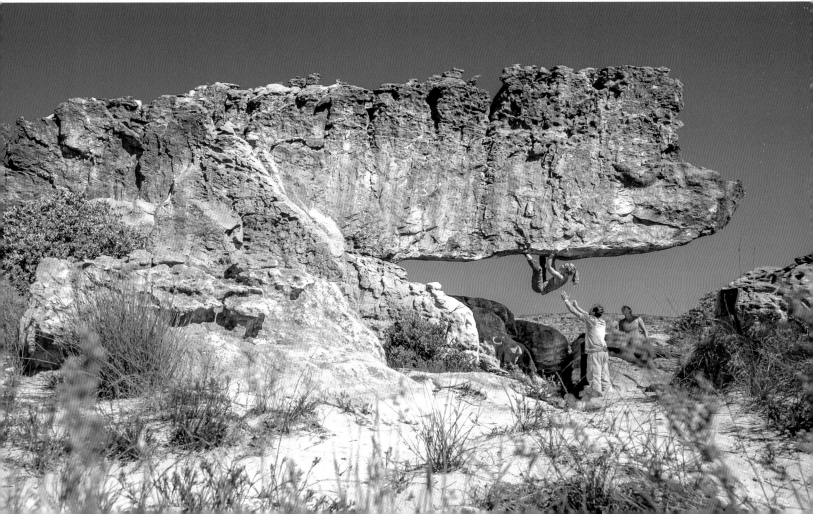

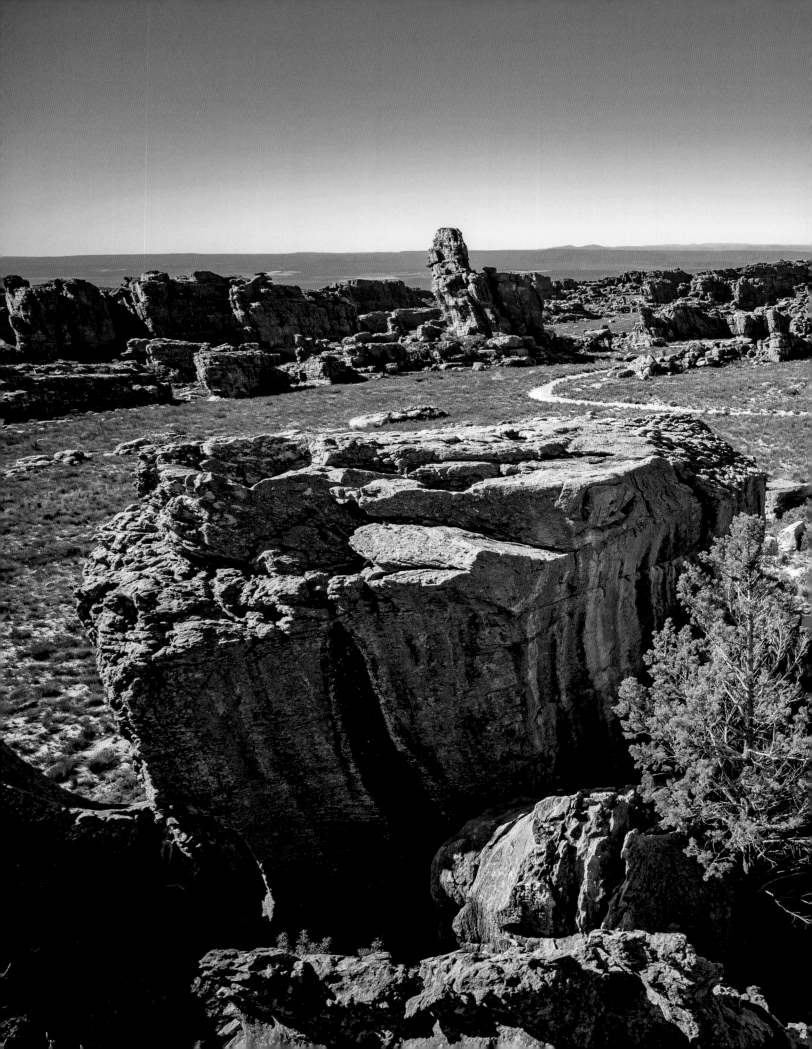

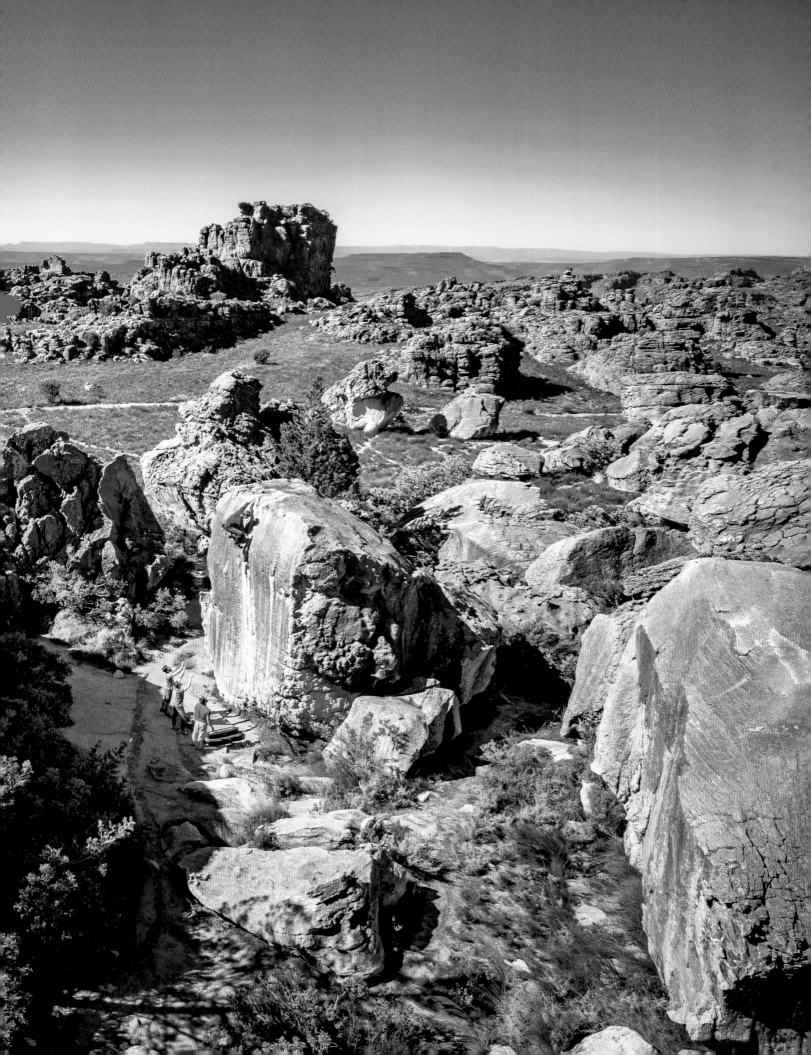

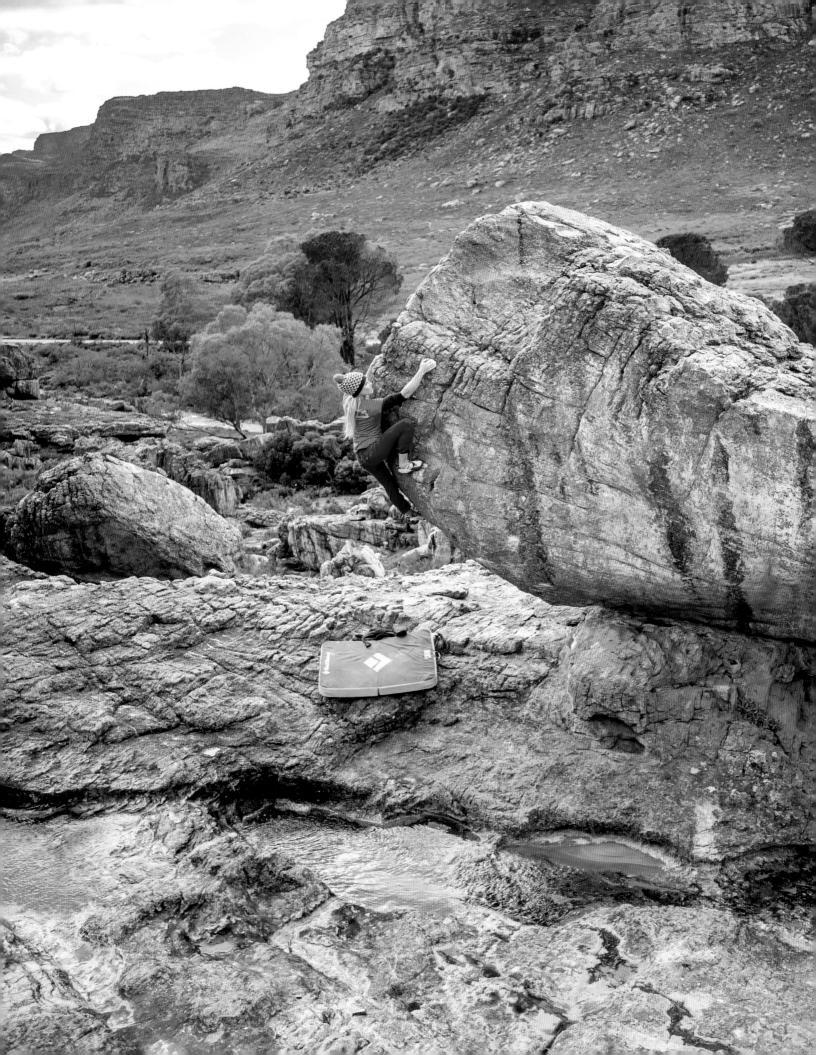

ROCKLANDS

in a Nutshell

CLIMBING TYPE

Bouldering

PROTECTION

Crash pads

SEASON

Summer (Southern Hemisphere winter)

WHERE TO STAY

Multiple campsites and guesthouses in the area

ONE MORE THING

Book your lodging as soon as possible, as many of the places are filled up by November or December the year before. Cape Town has a history of poverty and civil unrest, so be aware of current events in the country before you travel.

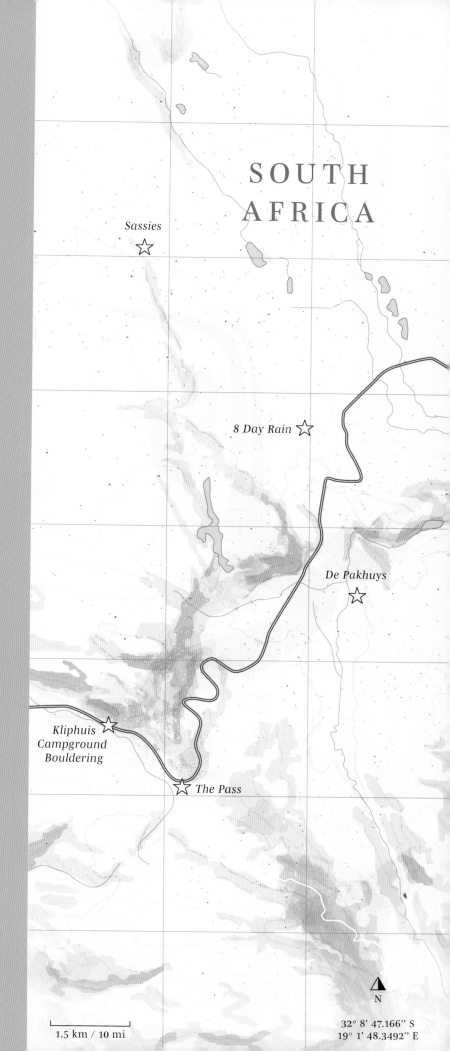

SOUTH AFRICA

Sassies ☆

8 Day Rain ☆

De Pakhuys ☆

Kliphuis
Campground
Bouldering ☆

☆ The Pass

N

1.5 km / 10 mi

32° 8' 47.166'' S
19° 1' 48.3492'' E

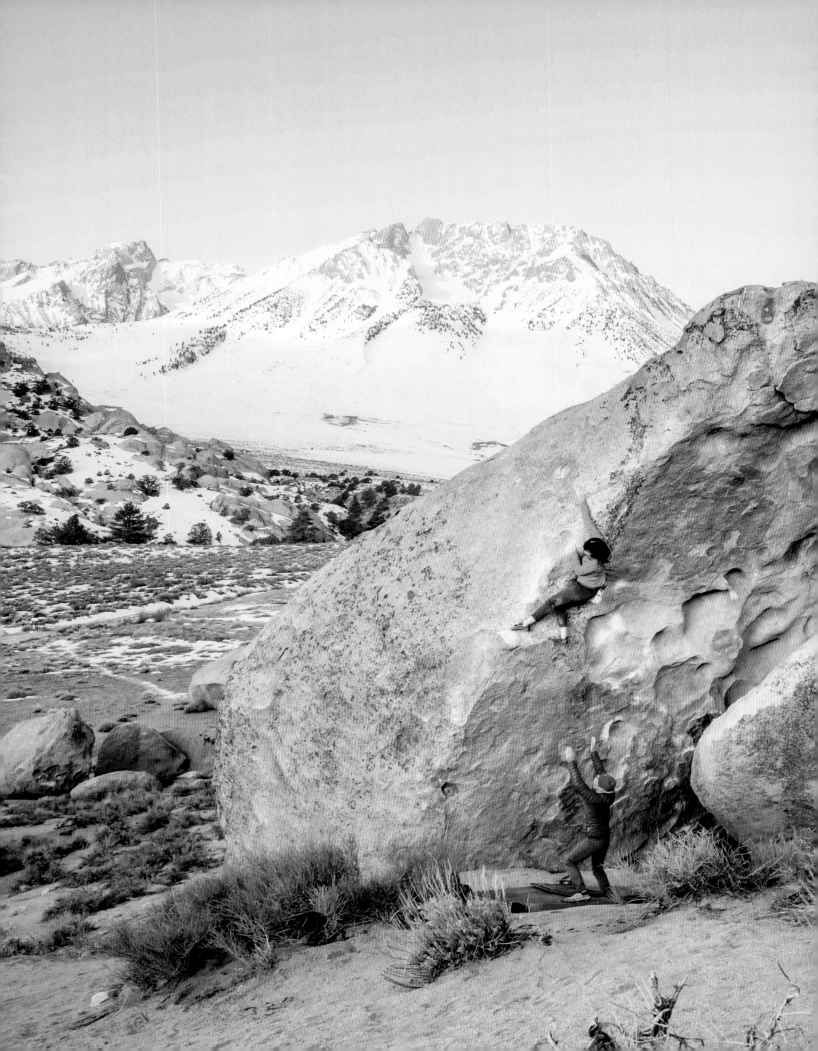

BISHOP

California · USA

This climber's paradise in California has it all:
a lifetime's worth of world-class bouldering,
sport climbing, trad routes, and alpine objectives.

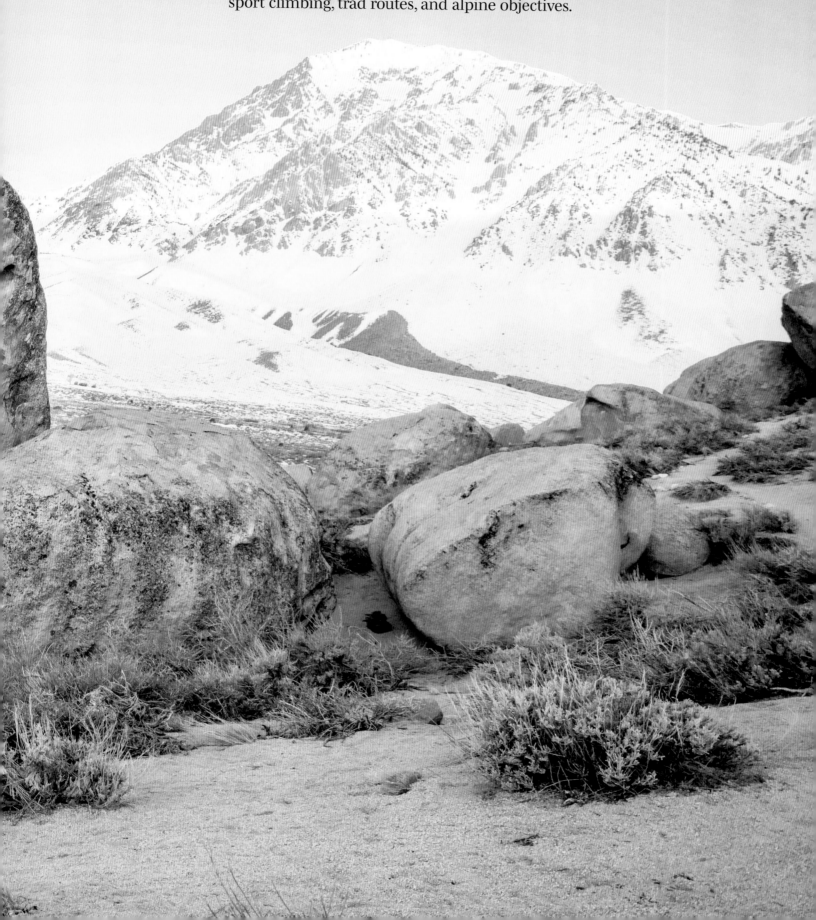

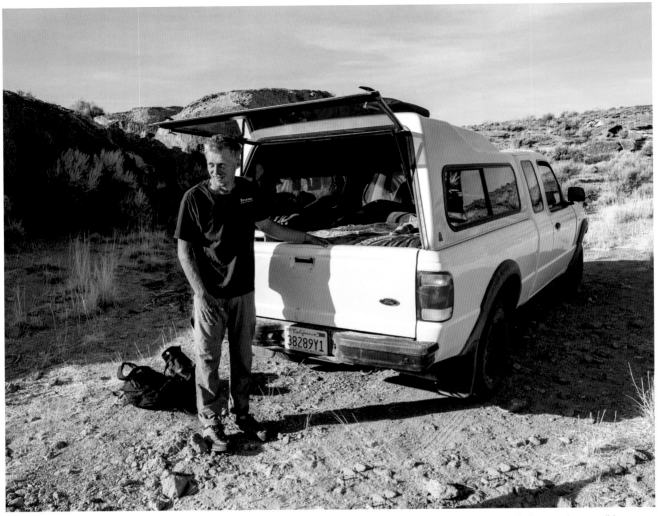

↑ *Above* Many climbers come to Bishop and live out of their truck or van on the public lands in the area so they can climb as much as possible.
→ *Right page* Pine Creek Canyon offers cool temps in the summer and warm sun in the winter.

Nestled at the base of the Sierra Nevada mountains in central California, near the Nevada state line, is the quiet ranching town of Bishop. At first glance it doesn't look much different than any other stopover town in the American West: a small grid of streets with restaurants, houses, grocery stores, and some shops, all surrounded by miles of rolling desert hills dotted by sagebrush and a craggy ridgeline set as the distant backdrop. What you can't see are the thousands of boulder problems spread out across a dozen areas, the Owens River Gorge and its miles of sport climbs, Pine Creek Canyon's splitter granite routes, and the dozens of other spots in between. It's close to Kings Canyon, Sequoia, and Yosemite national parks, with big walls like El Capitan, the 14,505-foot (4,421-meter) Mount Whitney, and even winter ice climbing in Lee Vining only a short drive away.

Perhaps the most well-known spot in Bishop is the Buttermilks, where undulating hillsides host massive egg-shaped boulders that range in size from a small shed to a five-story house. The granite is nearly perfect, known for a lot of vertical and slightly overhanging faces covered in small crimps and edges. It's rough on the skin, and boulderers will want to build up a nice layer of calluses on their fingertips—only to have them potentially ripped off by notoriously sharp holds. The problems range from 4/V0 to 8C+/V16. While there's something for every level of climber, it's known to be a little bit sandbagged—meaning problems here are harder than climbs of the same grade in another area. Many of the boulders are close to the car and each other so you can climb two dozen problems in a day, or camp out under one problem until you send it.

The Buttermilks have become known as the land of highballs (aka very tall boulder problems) thanks to its many humongous rocks, including the legendary Grandma and Grandpa Peabody boulders. The latter is host to a trifecta of hard highballs: *Footprints* (7C/V9), *Evilution Direct* (8A/V11), and *Ambrosia* (8A/V11), which tops out at about 50 feet (15 meters). In February 2018, American climber Nina Williams stood atop Grandpa Peabody after nabbing the first female ascent of *Ambrosia*, and thus successfully completing the trifecta of highballs after doing *Footprints* in March 2015 and *Evilution Direct* in February 2016. Two years later, she ticked another of Bishop's fabled highballs when she became the first woman to climb the 50-foot (15-meter) *Too Big to Flail* (7C+/V10) without a rope, making the seventh ascent overall. Grandpa Peabody is also home to two of the hardest problems in Bishop: *Lucid Dreaming*, an →

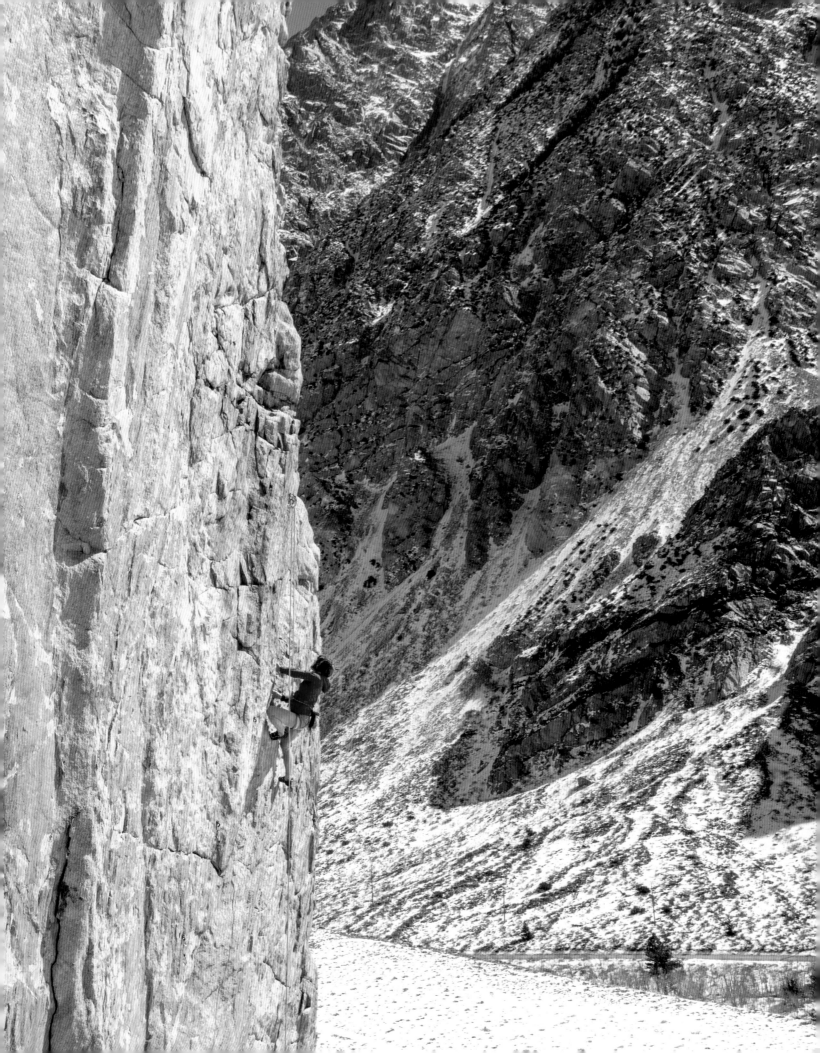

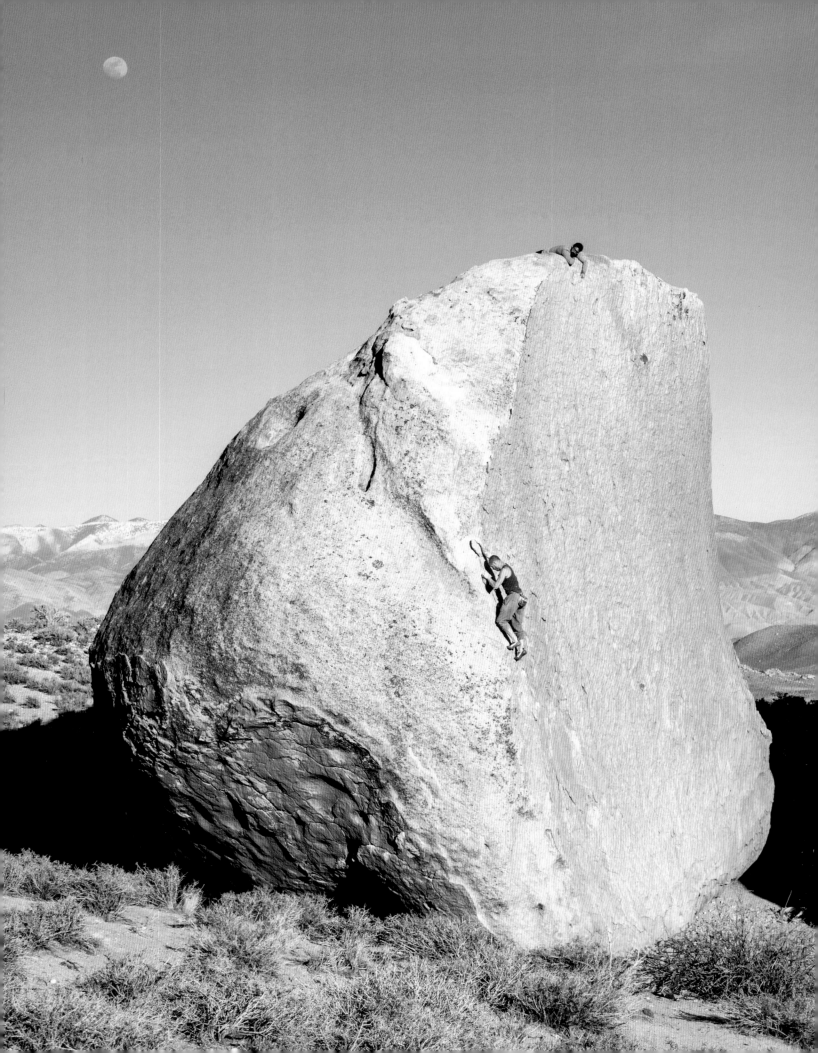

← *Left page* Graded 5b/5.9, Southwest Arête on the infamous *Grandma Peabody* boulder is considered a free solo and not just a boulder problem because it's so tall. ← *Left* Using a stick-brush to clean excess chalk off the small holds in the Buttermilks. ↑ *Above* Enjoying sun and friends in the Happy Boulders. →→ *Following spread* A highball 6A/V3, *East Side Story* is a boulder problem in the Buttermilks.

→ 8C/V15, and *The Process,* an 8C+/V16, both of which climb really hard terrain down low and then easier, low-angle rock to the top of the huge stone.

What the Buttermilks provide as far as aesthetic climbing in a beautiful location, the Owens River Gorge absolutely lacks. "The first time I visited the Gorge, I was *not* impressed. It looked like a very big hole to me, dry and crumbly like a quarry," writes legendary California climber Peter Croft in Marty Lewis's *Owens River Gorge Climbs* guidebook. "In fact, it seemed like someone had found a swell spot for some underground nuclear testing." The Los Angeles Department of Water and Power owns the land and has active power plants in the canyon, adding a nice industrial feel to the already-dismal ambiance. But in the Gorge, looks can be deceiving, as the area provides almost 1,000 routes, mostly sport

with some trad lines. The climbing ranges from pure fun clip-ups to sketchy, runout lines with questionable bolts that demand a heads-up attitude from both climber and belayer. Grades range from slabby 4/5.6 to completely horizontal 8b/5.13d. The three-mile-long (five-kilometer-long) chasm splits a volcanic tableland in the Great Basin Desert, and it's one of the few places you access from the top, meaning you park your car and hike down into the void, climb to your heart's content, and then do the "after-burner" hike straight up and back to your car. Originally from Canada but now living in Bishop, Croft, who has first ascents up to 7c+/5.13a all over the Eastern Sierra and some of the first hard free solos in Yosemite (think: a year or two after the famed free soloist Alex Honnold was born), will regu-larly show up at Owens at 4 a.m. He and his partner for the day will don headlamps,

warm up in the dark, climb a few dozen pitches, hike out just as everyone else is starting their climbing day, and be home by 9 a.m. That's the real beauty of the Gorge.

Bishop is also on the famed U.S. Route 395, a highway that stretches from Southern California to its terminus at the Canadian border. For the California section, it parallels the backbone of the Sierra Nevada mountains and is known as one of the most scenic and sparsely populated routes in America, making it a popular road trip route. The Owens River runs right through the town, and there are natural hot springs just north of Bishop, near the ski resort town of Mammoth Lakes. Between the mountains, rivers, and rocks, Bishop attracts all types of outdoor enthusiasts who want to ski, climb, trail run, mountain bike, go off-roading, fish, hike, and camp.

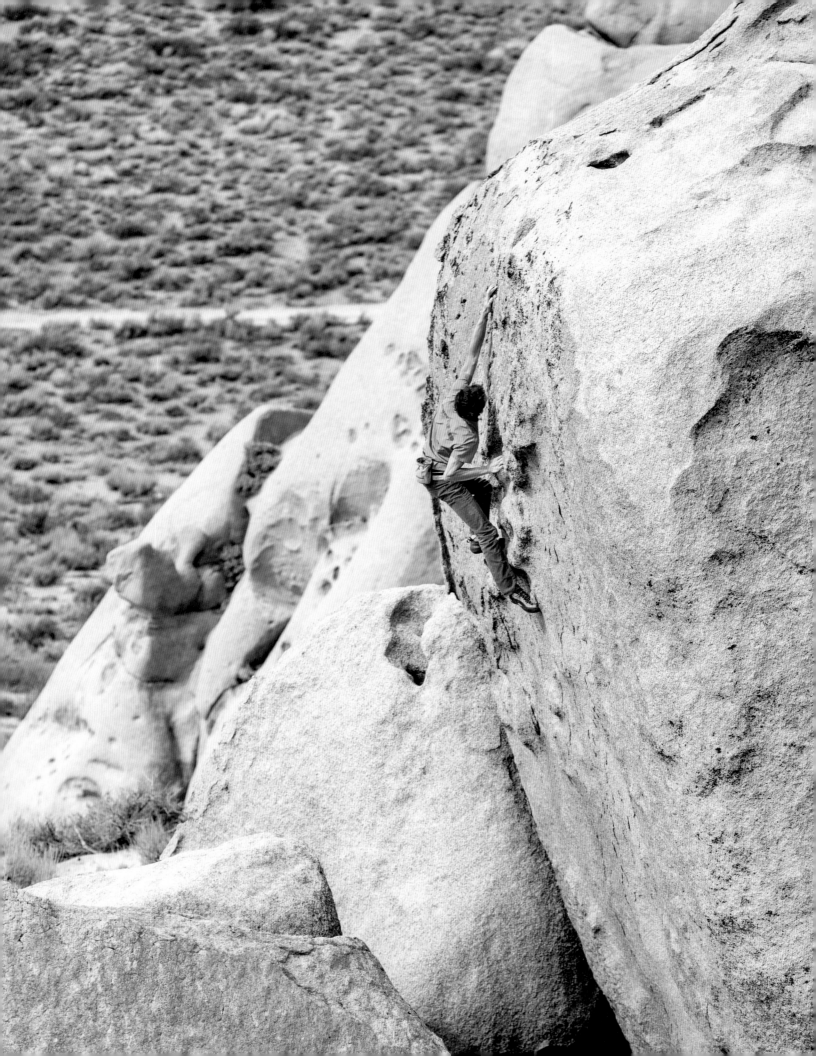

BISHOP

in a Nutshell

CLIMBING TYPE

Bouldering, sport, trad, multipitch

PROTECTION

Crash pads, quickdraws, trad rack

SEASON

Year-round, but summer is hot

WHERE TO STAY

Camp at one of the many campgrounds, or stay for free on Bureau of Land Management land.

ONE MORE THING

Bishop has exploded in popularity in recent years, so be sure to minimize your impact, stay on trails, park in designated areas, and pay attention to the signs that provide education on proper environmental practices. Be part of the solution, not part of the problem!

USA

CALIFORNIA

TOMS PLACE

ASPEN
SPRINGS

SWALL
MEADOWS

Owens
River Gorge

ROUND VALLEY

MESA

ROVANA

Pine Creek Canyon

Buttermilks

N

4 km / 2.5 mi

37° 30' 14.67" N
118° 34' 46.002" W

INCREASING ACCESS THROUGH ADAPTIVE CLIMBING

Paraclimbing has exploded in the last decade through dedicated organizations, social media, and international competitions, and climbers with all types of disabilities are pushing the limits of the sport.

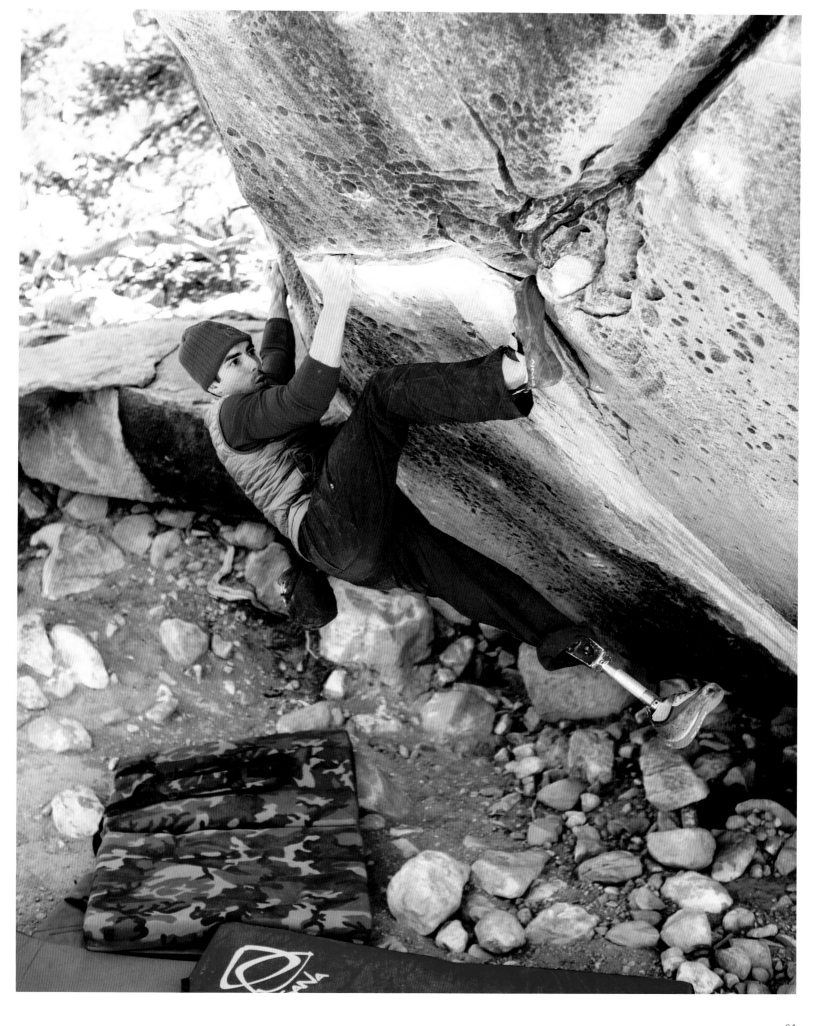

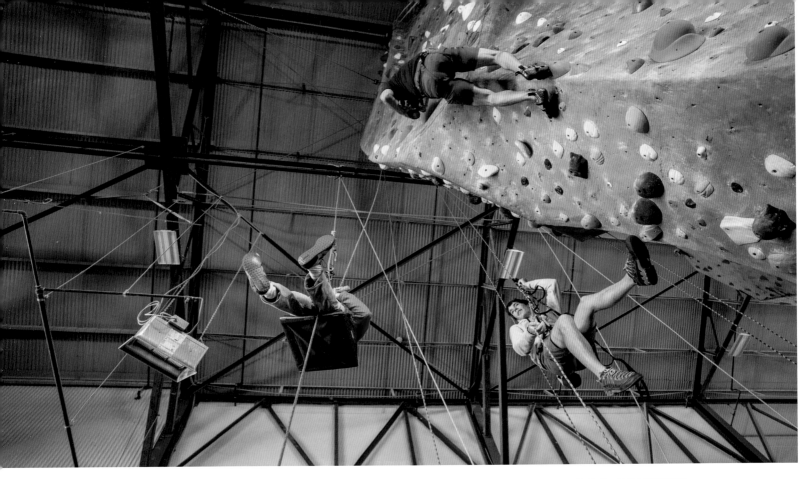

IT IS A TYPICAL MORNING SCENE FOR BIG WALL CLIMBERS ON THE 3,000-FOOT (900-METER) GRANITE MONOLITH OF EL CAP, GETTING READY FOR A LONG DAY ON THE WALL, CLIMBING, JUGGING, AND HAULING. THE ONLY DIFFERENCE IS THAT AMONG THESE THREE BIG WALLERS, THERE ARE FOUR LEGS AND FIVE ARMS.

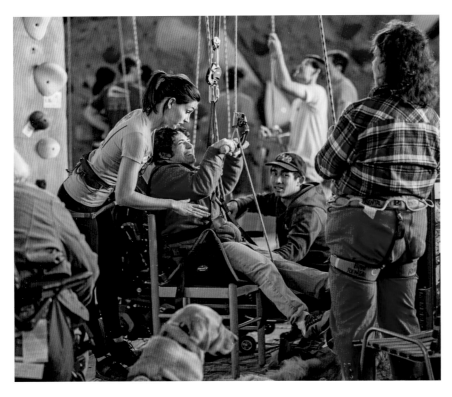

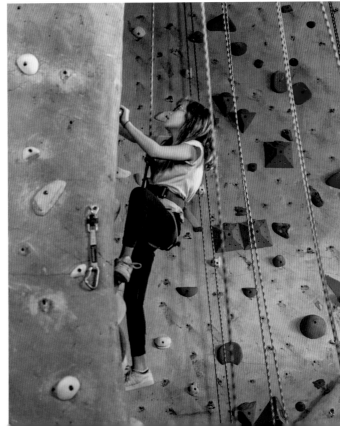

Several hundred feet off the forested valley floor of Yosemite, California, three climbers stand on a wide ledge high up on *Zodiac*, a 16-pitch route on El Capitan that is aid climbed at the grade of C3. Craig DeMartino racks up, clipping cams to his harness and deciding what gear he will need to take on this particular pitch. DeMartino looks up at the wide flake above him, one that will surely require offwidth techniques and big gear.

"I've got double sets, and a #4," DeMartino says.

"Craig, can you give me the cam hooks?" Pete Davis says, as he stuffs a sleeping bag in a haul bag. Jarem Frye sits on the portaledge, blowing on his hands to warm them.

"Hey Pete, can you hand me my leg?" Frye asks.

It is a typical morning scene for big wall climbers on the 3,000-foot (900-meter) granite monolith of El Cap, getting ready for a long day on the wall, climbing, jugging, and hauling. The only difference is that among these three big wallers, there are four legs and five arms. Self-described as "The Gimp Monkeys," these three climbers topped out in June 2012, completing the first all-disabled ascent of El Cap. While people with physical disabilities have surely been climbing since the beginning of the sport—Mark Wellman made the first paraplegic ascent of El Cap in 1989 after doing 7,000 pull-ups—the growth of paraclimbing, also called adaptive climbing, has exploded in recent years. This is due to increased visibility of adaptive climbing through achievements such as the Monkeys' climbs, as well as social media, specialized organizations, and international competitions.

In 2007, professional climber Timmy O'Neill and former U.S. Army Major DJ Skelton co-founded Paradox Sports, an organization whose "goal is to make climbing accessible for people with disabilities." Skelton rock climbed as a child, but lost vision in his left eye when he was injured in the Iraq War. O'Neill's brother, Sean, became a paraplegic after an accident when he was a teenager paralyzed him from the waist down. Using a specialized pull-up bar system, the O'Neill brothers have climbed big walls together from Yosemite to Alaska. Paradox, and other paraclimbing organizations like it, host outdoor climbing festivals, clinics at local gyms, and training sessions for non-adaptive climbers in order to put the word out there: everyone can and should climb.

It was through Paradox Sports that American climber Maureen "Mo" Beck got connected with other disabled climbers. Previously she had only climbed with non-adaptive climbers, but when she went to an ice climbing meetup in Ouray, Colorado, she says she found her people. A February 2019 *National Geographic* article, which named Mo the National Geographic Adventurer of the Year, says that around 2009, Mo "was witnessing the start of a recalibration in climbing: the idea that the sport could be mastered, and even taken to new levels, by disabled people, much like paracycling and paraskiing." Mo won the prestigious award in part because of her work in adaptive climbing, but also for her impressive competition climbing results. She has won six U.S. national titles in rope climbing and bouldering, and has been named World Champion twice.

The IFSC, or International Federation of Sport Climbing, the governing body for competition climbing around the world, has been hosting paraclimbing competitions since 2006. In 2010, the IFSC created a regular circuit of paraclimbing events, and then in 2011, the first IFSC Paraclimbing World Championships were held in Arco, Italy, alongside the IFSC Climbing World Championships. At the first event, almost 50 athletes from 10 countries competed in male and female divisions that were further divided into six disability categories. The 2019 Paraclimbing World Championships had more than 200 competitors. The event is held every other year and has the following categories: arm amputee, forearm amputee, three levels of visual impairment, seated, leg amputee, youth, and three levels of limited range, power, and stability. Competitors in the visual impairment categories use a sight guide, a partner who gives them verbal cues through a microphone and earpiece system as to where the holds are located and what type they are. However, the sight guide cannot tell the climber how to grab the holds or execute the moves. As the number of climbers grows each year, the categories are further divided, with the aim of grouping similarly abled climbers with each other.

Perhaps one of the most well-known paraclimbers is mountaineer Erik Weihenmayer, who became the first blind person to reach the summit of Mount Everest on May 25, 2001. Seven years later he ascended Puncak Jaya to complete the Seven Summits, reaching the top of the highest point on every continent. In March 2018, Justin Salas became the first blind adaptive climber to send 8A/V11 when he sent *Worm Turns*, in Joe's Valley, Utah. Craig DeMartino, who lost his leg after taking a 100-foot (30-meter) fall in a climbing accident, has made the podium in multiple international competitions and became the first amputee to climb *The Nose* of El Cap in a day. He now works as a motivational speaker and an advocate for the adaptive climbing movement. In a film that documents The Gimp Monkeys' 2012 ascent, he puts it best, saying, "We are climbers first and disabled second."

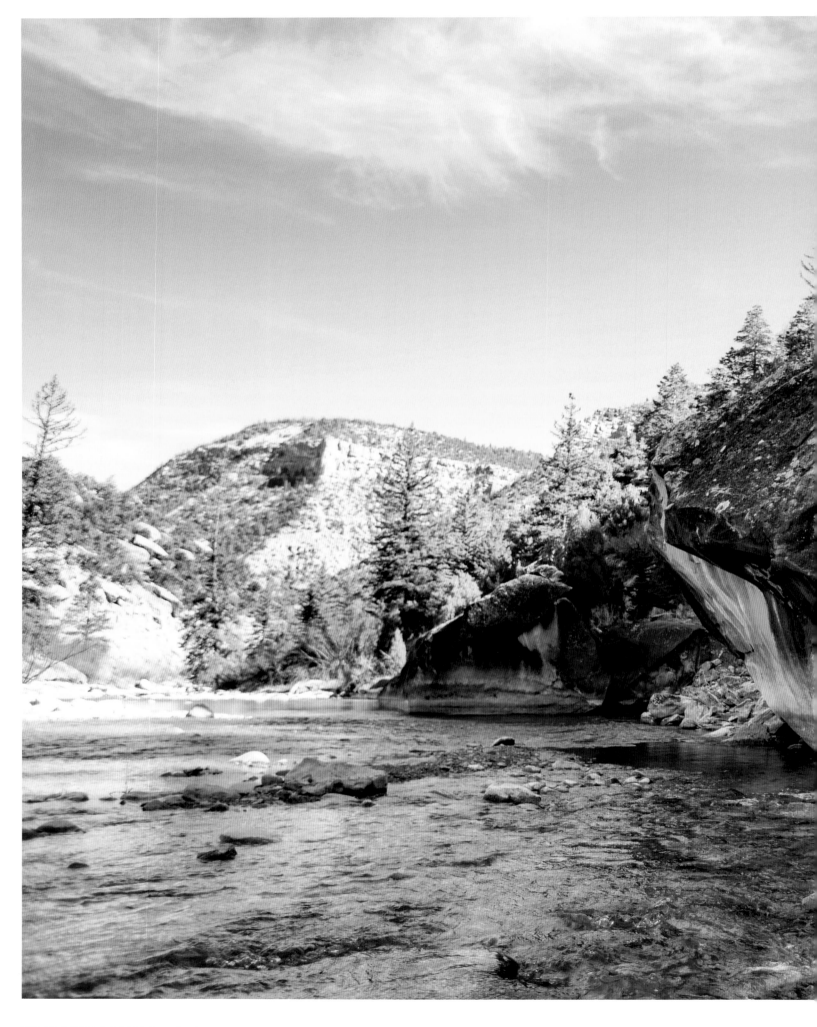

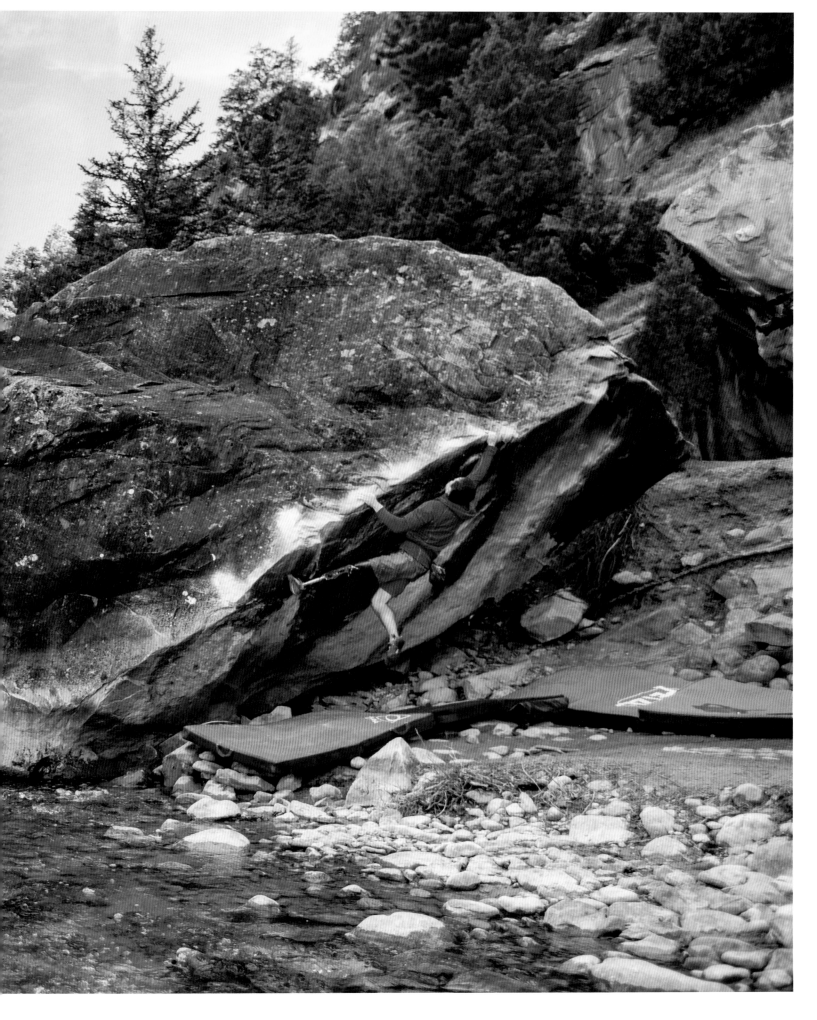

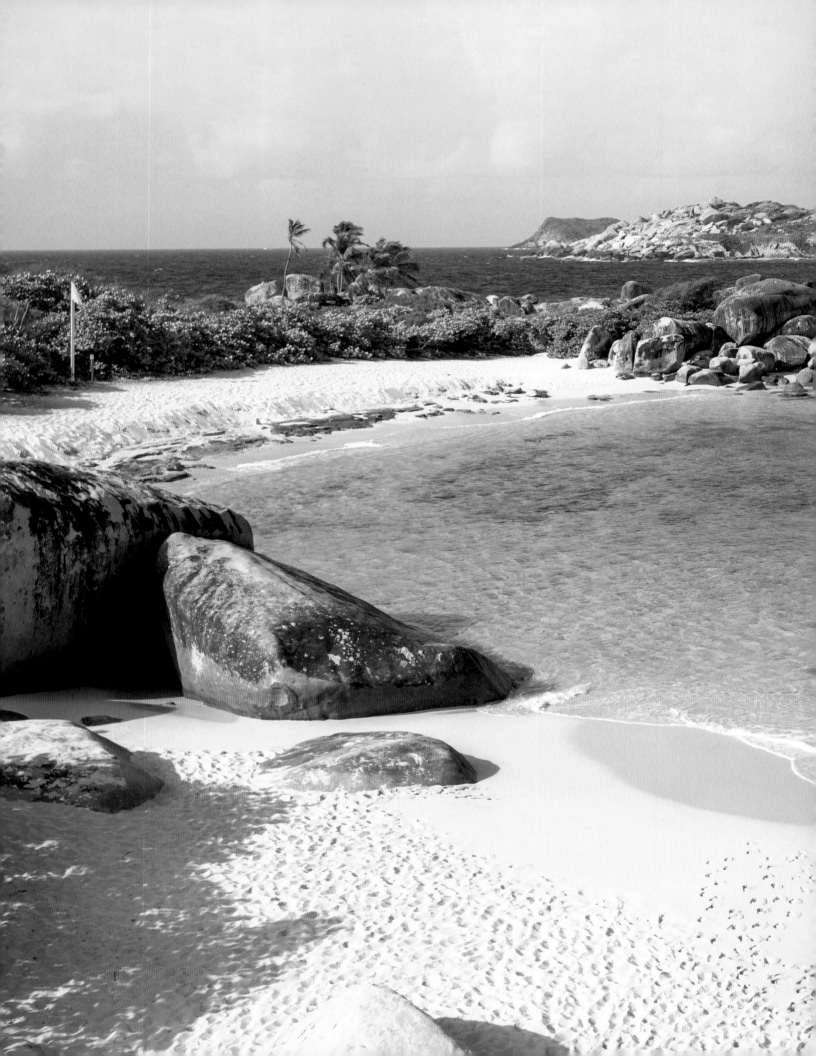

VIRGIN GORDA

British Virgin Islands

Have it all on this white-sand isle in the British Virgin Islands,
where dreamy beach vacation meets bouldering trip.

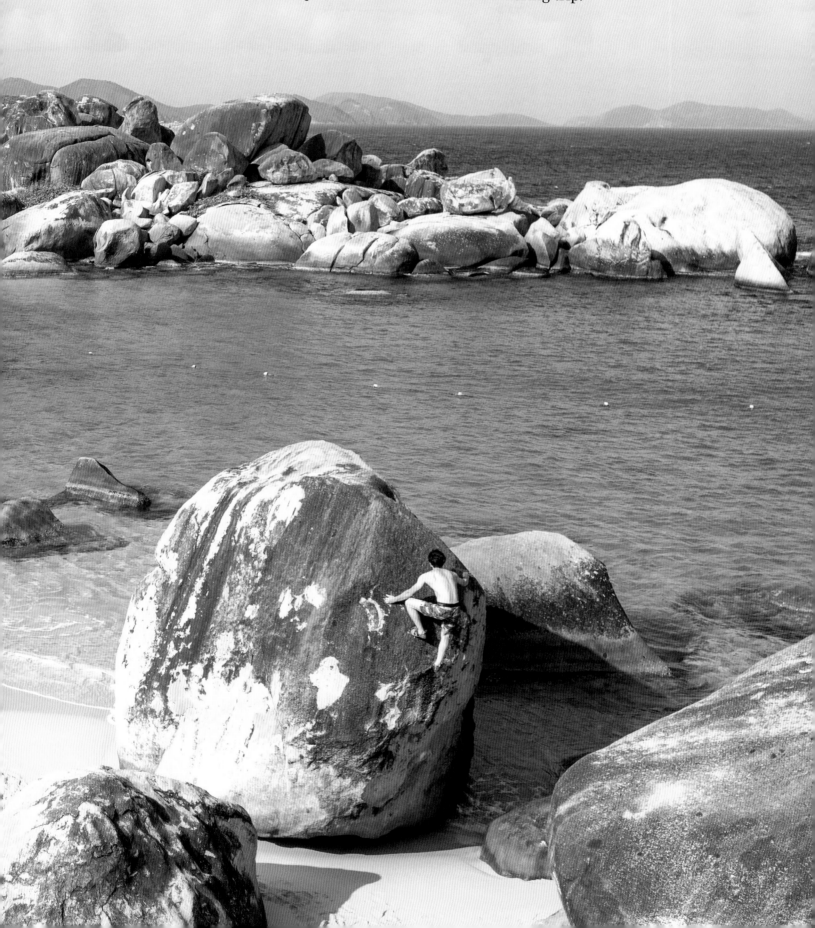

Winter can be a rough time for climbers. Most of our favorite crags are either covered in snow or miserably frigid. To keep up with fitness we attempt to drag ourselves to the gym, but most of the time it is easier to give into the comfort of our couch, a hot meal, and a night of staying in to watch television. It is hard to motivate yourself to do anything when it is dark outside before you even get off work. However, there is a mighty fine solution to this depressing doldrum in the form of a tiny little island in the Caribbean, just east of Puerto Rico.

Covered in soft, white sand and surrounded by warm, green-blue water, Virgin Gorda is the archetype of a Caribbean isle except for one thing. Egg-shaped granodiorite boulders are plopped all along the coast and throughout the interior. This fantastical island is an improbable combination of tropical paradise and climbable rock. Much of the climbing is very moderate, clocking in at 6C/6C+(V5) or easier, which is a good thing considering that the average year-round temperature is about 80 °F (27 °C). Hard bouldering requires cold, dry temperatures, so the warm and humid climate of VG can be a challenge for climbers looking to stick to rounded slopers and small edges. There are a few climbs in the 7B to 7C (V8 to V9) range, and the opportunity for harder projects that have yet to be done. Trade winds coming through the Sir Francis Drake Channel offer a consistent breeze that helps keep things cool, and most climbers will revel in the plethora of 4 to 6A/6A+ (V0 to V3) problems. With mellow grades, plenty of problems, and an island vibe, Virgin Gorda almost seems too good to be true.

The British Virgin Islands is made up of more than 50 small islands, only 16 of which are inhabited, with Virgin Gorda as the second-most populated after Tortola. While the geology of VG is elaborate, the basic story goes like this: An enormous batholith, or large igneous intrusion, formed in the Earth's crust. It cooled, then it cracked. Tectonic plates shifted, faults were created, and then some serious erosion occurred to expose the boulders. In the 20 million years since they were first exposed, the boulders were further worn down by slightly acidic rainwater into the sizes that they are today, ranging from the size of an elephant to a two-story house. This rain also carved out the many pockmarks, grooves, *huecos*, flakes, and edges that make the stones climbable. Spring Bay is the quintessential VG bouldering spot, with huge stones sprinkled along a curving sandy inlet in blue water. Near Spring Bay, the Baths is one of the coolest spots that attracts non-climbing tourists. Humongous boulders are stacked next to and on top of each other, forming a maze of hallways where you can wade through warm, knee-deep water to get to the next alcove.

The one thing every traveler to VG should keep in mind is the concept of "island time," the prevalent attitude for many of the Caribbean isles. People don't rush or hurry, and there is really no such thing as being late. Things happen when they happen, and there is not much to be done about it. This can make planning travel and logistics to the island, which are already quite complex and involve multiple planes and boats, even more challenging. Departure and arrival times are mere suggestions. Once you get there, though, it is best to soak in the essence of the culture and relax. The chickens and cows openly roaming the island do not hurry, so why should you? Get up, climb, sit on the beach, drink a fruity cocktail or two, swim in the ocean, and then do it all again the next day. It is a rough life, but somebody's gotta do it.

In September 2017, Hurricane Irma wreaked havoc on much of the Caribbean, killing four people in the British Virgin Islands. The eye of the category 5 hurricane traveled over three major islands, including Virgin Gorda, and Tortola, the largest island, received the most significant damage. The British government sent aid in the form of food, water, and medical supplies in the weeks and months following the storm. As of fall 2019, BVI was well on its way to recovery, with many businesses, charter companies, and restaurants reopening and tourism returning to this stunning archipelago.

↓ *Below* Matt Gentile (left) and Jimmy Webb enjoy all the perks of beach bouldering. → *Right page* Jimmy Webb climbs the first ascent of *Into the Black*, a highball V8/7B+. →→ *Following spread* Matt Gentile jumps into the turquoise waters surrounding Virgin Gorda. →→ *Page 72* Alton Richardson plays around on the sculpted granite formations.

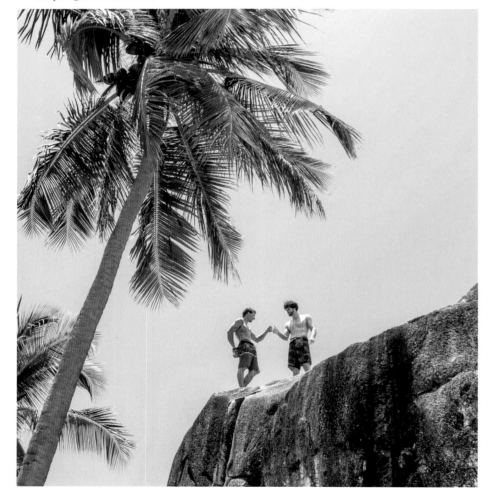

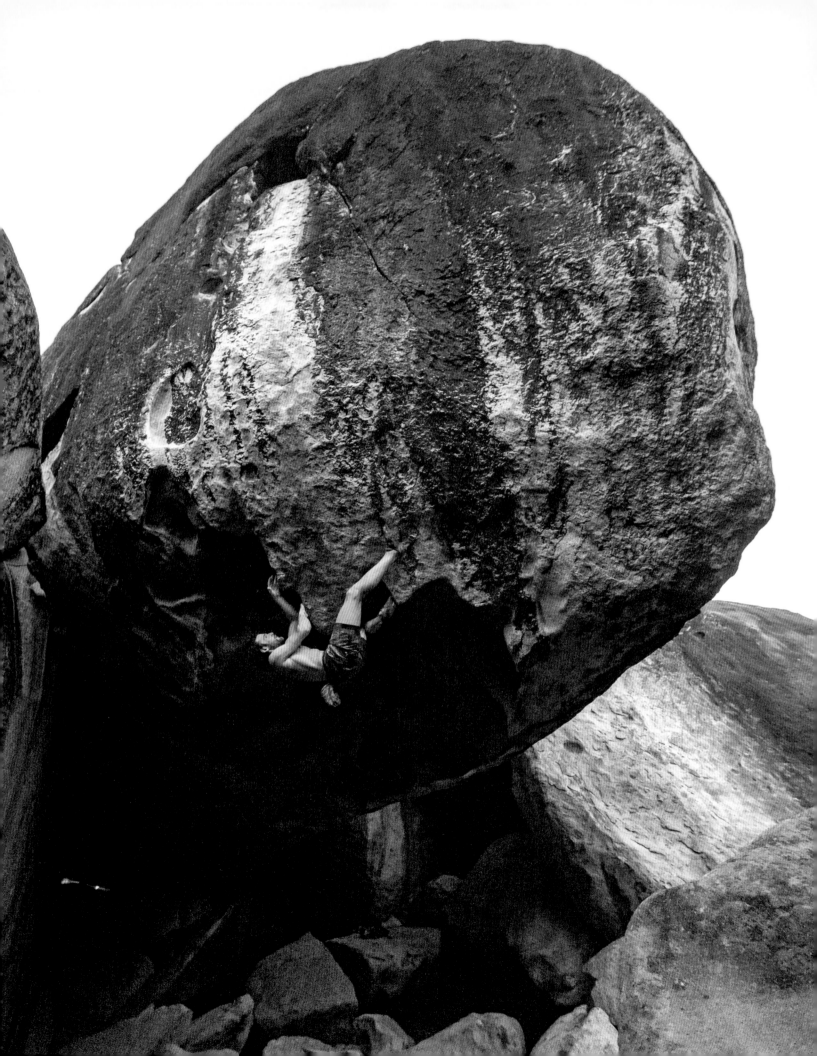

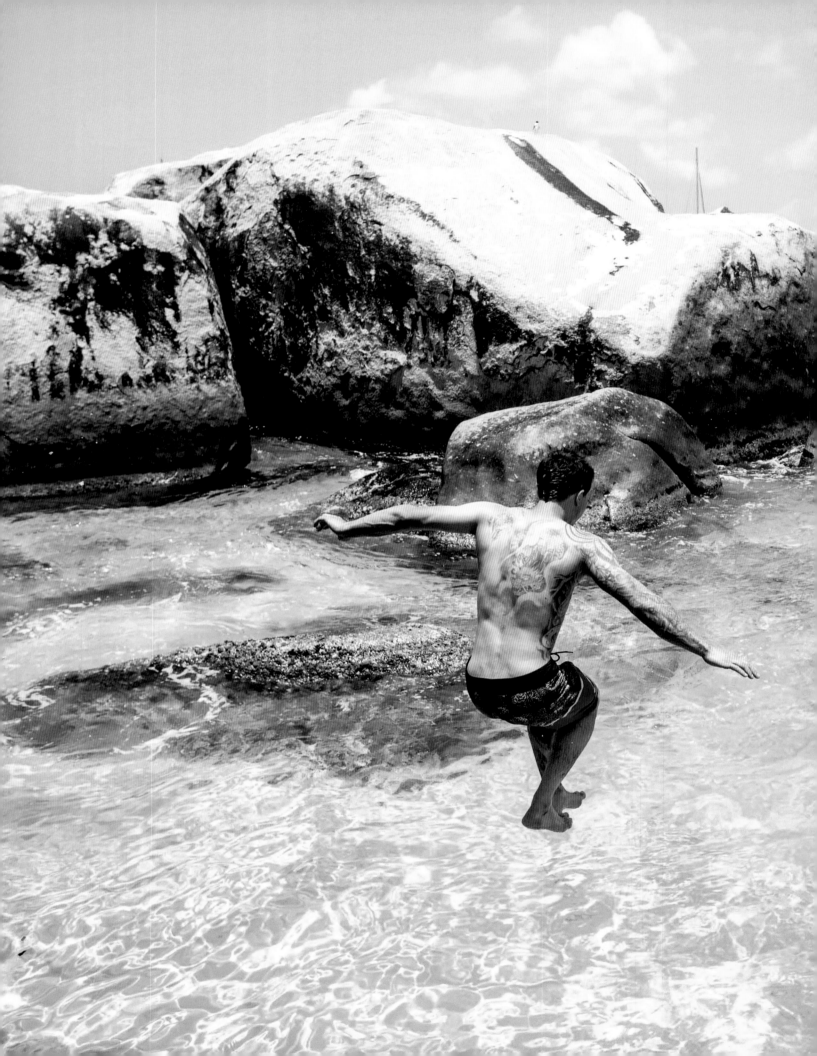

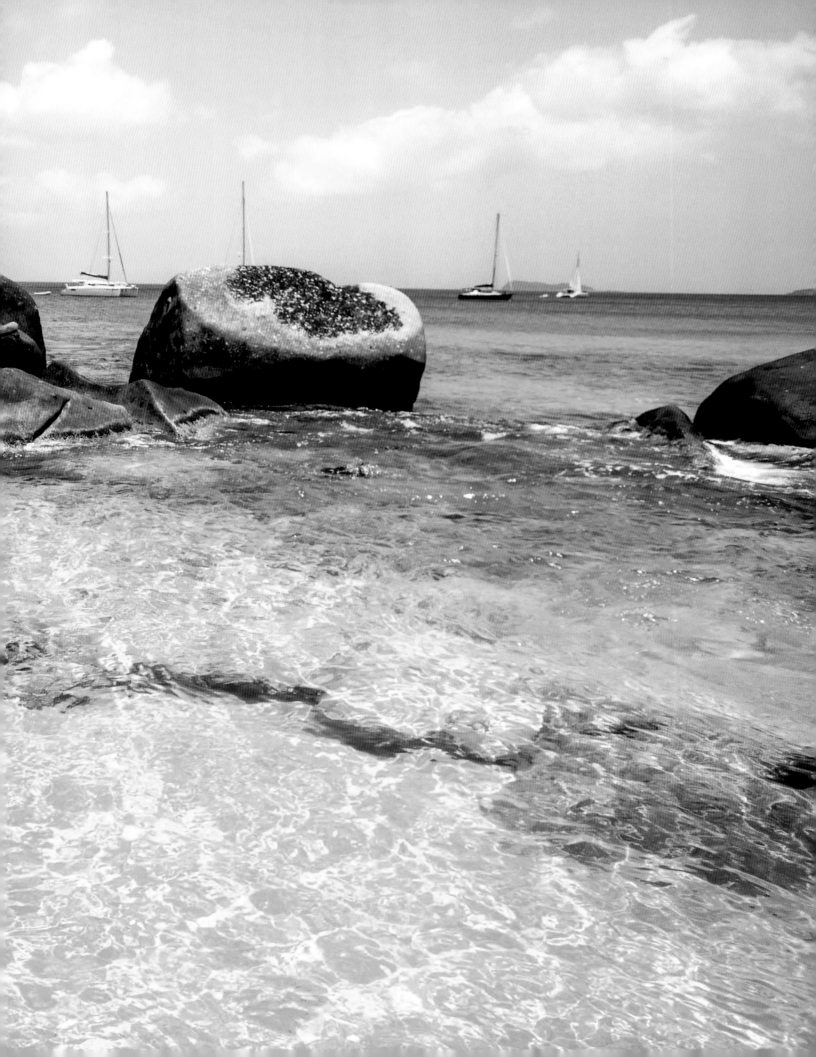

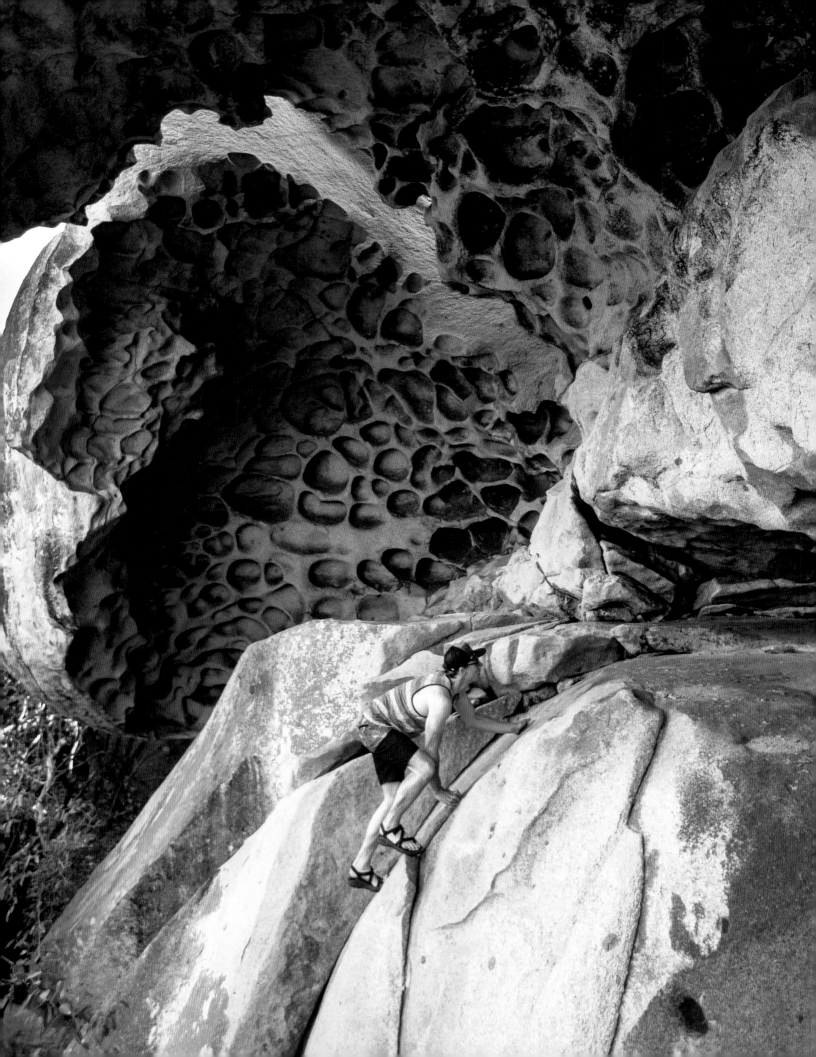

VIRGIN GORDA

in a Nutshell

CLIMBING TYPE

Bouldering

PROTECTION

Crash pad

SEASON

Year-round; temperatures
hover around 80 °F (27 °C)
in all seasons

WHERE TO STAY

Rent an Airbnb or a hotel room,
or check out Villas Virgin Gorda
or Guavaberry Spring Bay.

ONE MORE THING

Official hurricane season for
the Caribbean is June 1 to
November 30, with the peak in
August, September, and October.
For the best weather, including
slightly cooler sending tempera-
ture, consider the middle of
winter: December and January.

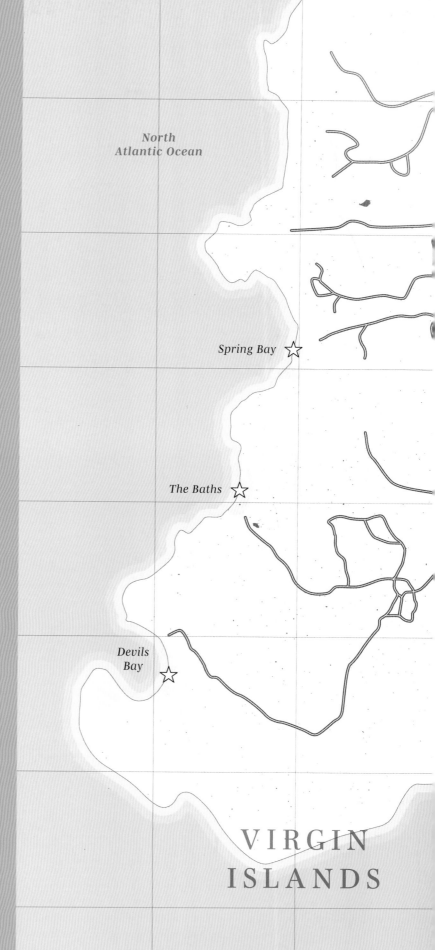

North
Atlantic Ocean

Spring Bay ☆

The Baths ☆

Devils
Bay ☆

VIRGIN
ISLANDS

N

100 m / 350 ft

18° 25' 45.9192'' N
64° 26' 39.2748'' W

SPORT CLIMBING

ASCENDING THE WORLD'S MOST PICTURESQUE CLIFFS AND STEEPEST CAVES WITH FULL-BODY FITNESS AND A LITTLE BIT OF GEAR

From the dripping tufas of Kalymnos, Greece, to the overhanging sandstone cathedrals of the Red River Gorge in the United States, sport climbing offers a unique athletic challenge set against the most striking backdrops on Earth. Wherever you go, there's no shortage of cliff lines emerging from forests or layers of limestone folding over to form caves on top of desert hills. If you look closely, you might catch the glint of metal in rock, looking closer to find another bolt and then another. These are the telltale signs of a sport climbing area, also called a crag, where muscular men and women come to test their mettle. It's called sport climbing because, like other physical activities, it focuses on the athletic aspect, where a high level of overall fitness is crucial.

The routes are usually about 40 to 150 feet (12 to 45 meters), and they require forearm endurance to stay on the wall, finger strength to grip the holds, thoughtful movement technique, occasional power for big moves, and a touch of mental fortitude to get high off the ground and take big (but safe) falls. The point is not to get so pumped that you take the whip! In other words, when your forearms give out (pumped), you'll freefall through space (whip) for a few seconds until the rope comes tight and you're dangling in the air. When you're trying a hard route, you're falling much more than you're succeeding, so it's best to get accustomed to it—even start to enjoy it.

Thanks to the permanent protection in the form of metal bolts and the use of a rope, figuring out your protection as you climb is not part of the puzzle. What is part of the puzzle is being able to discern challenging sequences—what holds to use and in what order—then having the fitness to do it all in one go. The key to completing sport routes at your limit is redpointing, a technique that involves rehearsing the climb over and over, often hanging on the rope for long periods ("hangdogging"). This is also called projecting, where you take the time to dial in the moves and get muscle memory to complete your chosen route, or project.

When rock climbing evolved out of mountaineering, the routes followed obvious cracks or fissures where the climber could place specialized gear for protection. The passageway was usually the easiest route up the mountain. The faces in between the cracks were smoother, and with only small pockets, edges, and protrusions, they seemed unprotectable and thus unclimbable. In the late 1800s, mountaineers employed pitons, or spikes with rings, that were used as protection. Made of soft metal, they were hammered into cracks as

the climber was leading the route and left there permanently. Climbers would have to find a decent stance and perch there until the piton was pounded in, which was difficult, tedious work. They would attach their ropes to the piton with tied cord in the early years and then with a carabiner, which was adapted from firefighting equipment around 1910 in Germany. To maintain the purity of the mountain, pitons were used moderately because they had to be left in the rock. When climbing a face without cracks, there was little or no protection until the next fissure.

In the first part of the 20th century, European climbers began co-opting expansion bolts and fasteners from cement, brick, and stone construction for smooth swaths of rock that were previously unprotectable. As they were climbing, they would drill a hole in the rock and hammer in the bolt from stances on lead. These bolts could not be easily removed, so they remained in the stone. Some climbers at the time considered the metal bolts left in an otherwise natural setting a disgrace. Back then, it was seen as a blatant violation of mountaineering ethics, which valued a pristine environment and minimal human impact. Bolts were used sparingly and without much documentation for the next few decades.

In 1939, American climbers with the Sierra Club ascended New Mexico's Shiprock (now closed to climbing due to its location on the Navajo Nation, where climbing is illegal) using four bolts, along with pitons and a slung horn. This ascent ushered bolts into the American climber's repertoire. But there remained two schools of thought on bolts: those who prized aesthetics and whose goal was to complete a climb with as few bolts and pitons as possible, and those whose goal was to complete a climb by any means necessary. Both groups were using a combination of free and aid techniques, meaning pulling only on the rock in some places and pulling on gear in others. →

↓ *Below* Sasha DiGiulian climbs the sculpted limestone of Getu Arch in China.

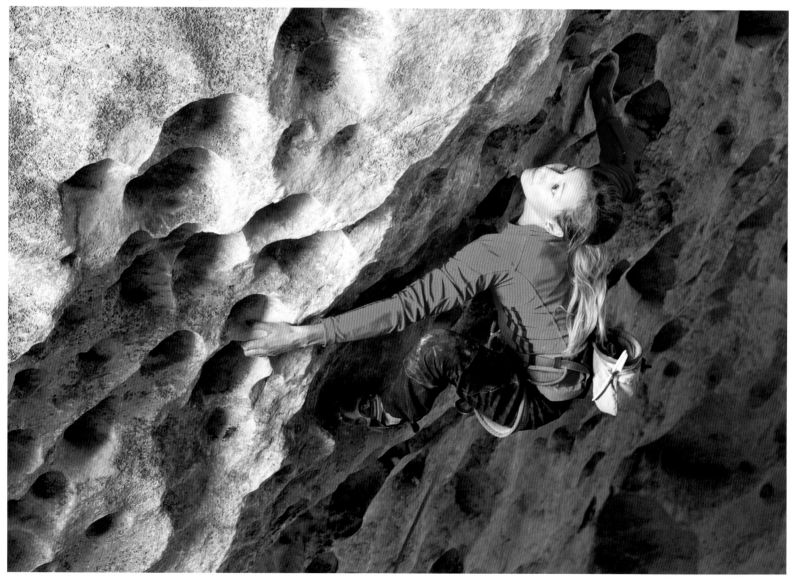

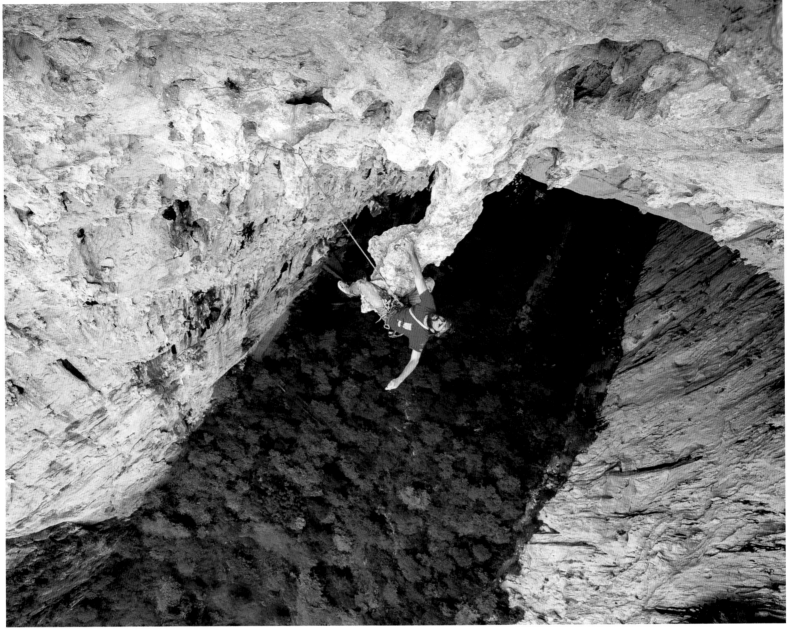

↑ *Above* Sean Villanueva O'Driscoll, belayed by Dani Andrada, in Getu Arch, China. → *Right page* This route in Ten Sleep, Wyoming, has smooth pockets thanks to spray from the neighboring waterfall.

→ Starting in the late 1950s, Yosemite Valley, California, became the battleground for the "bolt wars," where climbers like Royal Robbins and Yvon Chouinard were vying for ascents with climbers like Warren Harding, who didn't hesitate to bolt whatever he needed in order to get to the top. Harding's by-any-means style earned him the 1958 first ascent of *The Nose* on El Capitan, the 3,000-foot (914-meter) granite monolith that took 45 days and dozens of expansion bolts to complete. He used both aid- and free-climbing techniques. If clean climbers found the use of bolts on a route particularly egregious, they would chop the bolts. Meanwhile in Europe, climbers were practicing "direttissima" style, finding the most direct way from the bottom of a mountain to the top and drilling as many bolts as they had to.

While using bolts was becoming common practice in climbing big walls, they were still used for both protection and ascension. In these situations, climbers mixed free climbing—which uses natural holds in the rock to move up and only uses bolts for protection—with aid climbing, which involves using bolts and other gear to move up. It wasn't until the mid-1970s that pure free climbing using only bolts for protection, aka sport climbing, took a first step in Europe by way of France's Verdon Gorge. Prior to that time, climbers who visited the Verdon still had alpinism in mind, starting at the bottom of a formation and looking for obvious cracks that would provide upward passage. A road along the rim of the Verdon Gorge provided easy access to the top of the 1,000-foot (305-meter) limestone walls. French climbers who were looking for →

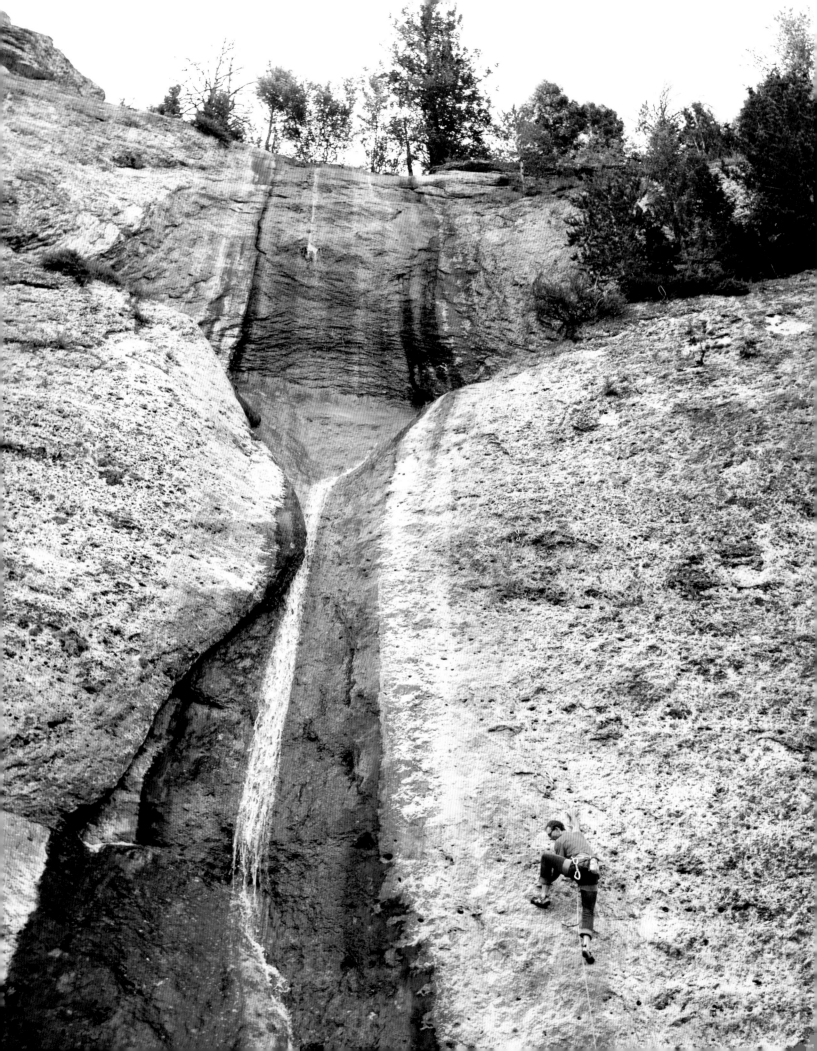

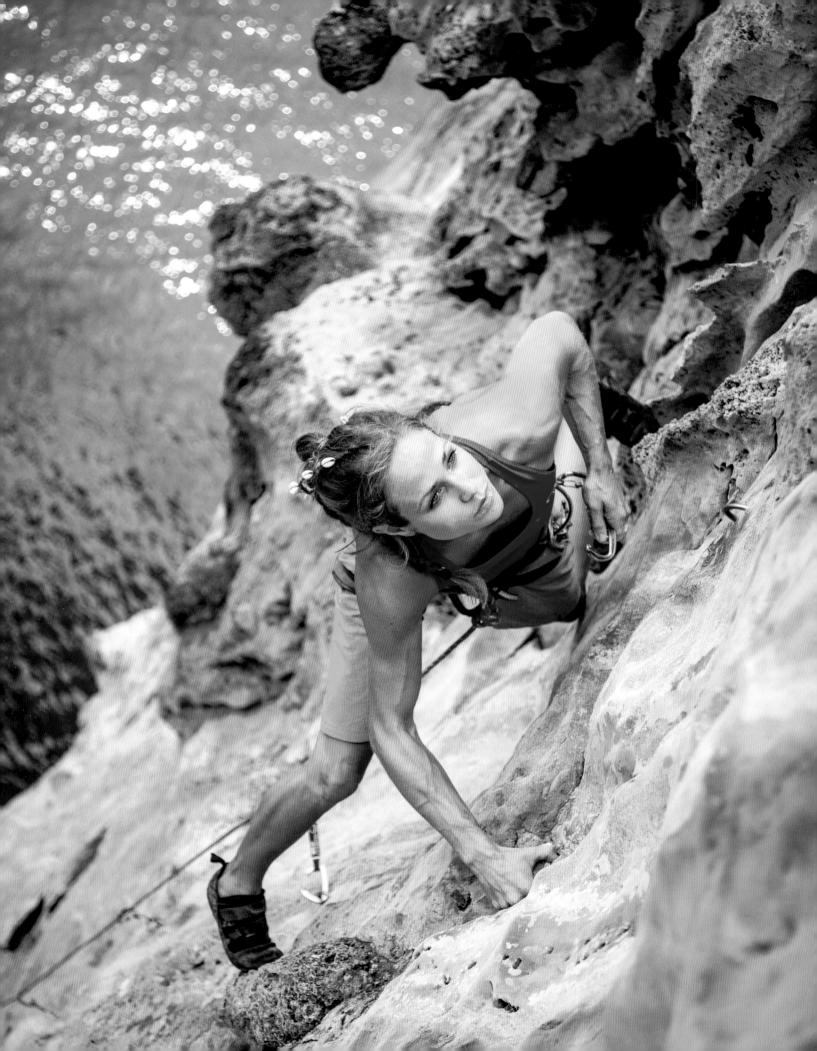

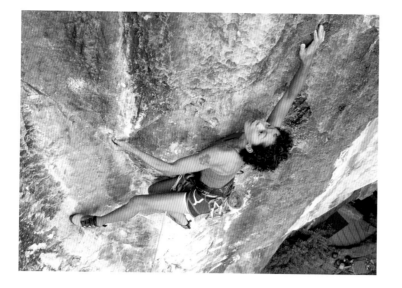

→ more routes decided to start there and rappel down to find potential lines. Along the way, they found dishes and ripples in the rock large enough to use as hand- and footholds. They began bolting these lines and eschewing all other forms of protection except the occasional slung rock. This top-down approach to bolting on rappel (all bolting in prior years was done ground-up, on lead) was revolutionary, but criticized.

While it did open up a new world of possibility, many purists thought it diminished the adventurous nature of climbing in which you start at the bottom, not fully knowing what you'll find. They also found fault with damaging the rock with bolts. However, climbers were able to explore faces and formations that were previously thought impossible to climb. Without having to think about protection or carry a lot of gear, climbers were able to focus on pure movement and strength. The level of skill and technique rose dramatically, along with the amount of climbable terrain. Sport climbing quickly caught on and expanded throughout Europe, the United Kingdom, and Australia over the next decade. →

THE LEVEL OF SKILL AND TECHNIQUE ROSE DRAMATICALLY, ALONG WITH THE AMOUNT OF CLIMBABLE TERRAIN.

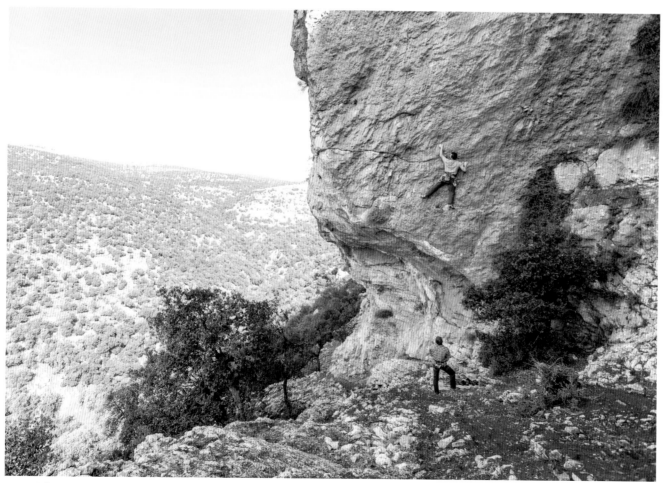

← *Left page* Rannveig Aamodt enjoys the seaside climbing of Thailand. ↑ *Top* The fun of sport climbing can come from getting into a flow state, where you turn off your mind and just let your body move over the rock. ↑ *Above* James Lucas and Ben Hoiness enjoy a sport climbing crag in northern Jordan, near Ajloun. →→ *Following spread* Matty Hong on the first ascent of *El Poder de la Cusqueña Negra* (8c/5.14b) in Chacco Huayllasca (Pitumarca, Peru) in July 2019.

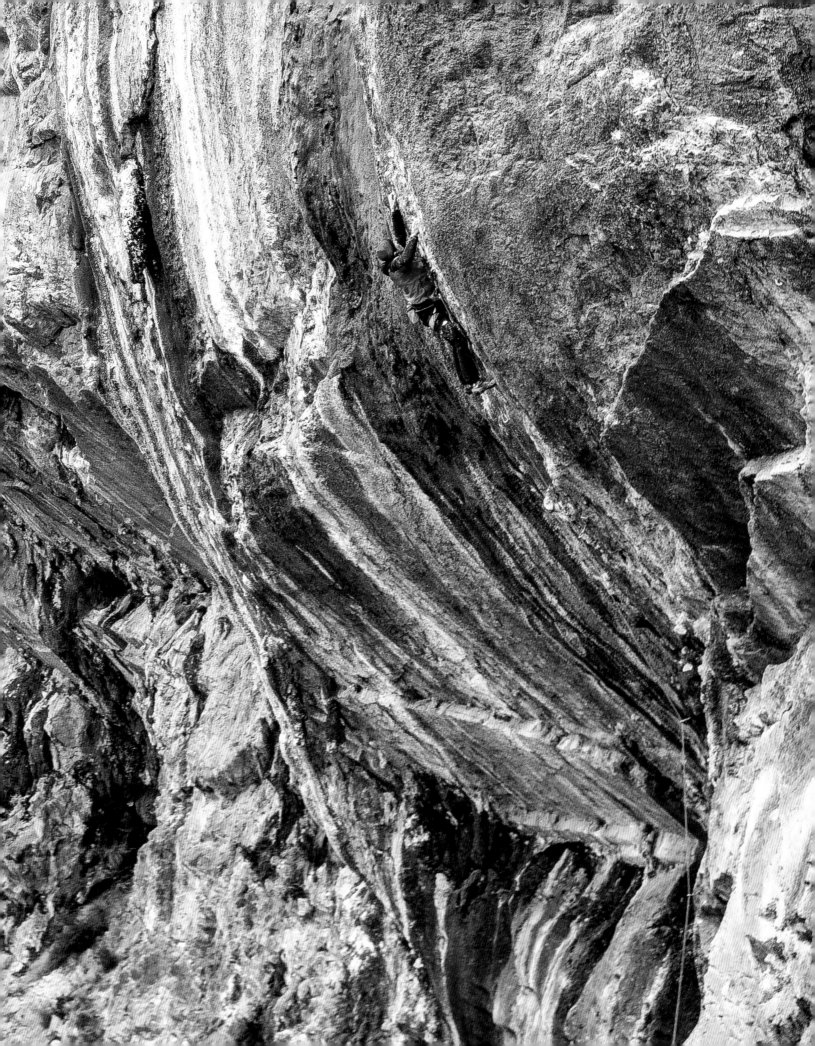

→ The shift in the United States happened at Smith Rock, Oregon, in the 1980s, when route developers, one of the most prolific being American Alan Watts, had done most of the cracks and corners on the area's volcanic rock. What remained were hundreds of remarkable faces and arêtes, so Watts started to rappel down the faces and bolt them. For Watts and his buddies, the goal was to make the routes as hard as they could. By 1985, Watts had freed a 5.13d, the *East Face* of the towering Monkey Face formation. The next year, French climber Jean-Baptiste Tribout had climbed *To Bolt or Not to Be*, the first 5.14a in America. "Eventually people just had to take notice because the climbs were much harder," Watts said. "It was becoming clear that sport climbing was becoming a whole new branch of the sport."

Fast-forward a few decades, and sport climbing is one of the most popular climbing disciplines, with bouldering being the other. Traditional climbing and mountaineering have taken a backseat to these two types of climbing that require minimal gear and technical knowledge and instead focus on fitness, measurable progress, and fun with friends. The grades of sport climbing have risen steadily, with the hardest climb in the world being *Silence*, a 5.15d / 9c done by Czech climber Adam Ondra in Flatanger, Norway in September 2017. It's the only route of this grade, and Ondra is the only person to have climbed it. The next month, Austrian Angela Eiter became the first woman ever to climb a 5.15b / 9b when she sent *La Planta de Shiva* in Villanueva del Rosario, Spain. Being the first person to climb a new grade on either →

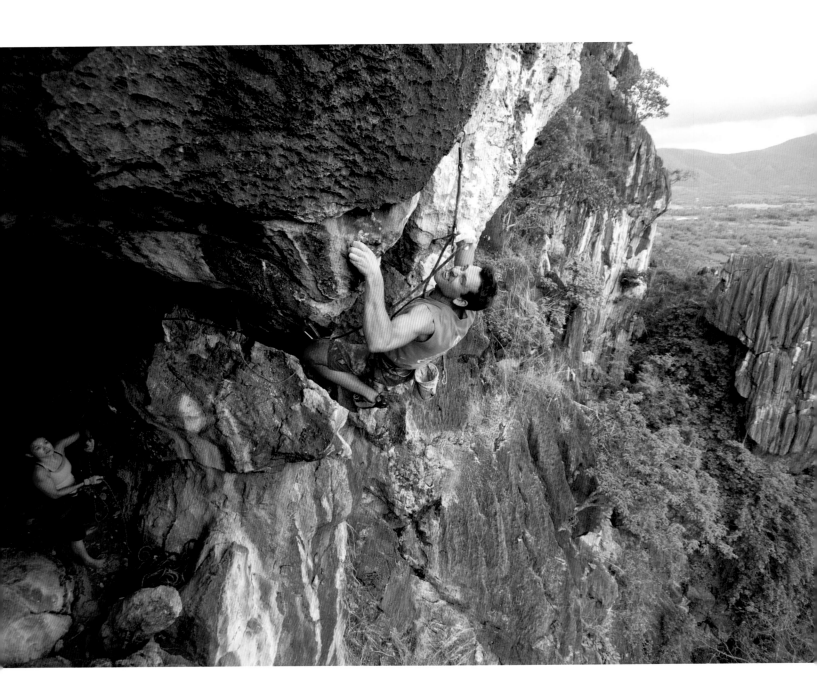

SPORT CLIMBERS ALSO
STRIVE TO FLASH OR ONSIGHT
A ROUTE, MEANING THEY
CLIMB IT ON THEIR FIRST TRY
WITHOUT REHEARSAL. THE
DIFFERENCE IS THAT WITH
A FLASH, THEY CAN RECEIVE
BETA, LOOK AT PHOTOS, OR
EVEN TOUCH THE HOLDS
BEFORE TRYING IT. FOR A
TRUE ONSIGHT, THE CLIMBER
MUST KNOW NOTHING ABOUT
THE ROUTE BEFOREHAND.

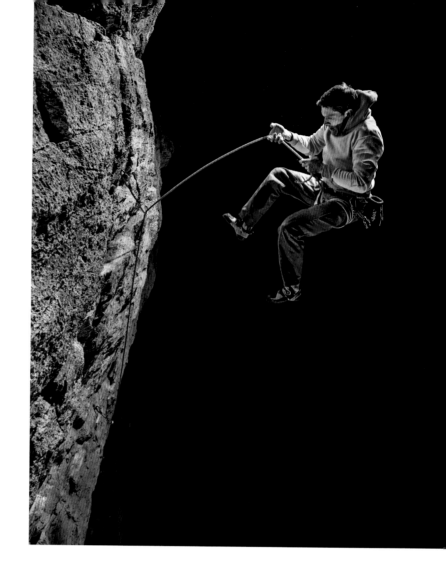

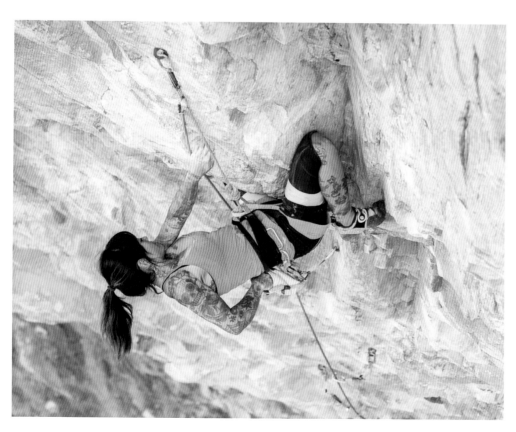

← *Left page* For protection, sport climbers
clip quickdraws connected to bolts as they
move up a route. ↑ *Top left* The view from
the top of a sport route. ↑ *Top right* "Taking
the whip" means enjoying a big fall, as seen
here in Siurana, Spain. ← *Left* Marina Inoue
finds a kneebar rest in Rifle, Colorado.

↑ *Above* Figuring out the beta, or movement sequence, from the ground can help a climber succeed on a route. ↓ *Below* The base of a sport climbing cliff can turn into a mess of packs, gear, and people!

BEING THE FIRST PERSON TO CLIMB A NEW GRADE ON EITHER THE YDS OR FRENCH SCALES MEANS A NEW LEVEL IS UNLOCKED。

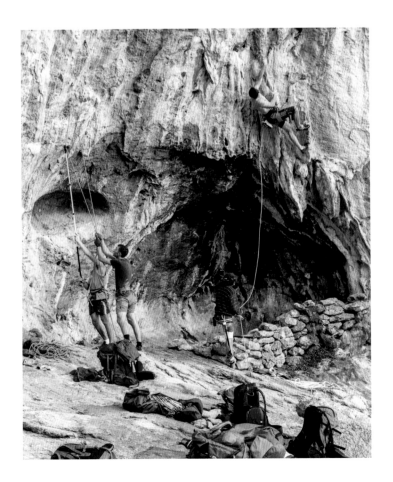

→ the YDS or French scales means a new level is unlocked. Sport climbers also strive to flash or onsight a route, meaning they climb it on their first try without rehearsal. The difference is that with a flash, they can receive beta, look at photos, or even touch the holds before trying it. For a true onsight, the climber must know nothing about the route beforehand. Ondra also achieved the hardest flash of a route when he climbed *Supercrackinette* (5.15a / 9a+) in Saint-Léger-du-Ventoux, France, in February 2018. Then there are the athletes like Italian teenager Laura Rogora, who climbed her first 5.14d / 9a at age 14 and has sent a half-dozen routes of that grade since, and New Yorker Ashima Shiraishi, who climbed a 9a and a 9a / 9a+ at 13, with a handful of 8c+ ticks. With these up-and-comers climbing with such strength at such a young age, there's no telling how far sport climbing can go.

SPORT CLIMBING

Good to Know

WHAT SETS IT APART

Sport climbing highlights thoughtful movement and athletic fitness (mostly endurance) rather than requiring boldness, fear management, or knowledge of technical systems. It's a full-body exercise with the problem-solving element of figuring out move-by-move sequences and staying on the wall for longer periods.

NECESSARY SKILLS

Basic knots, rope management, lead belaying, falling

FITNESS FOCUS

Endurance, finger strength, and a little bit of power

ICONIC LOCATIONS

Verdon Gorge, France; Red River Gorge, U.S.; Smith Rock, U.S.; Céüse, France; Catalonia, Spain; Railay and Tonsai Beach, Thailand; Frankenjura, Germany

NOTABLE FIRSTS

September 1991 First 9a/5.14d route: Wolfgang Güllich, *Action Directe*, in Frankenjura, Germany.

1998 to 2005 First woman to climb 8c/5.14b, 8c+/5.14c, 9a/5.14d, and the "slash" grade of 9a/9a+: Josune Bereziartu.

July 2001 First confirmed 9a+/5.15a route: Chris Sharma, *Biographie*, in Céüse, France.

February 2017 First 9a+/5.15a climbed by a woman: Margo Hayes, *La Rambla*, in Siurana, Spain.

September 2017 First 9a+/5.15a established by a woman: Anak Verhoeven, *Sweet Neuf*, in Pierrot Beach, France.

October 2012 First 9b+/5.15c route: Adam Ondra, *Change*, in Flatanger, Norway.

RATING SYSTEM

Yosemite Decimal System (YDS) or French scale

YDS-Scale	French Scale
5.2–3	1–2
5.4–5	2–3
5.6	4
5.7	4+
5.8	5a
5.9	5b
5.10a	6a
5.10b	6a+
5.10c	6b
5.10d	6b+
5.11a	6c
5.11b	6c+
5.11c/d	7a
5.12a	7a+
5.12b	7b
5.12c	7b+
5.12d	7c
5.13a	7c+
5.13b	8a
5.13c	8a+
5.13d	8b
5.14a	8b+
5.14b	8c
5.14c	8c+
5.14d/5.15	9a

EQUIPMENT: SPORT CLIMBING

As far as climbing with a rope goes, sport climbing could be considered the minimalist's approach. All you need are shoes, a harness, rope, and quickdraws. Bolts are already permanently placed in the rock, so you do not have to carry your own protection like you do with trad climbing. There is a lot of gear crossover with trad (harness, shoes, helmet, rope), but subtle differences in design and style make certain models specialized for each discipline.

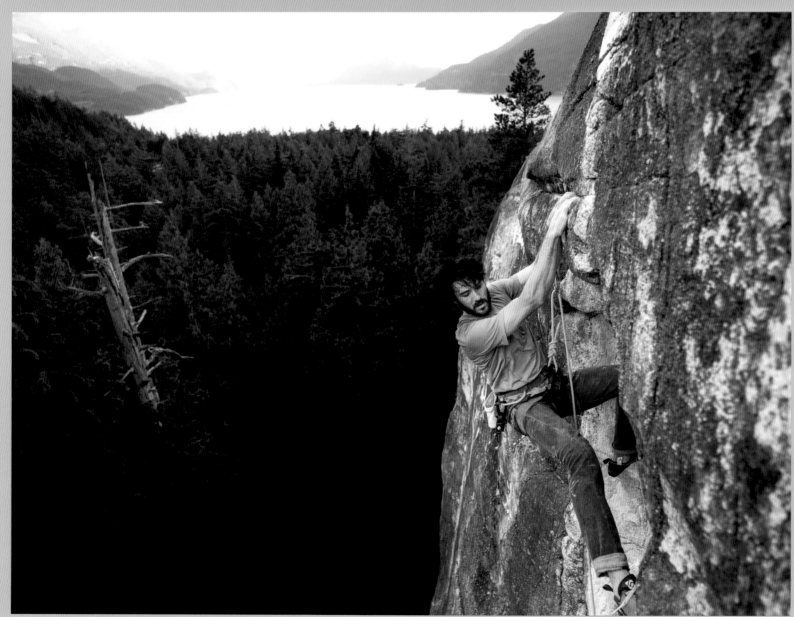

↑ *Above* Sport climbing near the Howe Sound in Squamish, Canada.

BELAY DEVICE: PETZL GRIGRI

Sport climbing involves a lot of falling, so the belayer's performance is even more important than the climber's, and a good belay device can make or break that performance. Since its introduction on the market in 1991 as the first assisted-braking device, the Petzl Grigri has been the top choice for bolt-clippers around the world. Assisted braking means it has a mechanical camming component that helps the belayer stop the rope from moving through the device. While the belayer must remain alert and ready to catch a fall at all times, the Petzl Grigri adds a lot of safety and control to every catch.

QUICKDRAWS

Also known as draws, these gadgets are essentially two carabiners linked together with sewn webbing (called a dogbone). Clip one end to the rope and the other to the bolt, and keep climbing. Often sport-specific draws have a thicker dogbone, making them easier to grab when the climber needs to make a desperate clip.

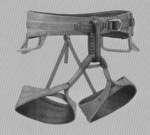

HARNESS

Sport climbers only carry about 12 to 16 quickdraws with them, so the harness doesn't need to be as beefy as in trad climbing. It should be slim and lightweight, but still comfortable enough to hang in for a bit—and cushy enough to handle big falls.

SPORT CLIMBING SHOES

The type of climbing shoes you use for sport routes is a matter of terrain and personal preference. If you are climbing steep overhangs, then you might want to go with a tight, downturned shoe, similar to boulder shoes. If you are climbing techy vertical faces, then you might want to go with a fitted (but not tight) flatter shoe, similar to trad, that lets you stand on edges. Sport climbing shoes must strike a nice balance between performance and comfort— you will be climbing hard, but you will also be wearing your shoes for 5 to 30 minutes at a time.

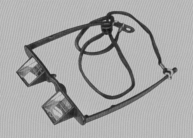

BELAY GLASSES

This eyewear is composed of glasses with a prism instead of regular flat lenses. The prism bends the perspective so that belayers can look forward but actually see the climber above them. With sport climbing, belayers spend a lot of time craning their heads upward while the climber rehearses a hard climb repeatedly. Belay glasses keep the eyes, head, and neck in a neutral position, preventing the overuse injury commonly known as "belayer's neck."

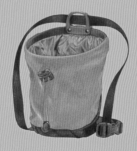

CHALK BAG

This is a small sewn pouch that acts as a chalk container and is worn around the waist while climbing. They are a little larger than hand size so climbers can dip their hands into the fine white powder any time they feel like their hands might be sweaty.

ROPE

Any single dynamic rope designed for climbing will work for sport climbing, but many bolt-clippers prefer a thinner diameter (less than 10 mm) for sport climbing in order to save weight. The biggest drawback is that thinner ropes are less durable than thick ropes, and thus will wear out faster. Rope length is also important, as it will dictate the routes you can climb. 60 meters is the minimum, but modern sport routes are getting longer, so 70- and 80-meter ropes are becoming more common.

LEAD BELAYING

When a trad or sport climber is on the sharp end, the belayer immediately becomes the most important person at the crag. Lead belaying is not complicated, but it is serious business—belayers literally hold the climber's life in their hands. Sometimes climbers ask to take (sit back on the rope) or know when they are about to fall, which gives the belayer a heads-up. But often, climbers must stay so focused in the moment that a fall can be completely unexpected. Maybe a foot slips or a hold breaks, so the belayer must remain just as attentive and focused as the climber.

Always keep a hand on the brake side of the rope. This is the belayer's mantra and the most important part of belaying. The belay device will create friction in the system that slows the rope moving through, but it is the belayer's responsibility to hold tight to the rope and ultimately stop it and arrest the fall.

The belayer stands close to the bottom of the route, but not directly underneath the climber. Lead belaying should be active, with the belayer moving around every so often to be in the best position to see the climber and react quickly for a catch.

The weight difference between the climber and belayer must be considered when deciding who should belay. A belayer who is much lighter will get pulled up when a heavier climber falls, which creates a "soft catch" for the climber but might pull the belayer into the rock above. A belayer who is much heavier must jump a little bit when a lighter climber falls in order not to "spike" the climber into the wall, meaning the climber hits the wall hard.

It is the belayer's job to alert climbers when they are climbing with the rope behind their leg, or if the rope has become twisted or caught on something. Both of these scenarios could cause a bad fall that flips the climber upside down.

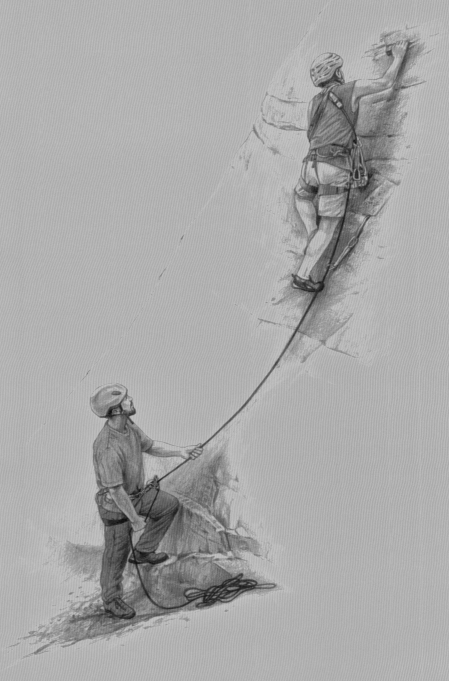

TAKING THE WHIP

There is a saying in climbing: "If you are not falling, you are not trying hard enough." The good news about falling while sport climbing, also known as taking the whip, is that once you learn to do it safely, it can be just plain fun. Big whippers even feel like a safe form of flying. Your body floats through space, and you feel weightless for a second before coming to a gentle stop at the end of the rope. Some climbers even take a "victory whip" after sending a hard route to celebrate their success. Read on for some mechanics of taking the whip.

Many falls are completely unplanned, but sometimes climbers will know if they are coming off the wall. Shouting, "Falling!" can be helpful so the belayer can be prepared to catch a fall.

Looking down can help climbers anticipate where the fall will put them. On a vertical wall, they will need to be ready to hit the wall feet first, soft but strong like a cat. On an overhanging wall, they might just swing into space.

Climbing ropes are dynamic, so they stretch as a way to absorb the impact of a fall. The distance of a fall equates to twice the length the climber is above the last piece of protection, plus a little more to account for rope stretch.

Hands should stay up and out to the side to avoid scraping them on the rock, and some climbers will hold the knot connecting their harness to the rope to keep their hands out of the way.

The biggest danger of falling is flipping upside down, which can happen if climbers fall with the rope behind their leg.

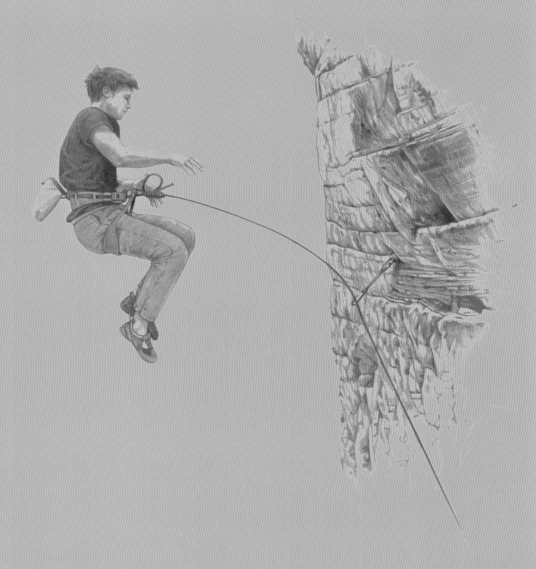

TRAINING

With muscly forearms, bulging biceps, and a powerful back, climbers are some
of the strongest and most ripped athletes out there. Different climbing disciplines
require different types of fitness, but it all revolves around full-body strength.
Boulderers focus on power and *snap* for concentrated hard moves, sport climbers
must have endless endurance to hang on steep routes, and alpinists must have
super-strong legs and great cardio for big missions in the mountains. In the early
years, climbers were limited by two main factors: location and weather. If climbers
did not live near rocks or have good weather, they were not going climbing.

In the 1950s and '60s, climbers started experimenting with drilling small rocks
and homemade wooden holds to interior walls so they could climb when the
weather was bad. In 1964, Don Robinson, a physical education lecturer in the United
Kingdom, built the first artificial climbing wall—small stones cemented to a brick
wall—so his climbing students could stay strong in the winter and not get injured
when spring came and they ventured back outside. Over the next 50 years, these
indoor walls started popping up around the world. Now there are tens of thousands
of gyms across the globe that provide climbers the chance to climb year-round.
While simply climbing will lead to improvement, certain tools and methods are
benchmarks for the training-obsessed climber.

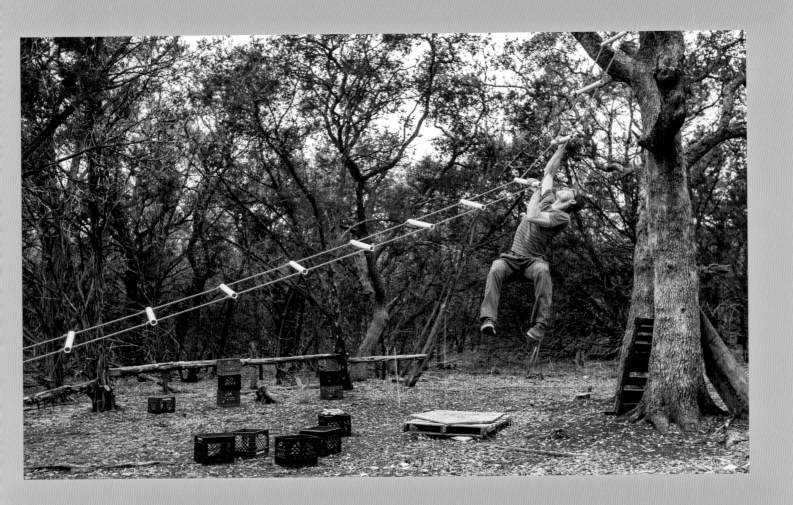

HANGBOARD

With a variety of hold types and sizes, this small wooden or plastic board is used to increase finger strength in a very precise way. The idea is to hang for a set amount of time, then rest a set amount of time. Climbers can choose to hang on certain holds that are difficult for them, like slopers or tiny pockets, or they can add weight and hang on larger holds.

CAMPUS BOARD

Invented by Wolfgang Güllich in 1988, this overhanging board with equally spaced wooden rungs targets finger strength and power. Typically climbers climb between the rungs without the use of their feet, and as they improve, they try to move larger distances between rungs. It requires massive upper-body strength, coordination, and the ability to grab a hold, latch it, and make a big move off of it.

FRONT LEVER

The simple look of this move belies the complete strength it requires. It is the ultimate core exercise that adds in upper-body strength and coordination. While hanging on a bar, people use their arms and shoulders to lift the whole body up, and then keep it in a straight line parallel to the ground.

ONE-ARM PULL-UP

Along with the front lever, boulderer John Gill brought this exercise into the climbing world from his background in gymnastics. Most elite climbers will have the upper-body strength to do regular two-arm pull-ups, but only the strongest of the strong will be able to do the same move with only one arm!

← *Left page* The Bachar ladder is a great training tool for campusing and gaining power.

91

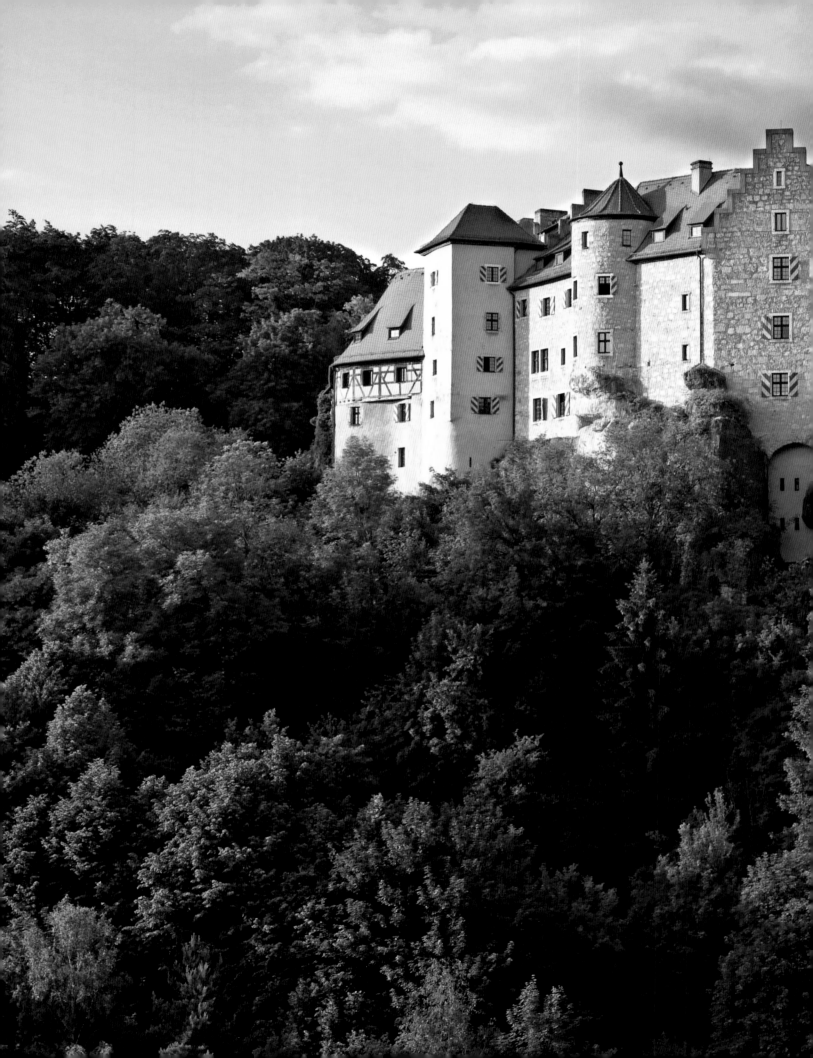

FRANKENJURA

Bavaria · Germany

The short limestone walls of this sport climbing
wunderland are where climbing grades were pushed, history
was made, and beer and cake are enjoyed.

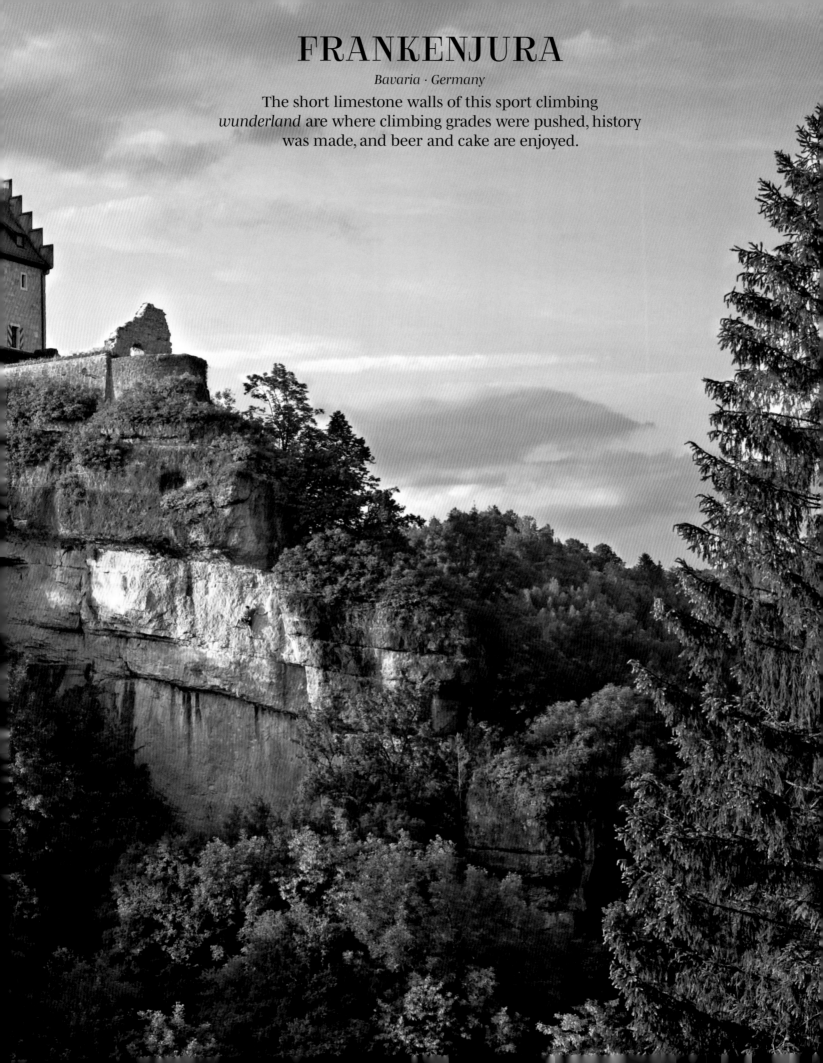

The thick, rolling forests of northern Bavaria, an area referred to as Franconia, are home to one of the largest and most historic climbing areas in the world: the Frankenjura. More than 10,000 routes are spread across 1,000 distinct areas in a 2,700-square-mile (7,000-square-kilometer) region. The cliffs and freestanding towers are short compared to other sport climbing destinations, usually 25 to 100 feet (8 to 30 meters) with many of rising 80 feet (25 meters) or less. All of the rock is limestone, characterized by mostly shallow pockets and small crimps that most climbers would consider quite bad. The climbs are short and bouldery, meaning they require a lot of power and physical strength to complete. While France's Verdon Gorge claims the title of being the spot where sport climbing originated, the Frankenjura is the spot where sport climbing experienced many of its benchmarks in both style and grade. Three of the men who raised standards and wrote sport climbing history—Kurt Albert, Wolfgang Güllich, and Alex Megos—got their start in the Frankenjura. The story of these men is the story of climbing.

Born in Nürnberg in 1954, Kurt Albert began climbing in the Frankenjura at age 14,

soon moving on to the bigger peaks of the Alps, like the north face of the Eiger and Pointe Walker on the Grandes Jorasses. At the time most climbing was done by aid, meaning climbers would pull on man-made gear to ascend. Free climbing, or using natural holds in the rock and focusing on the movement skills of climbing, was in its infancy, and conflicts between aid and free climbers were just starting to arise. In 1975, Albert was focusing on free climbing in the Frankenjura, avoiding the plentiful fixed pins in the area. Once he successfully free climbed a route, he would paint a red dot at its base, called *rotpunkt*, sending routes up to 7c+/5.13a. This was the birth of redpoint climbing, where climbers try a route repeatedly until they send it without falling. Today, redpointing remains the universal style in which hard sport climbs are completed. Albert went on to become a figurehead of the free-climbing movement, taking this climbing style to big walls in the Dolomites, the Karakoram of the Himalaya, and Patagonia—places where aid climbing was previously the only means of ascension.

Albert's longtime climbing partner and Frankenjura roommate for 11 years was Wolfgang Güllich, who started climbing

in the Südpfalz at age 13. In the 1970s he moved to Frankenjura and teamed up with Albert. Their partnership was so impactful that the German government awarded them the Silbernes Lorbeerblatt, the highest achievement in sport, for their contributions to climbing—and at that point, Güllich had not even climbed the routes he is so famous for today! Over the next decade, he pushed sport climbing grades four separate times, three of them in the Frankenjura. In 1984, he climbed the world's first 8b/5.13d, *Kanal im Rücken*, in Frankenjura, and the next year ticked *Punks in the Gym* in Mount Arapiles, Australia, the world's first 8b+/5.14a. Güllich sent *Wallstreet*, the first 8c/5.14b in 1987, then, in 1991, gave the world its first 9a/5.14d, called *Action Directe*, both in Frankenjura. In training for this final grade-pushing route, Güllich invented the now commonly used campus board, a training tool that increases power by climbing between small edges without using your feet. It was a natural evolution for a Frankenjura climber to invent the campus board, as the relatively short but supersteep nature of some of the rock facilitates most of the climbers' weight to

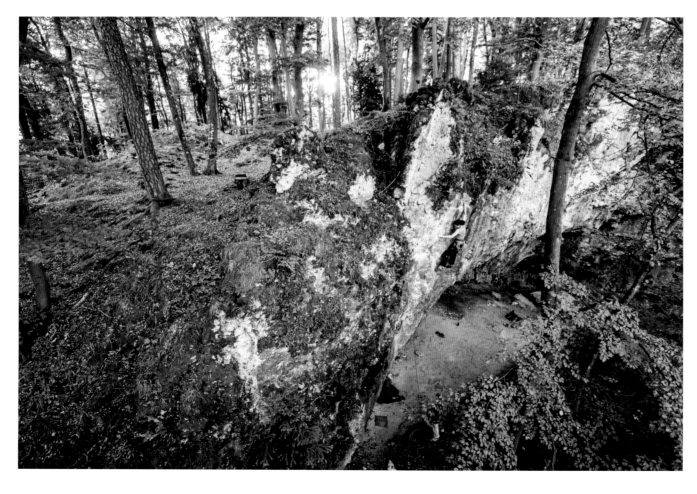

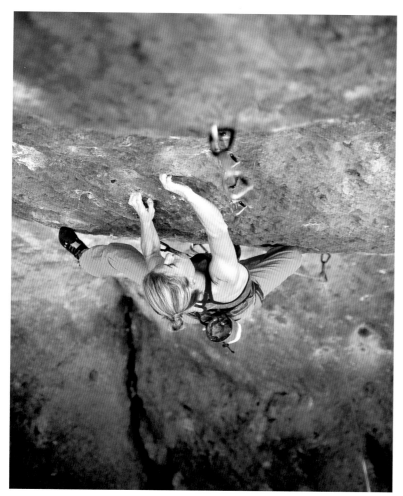

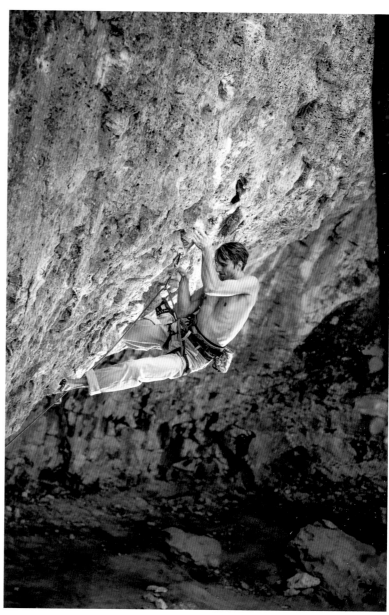

← *Left page* The routes of the Frankenjura are short but stout. ↑ *Above* Sarah Kampf pulls on teeny-tiny pockets. → *Right* No tricks allowed in the Frankenjura—you must have the power, or forget it here. →→ *Following spread* The limestone cliffs and caves are located throughout the green forests of Bavaria. →→ *Page 98* Sarah Kampf tries hard on one of the 1,000 cliffs in the spread-out climbing area.

be on their arms and not their feet. The hard routes are relatively short height-wise, but supersteep, meaning they pack a really big punch. *Action Directe* is only about 14 meters, but brutally overhanging. Elite climbers who aim to tick the more challenging lines will train specifically for the routes here, focusing on small holds and powerful, explosive movement. The most infamous holds here are "monos," which is short for *mono doigt*. These monos are pockets that are so miniscule that they only have room for one finger. The strongest digit is the middle finger, so climbers slide it into the shallow divot and bear down with all their might to make a big move to the next hold. The idea in the Frankenjura is that you must

have the power and strength to complete these moves, or you won't be able to send. Often in other places, climbers can use techniques like heel hooks or smaller inter-mediate holds to complete hard lines. In the Frankenjura, you have the holds you have and nothing more.

Two years after the first ascent of the famed *Action Directe,* and one year after Güllich died in a tragic car accident, Alex Megos was born in Erlangen. As a teenager, Megos worked his way through the Frankenjura's classics, and sent *Action Directe* in April 2014 at age 20. Although the area is famous for these incredibly hard routes, there are so many routes and crags spread out over a large area that there really is something for everyone. There is

diversity in the routes, but the rock itself is pretty distinct, with small pockets dotting the white and gray limestone. There is a crag for every type of weather and every level of difficulty, so all climbers can find something to suit their needs. However, there is one thing that all climbers must partake in, and that is the delicious coffee and cakes of the region. There is a bakery on every corner, churning out fresh cakes that change depending on what fruit is in season. Every climber must visit the local gasthaus twice: once at lunch for a kuchen cake in cherry, poppyseed, or cheesecake, had with a hot coffee, then again for dinner for *schäuferle* with gravy and knödel, or bratwurst, sauerkraut, and *kartoffelsalat,* enjoyed with a cold Bavarian beer.

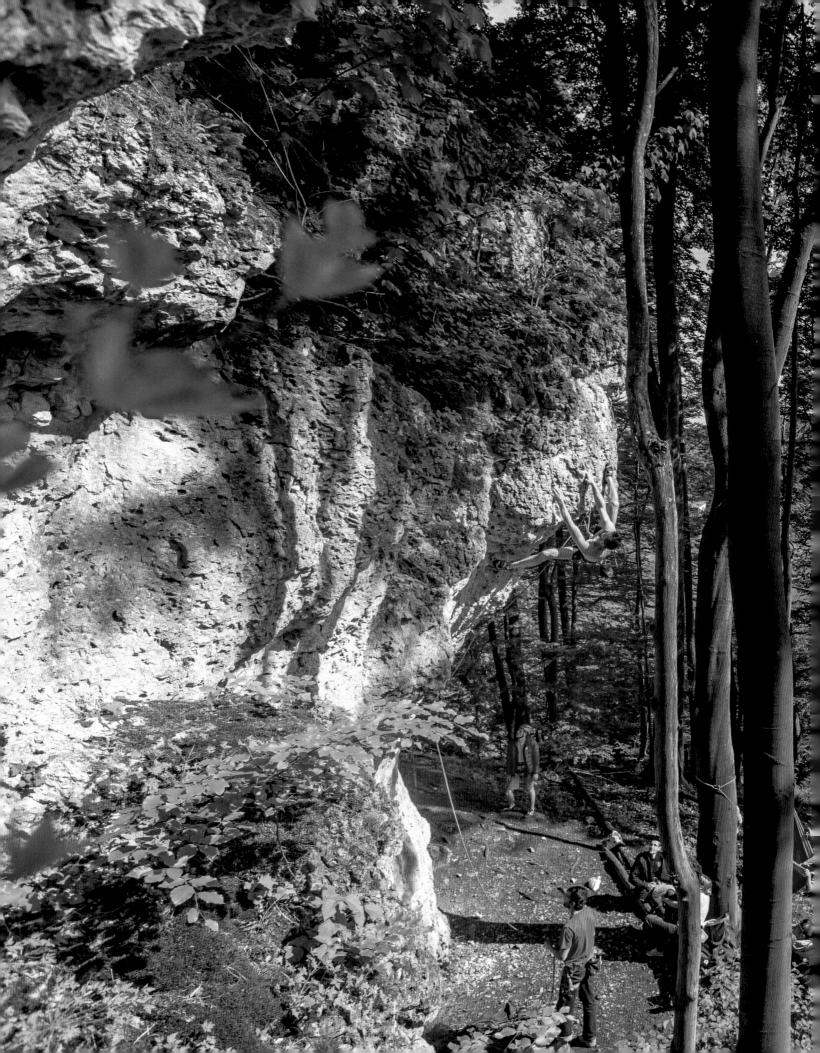

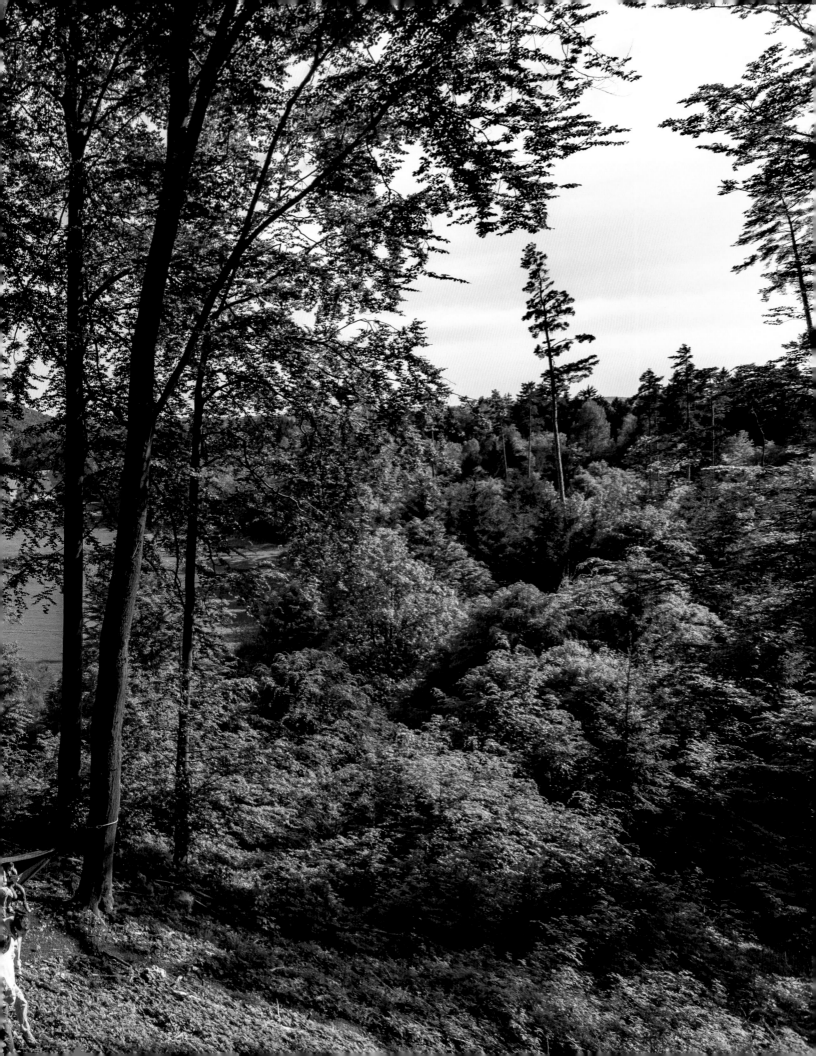

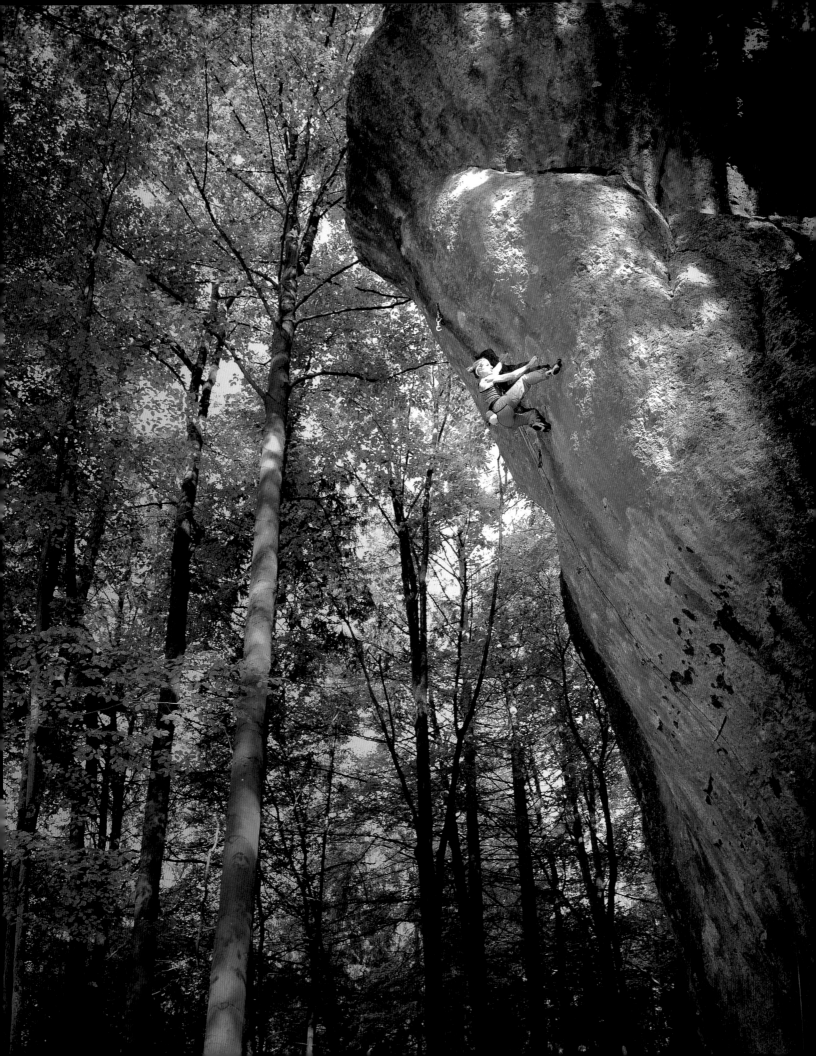

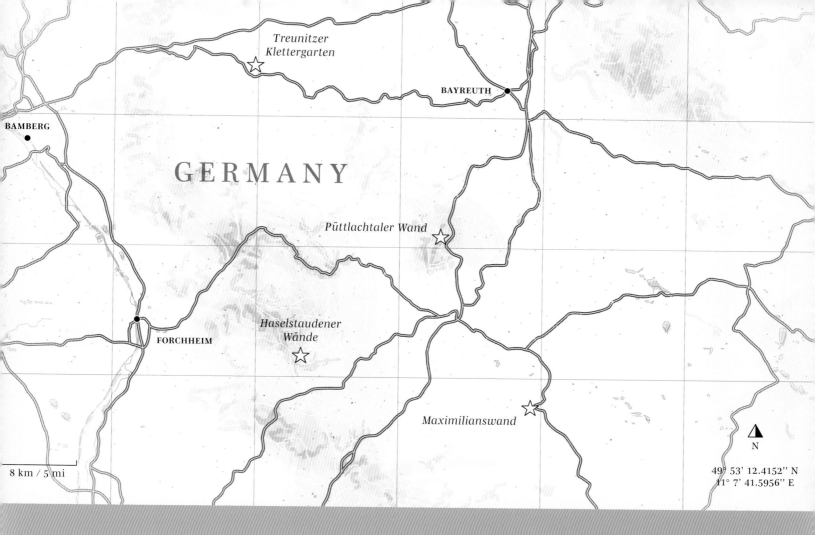

TREUNITZER
Klettergarten ☆

BAYREUTH ●

BAMBERG ●

G E R M A N Y

Püttlachtaler Wand ☆

FORCHHEIM ●

Haselstaudener
Wände ☆

Maximilianswand ☆

▲
N

8 km / 5 mi

49° 53' 12.4152'' N
11° 7' 41.5956'' E

FRANKENJURA

in a Nutshell

CLIMBING TYPE

Sport

PROTECTION

Quickdraws

SEASON

Spring, summer, fall

WHERE TO STAY

Campgrounds, hostel,
guesthouse

ONE MORE THING

While the Frankenjura mostly
gets its fame from the iconic
routes that are impossible for
most climbers, there are plenty
of beginner and intermediate
options spread out across the
1,000 cliffs.

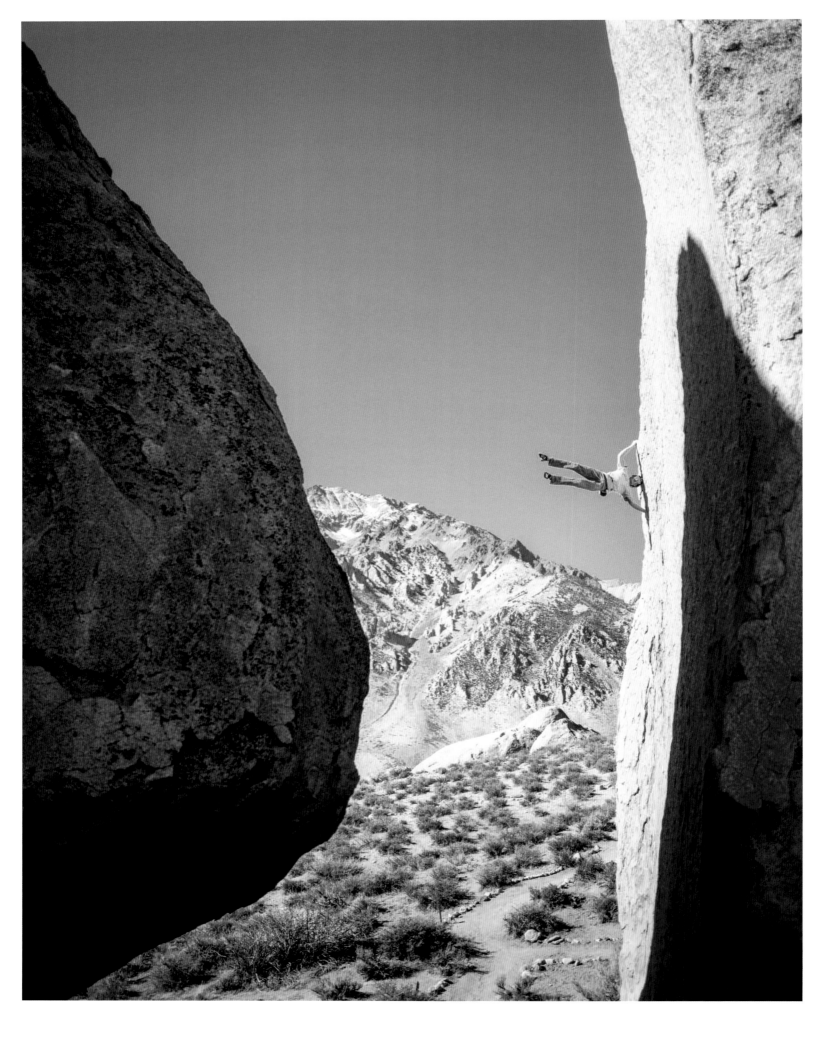

ALEX MEGOS

THIS GERMAN CLIMBER HAS MADE A NAME
FOR HIMSELF BY SENDING SOME OF THE
HARDEST ROUTES AND BOULDER PROBLEMS IN THE
WORLD—IN A HANDFUL OF TRIES.

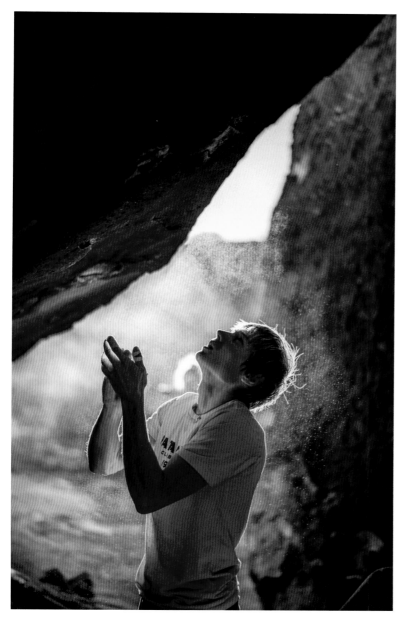

T wo years after the first ascent of the Frankenjura's *Action Directe*, Alex Megos was born on August 12, 1993, in Nürnberg, the second-largest city in Bavaria, Germany. It was one year after *Action Directe*'s first ascensionist, Wolfgang Güllich, a legendary German climber, died in a tragic car accident. Growing up in the forested mountains of Bavaria, Alex spent his childhood doing lots of outdoor sports and activities with his parents and younger sister. When he was six, Alex's father took him climbing for the first time in the Frankenjura. His father, Jorgos, started climbing in 1989 as a college student, when he took a course taught by Güllich and Kurt Albert, another famed Frankenjura pioneer. By age 10, Alex and his father would climb multipitch routes on holiday in France and Switzerland, and occasionally with a local kids' group. It was not until he was 12 that he started to really embrace climbing as his own passion, participating in local competitions. At 13, he started working with Dicki Korb and Patrick Matros, both highly respected climbing coaches, and training for bigger competitions. Between 2009 and 2011, he won two European Youth Championships (2009 and 2010) and climbed his first 8c/5.14b, 8c+/5.14c, and 9a/5.14d outside.

"I was always more of an outdoor climber, though, so from a young age I went out on rocks," Alex says. "Climbing was always more a lifestyle than only a sport, and being in nature was part of that lifestyle. I got more and more obsessed with climbing over the years, and by the age of 17 or 18, I was pretty much climbing as much as school would allow me." After graduating in 2012, he put all his focus into rock climbing. He took a trip to the Red River Gorge in Kentucky and cleaned up, climbing 11 routes in the 8c/5.14 range in three tries or fewer, including a flash of *Pure Imagination* (8c+/5.14c). Soon after, in March 2013, he onsighted *Estado Critico*, a 9a/5.14d in Siurana, Spain. Without any prior knowledge of the route, he climbed it on his first try; it was →

→ the first time a route of that difficulty had been onsighted. "I didn't really plan to onsight it," he says. "I simply wanted to see how high I could climb. Luckily I managed to reach the top." This was a standout achievement, one that caught the attention of the international climbing world and made Alex Megos a climber to watch. But his consistent success in this style of climbing—sending the world's hardest routes very quickly—confirmed Alex as one of the strongest climbers in the world.

A few days after flashing *Estado*, Alex almost flashed *La Rambla*, a 9a+/5.15a in Siurana, but fell at the top. He sent on his second attempt. Then he climbed *A Muerte* (9a/5.14d) on the second go. Alex went back to the United States in early 2014, but this time to focus on bouldering. During his first week in Bishop, California, he sent *The Swarm, The Buttermilker*, and *Mandala Sit Start*, as well as Red Rock's *Meadowlark Lemon*—all in the 8B/V13 to 8B+/V14 range. In an interview with *Climbing* magazine, he says he "spent two short sessions on each problem." That spring he went back to his home area of the Frankenjura, and over the course of a few months, did nine routes of 9a/5.14d and 9a+/5.15a difficulty and eight routes of 8c+/5.14c difficulty. Part of this sending spree included what Alex calls his most memorable day climbing outside: the day he sent *Action Directe*. It took Güllich dozens of tries over 11 days to send the route, which was the first 9a/5.14d in the world. It took Alex two hours.

Now he uses the Frankenjura for training, where he will climb up an 8b+/5.14a, downclimb an 8a+/5.13c, and repeat that three total times without touching the ground. Then he heads to the gym to climb for a few hours. Alex is known for an utterly impressive work ethic and ability to climb for days or weeks at a time, with little to no rest. His motivation to train so tirelessly comes from within himself, based purely on the enjoyment he gets from the act of climbing and training. He lives by a quote uttered by Güllich, which is also crucial for the style of climbing in the Frankenjura: "When you're climbing at your limit, there is nothing soft to reach for," Güllich once said. "You must make your grip a vise, or forget it." While he does partially credit his successes to being strong, he thinks a positive attitude and belief that he can do something is more important: "The right mind-set is at least as important, probably even more important than only physical training. The mind works differently for each one of us, so there is no formula that applies to everyone. That's something we have to figure out ourselves over time."

In May 2018, Alex combined his keys to success— "a positive approach, thoughtful projecting, and efficient attempts"—to get the first ascent of *Perfecto Mundo*, a 9b+/5.15c, becoming the third person ever to climb the grade. In August 2019 at the Climbing World Championships, Alex became one of the first confirmed athletes to compete in the 2020 Tokyo Olympics, which he counts as one of his proudest achievements. According to Alex, this accomplishment showed him that through hard work, he is capable of doing things that are important to him. While his heart lies with climbing outside, Alex still enjoys the challenge of

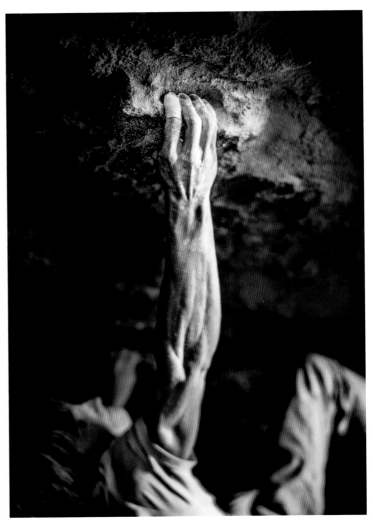

↑ *Above* Alex grabs the crux "bone hold" on the classic V14/8B *Esperanza* in Hueco Tanks, Texas. The route climbs out a near-horizontal roof, requiring immense power and finger strength. ↓ *Below* Alex climbs the powerful *Terminator*, an 8B/V13 boulder problem in Squamish, British Columbia. → *Right page top* Using an unorthodox climbing style, Alex holds a near-impossible swing to climb through the crux on *Specter* (8B/V13) in Buttermilk Boulders, near Bishop, California.

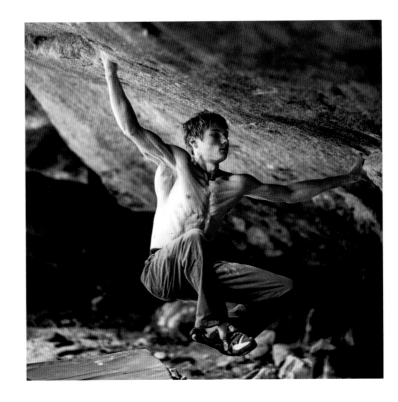

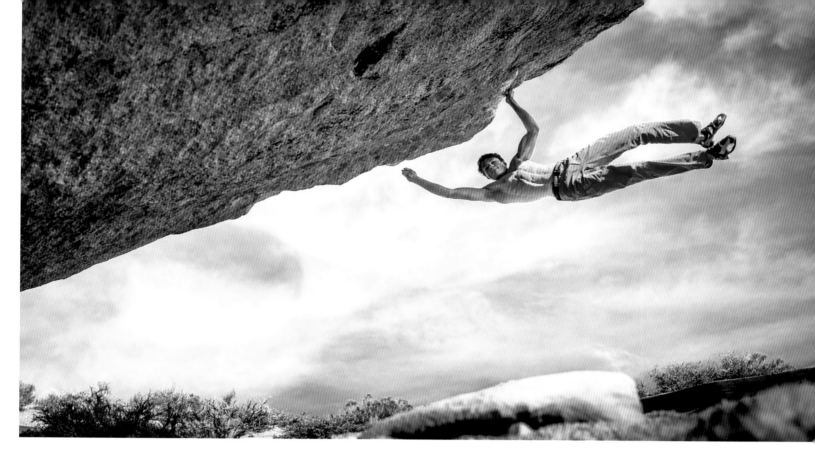

HE WILL CLIMB UP AN 8B+/5.14A, DOWNCLIMB AN 8A+5.13C, AND REPEAT THAT THREE TOTAL TIMES WITHOUT TOUCHING THE GROUND. THEN HE HEADS TO THE GYM TO CLIMB FOR A FEW HOURS.

competition climbing, although he sees competitions as a temporary part of his climbing life and the outdoors as a permanent fixture. "I realized more and more that comp climbing and outdoor climbing are growing apart over the last few years," he says. "They used to be very similar in style at some point, and in my opinion they are not anymore. Both have got their eligibility in our climbing world, and I wouldn't want to miss out on either of them for the moment."

Despite having already pushed the boundaries of what is possible in rock climbing, Alex is frank about his accomplishments—he knows he is a strong, good climber—but he also thinks he is capable of more. And he will work hard to find out what that "more" is. At 26 years old, he does not quite think he is on the same level as the other well-known German climbers who got their start in the Frankenjura: "Kurt and Wolfgang are legends of our sport and pioneers from back in the day. I don't see myself quite in that league. I just try to push my own limits in climbing, and I'm happy to be able to inspire some people with what I'm doing." While the late pioneers of the Frankenjura have left their mark on the history of climbing, Megos will shape the future of it.

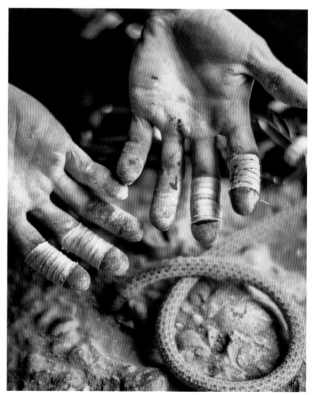

↑ *Above* The story is in the details: Alex's bloody and taped fingers after making the first ascent of *Perfecto Mundo* (9b+/5.15c) in Margalef, Spain. →→ *Following spread* Alex making the first ascent of *Fight Club* (9b/5.15b) outside of Banff, Canada. With this climb, he established the country's hardest route. He also achieved the first one-day ascent of *Dreamcatcher* (9a/5.14d) and flashed *The Path*, an 8b+/5.14 trad route, during the same trip.

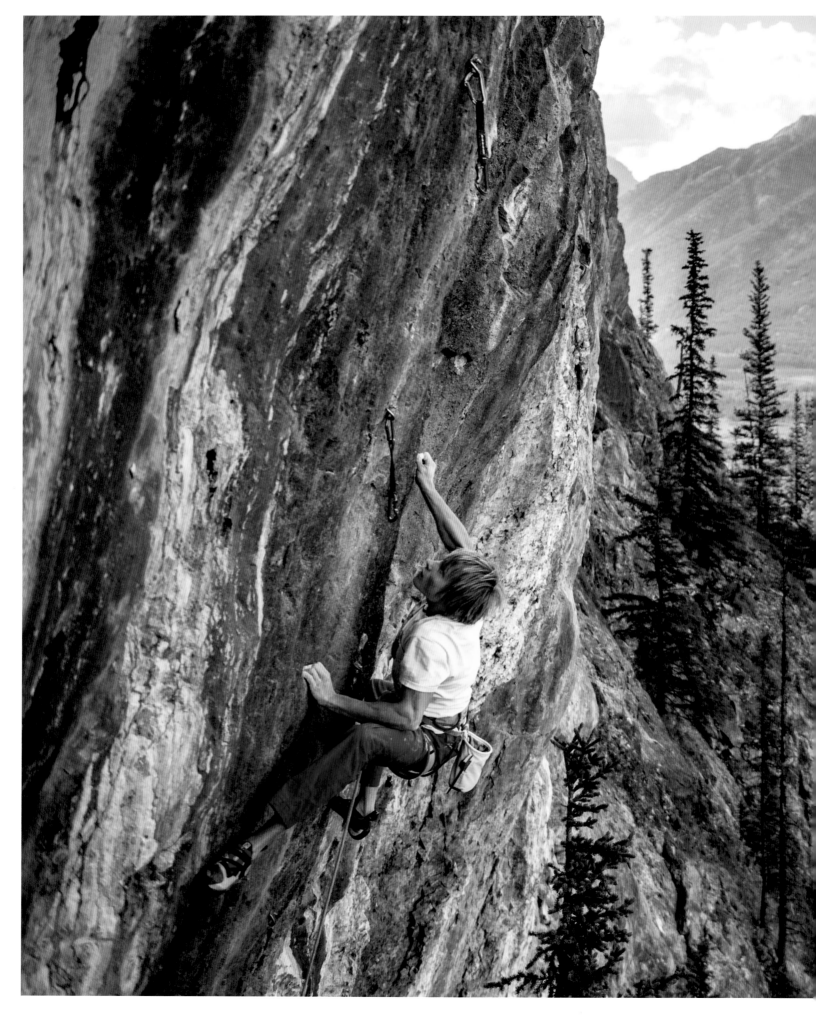

ALEX MECOS

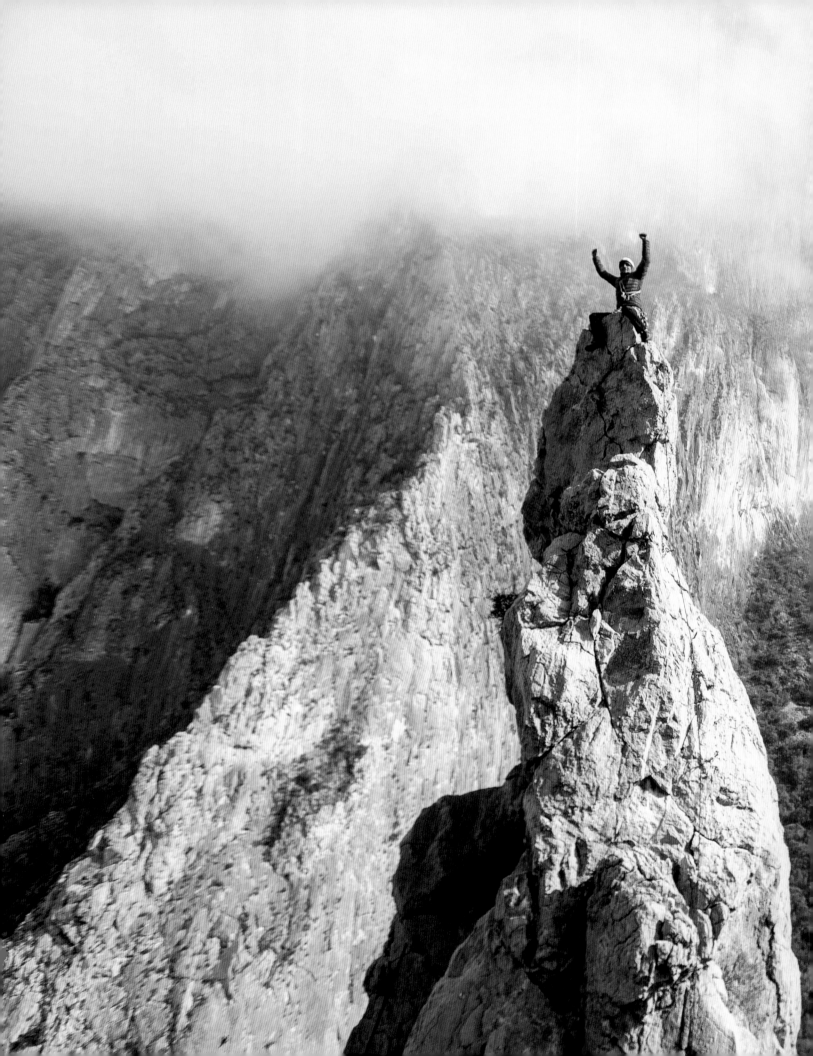

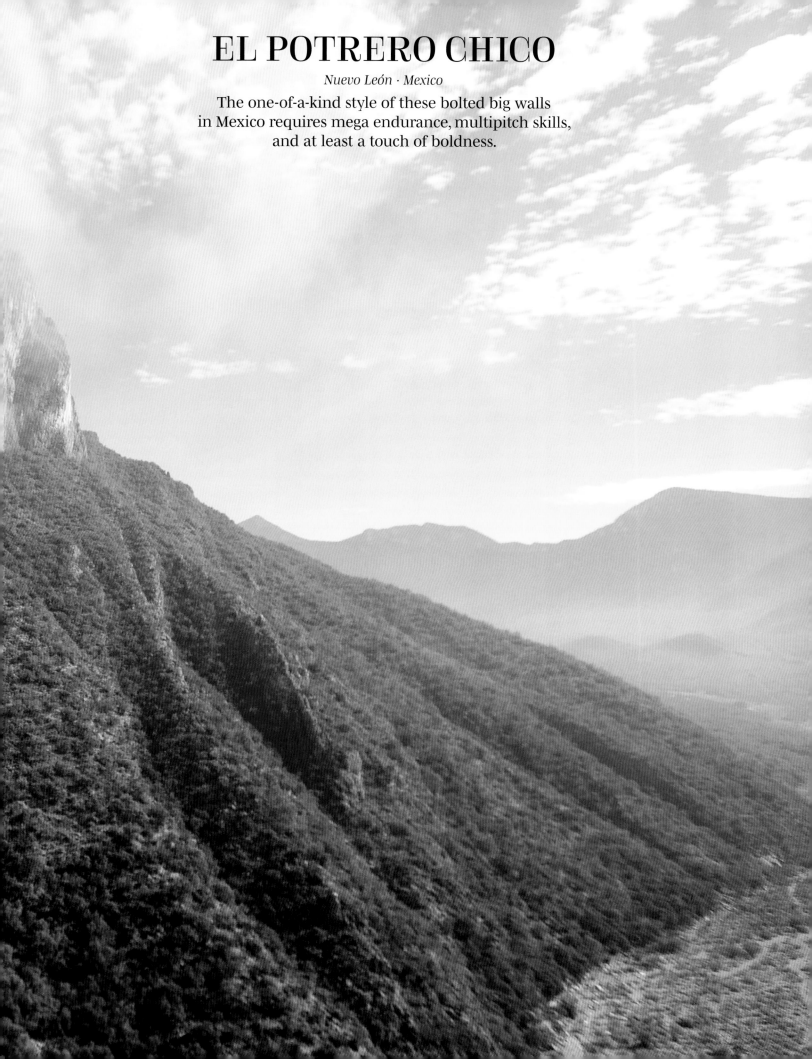

EL POTRERO CHICO

Nuevo León · Mexico

The one-of-a-kind style of these bolted big walls
in Mexico requires mega endurance, multipitch skills,
and at least a touch of boldness.

Mentioning big wall climbing usually conjures up images of soaring routes that take multiple days to complete, where two climbers must sleep, eat, and use the bathroom with each other—all while dangling several hundred meters off the ground. Enduring the hardships that Mother Nature throws at you just so you can keep climbing is part of the fun. Many climbers call that "type 2 fun," where it's not necessarily fun in the moment, but looking back on it, you can't help but think, "Yeah, that was fun." In this Mexican big wall paradise, you can get up late, climb a 12-pitch route in a half-day, then be back in time to have a bucket-size margarita before the sun sets. That's what we climbers call "type 1 fun." It's fun while you're doing it, and afterward.

El Potrero Chico, which means "little corral," is anything but. With more than 500 routes from up to 23 pitches, on solid limestone, Potrero has something to offer climbers of all ability levels. The difference here is that all the lines are bolted, so it's sport climbing and not trad climbing like most big walls. Instead of spending a lot of time fiddling with your own protection, you can whip out a quickdraw, clip the bolt, and keep climbing. You can move fast and cover a lot of terrain, which in standard limestone style offers all types of holds: pockets, crimps, edges, bumps, divots, slopers, and cracks. It's also a stellar destination for wintertime. When most crags are way too cold and snowy, Potrero is as perfect as it can get: mostly sunny and about 68 °F (20 °C). Maybe even a little too warm for trying hard. It's Mexico, so the cost of living and travel is crazy-cheap, and the food is the best you've ever had. There's no need to have your own wheels, as all the climbing is a few minutes' walk from the camping. If you need to get to the small town of Hidalgo for the festive weekly market, it's easy to hitch a ride with a local. The biggest problem you might face is how much your toes hurt after standing on tiny holds all day.

The 6-mile (10-kilometer) canyon features huge fins of rock on either side, with routes of all different lengths on both sides. Some of the climbs will ascend one side, and then descend the other. This is the case with the area classic, *Estrellita*, a 12-pitch 6b+/5.10d, that features a palm tree on the summit. Another classic for the more adventurous is the longest route in the canyon, *Time Wave Zero*, 23 pitches and 2,300 feet (700 meters). At a grade of 7a+/5.12a, it's very attainable for many climbers. If you're looking for something a bit harder and more sustained, but just as good, look no further than *El Sendero Luminoso*. The 1,500-foot (450-meter) route is on the imposing front side of El Toro. Seven of the 15 pitches are in the 7b/5.12b to 7c/5.12d range, so it's a lot of hard climbing right in a row. Established by area developers Jeff Jackson, Kurt Smith, and Pete Peacock in 1994, *Sendero* had been around for 20 years without much fanfare (paling in comparison to the popularity of the much "easier" *Time Wave*) before famed American climber Alex Honnold free soloed the route in 2014. With little climber traffic in the last two decades, *Sendero* had amassed dirt and vegetation on the holds and in the cracks. The ascent took him a little more than three hours after he and American Cedar Wright spent four days climbing, rehearsing, and cleaning the route. Of the experience, he wrote, "On the midway ledge, I popped my shoes off, and again five pitches higher, just to let my toes relax. The desert glowed orange below me— it was heating up to a pleasant day in the valley—but my attention was focused on the dim and seemingly endless rock above. I'd found exactly the experience I was looking for: I was only a small dot on a vast, uncaring wall, but for those few hours, I got to taste perfection."

↓ *Below* Paul Creme walks through the foggy canyon of El Potrero Chico. → *Right page* Paul Creme climbing into the fog in Mexico.

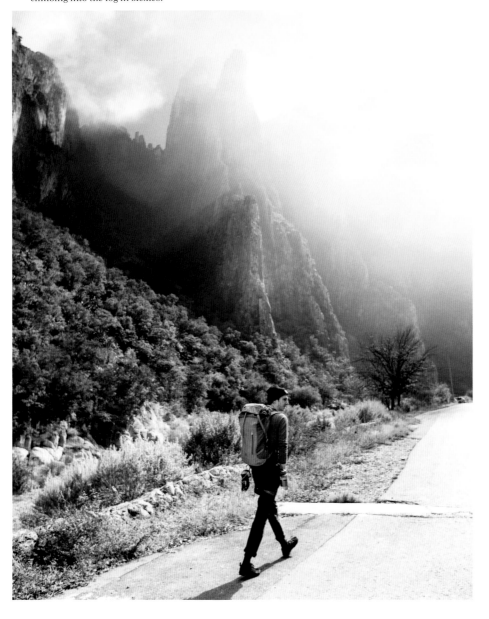

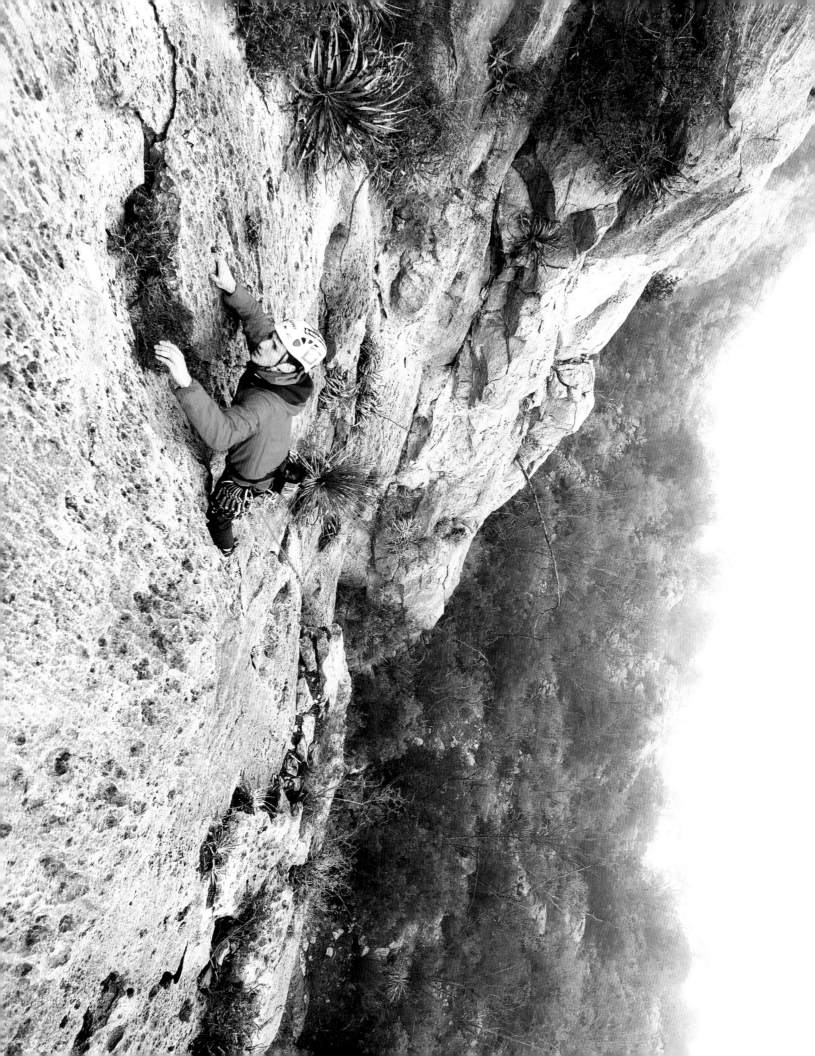

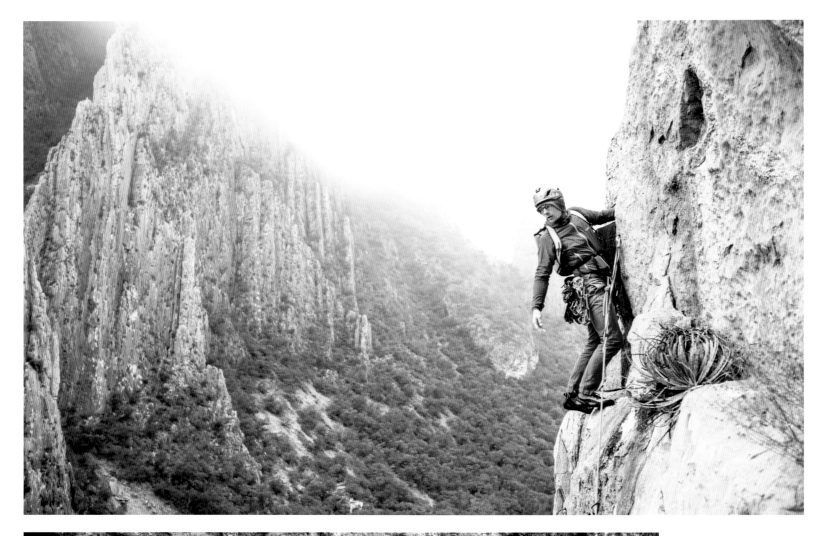

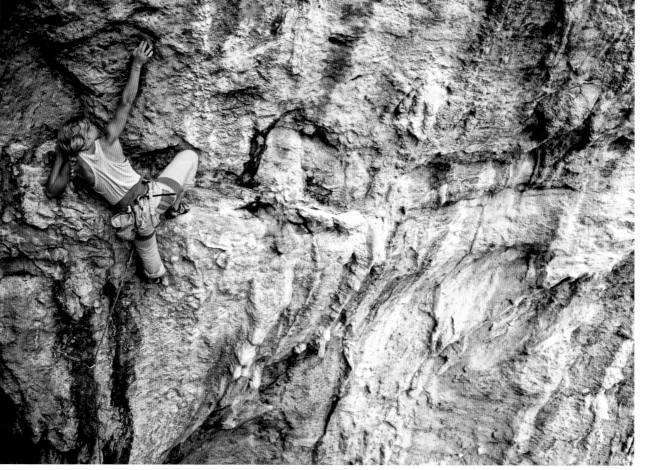

↑ *Above* Alton Richardson
takes a look behind him
while climbing *Estrellita*
(6c / 5.11a). ← *Left* Potrero
has tons of long sport
routes and difficult
single-pitch lines, like this
one Savannah Cummins
is working hard on.
→ *Right page* Throwing
the rope to rappel
off the top of one of Las
Agujas, the infamous
spires in Potrero.
→→ *Following page* The
towering limestone walls
are just a few minutes'
walk from La Posada, the
most popular climber's
campground in Potrero.

EL POTRERO CHICO

in a Nutshell

CLIMBING TYPE

Sport, multipitch and
single-pitch

PROTECTION

Quickdraws

SEASON

Winter

WHERE TO STAY

Plentiful campgrounds
in the area (La Posada is the
main one), or rent a casita
with friends

ONE MORE THING

This part of Mexico has been
known to have violence
and crime, but there haven't
been any major incidents
in recent years. Be aware of the
situation before you go, and stay
alert while you're there.

MEXICO

Las Estrellas

Virgin
Canyon

Las Agujas

Mota
Wall

N

150 m / 500 ft

25° 57' 22.7484'' N
100° 28' 35.814'' W

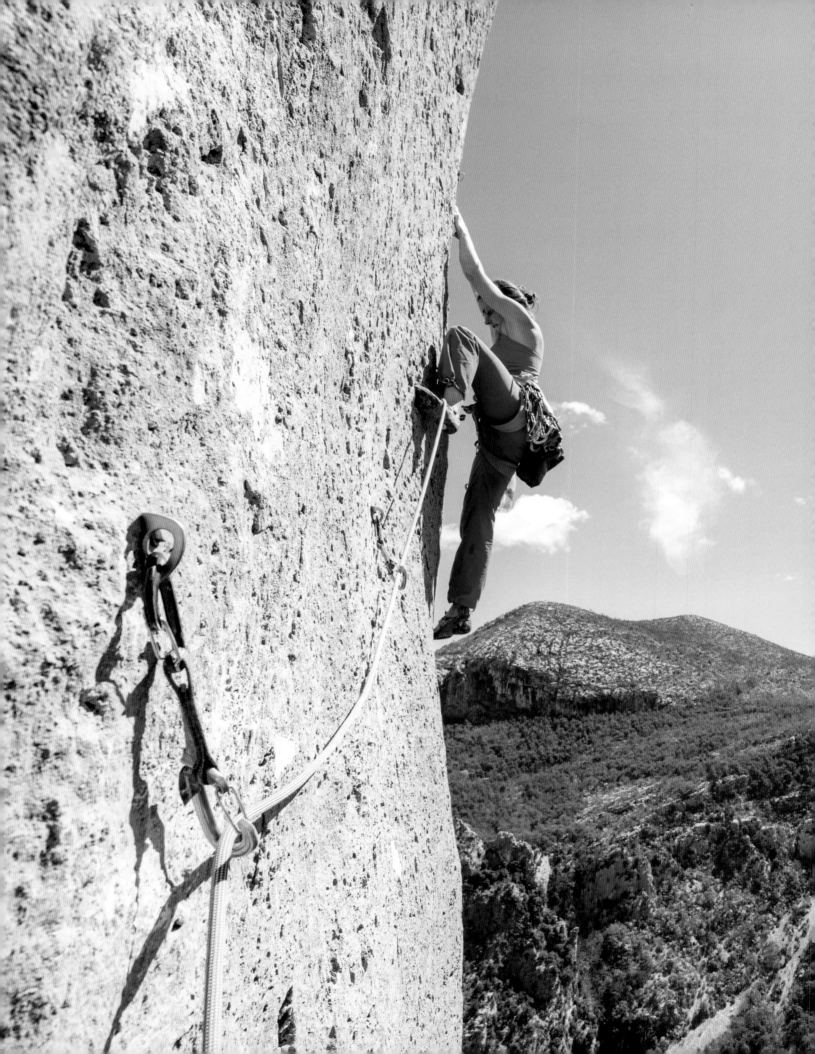

VERDON GORGE

Provence-Alpes-Côte d'Azur · France

Do not let the bolts fool you—these
towering walls of blue limestone offer lessons
in climbing history and commitment.

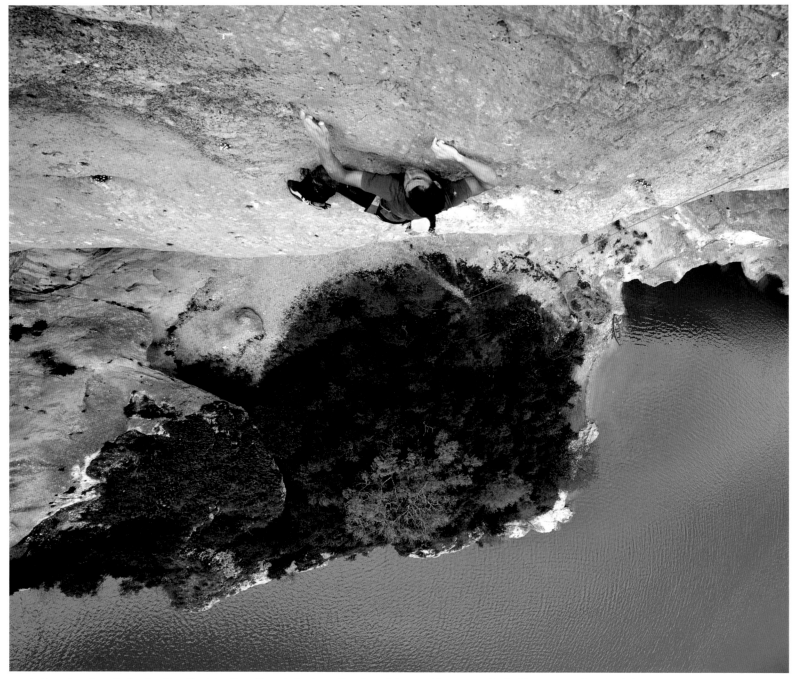

↑ *Above* American climber Jonathan Siegrist pulls on the notoriously small pockets of the area's limestone, with the blue-green Verdon River below. → *Right page* Southeastern France is home to Verdon Gorge, a geological wonder and a climber's dream. This breathtaking canyon is split by a bright-blue river with towering limestone walls on either side.

On the winding roads from Marseille to the Verdon Gorge, it is impossible not to feel like you are driving straight into a real-life postcard. This is the case in particular between July and August, when the lavender covering the gentle hillsides of southeastern France are at peak purpleness. The narrow, two-lane roads go from wide expanses of rural land down into tight hollows that heave the car up and down, and the bodies inside the car along with it. Right when you reach the tipping point of almost throwing up, the road pops you out into openness all around, with a quickness that leaves the head spinning. At those moments, you will be glad if you are not the one driving.

Eventually you will reach the quaint town of La Palud and a zigzagging road along the rim of a dramatic canyon. Going slow on the tight curves, you'll catch glimpses of the blue-gray limestone walls streaked with yellow. When you want to view the canyon in all its glory, or to scope your first climbing route, pull over at a *belvédère*, or a roadside pullout. Whether you're a new climber or experienced veteran, your palms will sweat at the dizzying heights and blank-looking walls. This is not a place for the faint of heart. The walls are big, the routes are long, and the protection is safe but sparse.

Even if you start with one of the area's "moderate routes," like a four-pitch 6a/5.10a that only covers about one-third of the entire wall, the intimidation factor is high. The Verdon is largely credited as the

birthplace of sport climbing, the spot where climbers in the 1970s started venturing out onto the huge, seemingly blank faces of blue and yellow limestone. What they found were dozens of perfect lines of climbing holds. Some were only 400 feet (120 meters) or so. Others were 1,150 feet (350 meters) of dishes, pockets, crimps, edges, tufas, pinches, and nubs stretching from near the canyon floor to the rim. Since there were no cracks and fissures to place gear, the first ascensionists had to hand-drill bolts into the rock for protection. It was a time-consuming and expensive process for a route longer than 150 feet (45 meters), so they used them sparingly, sometimes placing them 30 feet (10 meters) apart.

From the car, you can carry just the rope coiled as a backpack and quickdraws clipped to your harness. Even the normally loud sound of the metal clinking against itself will be muted by the wind that whooshes its way up from the canyon floor 2,000 feet (600 meters) below. Walk the short distance down a paved path and reach a conspicuous anchor bolted into the wall. At the anchor, you can peer over the edge to see the turquoise Verdon River snake its way through the canyon while griffon vultures, birds with 13-foot (4-meter) wing-spans, ride thermals in circles. In the few short minutes it will take you to arrive at the rappel anchor, if your headspace isn't strong, your psych might disappear completely. Maybe the three espressos you had that morning have worn off, or maybe the wind has blown the courage right out of your body. Either way, the route—and all of the Verdon—is about commitment. Once you rappel down to the start of any climb, you must be able to climb your way back out. There's no room for error or questioning your abilities. Despite the "friendly" nature of bolted climbs, every route in the Verdon is a serious endeavor. What if your or your partner makes a mistake on the rappel and you plummet to your deaths? What if you rappel down safely, only to be unable to climb back out? What if you get sketched out by one of the notorious runouts between bolts and can't commit to doing the moves? It's all possible in the Verdon—but the sweeping views, technical movement, and airy exposure make it worth the mental challenge.

Back off if you must, and spend the rest of the time driving the scenic Route des Crêtes along the north rim, enjoying the views from the *belvédères* and orienting yourself in the canyon. Whenever you decide to go for it, pick a line from one of the many options of length and difficulty. The area surrounding the *Dingomaniaque* route, a classic 560-foot (170-meter) 6c+/5.11b, has shady routes ranging from 560 to 989 feet (170 to 300 meters), with grades from 5c/5.9+ to 6c+/5.11b. Go longer at La Damande with the namesake route that's 6a/5.10a and 1,250 feet (380 meters). Try for the hard stuff at Pichenibule, where you'll find the *Pichenibule* route, a 1050-foot (320-meter) 7c+/5.13a. For exposure and air under your bum, try *Golem* (7a/5.11d), a 460-foot (140-meter) route with technical face climbing. If you want to test yourself alongside some of the world's best climbers, *Tom et Je Ris* (8b+/5.14a) should be your goal. This aesthetic endurance line is 200 feet (60 meters) of beautiful tufas, or pipe-like features on the rock, that will also test your determination with 30-foot (10-meter) runouts between bolts. Whatever route you choose, make sure to go about it the true French way—enjoying baguettes, cheese, and wine after a long day of climbing.

→→ *Following spread* All Verdon climbers, including Lauren McCormick who is pictured here, must have nerves of steel and a strong head in order to try hard—and potentially fall—with the massive exposure of hundreds of feet of air under their feet. →→ *Page 120* The first climbers to the Verdon only realized that the blank-looking walls were climbable because they were able to rappel down from the top and see the countless holds and route options.

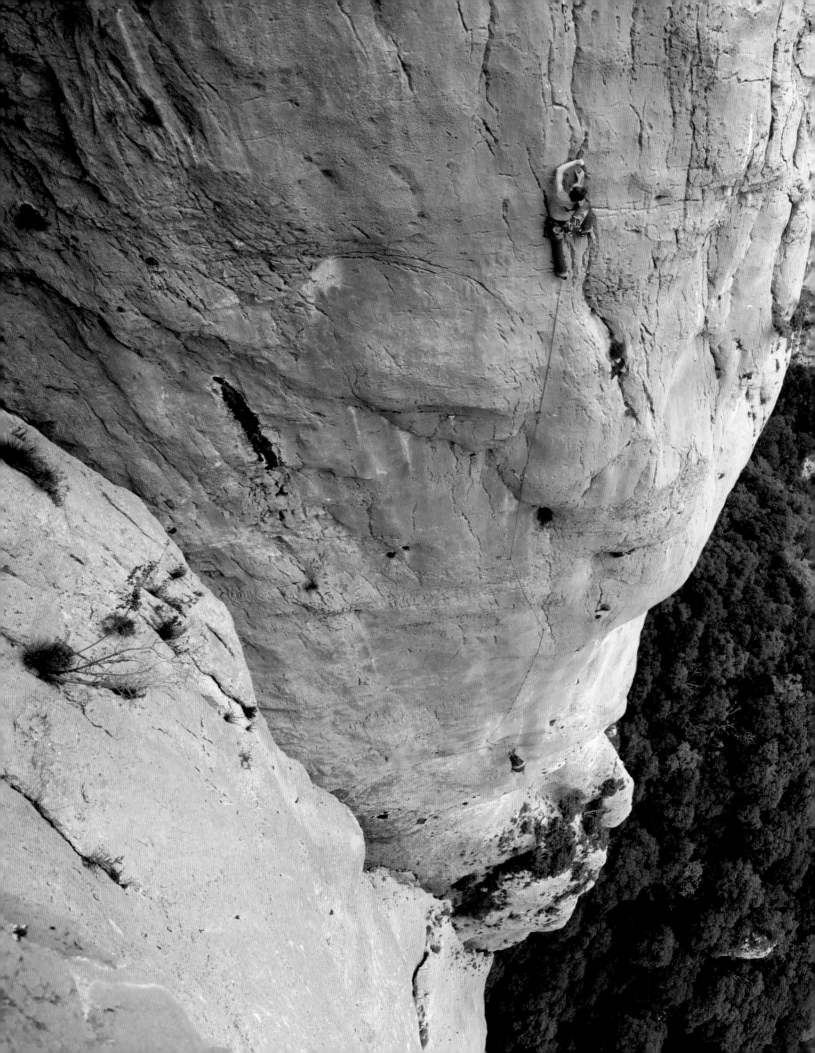

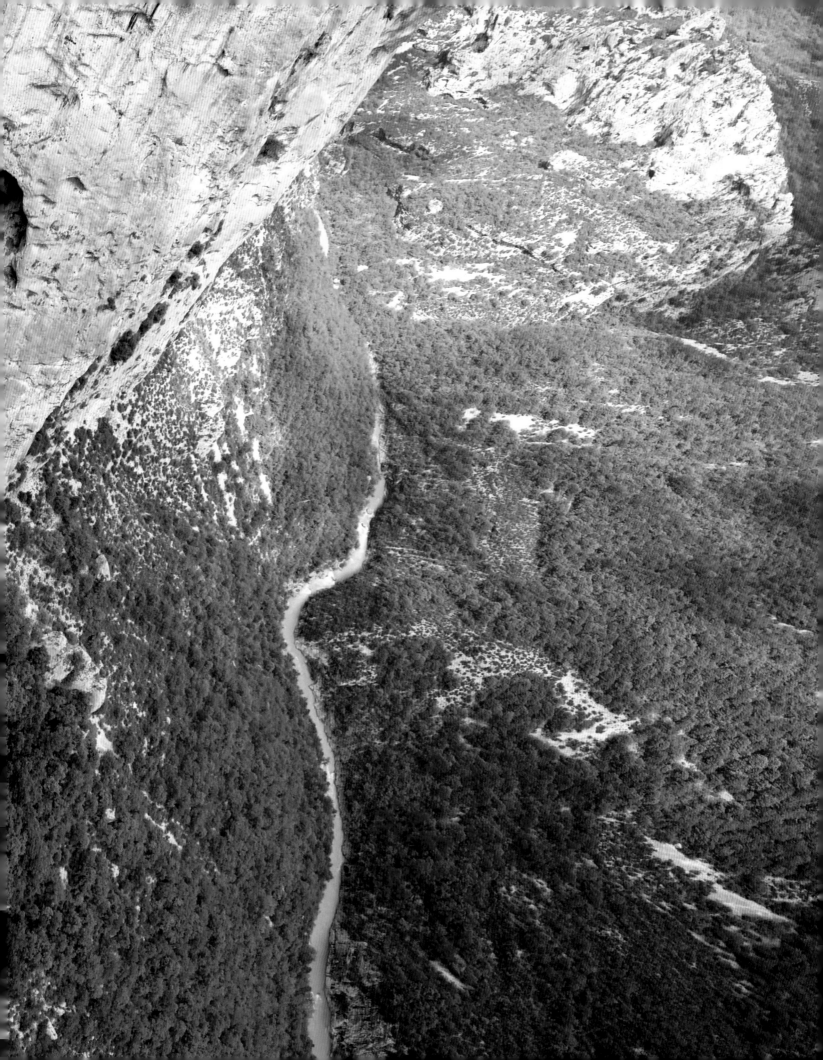

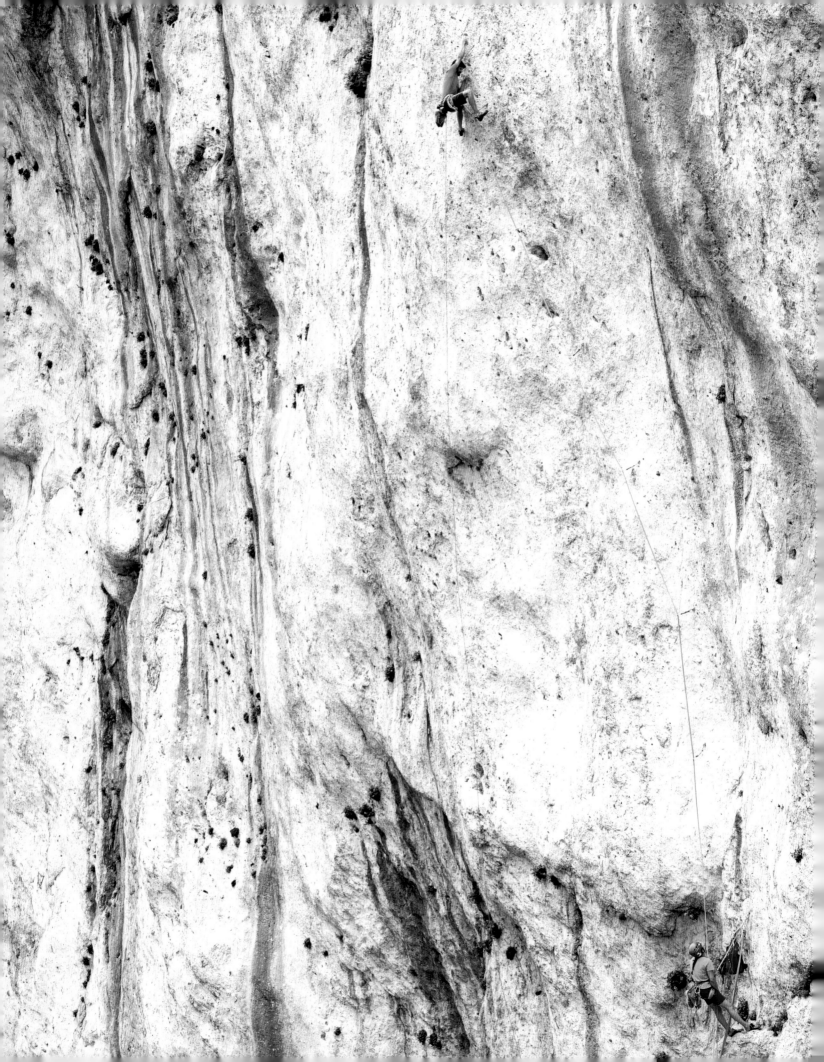

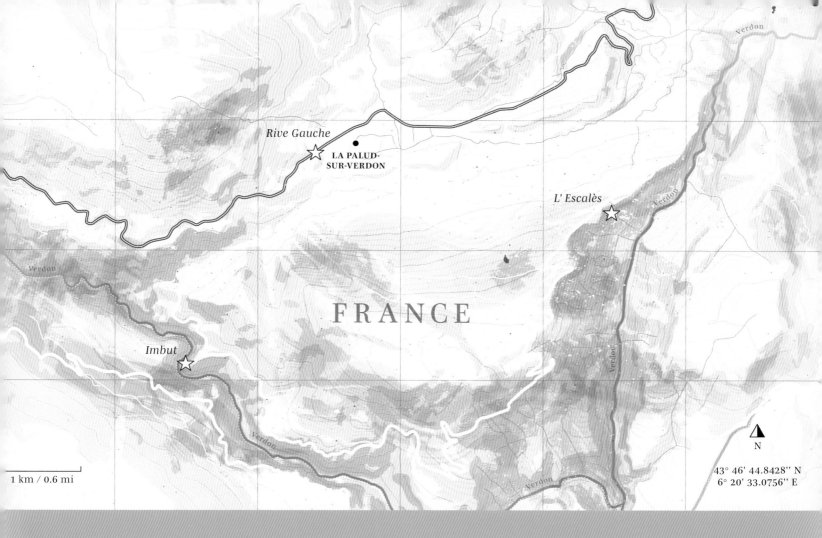

Rive Gauche

LA PALUD-
SUR-VERDON

L' Escalès

FRANCE

Imbut

1 km / 0.6 mi

N

43° 46' 44.8428'' N
6° 20' 33.0756'' E

VERDON GORGE

in a Nutshell

CLIMBING TYPE

Sport, some traditional

PROTECTION

Mostly quickdraws, but
many of the historic routes
require trad gear

SEASON

Spring, summer, fall

WHERE TO STAY

Rent an apartment or
camp in the nearby village
of La Palud-sur-Verdon.

ONE MORE THING

Even though the Verdon is
considered sport climbing, take
the committing nature of the
climbs seriously and do not get
in over your head.

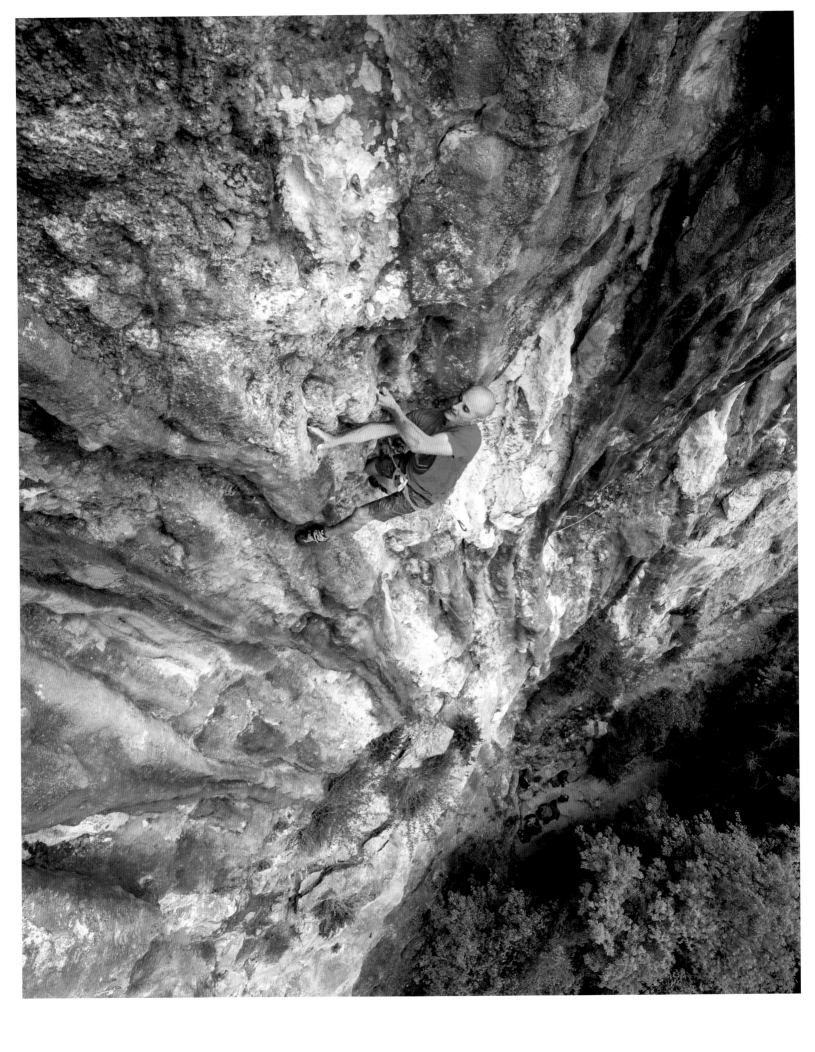

THE RABOUTOU FAMILY

THIS FRENCH AND AMERICAN FAMILY IS COMPRISED OF FOUR OF THE STRONGEST, MOST DECORATED CLIMBERS IN THE WORLD—AND THEY ARE JUST GETTING STARTED.

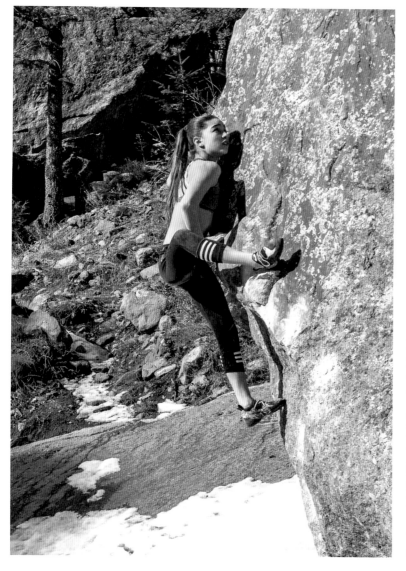

In January 1990, a 26-year-old Robyn Erbesfield sat behind the wall at the Massy Invitational climbing competition in Paris, France. She was currently in first place as she waited to go onstage to climb in finals. The year before, she had become a professional climber and won the first-ever World Cup in Leeds, England, in 1989. Her competition career was just picking up steam when she found herself sitting beside the French climber Didier Raboutou, who was also in first place and waiting to climb in the finals round. Robyn knew Didier as a successful competitor on the French National Team and one of the few climbers in the world who had sent the grade of 8b+/5.14a at the time. They also knew each other from traveling and training together—as an American, Robyn received little support from any national climbing organization back home and instead was embraced by the French Federation. Sitting behind the wall, Didier cleaned his shoes with *pof*, a dried pine tree resin put into a rag.

"I remember very specifically sitting next to him," Robyn says now, almost three decades later. "We had this moment where he shared his little *pof* thing with me, and we started sharing conversation." A year later, after Didier broke up with his girlfriend, the French and American climbers started dating when they spent a Christmas holiday at a mountain house in the southwest of France. "It wasn't until his relationship started to terminate with his girlfriend that he actually became kind of aware of me," she says. "I was like, 'Ooh. He's kind of cute.'" This was the beginning of the Raboutou family climbing dynasty.

From 1992 to 1995, Robyn went on to win the overall World Cup title four times in a row, also winning the Lead Climbing World Championships in 1995. She won five →

→ U. S. National Champion titles, and she won all 11 competitions she entered in 1993. Didier climbed 8c/5.14b outside, and podiumed in various Masters and World Cup competitions, including winning an Arco Rock Master competition. After retiring from competition in 1992, he stepped in to help coach and support Robyn in her climbing. The couple married in 1993. "We were able to support each other really well, all throughout our entire career of climbing," Robyn, who now goes by Erbesfield-Raboutou, says. "We've always been a positive influence on each other. He had what I always call 'bigger eyes.' He was able to put together plans for me that were larger than I might have imagined for myself."

Robyn had seen many athletes stay in the competition world when they had lost motivation, and do poorly as a result. So, when she won everything in 1995, she decided she would not compete in '96. Instead, she and Didier, who had started constructing climbing walls, did a tour of climbing clinics in climbing gyms around the world for the next two years. In 1998, their son, Shawn, was born, so they took him along while teaching clinics in Europe. Three years later, they had their daughter, Brooke. When Shawn was ready to start kindergarten, the Raboutous wanted him educated in the United States, so they started spending the school year in Boulder, Colorado, and summers in Saint-Antonin-Noble-Val, France.

In October 2004, Robyn and Didier founded ABC Kids Climbing, which stands for agility, balance, and coordination, in a specialized, kid-friendly room designed by Didier in the Boulder Rock Club. For Robyn, focusing on the youth was a way to build athletes who did not have perceived limits on what they could or could not do, a mind-set that adults can struggle with. Already passionate about climbing, Shawn and Brooke were two of Robyn's first students.

Fast-forward 15 years, and ABC Kids Climbing now has 7,200 square feet (670 square meters) of climbing terrain in its state-of-the-art Boulder facility, also designed and built by Didier. ABC Kids has also produced some of the best climbers in the world—two of which are Shawn and Brooke. With a passion for bouldering, Shawn has sent multiple 8C+/V16 problems, but his future in roped climbing looks just as promising. After not climbing on a rope for five years, Shawn sent his first 9a+/5.15a with a tick of *First Ley* in Margalef, Spain, in April 2018. While his most notable ascents are outdoor accomplishments, he has been competing for years, with plenty of wins under his belt. But modern competition climbing requires sacrificing outdoor time for indoor training time to be a top contender. "For Shawn, that just wasn't an option," his mother, who has coached hundreds of kids, says. "He's way too passionate about the outdoors. He still loves comps, and he's quite good at them. He just sees climbing, all outdoor climbing, as something that he'd like to push his limits at. And that's exactly what he does."

As a student at the University of Colorado Boulder, Shawn does one semester per year and then climbs and travels the rest of the time. On the other hand, Brooke "just really likes to stay busy." Between going to school at the

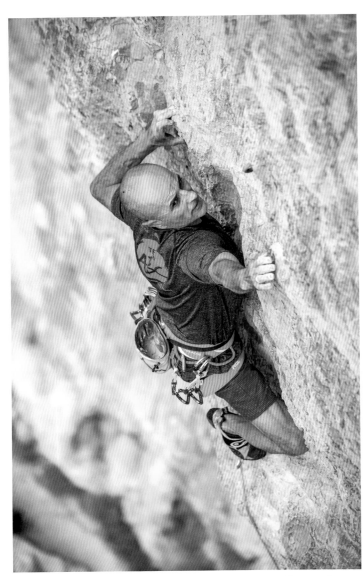

↑ *Above* Didier Raboutou on *Tapis Rouge* (7b/5.12b) at the crag of the Capucin, Saint Antonin Noble Val, France. → *Right page top* Brooke messes around near her home in Boulder, Colorado. → *Right page bottom* Shawn working the legendary Chris Sharma route *First Round, First Minute* (9b/5.15b) in Margalef, Spain.

ROBYN WON FIVE U. S. NATIONAL CHAMPION TITLES, AND SHE WON ALL 11 COMPETITIONS SHE ENTERED IN 1993. DIDIER CLIMBED 8C/5.14B OUTSIDE, AND PODIUMED IN VARIOUS MASTERS AND WORLD CUP COMPETITIONS.

University of San Diego full-time, being in a sorority, maintaining a social life, and training for climbing, Brooke managed to become the first U.S. athlete ever to qualify for climbing in the Olympics. She first earned the title of Combined Youth World Champion in 2016, then became the continental Pan-American Champion in 2017 and Lead Youth World Champion in 2018. She is no slouch in outdoor climbing either, having ticked up to 8c+/5.14c and 8B/V13, and in 2012, at age 11, she became the youngest person, male or female, to climb 8c/5.14b. "Brooke is that kid that loves climbing, and she would never give it up," Robyn says. "But she also loves her friends and she loves school. The only disappointing thing for Brooke, after making the Olympics, is that she had to decide to leave school, and leave all of her friends." As Brooke prepared for the Olympics in the first half of 2020, in addition to her parents, she tapped her brother as a coach. "As she was building her team around who she might look to for support, Shawn is the number-one person on her list for training power," Robyn says. →

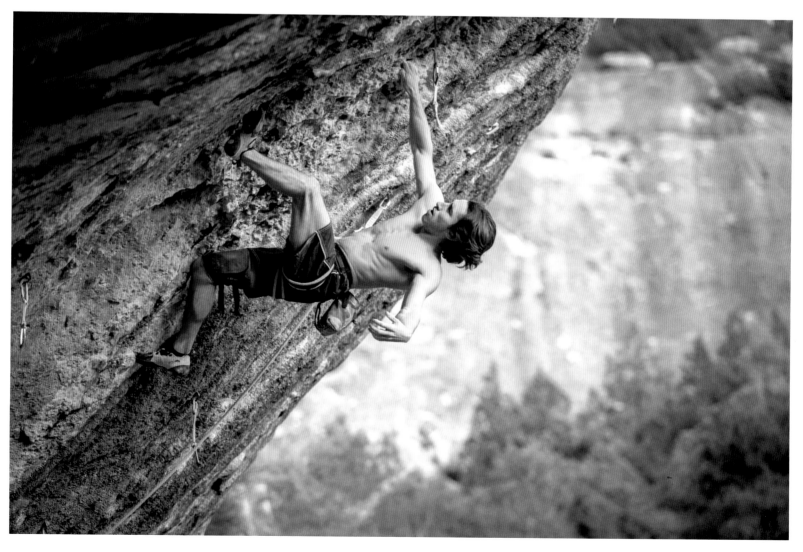

→ Didier and Robyn still climb together, and Robyn keeps the goal of climbing 8b+/5.14a every year. "I still always want to keep up with my climbing," she says. "I don't think that I would be the businesswoman that I am today if I wasn't able to get out and climb myself, and have goals, and have trips. My passion is still there." Despite Robyn and Didier's own impressive résumés and personal passions for the sport of climbing, Robyn denies any credit for her kids loving climbing so much. "Didier and I have to pinch ourselves often. We're like, 'How is it that they love climbing as much as we do?' I think it's just a little bit of luck, honestly. I've never pushed my kids. Perhaps that's where we went right. Maybe what I did right was doing nothing."

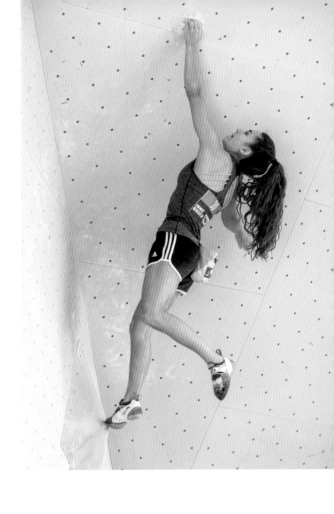

"DIDIER AND I HAVE TO PINCH OUR-SELVES OFTEN. WE'RE LIKE, 'HOW IS IT THAT THEY LOVE CLIMBING AS MUCH AS WE DO?' I THINK IT'S JUST A LITTLE BIT OF LUCK, HONESTLY. I'VE NEVER PUSHED MY KIDS. PERHAPS THAT'S WHERE WE WENT RIGHT. MAYBE WHAT I DID RIGHT WAS DOING NOTHING."

↑ *Above* Brooke boulders at Youth World Championships in Innsbruck, Austria. ← *Left* The Raboutou family are all accomplished climbers and still enjoy climbing together as a family. → *Right page* Robyn runs a lap on *Resonated* (7B+/V8) in Eldorado Canyon, near Boulder in the United States.

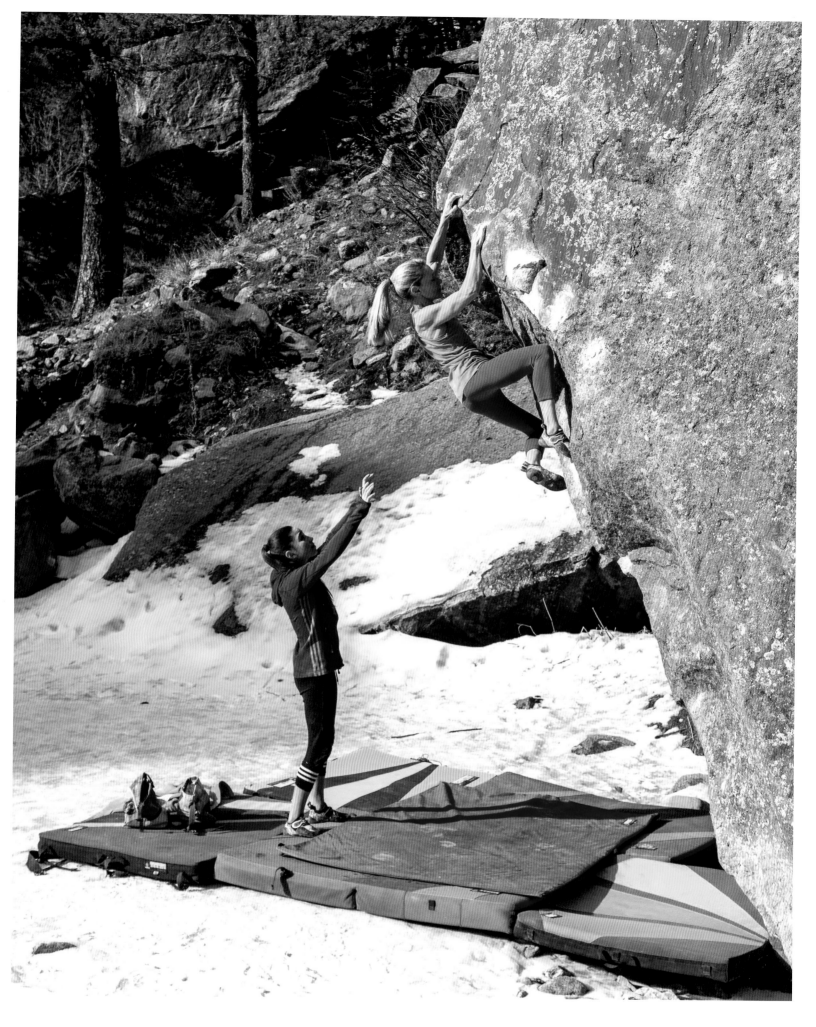

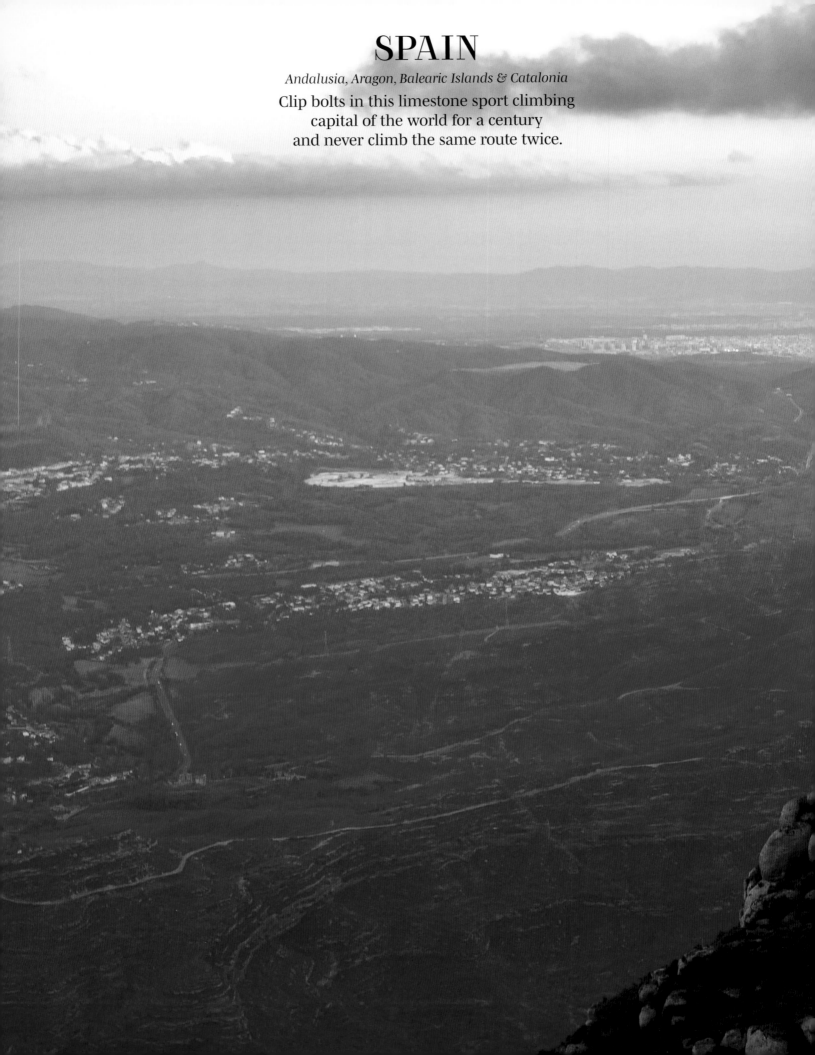

SPAIN

Andalusia, Aragon, Balearic Islands & Catalonia

Clip bolts in this limestone sport climbing
capital of the world for a century
and never climb the same route twice.

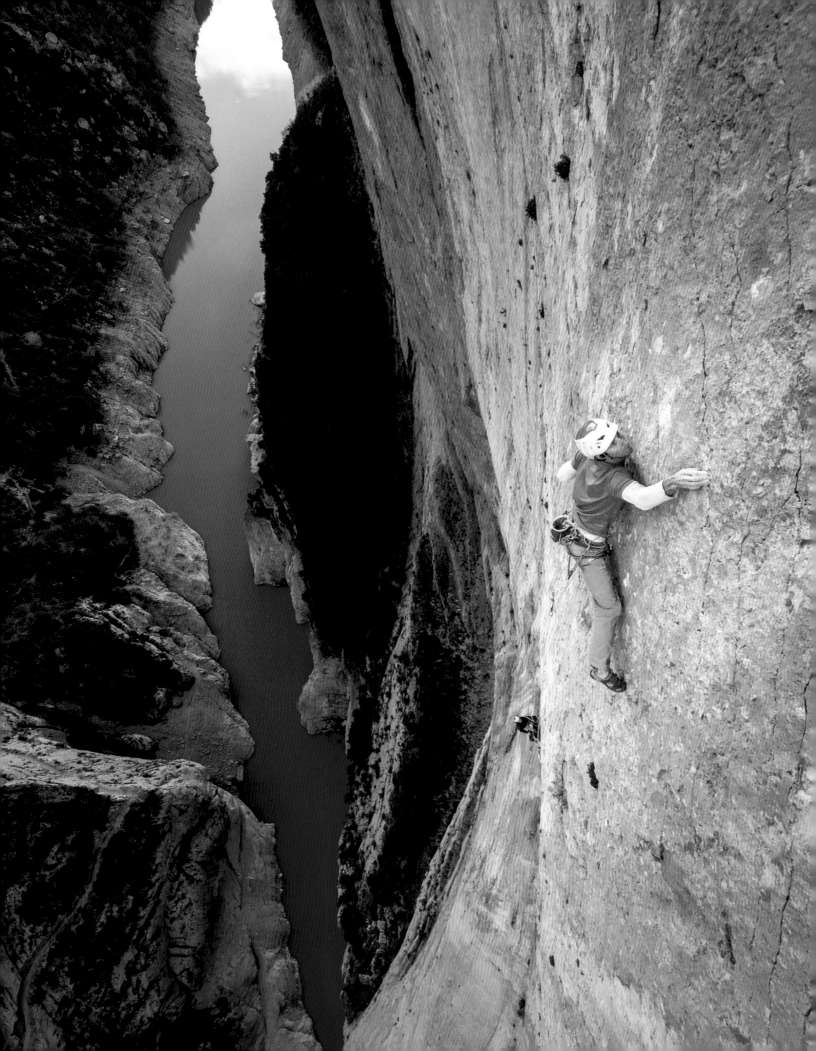

Spain is synonymous with sport climbing—for the vertically inclined, anyway. As the online resource Mountain Project describes it: "It's almost a crime to have as much rock as this country has." And there's a reason we're including the entire country. Many of the individual regions are so world-class in their own right that it would be impossible to call one or two of them out for being the best—they're all the best. So good, in fact, that Chris Sharma, an American long considered one of the best climbers in the world, moved to the town of Lleida, near Oliana, a renowned cliff stacked with hard routes. Sharma, still one of the top sport climbers, still lives in this land of limestone, terraced olive groves, mountains, and the sea.

Of course, the climbers born to this country have an advantage with their access to such a multitude of rock, and Spain has produced a legion of elite sport climbers. Josune Bereziartu was the first woman to climb the grades of 8c/5.14b, 8c+/5.14c, 9a/5.14d, and 9a/9a+ (5.14d/5.15a). Ramón Julián Puigblanqué has won many international climbing competitions and sent more than six routes of the 9a+/5.15a grade. Daila Ojeda, from the Canary Islands, has climbed up to 8c+/5.14c and sent plenty of 8c/5.14b routes. Patxi Usobiaga has sent routes up to 9a+/5.15a and is the first climber to onsight 8c+/5.14c. In 2018, Edu Marín got the first ascent of a 340-foot (104-meter) roof climb in Getu, China's Great Arch, graded 9a+/5.15a and 14 pitches long. And perhaps the most prolific Spanish sport climber is Dani Andrada. According to the climbing scorecard website 8a.nu, where climbers can track their climbing, as of November 2018, Andrada had climbed more than 4,000 routes of 8a/5.13b or harder, almost 800 of which he bolted himself. His hardest route ever is 9b/5.15b, and he has sent three routes of that difficulty—all in his home country of Spain.

With the Pyrenees Mountains in their backyard, Spanish climbers are no slouches when it comes to alpine objectives and big walls. Born in the Basque country, the Pou brothers, Iker and Eneko, have done ascents in the Karakorum and on the remote Baffin Island. Iker has also sport climbed 9a+/9b (5.15a/5.15b). Last but not least, Silvia Vidal is a big wall climber and alpinist from Catalonia, known for massive first ascents in the Karakoram and the Indian Himalaya, many of them done solo. She has spent more than a month alone on the wall, doing all the aid climbing, belaying, and hauling herself.

If anything, most of the climbing in Spain is the exact opposite of what Vidal does. Approaches are short, bolts are everywhere, and the sun is plentiful. The autonomous region of Catalonia in northeast Spain, bordering France, has the most crags, as well as the highest concentration of hard sport climbs in the world. (Andrada, Marín, and Usobiaga all live here.) Here you'll find Montserrat, Margalef, Oliana, Terradets, Siurana, and Santa Liña. The second-hardest route in the world, *La Dura Dura* (9b+/5.15c), is in Catalonia (Oliana sector), and there are more than 80 climbs rated 9a/5.14d or harder. In the neighboring autonomous community of Aragon, there's Riglos, Rodellar, and Santa Ana. Then southern Spain has Andalusia with El Chorro and Loja, where climbers seeking moderate grades like 6c/5.11a will find plenty to do.

Perhaps one unique place does deserve special recognition: the island of Mallorca. While it has the tufas, pockets, and crimps on the bolted sport routes of the rest of Spain, this Balearic Island off the eastern coast of mainland Spain (almost directly south of Barcelona) has become well-known for deep-water soloing. That's thanks to 360 degrees of coastline, much of it towering cliffs of streaked limestone. Known as DWS, this is when climbers ascend a longer route without a rope or a belayer. If they fall, they fall into the water. While DWS might seem more relaxed than taking big falls that leave you dangling in space on the end of the rope, when the angry waves of the Mediterranean are crashing below and you're about to go for a dynamic move at your limit, you might not feel so *tranquilo*.

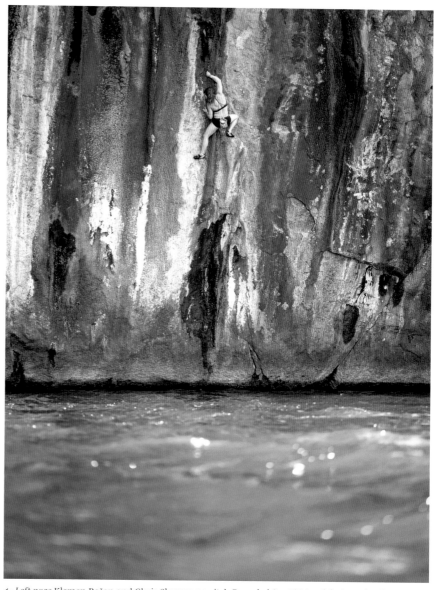

← *Left page* Klemen Bečan and Chris Sharma on pitch 7, graded 8c+/5.14c, of their project in Mont Rebei, Spain. ↑ *Above* Jill Sompel enjoying the world-class limestone of Mallorca.

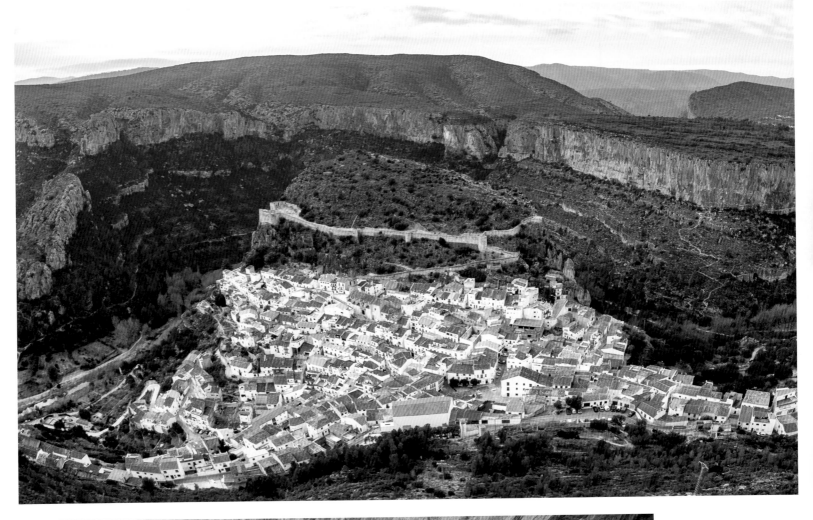

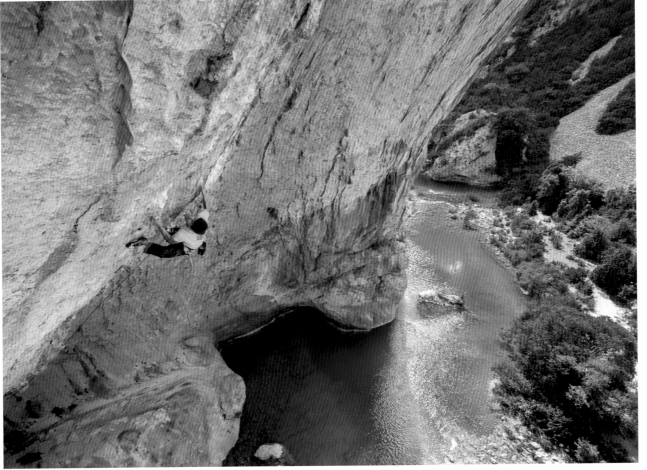

↑ *Above* The old and beautiful village of Chulilla, Spain. ← *Left* Damien Tomasi on *Pim Pam Plouf* (7b+/5.12c) at the Piscineta sector, Rodellar, Spain. → *Right page* Pep Ferer on *Misplaced Childhood* (6b/5.10c) in Siurana, Spain. →→ *Following* page About to take a swim after falling off a DWS route in Mallorca, Spain.

SPAIN

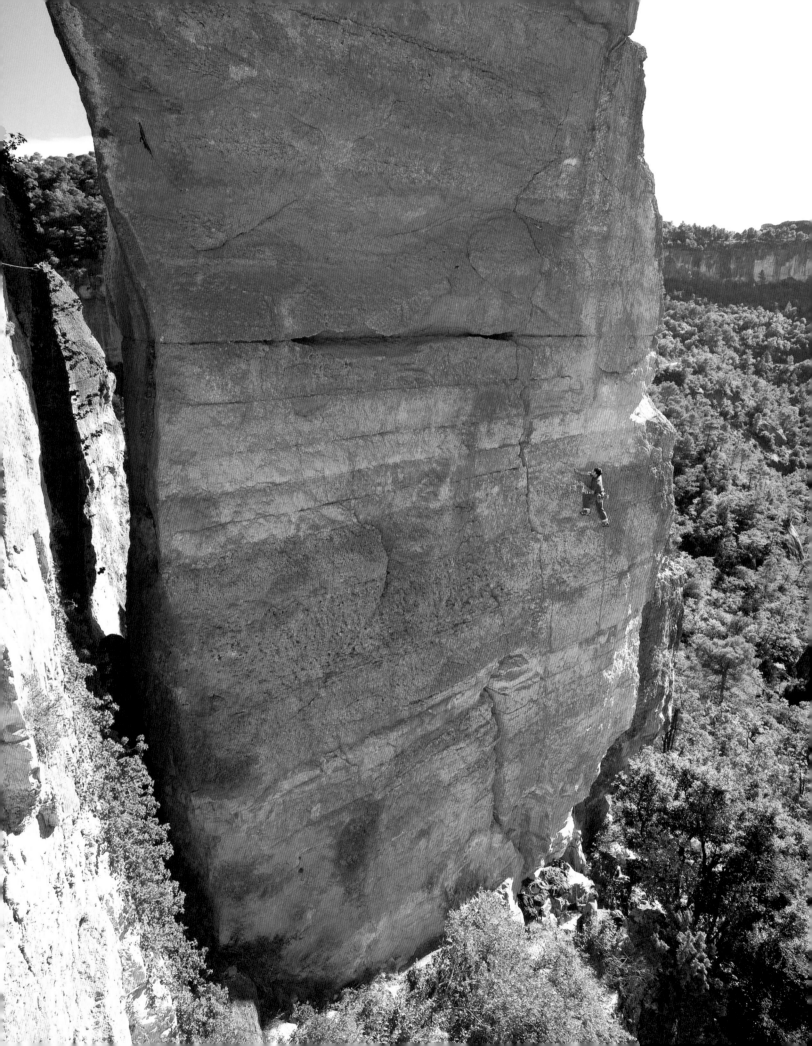

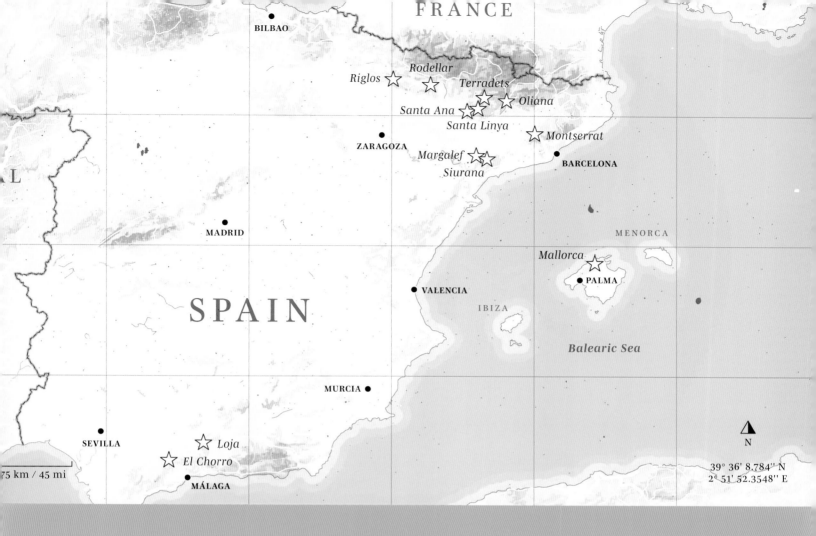

SPAIN

in a Nutshell

CLIMBING TYPE

Sport, deep-water soloing

PROTECTION

Quickdraws

SEASON

Spring, winter, fall

WHERE TO STAY

Rent an apartment in any
of the small Spanish towns.

ONE MORE THING

No matter your ability level,
if you like sport climbing at
all, Spain is your spot. Enjoy
the cultural norms and relaxed
way of life that mean slow
mornings, siestas after lunch
(when many stores are closed
for a few hours), and late
nights with lengthy dinners
and red wine.

HOW CLIMBING CAN HELP REBUILD AN ISLAND

With a history of mining, this tiny raised atoll called Makatea in
French Polynesia hopes to use climbing and other forms of ecotourism to grow
and rebuild its community with a sustainable economy.

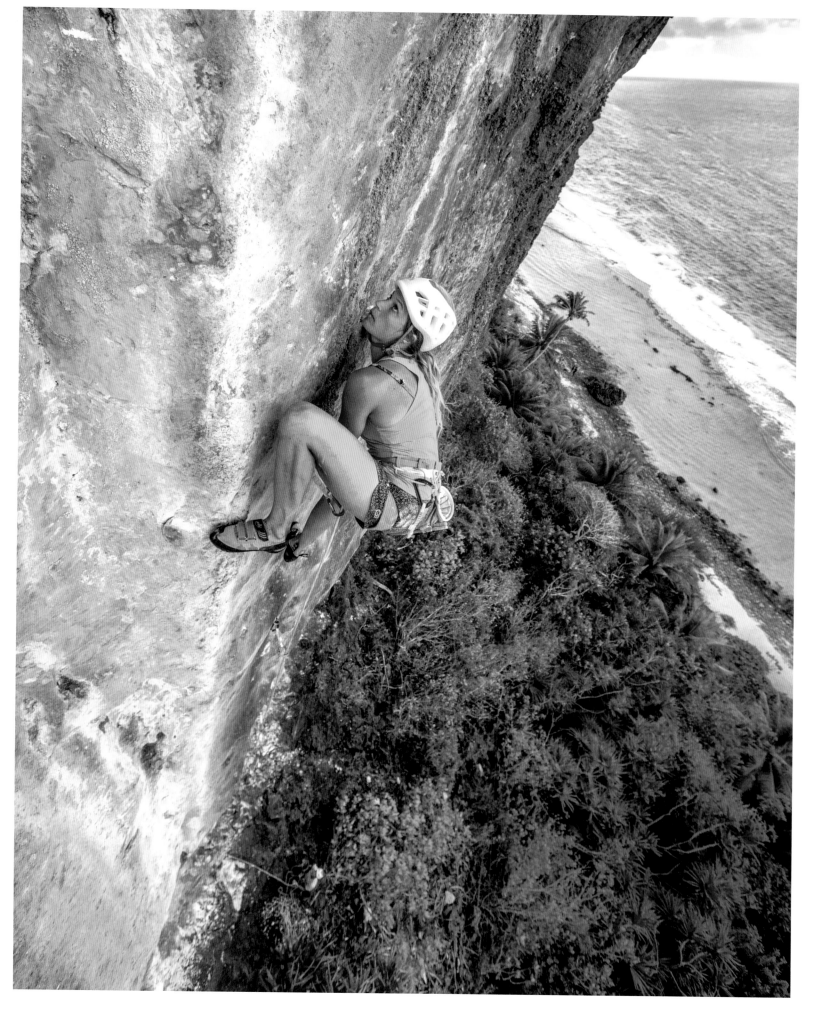

In the South Pacific Ocean, thousands of miles from any major landmass, lies French Polynesia, an overseas collectivity of the French Republic. Spread out over a stretch of 1,240 miles (2,000 kilometers) country comprises a chain of 118 islands and atolls that are divided into five groups. In the midst of these clustered dots is Makatea, a raised coral atoll in the northwest sector of the Tuamotu Archipelago. It is unique because, in addition to being a coral atoll—that is, a ring-shaped island formed of coral—it is also classified as "uplifted," meaning tectonic activity has raised it higher than other atolls, which are typically no more than 17 feet (5 meters) high. This might be the last place in the world one would look for rock climbing, but thanks to an ancient seismic shift, the rim of Makatea includes 10 miles (16 kilometers) of dramatic limestone cliffs up to 260 feet (80 meters) above sea level.

Like many uplifted coral atolls, Makatea's history is based around phosphate mining. Starting in 1917, mining companies drilled holes deep into the rock to extract a pure form of phosphate, which is used as a fertilizer for crops. For decades, people on Makatea did the hard physical labor of moving the phosphate by hand, and that was the main industry. With a bustling population of more than 3,000 people, Makatea was an economic powerhouse in the region. In 1966, France started doing nuclear testing on nearby islands in French Polynesia, and they needed trained technicians to come work the experiments on other atolls. Mining was quickly abandoned, and the workers left Makatea. With only about 10 families on the island, it became a ghost town with no electricity, about 30 people, and rotting mining equipment.

More than 50 years after it was abandoned, the population has grown to about 100 people, and mining has reentered the picture, along with its economic potential. New technology allows mining companies to dig deeper, and the mayor, Julien Mai, had seen how it had brought money again to other islands. However, the son of the mayor, Heitapu Mai, happens to be a climber and knew the potential of the island's striking limestone. As the president of the Makatea Climbing Association, he and other local climbers had already established about 15 routes. Then Heitapu met Maciek Buraczynski, a rope access technician from Tahiti, and told him of the climbing potential on Makatea. The duo conjured up the idea to bring a bunch of climbers to the island to develop routes, and then enlisted the help of Erwan Le Lann, who had organized many climbing trips where the goal was new-routing. Erwan, the president of the Maewan Association, arrived on the island and immediately recognized the climbing possibilities, as well as the uniqueness of this cliff-covered island among other Polynesian isles that are mostly jungle. Having worked for Petzl, the French gear manufacturer, for more than a decade, Erwan had organized their annual RocTrip, where tons of routes are added to an undiscovered area, then elite climbers are invited to climb and experience the place. He knew exactly what to do. Thus, in 2019, more than 20 elite climbers from all over the world—France, the United States, Brazil, Germany, and others—traveled to the island to establish new climbs with the hope of bringing ecotourism and a new form of sustainable economy.

Guillaume Broust was hired to document the process and create a film about the Makatea project. He says eight to ten bolters showed up for about two weeks, and "just bolted like hell in two main sectors." Then a dozen or so climbers came and sampled all the new routes. "The first sector, Temao, more of something dark, like black rock, which was very crispy, very hard, and very painful with many hold shapes," Guillaume says. "To get there, you just walk to the beach and then you have the lines everywhere. The other sector, Moumu, is on the other side of the island, on the east side. This is more blank, white limestone with pockets. On half of the island, because of the digging there, is like a limestone labyrinth with holes everywhere. The landscape is just crazy to watch, very dangerous, almost inaccessible to get there because it's very tricky. You walk on the very edge and if you fall, you fall 50 meters [165 feet] in a hole."

Another issue was the types of bolts used, because the harsh marine environment corrodes bolts quickly, with so much salt and moisture in the air. It is similar to Thailand in that way, but Guillaume says it will never be as popular and well-traveled a destination as the limestone mecca of Thailand: "You have to get to Tahiti first, then wait for the boat. It's kind of an expedition. It's 14 hours of boat from Tahiti, and one boat that goes twice a month for food shipment, beer, and stuff they don't have on the island. It's kind of a secret island." He says with how remote Makatea is, as well as its lack of infrastructure, the tourism will be small, but everything will make a difference. "Making it as big as Thailand was not the idea with the Maewan development. Even for food or for lodging or even for the boat harbor. There is basically not really a harbor. So for now, it's local tourism. You would not go there without already being in the area."

All in all, there are about 100 routes on the island, with the potential for many, many more. The climbing ranges from short, easy clip-ups to moderate multi-pitches to difficult single rope lengths, and everything in between. During bolting, the rock was very naturally clean and did not require much removal of plants or loose blocks. Guillaume says that the people in all of Polynesia are friendly, but in Makatea, it was something special. They understood what the climbers were doing, and they were thankful. The three goals for the project were: sport development, environment, and human development. Part of that was building a program with the kids on the island to make them aware of the sustainability of the resources. Marion Courtois, the global coordinator of the project through Maewan, went to the school for three weeks, spending every day building a program teaching them about the island's natural resources.

The finale of the Makatea project to increase tourism on the island was a four-day festival to bring visitors to the island and show people the remarkable nature of this small raised atoll. The festival, called Makatea Vertical Adventure, gathered more than 150 individuals from all over the world for climbing, doing the newly installed *via ferrata*, rappelling, touring the historical sites, hiking, and caving. With so many ecotourism possibilities, including incredible rock climbing, the hope is that Makatea will continue to grow its economy in a sustainable and environmentally friendly way.

→ *Right page top left* The Maewan boat, driven by Erwan Le Lann and Marion Courtois, the leaders of the Makatea expedition.
→ *Right page top right* Olivier Testa explores one of the numerous holes left by mining to see if there is any water connection.
→ *Right page bottom* The overall view of the "Moumu Sector" on the very far east end of the island. →→ *Following spread* The Paraclimbing World Champion Solenne Piret, takes a rest on *Esprit Traditionnel* (6b+ / 5.10d).

ALL IN ALL, THERE ARE ABOUT
100 ROUTES ON THE ISLAND, WITH THE
POTENTIAL FOR MANY, MANY MORE.
THE CLIMBING RANGES FROM SHORT, EASY
CLIP-UPS TO MODERATE MULTIPITCHES
TO DIFFICULT SINGLE ROPE LENGTHS, AND
EVERYTHING IN BETWEEN.

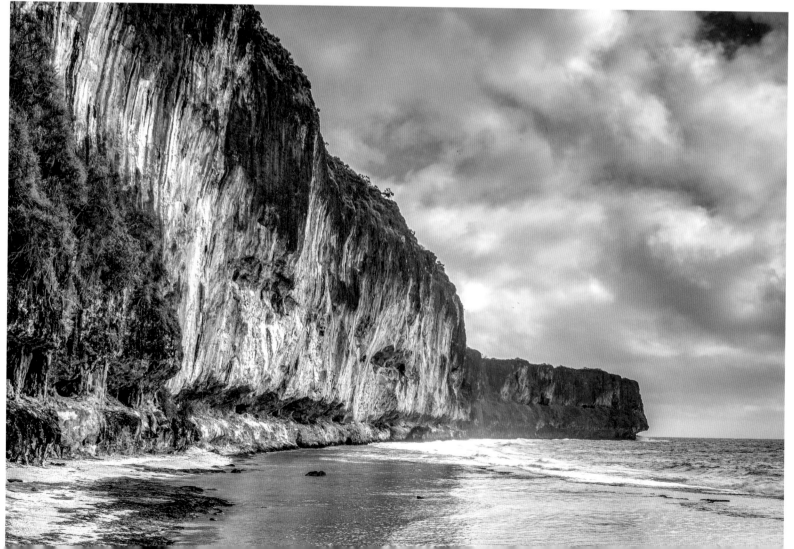

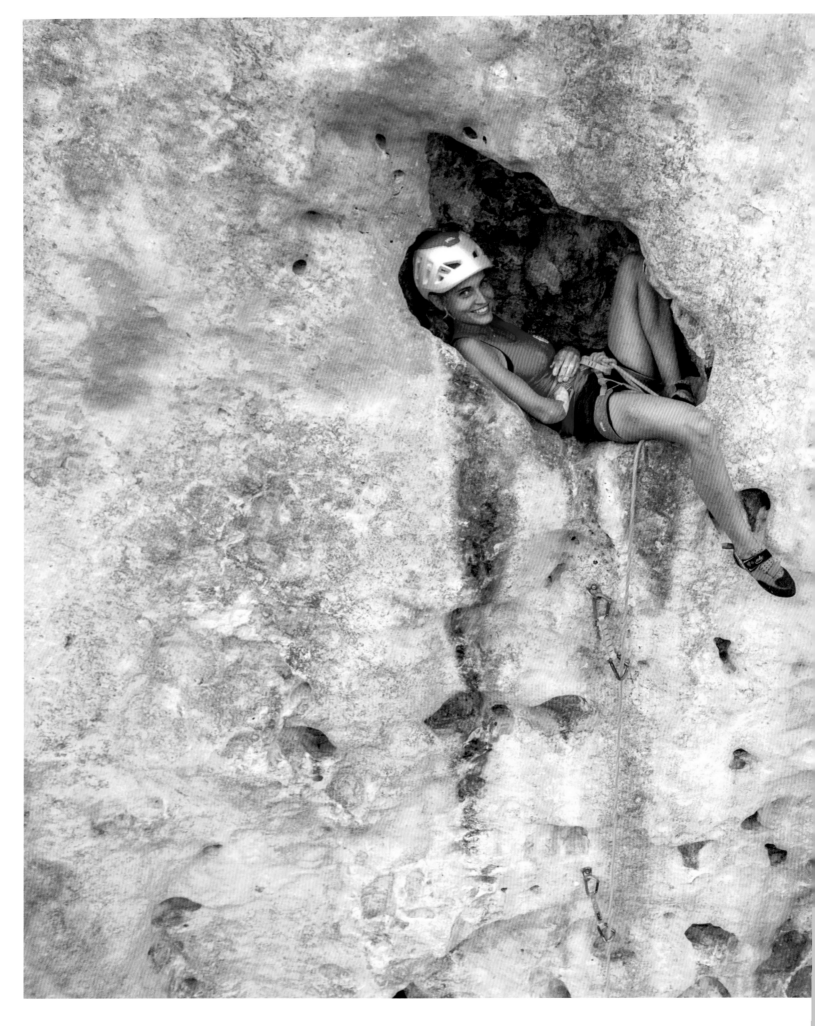

THAILAND

Krabi, Surat Thani & Chiang Mai

With history as a holiday hot spot, this
country in Southeast Asia has an
abundance of sport climbing—and some
mounting issues.

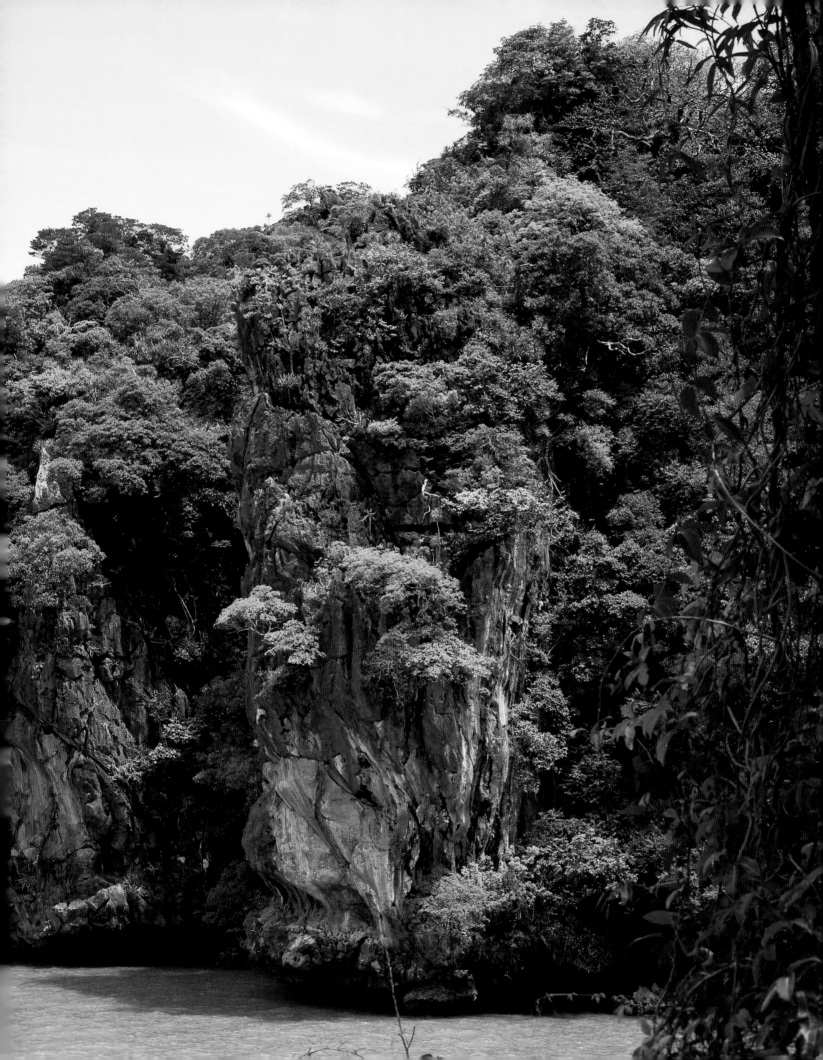

Crescents of stark white sand curved around warm turquoise waters. Tasty, spicy, cheap street food. Wild, all-night beach parties. Longtail boats, tuk-tuks, and scooters. These are the visions that get most travelers champing at the bit to go to Thailand, a country with a long-standing history of tourism. Throw in Railay Beach, Krabi Beach, Ton Sai Beach, Chiang Mai, Koh Phi Phi, and Koh Tao, and most climbers will start drooling, too. Combine the things that most travelers love (food, culture, beach) with the things most sport climbers love (limestone caves, towers, cliffs, a plethora of single- and multipitch routes of all grades, particularly moderate levels) and voilà—that is Thailand, the Land of Smiles.

Like any tropical destination, the conditions in Thailand are not ideal for hard climbing. Northern Thailand can get cool at night, but southern Thailand on the coast stays warm at night with an average year-round temperature of 82 °F (28 °C). Climbing is possible any time. Winter offers the coolest months, but it is still going to be hot and humid—sweating profusely might be the theme of your trip. But for most people coming to Thailand, it's not about sending the hardest route. Climbing is secondary to the atmosphere and adventure of being in Thailand.

Because of the super-featured rock (meaning: big holds that you can sometimes sit on) with tufas and stalactites, there is tons of climbing in the 6a/5.10a to 6c/5.11a range. In fact, that is where Thailand shines as a climbing destination—anyone can climb here and have fun. It is three-dimensional, so climbers are not just going up; they must move in all directions, sometimes looking behind them to find a massive stalactite they can wrap their legs around.

Koh Phi Phi is the original climbing area in Thailand, and it is "hands-down the best 5.10 multipitch climbing in Thailand," according to the online guidebook MountainProject.com. Many new climbers will love this area, especially those who are familiar with climbing in a gym. Ton Sai Beach provides the nightlife scene that many tourists are looking for on an island southwest of the mainland. The bars and restaurants are right next to climbing, with nightly fire dance performances, Muay Thai boxing matches, and frequent huge parties. The climbing variety ranges from easy single-pitch on the beach to harder multipitches that ascend giant limestone towers coming straight out of the ocean. The Ton Sai area also has deep-water soloing, where climbers quest out steep, jug-filled roofs directly over the Andaman Sea. Chiang Mai in the north is further inland and more mountainous, which makes for slightly cooler temperatures and a totally different style of climbing. It is still limestone, but there it is more subtle, with ripples, pockets, and edges. Pro climber Alex Johnson called this area the "Land of 5.11" after a visit in the winter of 2015.

But climbing in Thailand is not all sunshine and beaches. Two main issues plague the region: waste management and bolt degradation. Overcrowding in these small places has put a great strain on communities that do not have sustainable infrastructure to deal with the influx of people. Thailand produces almost 30 million tons of solid waste that has nowhere to go.

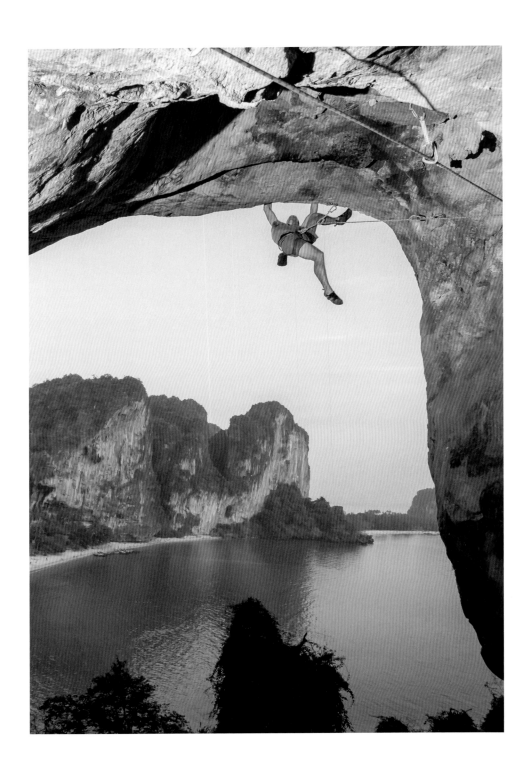

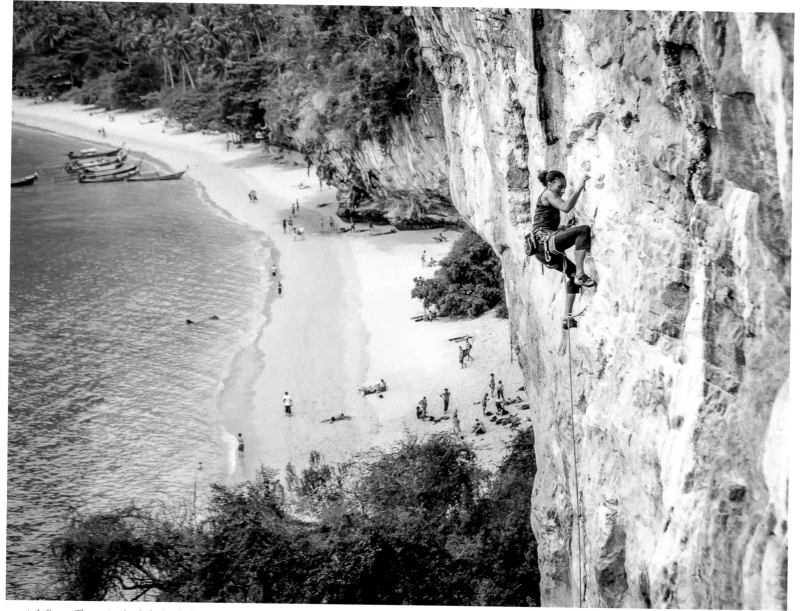

← *Left page* The protection bolts in Thailand must be watched closely; the harsh marine environment can cause them to corrode quickly and fail. ↑ *Above* You can push yourself on a sport route while other tourists lounge about on the beach.

Much of it ends up in the ocean, with large masses of trash found floating off the coast like little garbage islands. Many business owners use plastic and Styrofoam because it is cheap, and then either hide the trash or burn it. These materials are widely known as two of the worst offenders to the environment because they do not biodegrade. Another waste management issue in Thailand is human waste. Without proper wastewater treatment systems, some communities dump sewage directly into the ocean. There are rumors of many of the popular beaches being littered with human feces. These are things that any climber visiting the island can be aware

of and plan accordingly. Refuse the plastic and Styrofoam that is handed out at restaurants and shops. Bring a reusable plastic container and water jug with you. Say no to drinking straws. And follow strict human waste guidelines like you would if you were in the wilderness—pack it out.

The issue that is specific to climbers is bolt corrosion. Climbers have died because bolts they probably did not think twice about have failed completely. The really scary part? Many of these deadly bolts show no visible signs of wear or rust, so no one has any idea that a bolt is bad. The coastal environment is very tough on metal, particularly the stainless steel

expansion bolts that are common at sport crags around the world. The American Safe Climbing Association, which deals with equipping routes and rebolting, says, "This type of bolt placed in a sea cliff is a bomb with a short fuse." Many efforts (read: time and money) have gone into safely rebolting much of Thailand's seaside climbing areas with titanium glue-in bolts. Since 2011, many of the most endangered routes have been rebolted, and dedicated climbers continue the work, but this type of bolt is very expensive and time-consuming to place, so it is an ongoing project. Check out the Thaitanium Project for more information.

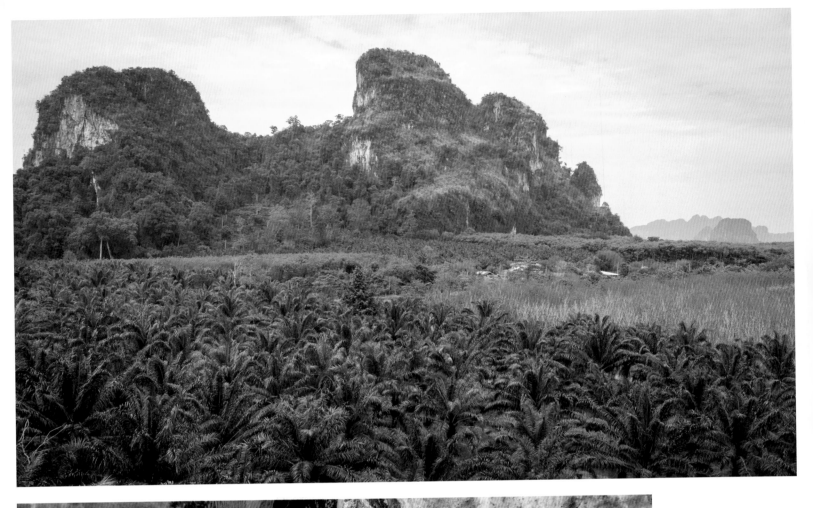

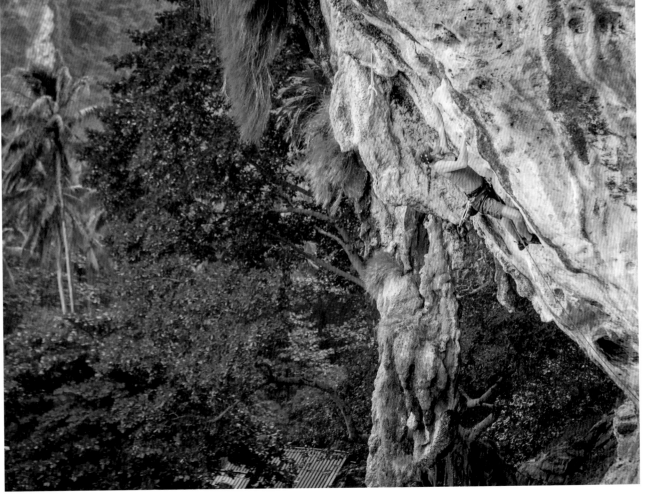

↑ *Above* The green jungle of this paradise in Southeast Asia. ← *Left* Rannveig Aamodt tests her mettle on a steep route.
→ *Right page* Climbing in northern Thailand, the rock is similar, but the climate is a bit cooler and less humid.
→→ *Following page* The sculpted limestone formations result in interesting and unique climbing movement.

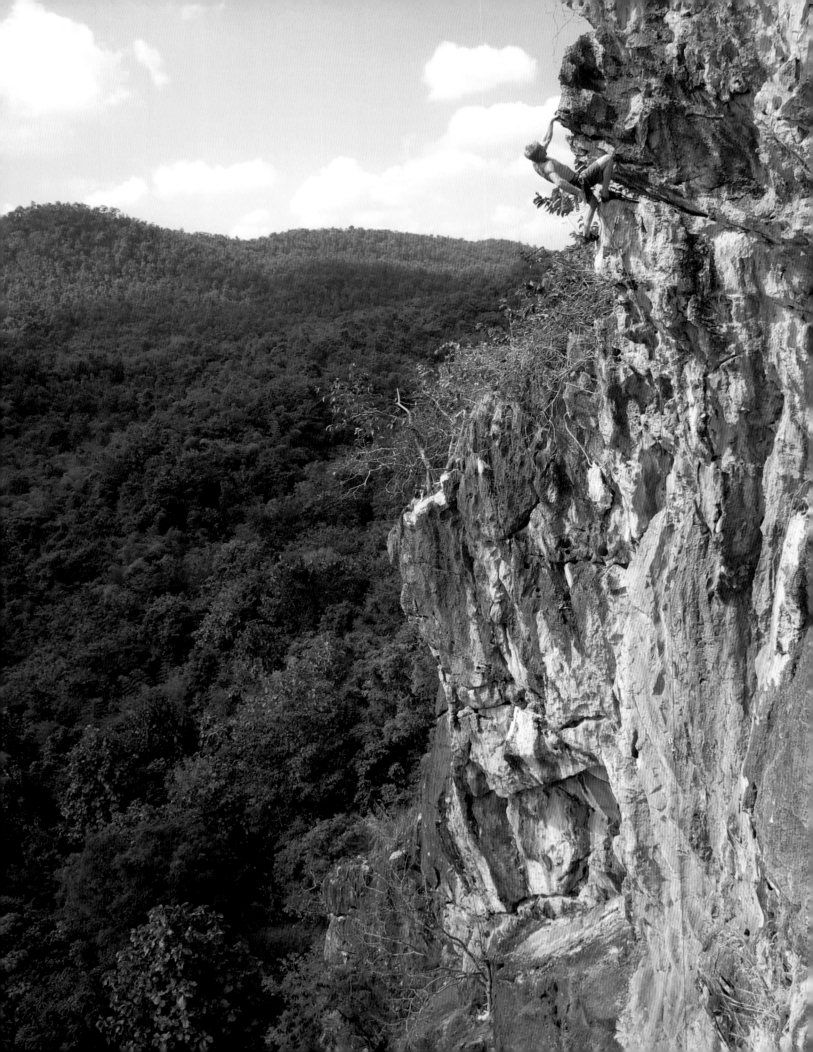

THAILAND

in a Nutshell

CLIMBING TYPE

Sport, single- and multipitch

PROTECTION

Quickdraws

SEASON

Winter is coolest, but you can climb year-round.

WHERE TO STAY

One of the many hostels, Airbnbs, or hotels

ONE MORE THING

With so many climbers visiting these areas, a lot of the rock is very polished, meaning it has lost the rough surface and become smooth. This, combined with hot, muggy temperatures, can make climbing easy grades feel much harder!

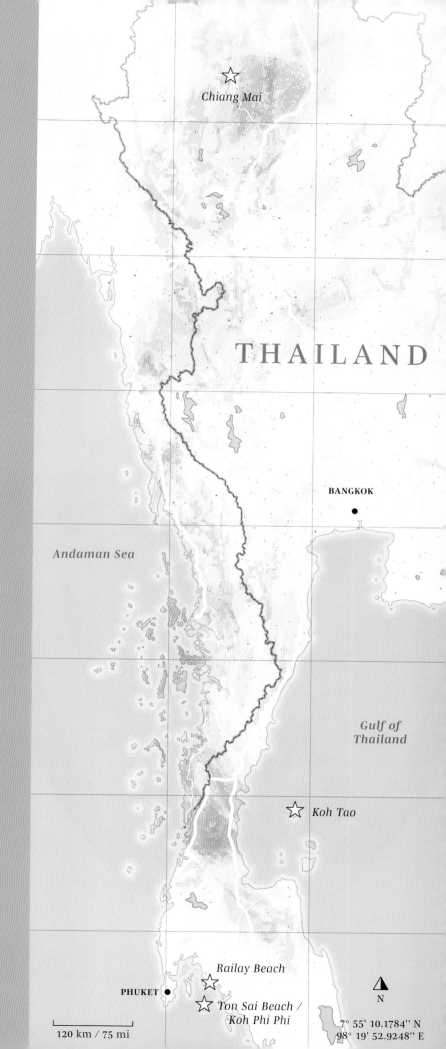

☆ Chiang Mai

THAILAND

BANGKOK ●

Andaman Sea

Gulf of Thailand

☆ Koh Tao

Railay Beach

PHUKET ● ☆

☆ *Ton Sai Beach / Koh Phi Phi*

▲ N

120 km / 75 mi

7° 55' 10.1784'' N
98° 19' 52.9248'' E

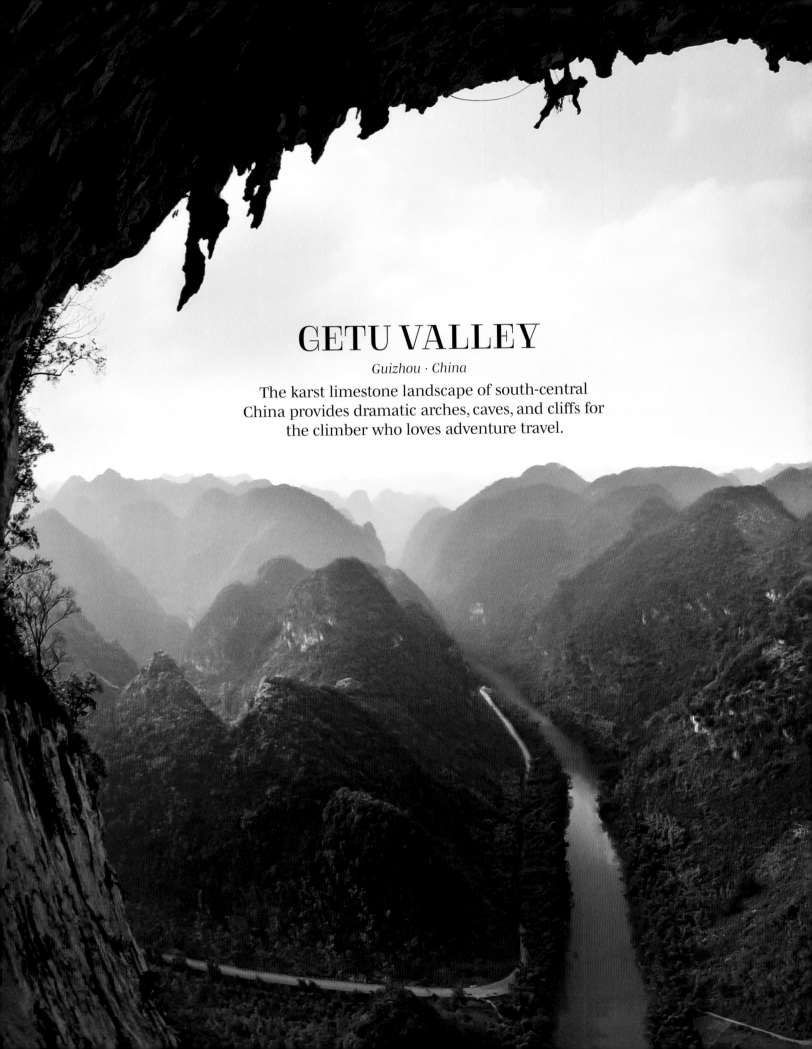

GETU VALLEY

Guizhou · China

The karst limestone landscape of south-central China provides dramatic arches, caves, and cliffs for the climber who loves adventure travel.

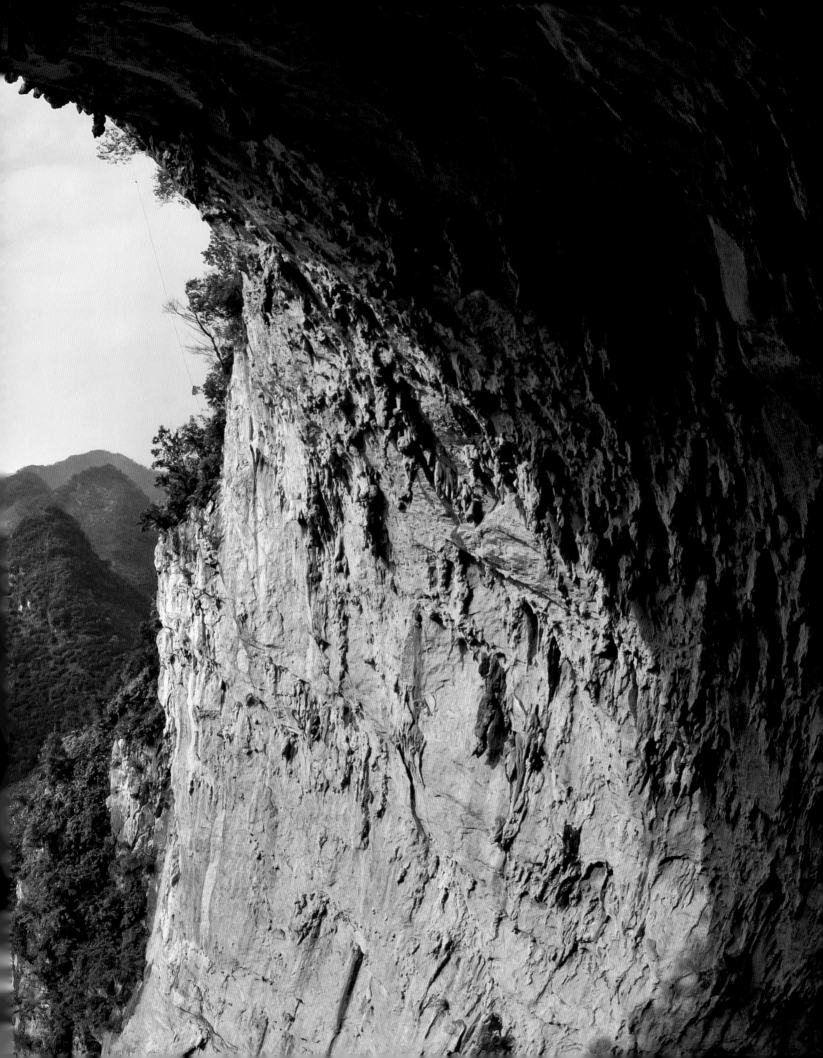

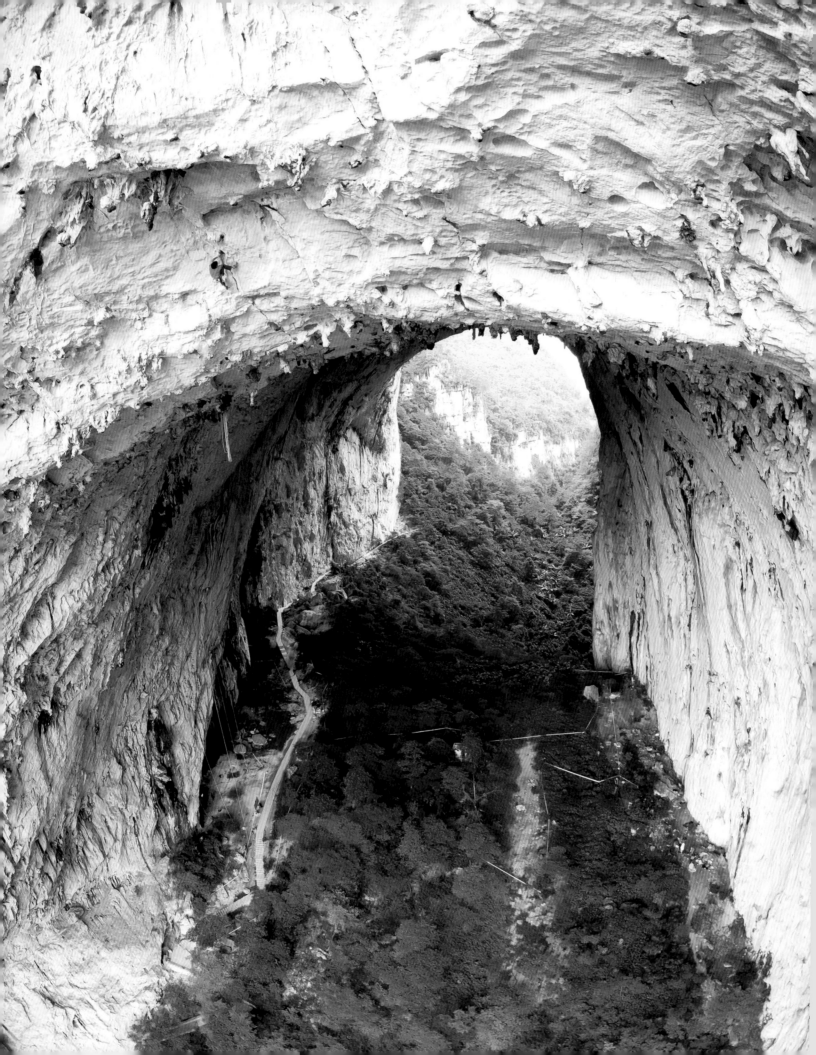

Deep in the heart of China, hundreds of miles from any major city, is a mountainous region home to spectacular rock features that were completely unknown to the Western world until a decade ago. Amid the green rice paddies of the Getu Valley, the Getu River and other waterways have eroded the soluble rock underneath, leaving a karst topography of limestone towers and caves. This landscape stretches 1,490 miles (2,400 kilometers) through China and into Vietnam, with innumerable formations. But perhaps the standout feature—to rock climbers and the thousands of non-climbing tourists who visit each year—is the Great Arch, or Chuangshang Cave. The natural tunnel is about 165 feet (50 meters) tall, 230 feet (70 meters) wide, and 450 feet (137 meters) long, and it is covered with dripping tufas, pinches, pockets, and small caves big enough to fit a person (or two). The arch is accessed after a short boat ride across the muted green water of the national park's namesake Getu River and then a hike up approximately 1,500 stairs.

While many of the climbing areas in this book are celebrated because of their historical significance, these limestone cliffs in China were only discovered by Western climbers around 2010. The modern bolted climbing in Getu might be new, but the concept of climbing the wavy, sculpted limestone features is not. For generations, the Miao people, an ethnic group in South China, would climb to the top of the cliffs to place the bodies of their relatives in order to protect them from scavengers. (Tourists can still view coffins high up in the cave.) While this practice stopped over a century ago, a traditional method of harvesting bird droppings has continued up until this day. Locals from the village, mostly young boys, scale the walls without ropes in order to gather guano that is used as fertilizer for the many farms in the valley. This custom is slowly dying out, with the new generation refusing to take on such a dangerous task. However, the climbing skills developed from these ancient techniques now are being used as a tourist attraction in the national park. These days, about half a dozen "Spidermen" free solo a 100-meter route directly over the Getu River several times a week for tourists' entertainment. These Spidermen are paid by the national park.

The area became a national park in the late 1990s, with trails, stairways, and signs. A few years later the government organized a climbing competition to bring attention to the area. They drilled six meters of plaster holds into the natural rock and built a 10-meter artificial climbing wall in town. This part of the Guizhou province is rural, poor, and remote. Electricity, running water, and paved roads didn't arrive until 2003. In 2007, the Guizhou Mountaineering Association invited Olivier Balma, a French mountain guide who was living in Beijing and teaching mountaineering to future alpine guides of the Chinese Mountain Development Institute, to the area. Balma and the CMDI bolted 30 moderate pitches for training purposes. Two years later, Balma was contacted by his friend, fellow French climber Erwan Le Lann, who was looking for a spot for the next Petzl RocTrip. Petzl, the French gear manufacturer, puts on the RocTrip each year, a climbing event designed to bring the world's top climbers together in one area to climb and give back to the community. Le Lann knew he wanted the event to be held in China, but when he researched areas, he came up short. He reached out to Balma, who eventually took him to Getu.

In 2010, Petzl climbers headed to Getu and put up 50 routes in 15 days on the Great Arch, Buddha Cave, and Devil's Cave, mostly between 6c/5.11a and 8c/5.14b. →

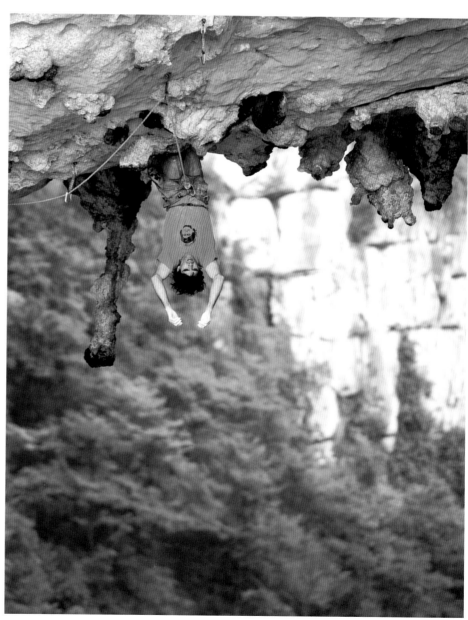

← *Left page* Dani Andrada and Ramiro Calvo on pitch eight of *Corazón de Ensueño* (8c/5.14b) at the Great Arch. ↑ *Above* Dani Andrada finds a "bat-hang" rest on pitch six of *Corazón de Ensueño*.

→ The next year, a second trip was organized, and bolters established 200 pitches. All in all, the drilling team, made up of big names like Dani Andrada, Arnaud Petit, and Stéphanie Bodet, equipped 250 more pitches from 4b/5.6 to 9a/5.14d on walls that tower up to 1,312 feet (400 meters). The roof itself spans almost 490 feet (150 meters), and the flagship route, put up during that year's RocTrip, goes across the entire arch. Andrada sent the eight pitches of *Corazon de Ensueño* and graded it 8c/5.14b. Getu Valley currently has more than 300 routes from 4b/5.6 to 9a+/5.15a.

One of the special aspects of Getu is that climbing developers worked with the government and local farmers to progress the situation in the agrarian area. The national park built approximately 1,500 concrete steps that take visitors to the base of the Great Arch in the early stages of park development, but many of the newer cliffs must be accessed via approaches on private land. The farmers were in favor of climbing, and after government officials attended the RocTrip, they were pro-climbing too. Because of the popularity of the event, they expected a big wave of tourism, erecting

a shiny new tourism center in town, as well as a glass elevator and walkway along the side of a secondary arch adjacent to the Great Arch. The area has boomed with climbers in recent years, but not to the levels expected with these grand construction projects. While you might look around and see the glass and metal of a more urban area, the tens of thousands of swallows in the arch, sweeping views of green fields and rugged towers, and tough language barrier will remind you that you're climbing in one of the most remote parts of a far-flung country.

← *Left* Read the writing on the (climbing) wall. ↓ *Below* On most overhanging multipitch routes on the Great Arch belay seats are installed permanently and made with the material that is found most in the region, bamboo. → *Right page* Getu offers sculpted limestone with all different types of holds →→ *Following page* The Great Arch of Getu on top and Getu River crossing through the mountain down below. →→ *Page 158* Michaël Fuselier and Nina Caprez on *Lost in Translation*, a 8a+/5.13c climb at the Great Arch.

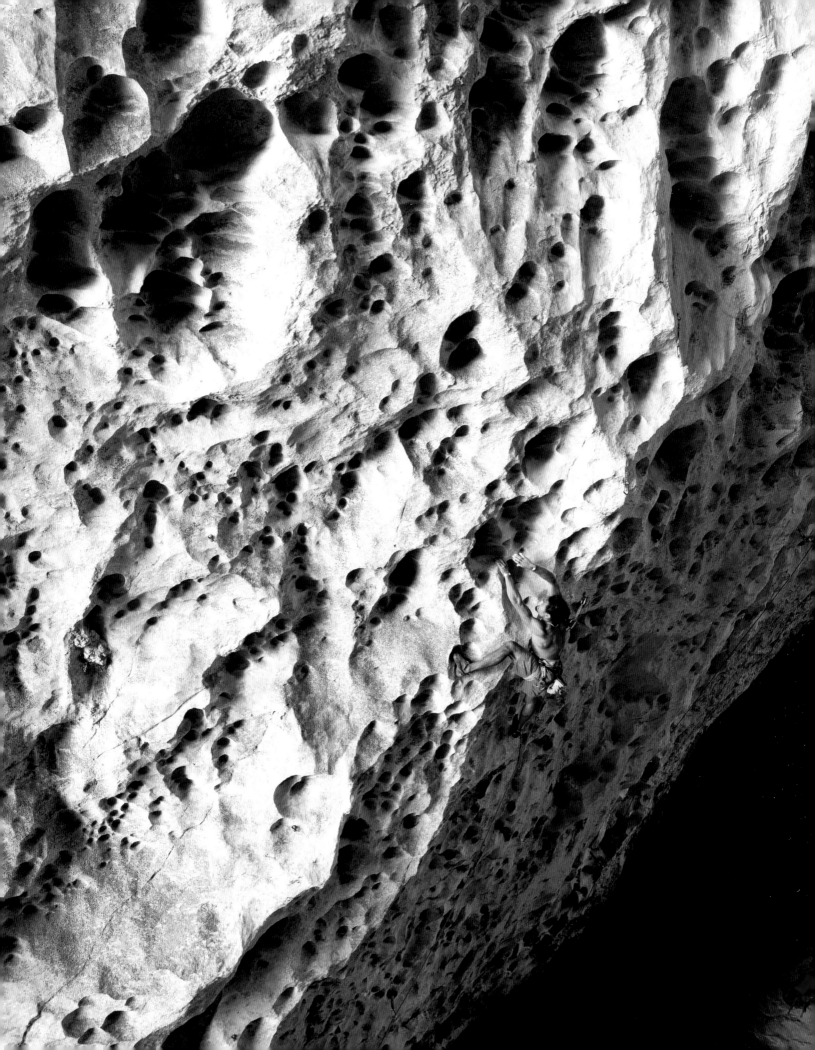

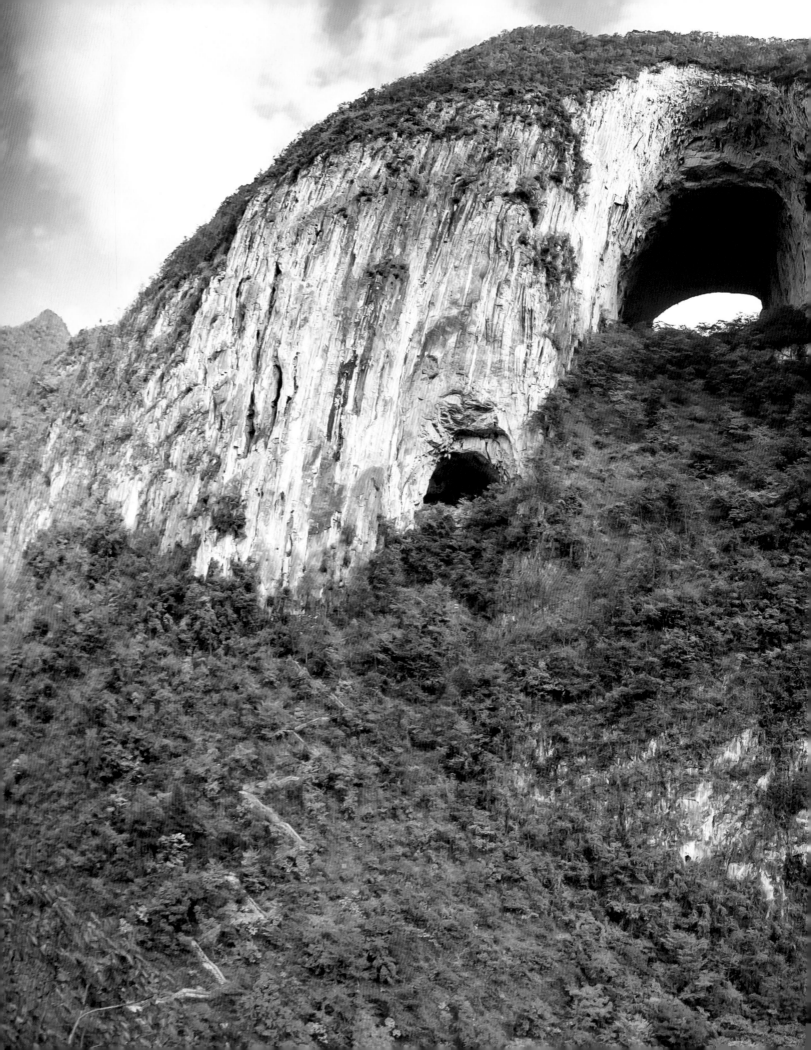

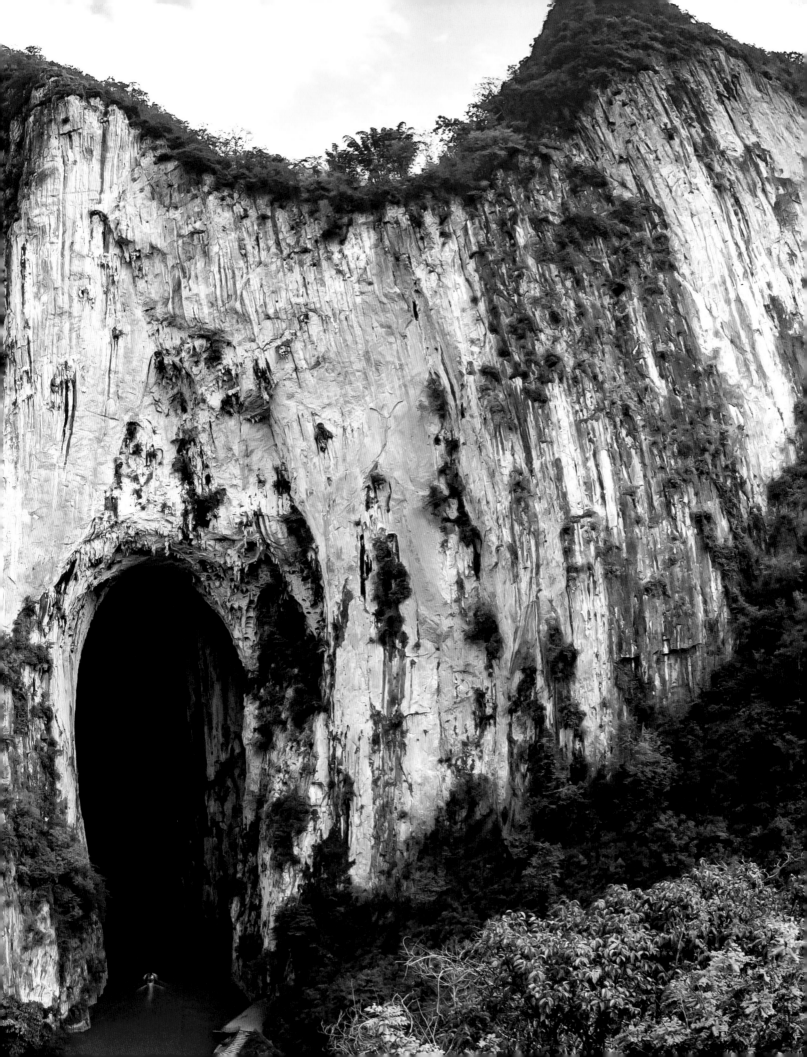

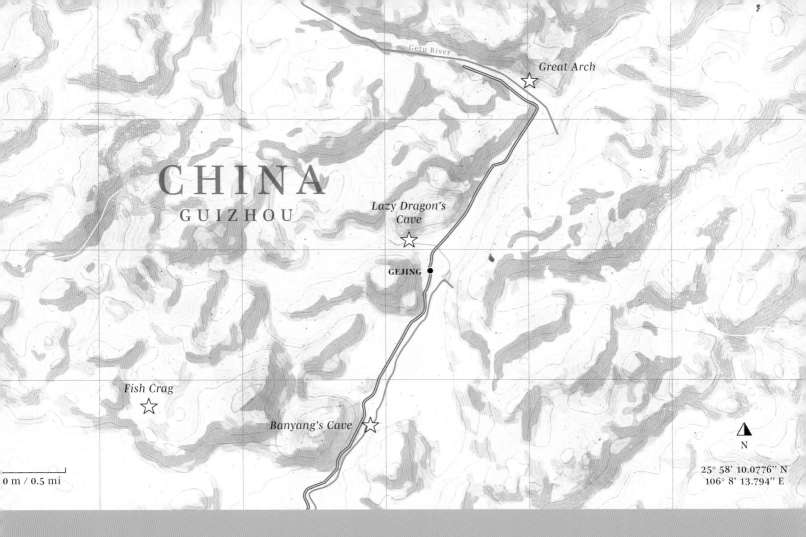

CHINA

GUIZHOU

Getu River

Great Arch

Lazy Dragon's
Cave

GEJING

Fish Crag

Banyang's Cave

N

25° 58' 10.0776'' N
106° 8' 13.794'' E

0 m / 0.5 mi

GETU VALLEY

in a Nutshell

CLIMBING TYPE

Sport, single- and multipitch

SEASON

Fall

ONE MORE THING

In recent years, the Getu Arch
and surrounding area has
undergone a lot of construction
in order to increase tourism,
which has resulted in limited
access and frequent closures of
various cliffs. Make sure to check
on the current status of the
climbing access before your trip.
The small village of Getu has
very limited amenities, so stock
up in Guiyang beforehand.
Traditional Chinese fare can be
rough on stomachs accustomed
to Western diets—noodles
and oil are common base
ingredients—so keep that in
mind for planning.

PROTECTION

Quickdraws

WHERE TO STAY

This rural area has limited
lodging: Ziyun Hotel, Gezhen
Hostel and Getu Villa are the
best options.

TRAD CLIMBING

THIS THOUGHTFUL AND ADVENTUROUS STYLE OF CLIMBING CAN GET YOU WAY OFF THE GROUND IN BREATHTAKING PLACES—BUT ONLY IF YOU HAVE THE HEAD FOR IT

Looking down, you see 650 feet (200 meters) of air below your feet and a clean swath of granite sweeping to the valley floor below. Your belayer is out of sight, the 30 meters of rope stretching between you and her the only connection you have to another person. There's not another human in sight. Not only have you never felt more *out there*, but you've also never felt more alone. The wind rushes up all around you, creating a constant buzz that muffles every other sound to the point where the only thing you can hear is the voice in your head. *Where does this pitch go exactly? Does my belayer still have me on belay? My arms are getting tired. Gosh this place is so beautiful! How come there aren't more climbers up here? The next gear placement looks far away. Do I even have the right gear for it? I can't believe I get to be up here! This climbing is fun, but I am so hungry…*

The appeal of traditional climbing is in the adventure of it. Starting at the bottom of a towering rock face, you and your partner must have all the tools and knowledge to safely navigate your way to the top. Route-finding is paramount—there's not usually chalk or fixed gear leading the way. Instead, you gather information from other climbers, online resources, and the guidebook beforehand. Then when you're on the rock, you must synthesize that data with what you see in front of you. Descriptions can be vague and confusing, especially when measured against the infinite possibilities of real rock.

Climbers use dozens of wandering cracks, corner systems, intimidating roofs, and hold-filled faces to ascend, placing protective gear where they can, then removing it when they're done. Putting your own temporary protection in the rock—and trusting it enough to move upward—provides a mental challenge that requires equal parts boldness and problem-solving. Not only must you carry the right gear with you (based on gathered information), but you must also make sure you have the right piece at the right time. That is, if you're looking at a one-inch (three-centimeter) crack, you had better hope you have a piece that fits into a one-inch crack! Otherwise you must keep climbing higher above your last piece of protection, thus increasing the distance of a potential fall, and hope that whatever gear you still have on your harness will fit somewhere, *anywhere*. Then there's the actual movement of climbing, whether it's the delicate dance required by slabs or the repetitive and painful motion required by cracks. The thing is, it doesn't matter if you have the movement technique perfected and the strength to carry it out.

If you don't have the head for it, you won't succeed. Trad climbing is scary, thoughtful, and physically hard. But that's exactly what makes it fun.

Nowadays, the term traditional climbing is commonly used to distinguish it from sport climbing. Trad is where climbers place their own gear in the rock to protect against falls. They then remove the gear when they are done with the pitch. With sport climbing, the protection is all bolts, which are pre-placed and permanent in the rock. When the term "traditional" was introduced to the climbing vocabulary in a 1984 essay, it meant something a bit different. Tom Higgins wrote the essay "Tricksters and Traditionalists" for *Ascent*, a journal published by the Sierra Club, in response to a shift in how climbing routes were being established (although not sport routes specifically, as it would be several more years before sport climbing would gain traction in the United States). Higgins suggested that the style of an ascent was more important than just getting to the top. Using bolts for protection had long been a part of climbing, but Higgins now wondered if modern ethics of bolting had strayed too far from the original vision of starting from the bottom and placing all gear, whether permanent or not, on lead. After describing ladders being dragged to the base of routes in Colorado, holds being chipped and chopped on Yosemite's El Capitan, and bolts being stood on in order to place other bolts on the domes of Tuolumne (the high country of Yosemite National Park), Higgins wrote:

Clearly, rock climbing styles are changing. "Tricksters" are bending and altering the traditional rules of the climbing game. In the traditional style, climbers do not alter the rock in order to free climb it. Nor do they preview routes on rappel, or fix protection on aid or on rappel with the intention of →

↓ *Below* The cracks and fissures of Cadarese, Italy, are perfect for trad climbing.

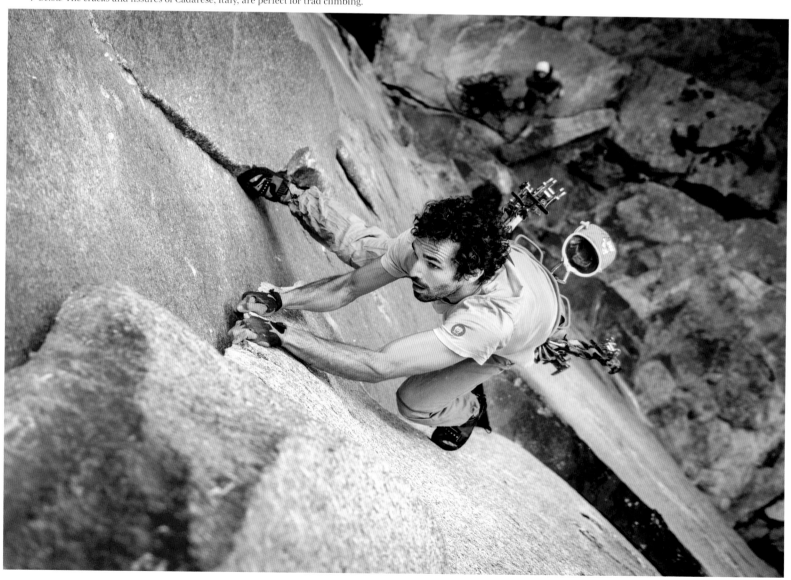

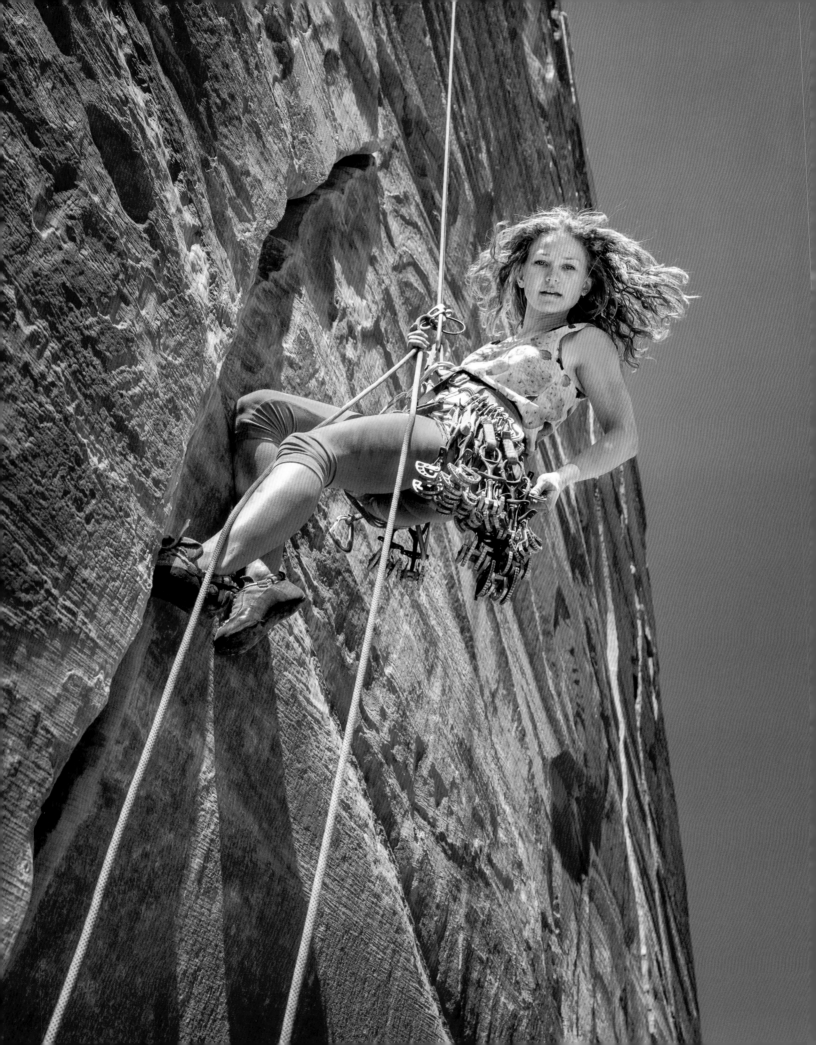

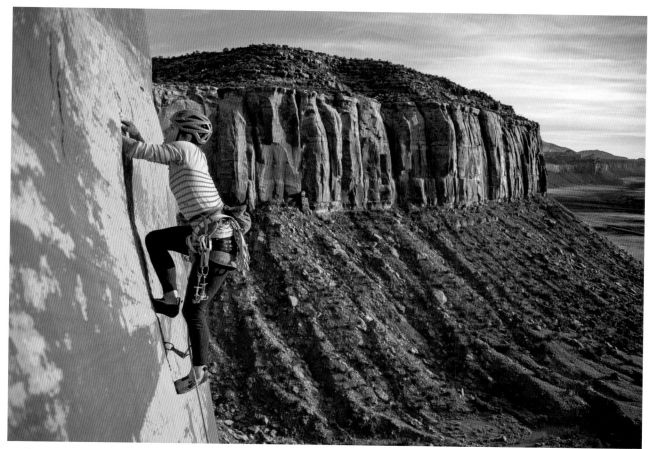

← *Left page* Mary Eden rappels off a route on Maverick Buttress near Moab, Utah. ↑ *Above* Kim Groebner puts her hands in the splitter cracks of Indian Creek, Utah. ↓ *Below* Hazel Findlay is known for her bold trad ascents. Here she climbs *Temporary Insanity* (7c+/5.13a) in New River Gorge, West Virginia.

→ *immediately trying to free climb. Aid climbing is done to get to the top, not to set up a route for free-climb attempts. Likewise, in traditional style the climber might fall a few times trying a free climb, but he or she doesn't rest on the protection between attempts. The traditionalist knows there is a time and place to give up.*

Trad climbing is all about the gear, or specialized equipment that's placed in the rock to protect climbers as they move up. This protection, or "pro," is then removed from the rock (unlike the bolts of sport climbing), so it can be used again higher up on the climb. The pro a climber carries on a route is known as "the rack." It consists of passive and active protection, the main difference being that active pro has moving parts, and passive pro does not. Just like the various disciplines of climbing, trad gear has seen dramatic advancement over the last century. Below is a glimpse into that evolution.

1920s British climbers carry pebbles in the pockets of their knickers (they were fashionable at the time!), slot them into cracks, and tie a hemp cord to them to attach the rope.

1930s Pitons become more widely used in Italy, Germany, and Austria, not just for protection, but as aid for climbing. →

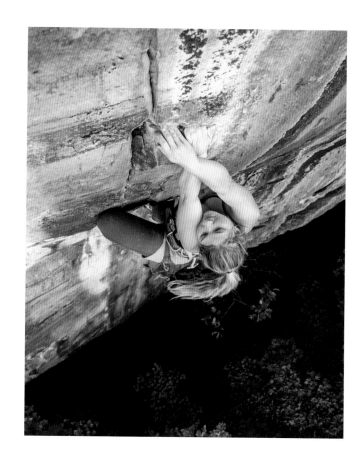

← ← *Previous spread* Rob Pizem is known for establishing first ascents of difficult and long trad routes. ↑ *Above* Finding a good spot to place protection on a trad route in Squamish, Canada. → *Right page* Many beautiful peaks around the world have moderate trad routes to the summit.

→ The climbers would pull on the pitons themselves to ascend a route. Free-climbing purists saw this as bad style, and in response they would forgo pitons entirely, sometimes resulting in unprotectable climbs that were very dangerous.

1946 John Salathé, a Swiss immigrant to the United States and former blacksmith, creates a stronger piton that can be placed, removed, and reused.

1950s British climbers in Wales use steel machine nuts found along the railroad tracks as chockstones slotted into cracks and then slung. The hexagon shape provided a solid wedge into a fissure, and the hole in the center made it easy for the nuts to be pre-slung with cord. Climbers start to use a wide range of nut sizes and make homemade modifications to them, including filing off threads. →

THE CLIMBERS WOULD PULL ON THE PITONS THEMSELVES TO ASCEND A ROUTE. FREE-CLIMBING PURISTS SAW THIS AS BAD STYLE, AND IN RESPONSE THEY WOULD FORGO PITONS ENTIRELY.

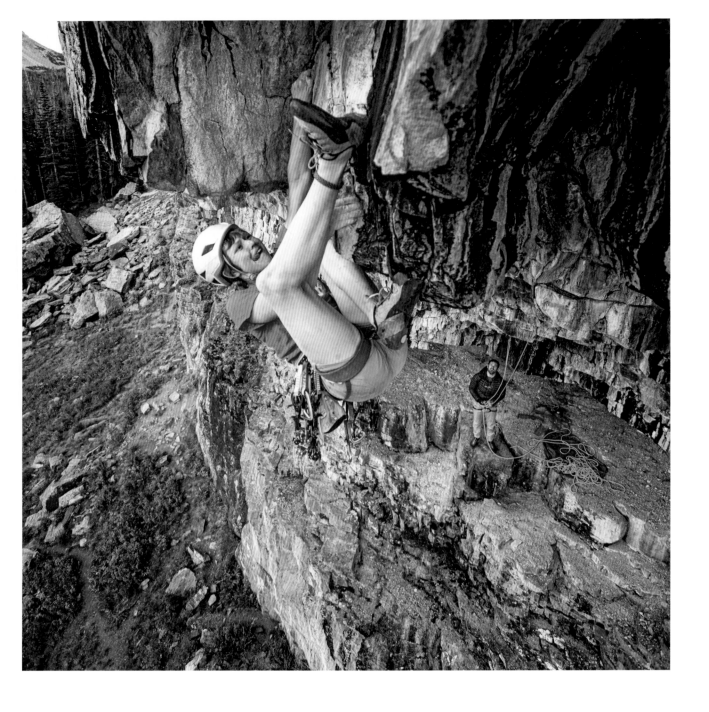

→ *1961* John Brailsford, a blacksmith in Sheffield, England, makes the first commercial nuts for climbing. These cone-shaped aluminum nuts are called Acorns. Many small companies follow suit with their own versions.

1966 Royal Robbins, an American climber and pioneer in Yosemite Valley, visits England and Wales and climbs many routes "all clean," meaning with just nuts and no pitons. Robbins returns to the States with British nuts, but fellow Yosemite climbers are not impressed. At the same time, American climbing is experiencing its "Iron Age," when Yosemite climbers are using new hard-steel pitons that are repeatedly hammered in and removed from the rock. This creates scars in otherwise impeccable cracks.

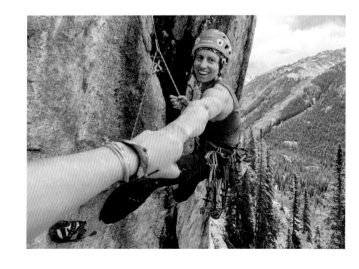

MANY CLIMBERS
STARTED TO AT
LEAST TRY NUTS FOR
PROTECTION, AND
THEY QUICKLY SAW
HOW MUCH BETTER
NUTS WERE FOR FREE
CLIMBING. THEY'RE
SECURE, AS WELL AS
FASTER AND EASIER
TO PLACE AND
REMOVE THAN A
PITON. THUS A NEW
ERA OF CLEAN
CLIMBING BEGAN.

← *Left page top* Sometimes the proper beta is to go feet-first. ← *Left page bottom* The short but stout trad routes of Independence Pass, Colorado. ↑ *Above* Ben Hoiness sorts his trad gear on a climbing trip to Zion National Park in Utah. →→ *Following spread* Trad climbing near the water in Capo Pecora, Sardinia.

1967 Climbing with his wife, Liz, and using only British nuts for protection, Robbins establishes a route in Yosemite that he calls Nutcracker (5.8/5a). By doing a first ascent without the use of pitons, Robbins was able to advocate for "clean climbing," where the goal is to prevent damaging the rock. This marked a major evolution in climbing.

1970s A wave of articles in America praises clean climbing on the national stage, including the notable "The Whole Natural Art of Protection," by Yosemite climber Doug Robinson. Many climbers start to at least try nuts for protection, and they quickly see how much better nuts are for free climbing. They're secure, as well as faster and easier to place and remove than a piton. Thus a new era of clean climbing begins.

1971 American climber Ray Jardine, a former aerospace engineer, begins to work on his first prototype of a spring-loaded camming device. These "cams" could be placed in parallel-sided cracks for protection, whereas nuts needed constrictions where the crack narrowed down to stay in place. Cams become the first active protection and exponentially increase climbing possibilities.

1975 Australian Roland Pauligk uses brass, instead of the mainstay aluminum, for his specialty nuts, called "RPs." Pauligk also employs an innovative wire attachment, fortifying the weakest point of other micro-nut designs. This allows RPs to be much smaller and just as strong as other nuts, so now even smaller cracks are protectable. →

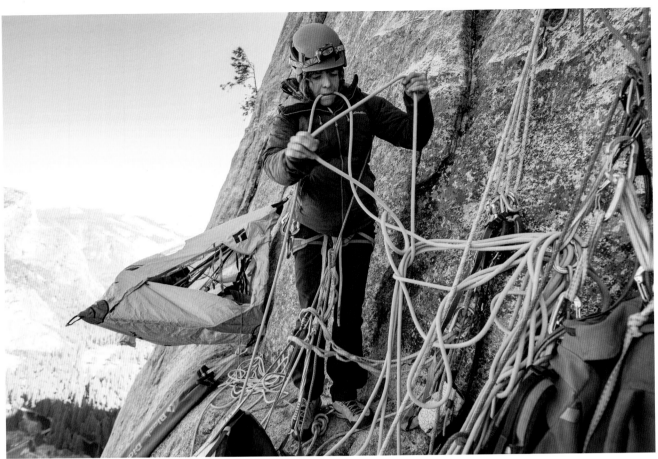

↑ *Above* Learning how to trad climb can be one step toward big wall climbing, where climbers spend the night on the wall. ↓ *Below* Ashley Schenck figures out the full-body puzzle of offwidth climbing on *Big Guy* (6c / 5.11-). → *Right page* Topping out a trad route in Squamish.

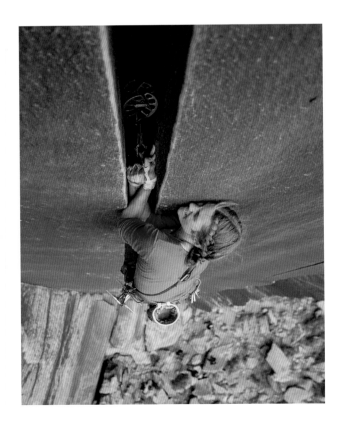

THESE "CAMS" COULD BE PLACED IN PARALLEL-SIDED CRACKS FOR PROTECTION, WHEREAS NUTS NEEDED CONSTRICTIONS WHERE THE CRACK NARROWED DOWN TO STAY IN PLACE. CAMS BECAME THE FIRST ACTIVE PROTECTION AND EXPONENTIALLY INCREASED CLIMBING POSSIBILITIES.

→ *1978* British gear manufacturer Wild Country introduces the Friend to the market, and within six months the first cams are being exported to 15 countries.

1980s Many specialty nuts and passive pro are now in use, including offset nuts, curved nuts, and Tricams.

1987 The Big Bro, an expandable tube, hits the market as one of the only ways to protect wide cracks called offwidths. Colorado State University student Craig Luebben developed this new active protection as his senior honors thesis for mechanical engineering.

TRAD CLIMBING

Good to Know

WHAT SETS IT APART

Trad climbing is equal parts mental challenge and physical challenge, where boldness, fear management, and knowledge of technical systems combine with the movement technique and endurance required to ascend routes that can take all day. Problem-solving is less focused on the movements and more shifted to figuring out how to place your own gear in the rock, as well as figuring out where routes go.

NECESSARY SKILLS

Gear placement, anchor building, multipitch systems, route-finding knots, rope management, lead belaying, falling, rappelling

FITNESS FOCUS

Full-body fitness, endurance, finger strength

ICONIC LOCATIONS

Indian Creek, U.S.; Yosemite Valley, U.S.; Shawangunks, U.S.; Squamish, Canada; Arapiles, Australia; Joshua Tree National Park, U.S.; Peak District, U.K.; Lofoten Islands, Norway; Liming, China; Cochamó Valley, Chile

RATING SYSTEM

Yosemite Decimal System (YDS) or French scale (see page 85)

NOTABLE FIRSTS

1958 Warren Harding makes the first ascent of *The Nose* on El Capitan, Yosemite.

1970s The clean-climbing movement takes off in the United States.

1973 Beverly Johnson and Sibylle Hechtel make the first all-female ascent of El Cap.

1984 Tom Higgins coins the terms "traditional climbing."

1993 Lynn Hill makes the first free ascent of *The Nose* at 5.14a/8b+.

1994 Hill returns and makes the first free ascent of *The Nose* in a day.

2008 Beth Rodden climbs the hardest trad route in the world at the time, *Meltdown* (5.14c/8c+).

2015 Tommy Caldwell and Kevin Jorgeson make the first free ascent of the *Dawn Wall* (9a/5.14d) on El Capitan.

2019 Jacopo Larcher climbs *Tribe*, potentially the world's hardest trad line at 5.15a/9a+.

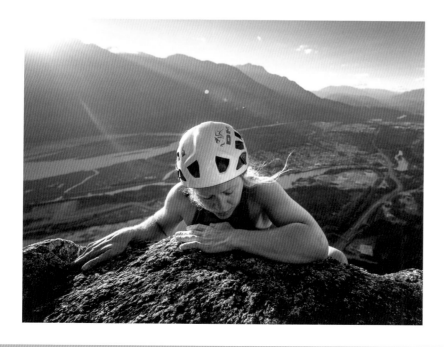

EQUIPMENT: TRAD CLIMBING

Anyone who is gear-obsessed will love trad climbing. The cams, nuts, hexes, slings, nut tools, and carabiners are collectively called "janglies" because of the tinkling sound made when they all bounce around on your harness. The fun puzzle of trad climbing is equal parts gear (what piece goes where) and movement (what body part goes where and when). Traddies tend to become attached to their gear, literally and figuratively!

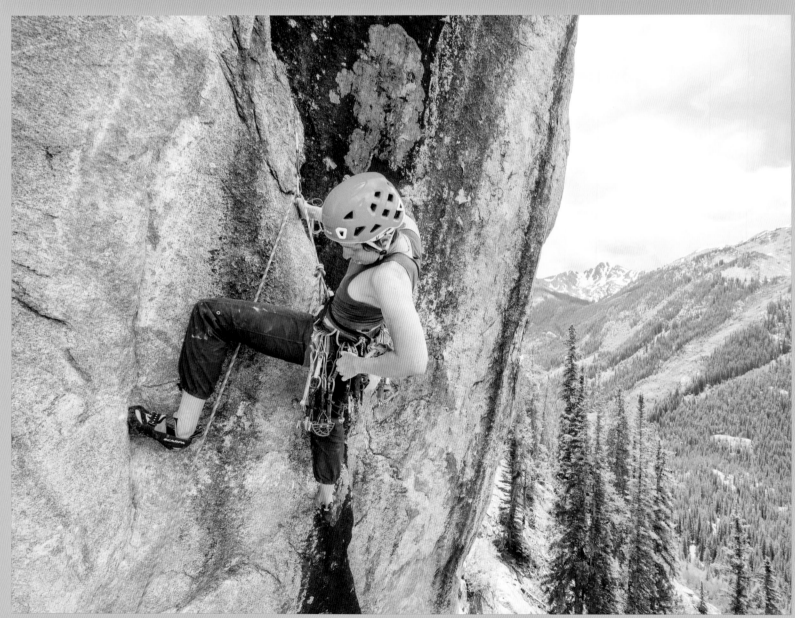

↑ *Above* Madaleine Sorkin searches for the right-sized cam to place in the crack on a route at Independence Pass, Colorado.

BELAY DEVICE: AUTO-BLOCKING TUBE STYLE

This type of belay device is lightweight and versatile, which is exactly what you will need for trad climbing. You can belay the leader, and do a single- or double-rope rappel with any tube-style device. On a multipitch route, the auto-blocking models (sometimes called "guide mode") can also be used to belay a follower from the top down in an assisted mode. The belayer stays ready to catch a fall, but the device adds enough friction that it will stop the rope from moving through the device.

HELMET

Climbers can (and should) wear a helmet for any type of roped climbing, but it is especially important for trad climbing because of the adventurous nature of the routes. Often they are very long and less traveled than sport routes, meaning there is a higher chance of loose rock that could fall down. When doing a multipitch, the leader will climb above the follower and could accidentally kick rocks down.

ROPE

You won't see a rope defined as a "trad climbing rope," because any single dynamic rope rated for climbing will do, but trad climbing puts slightly different demands on a rope than sport or alpine. Thicker ropes are preferred because trad routes often wander around large rock features and in zig-zagging directions, which creates a lot more wear and tear. Rope length is important, as well as a middle mark, which delineates the middle. This comes into play when rappelling a multipitch route.

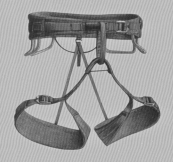

HARNESS

Trad climbing equates to carrying a lot of gear on your body for many hours at a time, so your harness should have enough padding to make it easy to wear all day. Gear loops are also important; most harnesses have four, and trad climbing harnesses should have gear loops that are stiff and sturdy so they can handle the weight of a full rack. Pay attention to durability as well, since trad routes can have abrasive, wide cracks, corners, and chimneys you must scrape your whole body against.

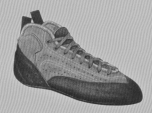

TRAD CLIMBING SHOES

Trad shoes should be comfortable enough to wear all day for long routes, with a stiffer, flatter sole that provides more support so your feet are not screaming after you crammed them in cracks and stood on miniscule edges for eight hours. High-tops that cover the ankles offer extra protection on rough granite and sandstone.

THE RACK: CAMS & NUTS

This is the quintessential gear for a trad climber: a collection of cams, nuts, and other removable protection that make up a prized rack. Climbers become accustomed to their own gear, growing familiar with the sizes, colors, and brands they use regularly. The rack should also include a nut tool, which is a specialized metal hook used for removing nuts or stoppers.

KNOTS & HITCHES

Sailors might be the only other recreationists who love their knots and hitches as much as climbers. And climbers love them for good reason—they are our connection to the rope, our partner, and ultimately, the wall. They can get us out of a sticky situation where we must rescue ourselves or another climber, and they can make complex rope systems much cleaner and simpler. The main difference between a knot and a hitch is that a knot is tied just with a single rope onto itself. A hitch is one rope tied *onto* another rope or piece of gear.

DOUBLE FISHERMAN'S

This is a great "stopper knot," meaning it is tied into the end of the rope whenever you are climbing or rappelling. This will prevent the rope from going through the belay device unintentionally, which might result in a fatal fall.

FIGURE EIGHT FOLLOW-THROUGH

The most common way that modern climbers connect themselves to the rope. This knot is easy to learn, as it is simply a figure eight knot that is retraced back through itself. Tie a figure eight, run it through both tie-in points on the harness, and put the end of the rope back through the original figure eight. If tied correctly this knot cannot come undone, but it can be difficult to untie if the climber has fallen and "welded" the knot.

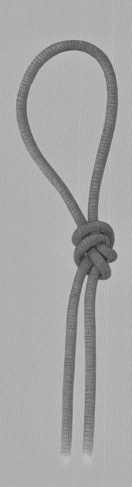

OVERHAND OR FIGURE EIGHT ON A BIGHT

Both the classic overhand ("granny knot," see illustration) and figure eight knots can be tied "on a bight." A bight of rope is a curve of rope somewhere in the middle that is used to tie the knot, which results in a closed-off loop on one side of the knot.

MUNTER HITCH

The Munter is typically tied onto a carabiner and used to control friction in the rope for belaying and lowering. It can be used instead of a modern belay device, and is popular with mountaineers and guides because it serves the same function as a belay device but reduces weight. The Munter is named after Swiss guide Werner Munter; it is also called the Italian hitch and the crossing hitch.

CLOVE HITCH

As the most common way climbers attach them-selves to an anchor on a multipitch, the clove hitch is a closed hitch. When it is tied, the clove acts more like a knot and the rope stays in place when weighted. The biggest advantage, though, is that when unweighted, climbers can push rope through and adjust how much rope is on either side of the hitch. This means they can move closer or farther away from the anchor or another piece of gear quickly and efficiently.

BOWLINE

This is how climbers originally tied into the rope, before modern harnesses. They would wrap the end of the rope around their waist and tie a bowline. However, the bowline can untie itself without a backup knot. There have been several accidents because of this, so now most climbers use the figure eight follow-through. One advantage to the bowline is that it is still easy to untie after it has been fallen on.

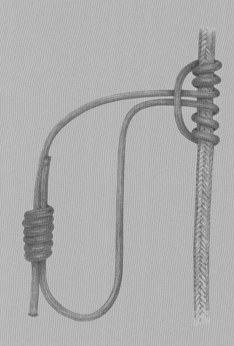

PRUSIK

The best hitch for ascending a fixed rope, which might occur if you are trying to go back up a route you just came down or find yourself dangling in a deep crevasse and need to perform self-rescue.

SUSTAINABILITY: RESPECTING THE ENVIRONMENT

There is no doubt that the popularity of rock climbing has exploded in recent years. What started as a small subculture of mountaineering is now more mainstream than ever, with thousands of climbing gyms around the world, climbing films winning major awards, and formerly unknown climbers becoming household names. In the early years, climbers were a small group of people who focused on developing and climbing routes.

Back then, without gyms or formal instruction available, new climbers spent their formative years under the tutelage of other climbers who were more experienced. Beginners had mentors who would show them the ropes and teach them technical systems. All climbing was done outside, and hence dictated by weather and location, so learning the necessary skills and getting strong was a gradual process. This informal apprenticeship would last for years, with the climber gaining experience over time. Part of this "climbing syllabus" would include how to interact in the natural environment without leaving a large footprint. Plus, with so few climbers doing it in the beginning, it didn't seem like climbing had much effect on the environment.

In the last decade, climbing gyms have opened up the floodgates of climbing. What has changed drastically with modern climbing is the sheer number of climbers, how they are getting into the sport, and the speed at which these climbers can improve. Most climbers get into the sport through climbing in gyms. They can get really strong, really fast, and without any entrance exam for taking those skills outside, they start visiting crags and boulder fields. Many of these climbers are used to climbing in an indoor space, so when they go climbing outside, the best practices to preserve these fragile environments go by the wayside. This has created a disconnect between climbers enjoying the natural environment and learning how to take care of it.

Now the number of people climbing outside is astronomical compared to what it was, and the increased human impact has become problematic. With tens of millions of climbers around the world, outdoor areas are experiencing major issues associated with increased traffic: human waste, trampling of vegetation, expanded footprints, soil erosion, disturbance of wildlife, and degradation of cultural artifacts, to name a few. Not to mention that the climbing routes themselves have changed—softer rock like sandstone and limestone have become worn down and polished with shoe rubber.

It is up to all climbers—whether you have gone outside once or you have been climbing for 40 years—to reduce human impact at our beloved crags and boulder fields. No one group is more to blame than anyone else, but old and new climbers alike must do something about it. If we want to continue to climb outside, we must not only mitigate these environmental issues, but we must also take steps to reverse them and put nature ahead of personal climbing goals. It is important to read and adhere to any educational signage in an area, whether it shows where to park or what cliffs might experience seasonal wildlife closures. Research online and ask fellow climbers about the environmental issues in a climbing area before you visit, and consider another destination if your visit there will add to the problem. See if there are any ways you can volunteer at a trail day or help with cleanup through a local climbing access organization. Always follow Leave No Trace principles, stay on the trail, pick up trash (even if it is not yours), and leave every place better than you found it. Remember that nature is a fragile resource, and one that deteriorates specifically because of human impact. If we want to enjoy our climbing areas for generations to come, we must respect and take care of them.

→ *Right page* A busy day in California's Buttermilks. As climbing becomes ever more popular, the increased number of people can have a negative impact on the fragile environments where climbing takes place.

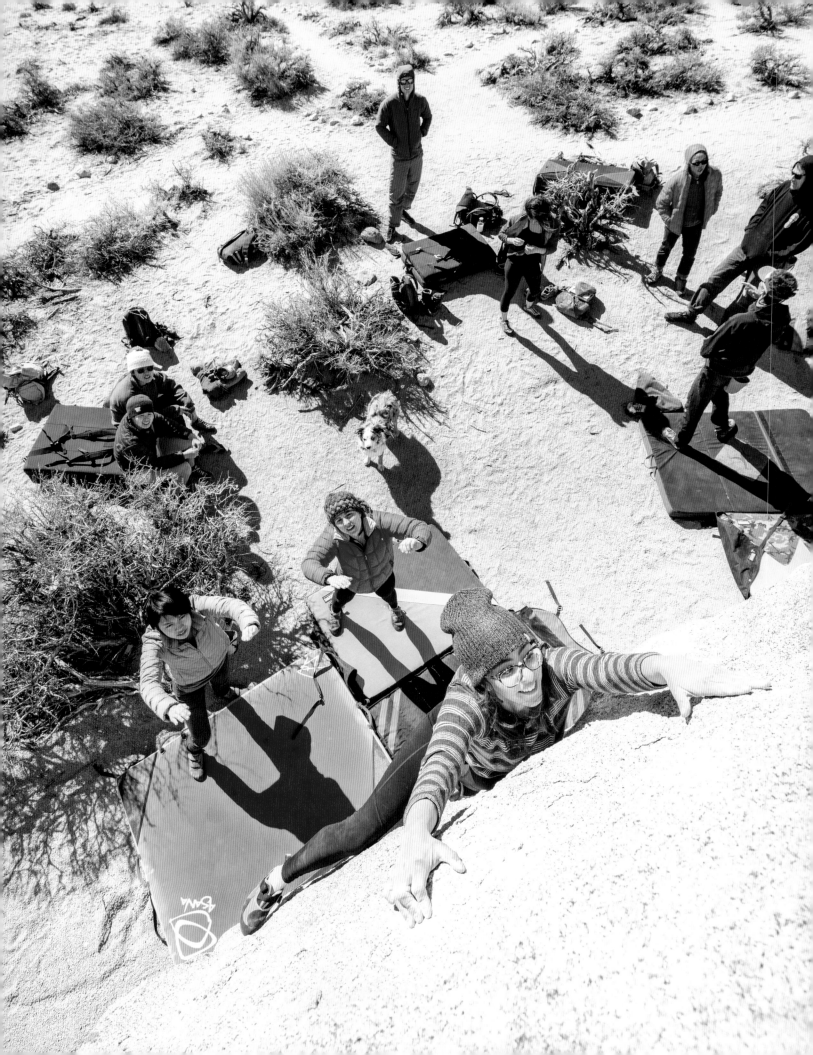

MULTIPITCH CLIMBING

"How do they get the rope up there?" is probably the most common question asked by non-climbers. For the vertically inclined it is not that complicated, but for everyone else, it might seem baffling. Multipitch climbing can be trad or sport, and it refers to two people ascending multiple pitches together, usually going high off the ground for a few hours. This is opposed to single-pitch climbing, also trad or sport, where the climber ascends one pitch before coming back to the ground, where the belayer is. Multipitch climbing encompasses everything from a two-pitch climb at the local crag to a 30-pitch big wall on El Capitan in Yosemite Valley. As long as the climber and the belayer both leave the ground and ascend more than one pitch, it is a multipitch.

Both climbers and belayers start on the ground. The leaders climb and place protection as they move up, stopping at the top of the first pitch. Some multi-pitch routes have bolted anchors, but if not, the leader builds an anchor, and then pulls the rest of the rope up. Leaders then put their partner on belay from the top.

The partners, called the followers or seconding climbers, climb to the anchor at the top of the pitch where the leader is. As they are climbing, they are removing the gear that the leader placed on the way up. Both at the anchor, the leader and partner spend a few minutes exchanging gear and getting the rope organized.

One of the climbers will lead the second pitch and place gear along the way. Sometimes one person will lead the entire multipitch route, and sometimes the two climbers will trade off who leads each pitch. It is a decision they make together based on personal strengths or preferences.

Leaders stop at the second pitch anchor and belay their followers up to where they are. The two repeat this process, one climbing and one belaying, until they reach the top. To get down, the climbers must either walk off the formation or descend via rappel.

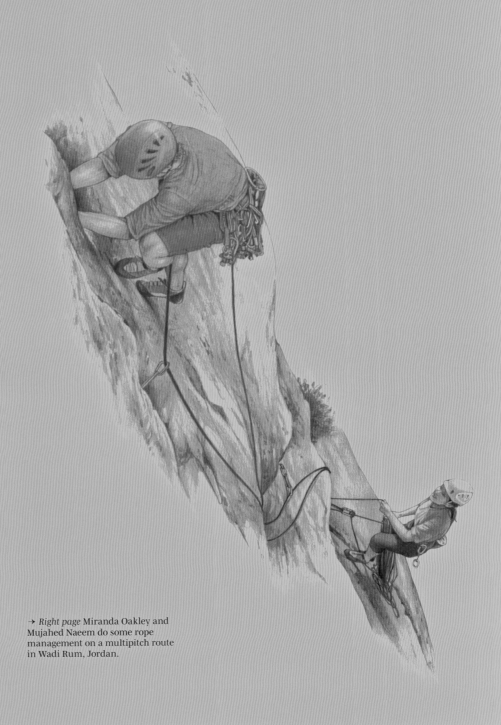

→ *Right page* Miranda Oakley and Mujahed Naeem do some rope management on a multipitch route in Wadi Rum, Jordan.

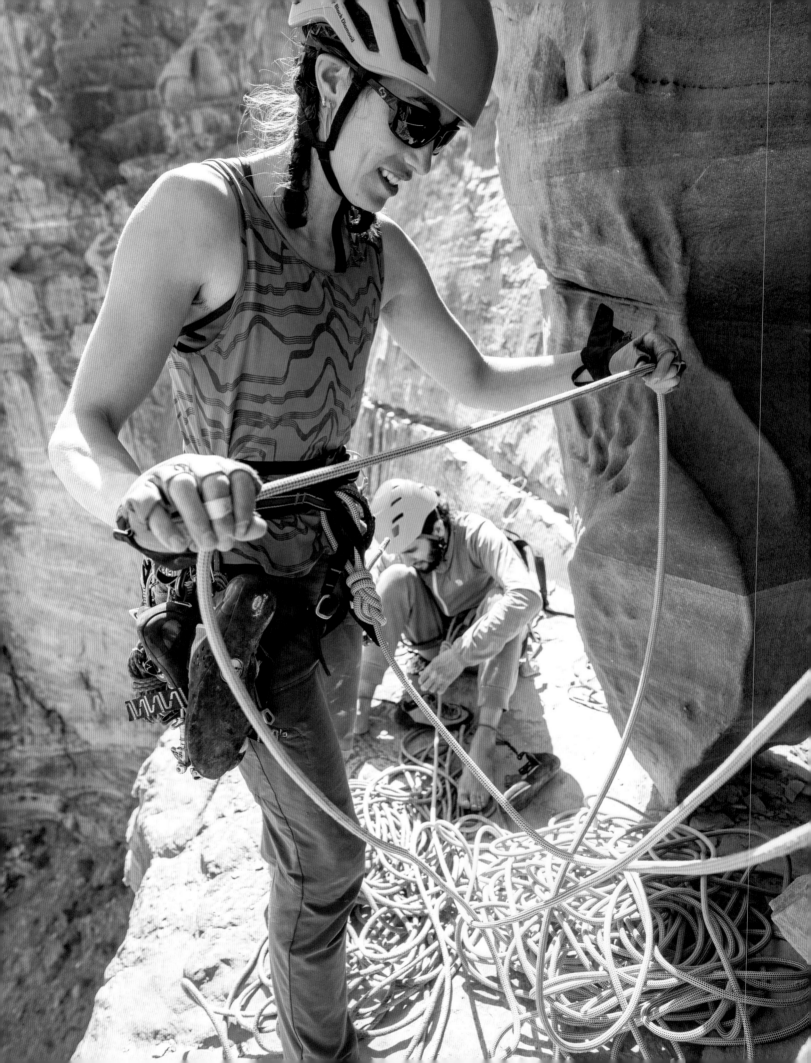

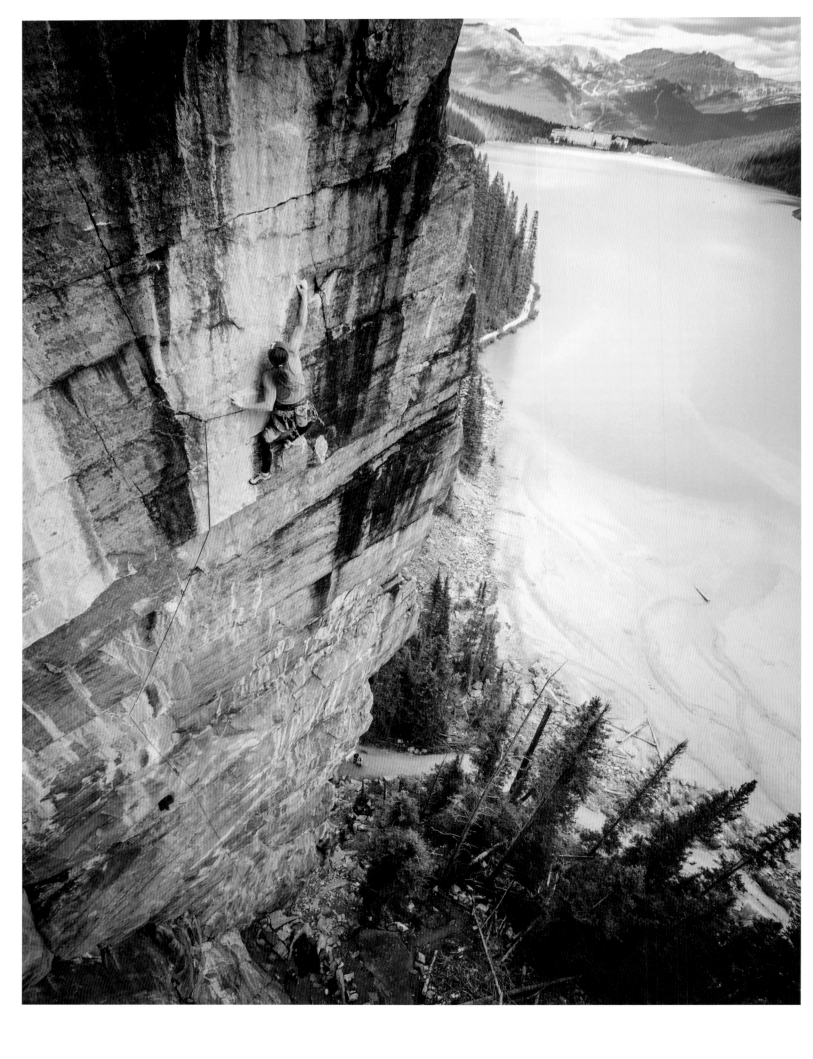

BARBARA "BABSI" ZANGERL

WITH HARD TICKS IN BOULDERING, SPORT CLIMBING, ALPINE, AND BIG WALL CLIMBING, THIS UNASSUMING AUSTRIAN CRUSHER IS ONE OF THE BEST ALL-AROUND CLIMBERS IN THE WORLD.

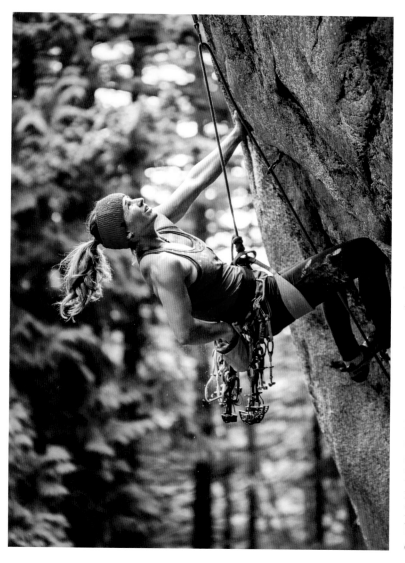

About halfway up *The Shadow*, a 7c+/5.13a in Squamish, Canada, in July 2018, 30-year-old Barbara Zangerl takes a quick rest in the granite dihedral by pushing against the wall on either side. She removes her feet from the wall and dangles them below for a few seconds. At 5 foot 3 inches (160 cm) tall, with light brown hair, Babsi's petite build belies the strength it requires to hold her entire body up simply by pressing outward with her palms. The rock resembles an open book, and with no large holds or features, she must rely purely on the friction between the rock and her hands and feet to move upward.

The 165-foot (50-meter) route is slightly less than vertical, so most of her weight is directed into her toes, creating enormous force on her calves; this stemming corner demands resting the feet and calves as much as possible. She starts climbing again, a delicate and subtle dance of figuring out just the right amount counterpressure—shifting her weight between palm presses and imperceptible foot nubs. She had rehearsed these moves several times over the last few days. She is stubborn; her motivation only increases when she cannot figure out the right sequence. It is this determination and focus that earned her the nickname "The Technician"— she is known for throwing herself at seemingly impossible moves until she can do them once, twice, three times. After several feet of climbing on *The Shadow*, the thin crack in the corner of the open book opens up slightly, and Babsi can fit her small fingers into it. She jams her digits in, torquing them into the fissure and removing her feet from the wall again. Hanging purely on the finger locks, she flutter-kicks her feet back and forth to rest her calves again, looking calm and collected despite the pain she must be feeling. →

→ *The Shadow* is well below the hardest route Babsi has ever sent, but it is a benchmark climb in a notoriously difficult style, and Babsi ticked it on her first redpoint attempt. Her trip to Squamish, along with boyfriend and climbing partner Jacopo Larcher, was in the midst of an impressive year of climbing for Babsi. Eight months earlier, in December 2017, she and Jacopo made the second free ascent (first female ascent for her) of *Magic Mushroom* (8b+/5.14a) on El Capitan in Yosemite Valley, California. At 31 pitches and almost 3,000 feet (900 meters), *Magic Mushroom* was long considered the hardest route on El Cap until the *Dawn Wall* was climbed in 2015. It took the duo, who live together in Bludenz, Austria, 11 days to complete the line, both battling their own personal cruxes. Babsi notes that route as her proudest climbing achievement: "I got sick on the wall after the first day on our final push. I couldn't eat for three days because of gastritis. I had some really hard days where I questioned the whole thing. I almost gave up 80 meters below the top because of a single move I struggled with. We invested the longest time in this climb, and I could stand together with Jacopo on top. We both climbed it together, and it was the best, most beautiful line I have done on El Cap."

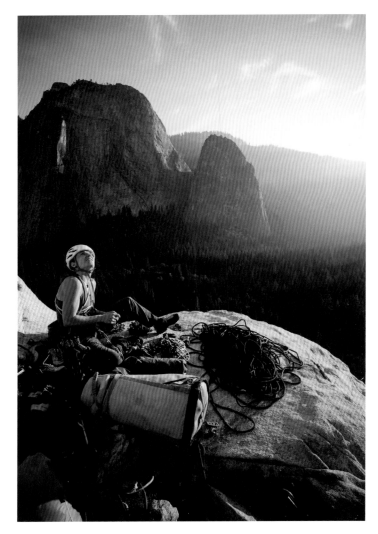

The month before the Squamish trip, she had just climbed her first 9a/5.14d sport route when she ticked *Speed Intégrale* in Voralpsee, Switzerland. Then the month after Squamish, in August 2018, Jacopo and Babsi would free a 33-pitch route on the north face of Switzerland's Eiger called *Odyssee*. They did the 33 pitches ground-up in four days, meaning they never returned to the ground while both sending the 4,600-foot (1,400-meter) 8a+/5.13c. Babsi and Jacopo are a unique climbing team in that their goal is to individually lead each hard pitch of a rock climb. Whereas other notable climbing duos will swap leads, meaning one of them climbs it cleanly on lead and the other climbs it cleanly on top rope, Babsi and Jacopo will keep trying and pulling the rope until they have each done every crux pitch on the sharp end. (They do swap leads on easier pitches.) Sometimes one sends and the other doesn't. "For sure there are moments, like on the *Pre-Muir* wall, where it is a little frustrating." In June 2019, they attempted the 8b/5.13d route on El Capitan. With a cruxy stemming corner, similar to *The Shadow*, Babsi was able to free all 34 pitches, but Jacopo came up short. "Jacopo got so close on the corner pitch but fell at the very end, then got too tired to climb it finally," she says. "We didn't finish that line together. It is definitely a different experience and half as good compared to succeeding together on a climb. But at the end it is the quality time together on the wall that makes that experience great." Sending *Pre-Muir* marked Babsi's fourth free ascent of El Capitan at age 31. Five months later she and Jacopo both sent El Cap's most famous line: *The Nose* (8b+/5.14a). She now has five free ascents of El Capitan—many elite big wall climbers try an entire lifetime to free climb it once.

With such a mind-blowing big wall and alpine résumé (she is one of few climbers—and the first woman—who has climbed the Alpine Trilogy, a trifecta of long, high-altitude 8b+/5.14a routes in the Alps), it is hard to believe Babsi got her

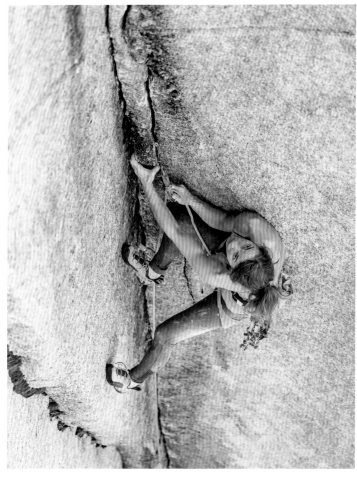

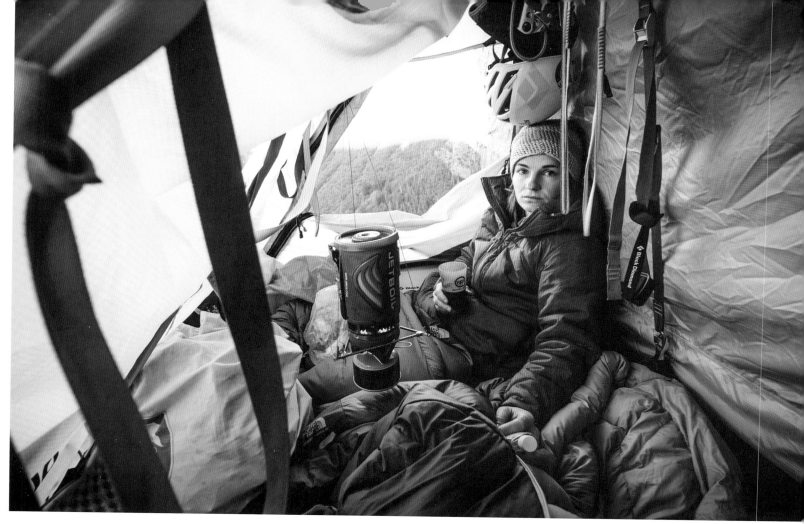

SHE NOW HAS FIVE FREE ASCENTS OF EL CAPITAN—MANY ELITE BIG WALL CLIMBERS TRY AN ENTIRE LIFETIME TO FREE CLIMB IT ONCE.

start climbing in the gym. Her older brother, Udo, took her and her sister, Claudia, to the gym in the village of Flirsch am Arlberg, 10 minutes away from where she grew up in Strengen, Austria. She started going to the gym three times a week and improved quickly, eventually going outside to combine her new love for climbing with a Zangerl family passion for the mountains. After six years of climbing, she ticked *Pura Vida*, an 8A+/8B (V12/V13) boulder problem in Magic Wood, Switzerland.

Around that time, a back injury forced Babsi to stop bouldering and start sport climbing. After a year of that, she tried trad climbing. Her first trad route was *Super Crill*, a nine-pitch 8a/5.13b in Ticino, Switzerland, in 2012. →

← *Left page top* Taking a look at the upcoming climbing after the first pitch of the 3,000-foot (900-meter) *Magic Mushroom* (8b+/5.14a) on El Capitan, Yosemite.
← *Left page bottom* In the middle of *The Shadow* (7c+/5.13a), in Squamish, Canada. ↑ *Top* It's not all fun and games—Babsi experienced some stomach issues during her free ascent of *Magic Mushroom* (8b+/5.14a) on El Capitan in December 2017. ↑ *Above* Hanging out with a dog named Chicken in Squamish, British Columbia, Canada, in summer 2018.

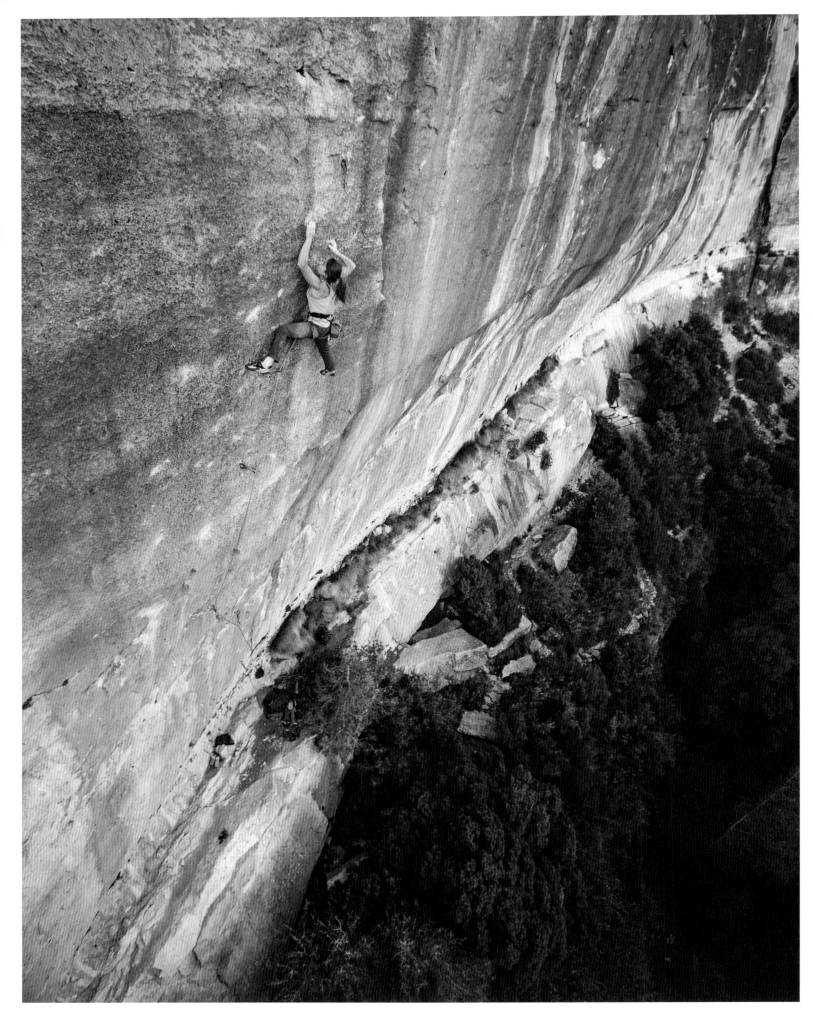

→ (Most trad climbers go their whole lives and never climb anything even near this level of difficulty.) She was motivated by the new types of challenges she found with long trad routes in the mountains: placing her own gear, climbing on exposed walls, getting scared, overcoming her fears, and forgetting about falling. She continued to trad climb, visiting places like the Dolomites, Indian Creek, and Yosemite Valley. While she still loves all types of climbing, she has found the perfect recipe of challenge and difficulty in big walls. She and Jacopo plan to climb big walls in Madagascar, Pakistan, and Patagonia in the coming years.

"At the end, every single discipline is important to climb on those big walls. You definitely need to boulder to figure out the single sequences. You need the power-endurance of sport climbing, and you need to keep it all together in the mental point of view. It definitely was a long learning process. With gaining experience I got more confident in doing what I love the most, and sharing all this with good people that leads to unforgettable moments."

WHILE SHE STILL LOVES ALL TYPES OF CLIMBING, SHE HAS FOUND THE PERFECT RECIPE OF CHALLENGE AND DIFFICULTY IN BIG WALLS.

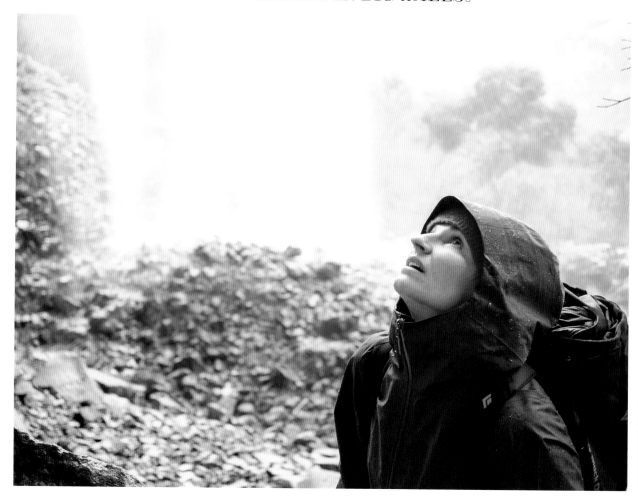

← *Left page* Trying hard on *Chikane* (8c+ / 5.14c) in Siurana, Spain. ↑ *Above* After a short and cold night in a bivy at the base of the Marmolada south face in the summer of 2017. ← *Left* Looking for some dry rock in Sonora, California, during a very wet climbing trip to America in the winter of 2018.

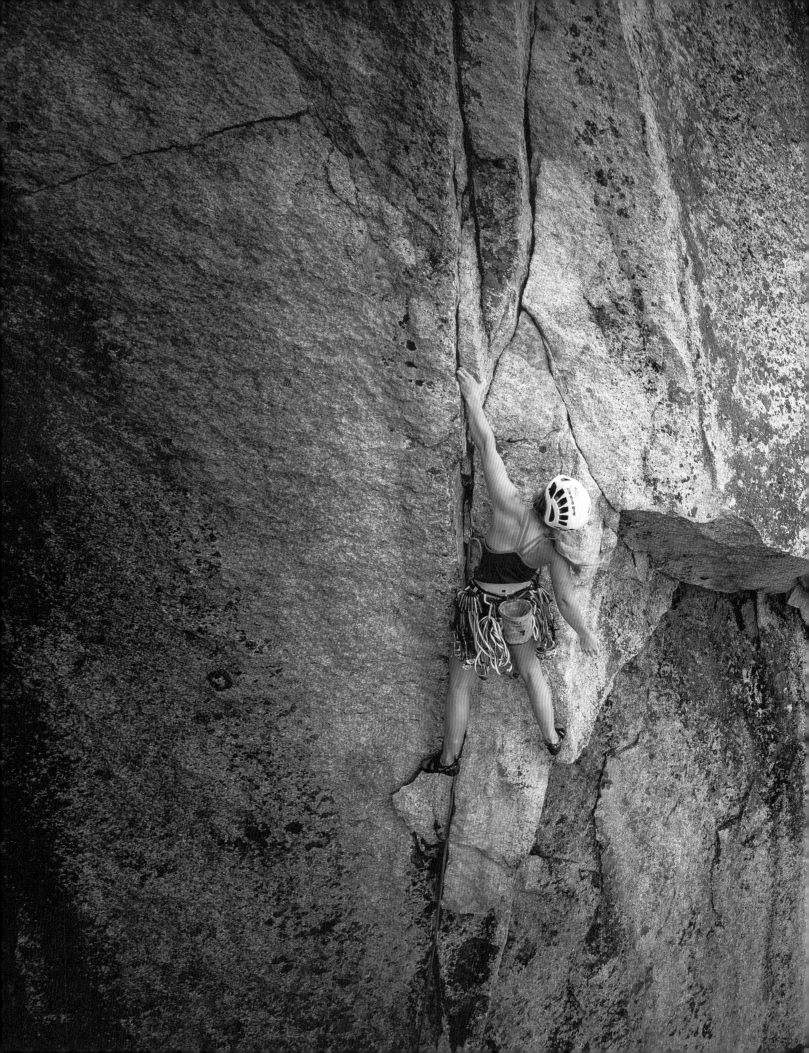

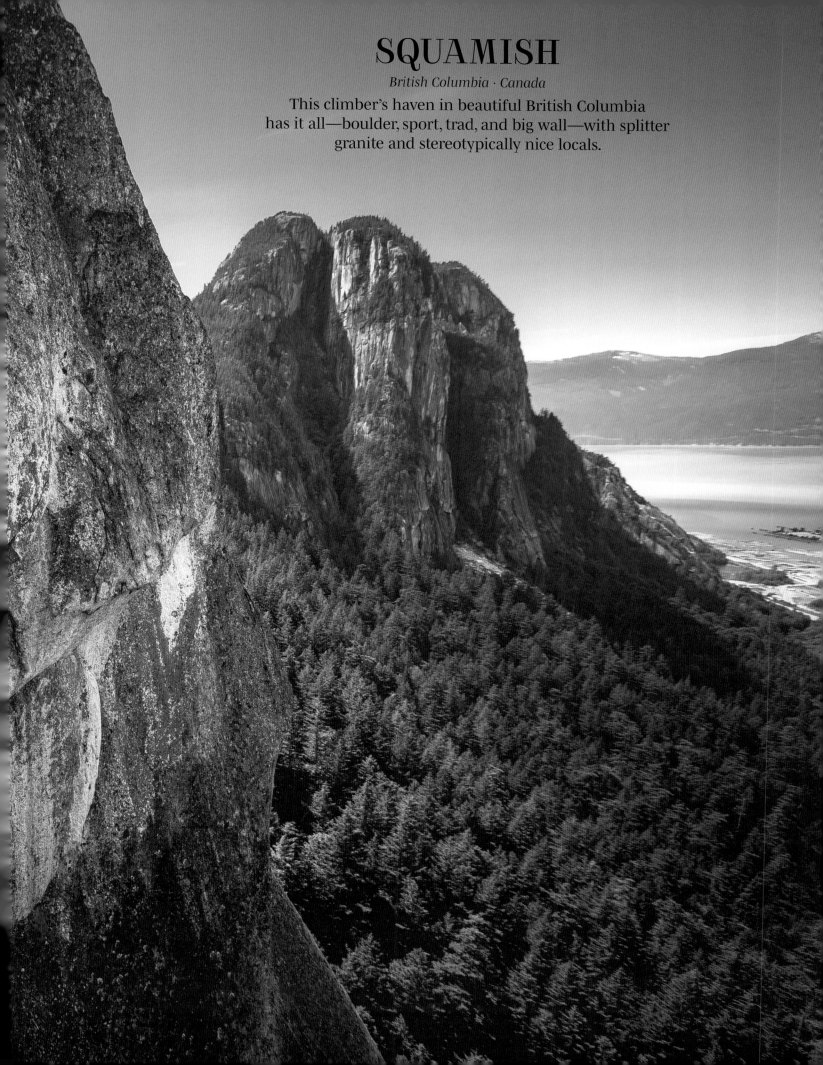

SQUAMISH

British Columbia · Canada

This climber's haven in beautiful British Columbia
has it all—boulder, sport, trad, and big wall—with splitter
granite and stereotypically nice locals.

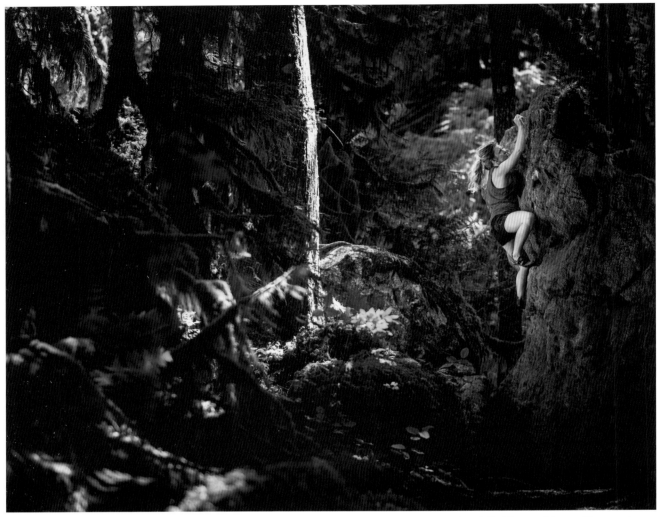

↑ *Above* Squamish is unique in that it has the climber's perfect trifecta: bouldering, sport climbing, and trad climbing. → *Right page* The sun sets on Mina Leslie-Wujastyk as she climbs *Gemini* (7b+/5.12c) in Squamish.

Magical is the only word to describe the endless rock and sweeping forests of Squamish. Western red cedars and Douglas firs line the base of the Stawamus Chief, the area's famed granitic dome that rises 2,300 feet (700 meters) from sea level with dozens of multipitch routes. The trees hide a cache of geometric boulders, with laser-cut arêtes and chiseled eatures that require cryptic sequences and subtle technique to ascend. Once you enter the forest, there is a quiet that pervades, as if breaking the silence is somehow unholy. Even the busy Sea-to-Sky Highway that is only a few hundred feet away seems muted in this land of giants.

Most climbing areas are described in terms of their quantity or quality. Either the rock is good and the climbs aesthetic, or there is just a ton of climbing. Squamish has a ton of climbing that is all superb. Seriously, there are more than 3,000 boulder problems

and 1,200 routes. Most of the approaches are 15 minutes or less, and all of the granite is world-class. The base of the Chief provides single-pitch trad routes; ascend the entire formation for an all-day, 15-pitch adventure. Across the street from the Chief is Murrin Park, with a multitude of hard sport climbs and a few trad routes. Five minutes away in the middle of town are the Smoke Bluffs, a short cliff line that comes right out of a neighborhood and sits on a heavily trafficked walking path. Home to hundreds of single-pitch trad lines, the Bluffs are the perfect spot to get in a few pitches after work, or after a morning of rain.

Like most granite areas, Squamish routes are famed for their cracks and slabs, so the technique on any single line can vary from stuffing your hands and feet into fissures big and small to gingerly placing your toes on the smallest of nubs and hoping your fingertips stick to slopy dishes

on a low-angle face. If you are already a granite master, you will come here and crush. If your granite techniques could use some work, then this is the spot for you. Both first-time leaders and 20-year veterans can find plenty of routes at just the right grade. With plenty of good gear options (meaning it is easy to place) and bolted belays, everyone can push themselves to try something a little bit harder.

Potentially the most well-known route in Squamish is the *Grand Wall,* an eight-pitch line that ascends the impressive center face of the Chief. The meat of the route is the row near the upper half formed by *Split Pillar* (6a+/5.10b), *The Sword* (6c/5.11 A0), and *Perry's Layback* (6c/5.11a). The *Split Pillar* will test your jamming skills as well as your endurance—the pump you feel as your forearms get tired at the top can spit you right off. *The Sword* involves a thin crack, and delicate face climbing moves into →

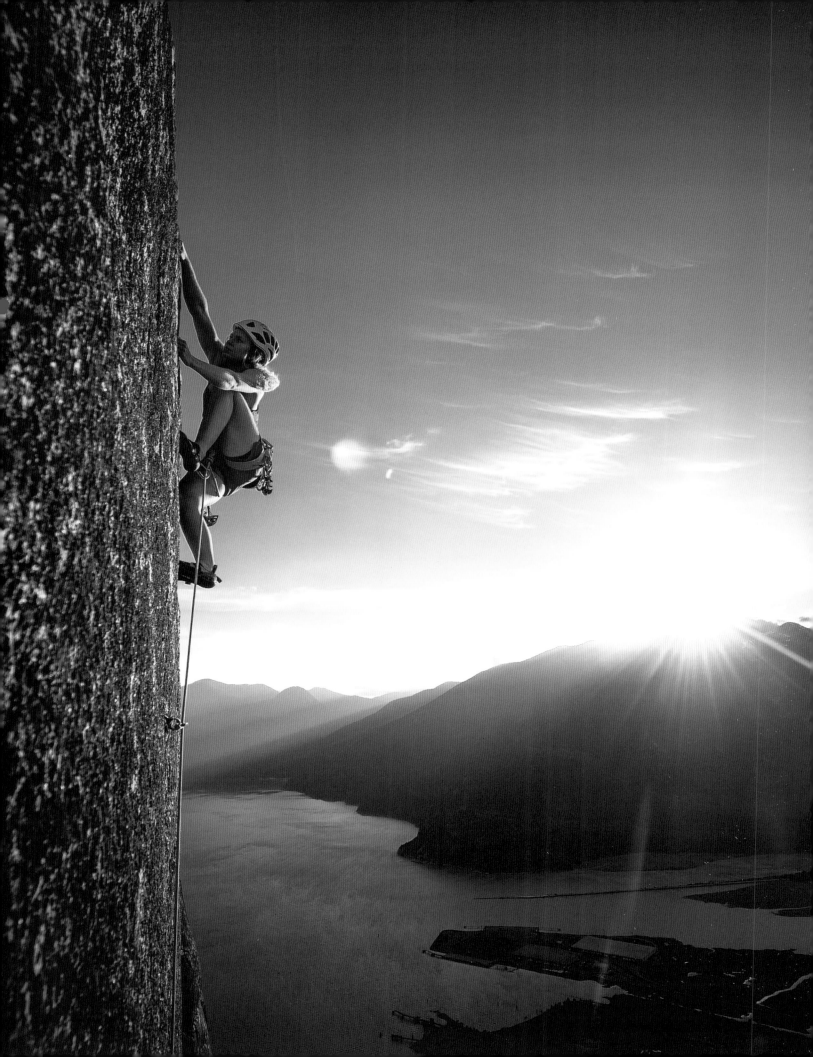

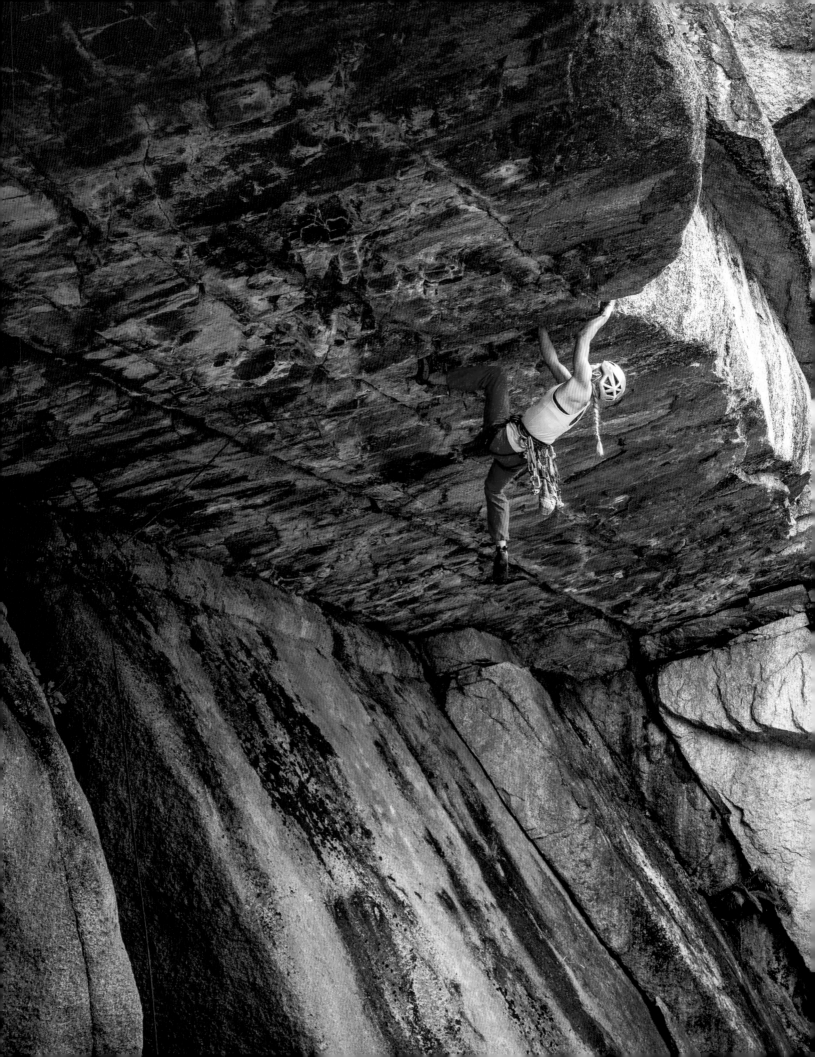

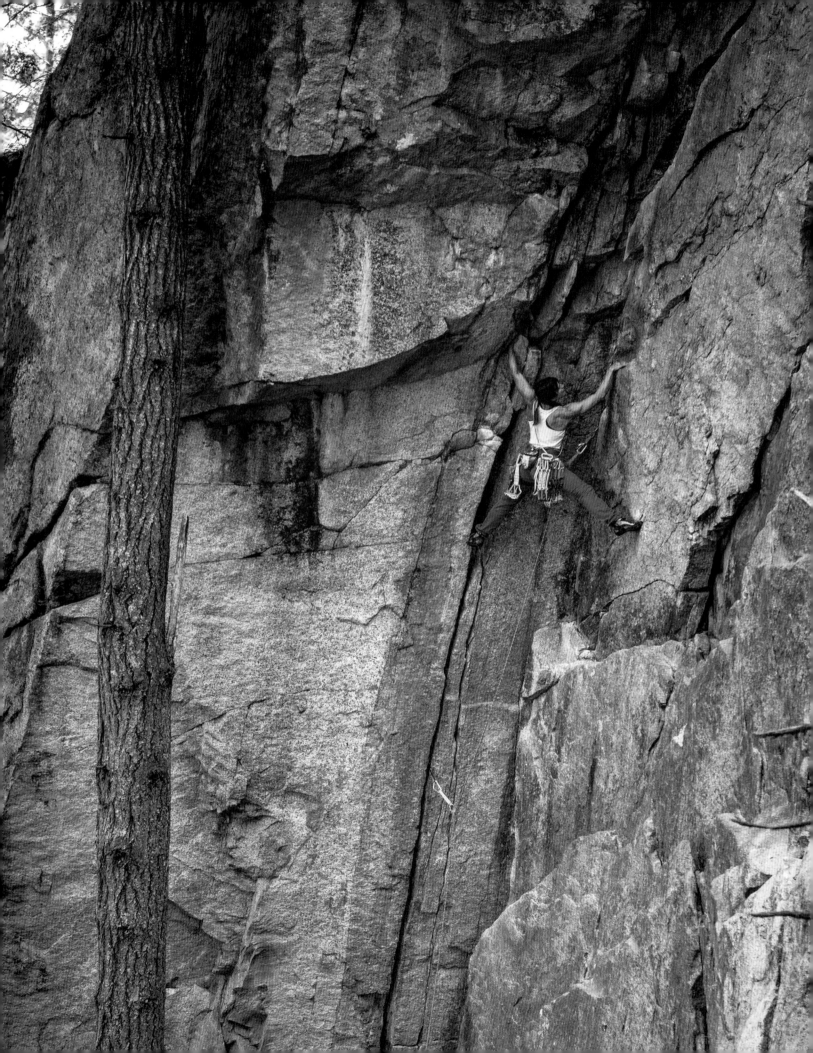

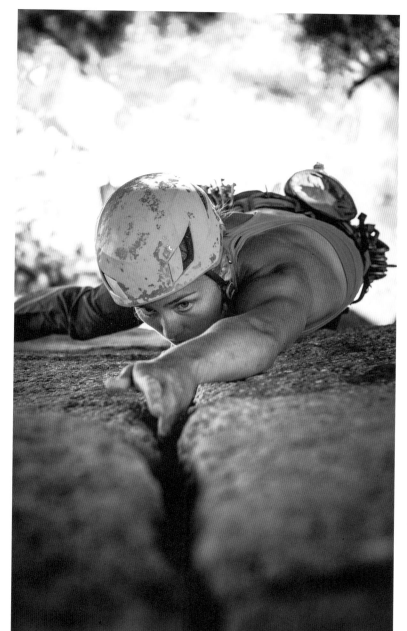

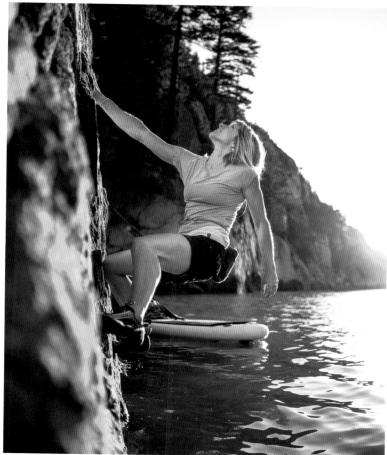

←← *Previous spread* Kristen Selin on *Zombie Roof* (7c+/5.13a), in Squamish, Canada. ← *Left page* Sarah Thompson on *Reacharound* (5b/5.9) in Squamish. ← *Left* Kristen Selin climbing *Vital Transformations* (7b+/5.12c). ↑ *Above* For souls willing to brave the cold water, Squamish even has deep-water soloing. →→ *Following page* Kinley Aitken learns to fly on *Learning to Fly*.

→ a powerful layback. Then you must practice your aid climbing skills on a short bolt ladder (hence the "A0" in the grade) before the anchor. Lastly, *Perry's Layback* is short and bolted like a sport climb, but at that point you have already done five pitches of strenuous climbing. *Perry's* is like a kick in the stomach when you are already down. Smear your feet against the face, pull against the flake that angles right, and just keep your head down as you climb up! A few more moderate pitches, then you exit right on the infamous Bellygood Ledge that is a highly exposed traverse along the upper reaches of the massive Chief. It is part of the descent, but you will need to stay heads up and get a

belay as you tiptoe along a perfectly flat ledge that's only 12 inches (30 centimeters) wide.

For something easier but more adventurous, check out *Angel's Crest* (6a+/5.10b), 13 pitches of wandering cracks and faces up the obvious and impressive ridge on the north side of the Chief. It is an all-day outing that requires plenty of route-finding through vegetated ledges and small rock formations. Even though you are never more than a few hundred meters above sea level, and you can see the highway the entire time, you might feel like you're in the alpine!

Nestled at the northern end of the Howe Sound, Squamish is a port town that

once relied on logging and forestry for its economy. With the fading of those industries, tourism has become the main source of income. Outdoor recreation in particular has boomed, with climbing, kite-surfing, hiking, trail running, and BASE jumping as the main attractions. Squamish is named for the Squamish people, an indigenous population that inhabited the region before European settlers, and many of the nearby waterways and formations have names derived from the Squamish, or *Skwxwú7mesh*, language (the 7 represents a glottal stop): *Ch'iyákmesh* or Cheakamus river and canyon, *St'á7mes* or Stawamus, *Mámxwem* or Mamquam River.

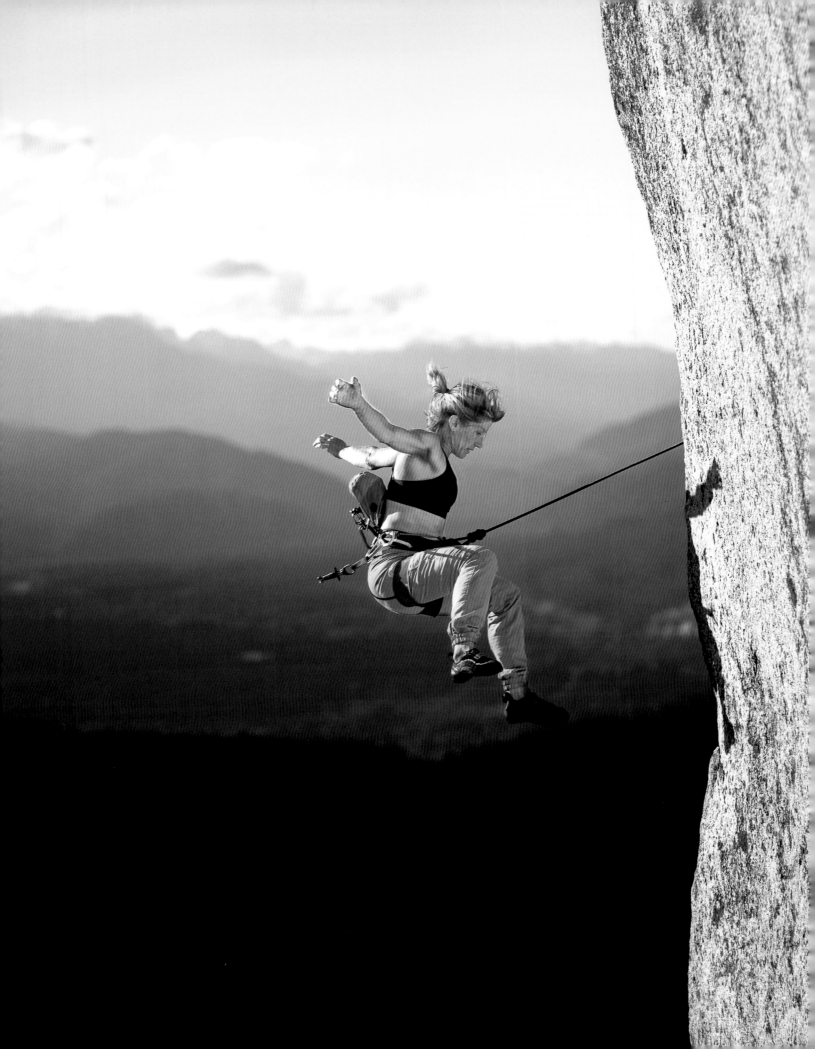

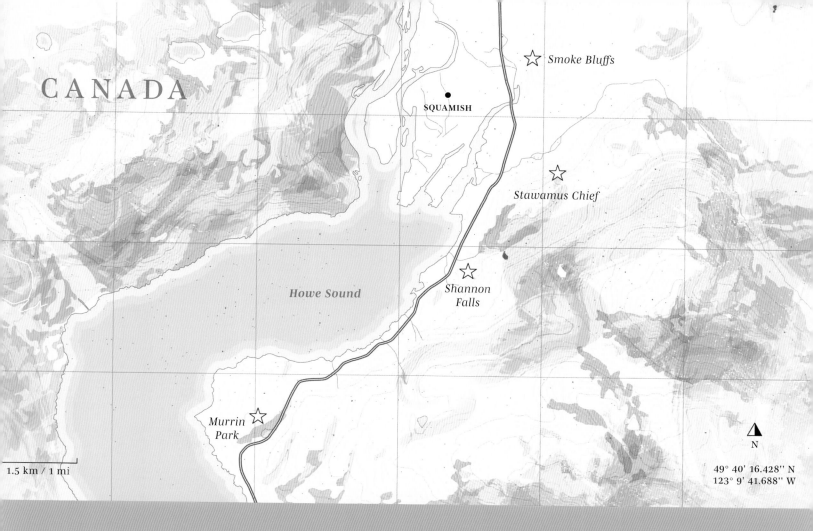

CANADA

Smoke Bluffs

SQUAMISH

Stawamus Chief

Shannon
Falls

Howe Sound

Murrin
Park

N

49° 40' 16.428'' N
123° 9' 41.688'' W

1.5 km / 1 mi

SQUAMISH

in a Nutshell

CLIMBING TYPE

Bouldering, sport, trad,
multipitch

PROTECTION

Crash pads, quickdraws,
trad rack

SEASON

Summer

WHERE TO STAY

Camp at a nearby
campground, or rent
an Airbnb in town.

ONE MORE THING

Squamish is about an hour
north of the large city of
Vancouver, and it's a very
popular tourist destination
in July and August when
it tends to be drier. June and
September are rainy, but
there are way fewer people,
and often the rocks are dry and
climbable by the afternoon.

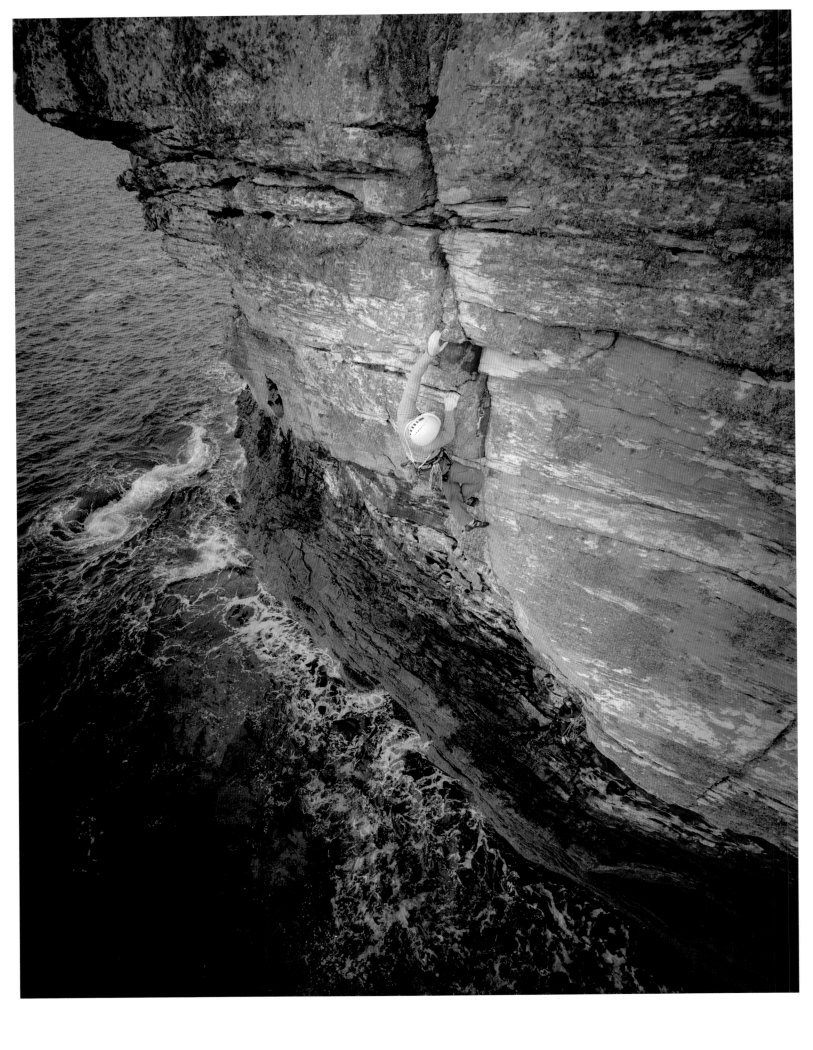

PETE WHITTAKER

THIS CRACK-CLIMBING ACE HAS BECOME
A SUFFERING EXPERT: FREE CLIMBING ICONIC
BIG WALLS—VIA ROPE-SOLO—AND TICKING
THE HARDEST, MOST PAINFUL WIDE AND THIN
CRACKS AROUND THE WORLD.

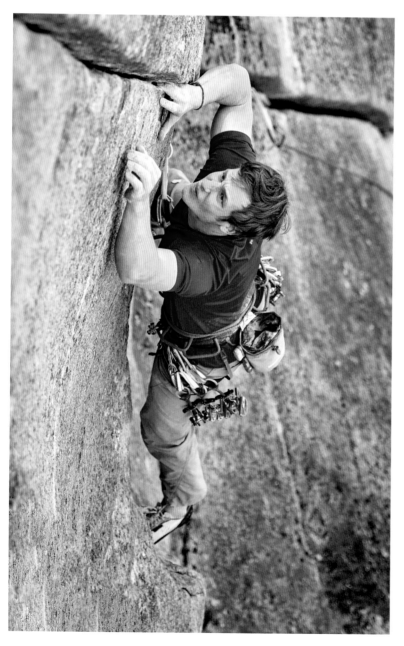

While some climbers choose to stick with the style of climbing they are best at, British climber Pete Whittaker takes a different approach. As soon as Whittaker has gotten good at a particular style of climbing, he is ready to move on. "When I've done something or mastered one type of climbing, it becomes less challenging and then the love for it drops off," he says. "I'm always searching for the next thing."

That search has carried him through an illustrious climbing career centered around the hardest crack climbs in the world, including a tour of America's hardest offwidths, painful finger fissures, and big wall endurance challenges. In 2011, Whittaker gained notoriety after sending *Century Crack*, a wild, 8c/5.14b roof crack that runs horizontally for 40 meters in the sandstone heaven of Utah's Canyonlands in the United States. At the time it was the hardest wide crack in the world. Five years later, Whittaker became the first person to free climb El Capitan in less than 24 hours via rope-soloing, a technique where the climber does not have a partner, but is still protected by ropes and other safety equipment. He climbed *Freerider*, a 7c/5.13a, in 20 hours, 6 minutes. That same year he nabbed the first ascent of another 8c/5.14 roof, *Millennium Arch*, which is 300 feet (90 meters) long and also in Canyonlands. In August 2019, Whittaker got the third free ascent of *The Recovery Drink*, an 8c+/5.14c in Norway. This thin crack, which requires a completely different technique than an offwidth, is considered one of the hardest crack climbs in the world.

For many of Whittaker's impressive endeavors, he has been accompanied by fellow Brit Tom Randall, who sent *Century Crack* and *Millenium Arch* at the same time as Whittaker. Together the duo is known as the WideBoyz, a name that came from a travel blog documenting that first American offwidth tour and has since grown into a business venture that sells large climbing holds that mimic different-size cracks. When Whittaker was 17, 10 years after he started climbing with his parents on the United Kingdom's →

→ infamous gritstone, he met Randall at the local climbing wall in Sheffield. Randall was working as a route-setter and looking for someone to help him break the world record for number of routes climbed in a day (at the time, 536).

"Understandably, he couldn't find anyone," Whittaker says. "He asked me, and being the keen 17-year-old I was, I just said yes straightaway. I was just psyched someone older had asked me to climb with him, to be honest. The first thing we did together was this challenge, and we climbed 550 routes each. From there we went on a few European trips together, and then the American trip happened when I was 20." The American trip came about in a snowball way, where one idea morphed into the next, and then the next. After a new-routing trip to Italy where they had climbed a few wide first ascents and had fun doing it, they thought to go to America and climb offwidths. "Then we thought, 'Why don't we do a tour of American offwidths?'" Whittaker says. "Then we thought, 'Let's just go and repeat all of America's hardest offwidths.' Then we thought, 'Why don't we just establish the hardest offwidth in the world,' and it spiraled on from there. I was 18 when all these ideas were floating around and obviously massively keen for anything." They wanted to be fully prepared for the trip, so they dedicated two years to training for these physically grueling wide cracks. To do that in the United Kingdom, a place that notably has very few wide cracks, they built their own crack simulators using wood in Randall's cellar, a place that, despite not being tall enough to stand up in, gained notoriety as the "Crack Cellar."

The training paid off for that first trip, when Whittaker says, "My technique for offwidthing was pretty crap, but I was fit and strong from all the training." Crack climbing, particularly wide cracks, is known for its tricky techniques, or ways of putting your hands and feet in the crack to be able to move your body up. No one ever taught Whittaker these skills, such as how to hand jam or hand-fist stack, but he kept trying. "If something feels bad, I like to work out why it feels bad and then make it not feel bad," he says. "Also, if something feels bad, I'm good at getting on with it. It's probably just a personality thing. Crack climbing shouldn't be painful if you get it right, but it's difficult to get it right at the beginning, so sometimes it can be a bit painful. I kind of like pain though, so it's a bit of a winner."

His affinity for suffering has also contributed to success with endurance-focused mega-projects, whether it is two years of training for one climbing trip, a solo linkup of El Cap and Half Dome in less than 24 hours, or writing a book about crack technique, called *Crack Climbing*. "I always have a list of big climbing projects, so I'm always trying to work toward those, ticking off little intermediate goals to bring me closer to reaching them," he says. "The same goes for my book. It's been a long project of mine, from proposing ideas to publishers, getting a publisher, and writing it. I put the same amount of energy, work, and passion into it that I have with any of my climbing projects, so I'm happy to see it finally finished. I hope people will be able to learn something from it."

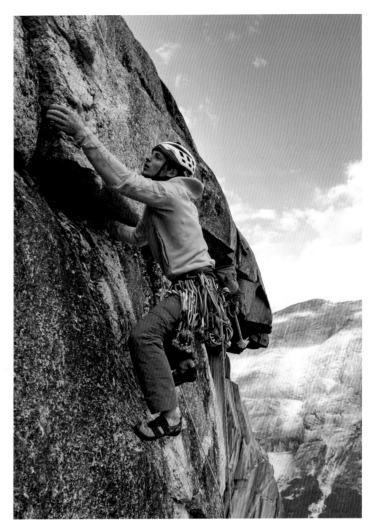

↑ *Above* Pete Whittaker on the south face of Mount Watkins in Yosemite, California. ↓ *Below* Pete lets his blisters air out on the top of El Capitan after climbing long routes in Yosemite. → *Right page top* Pete belays at Suidhe Biorach, Scotland. → *Right page bottom* Climbing some mossy rock on a little-traveled route in Scotland. →→ *Following spread* Pete Whittaker leads pitch 18 (out of 19) on the south face of Mount Watkins (VI 5.13b / 8a, 19 pitches), Yosemite, CA.

HIS AFFINITY FOR
SUFFERING HAS ALSO
CONTRIBUTED TO
SUCCESS WITH
ENDURANCE-FOCUSED
MEGA-PROJECTS,
WHETHER IT IS TWO
YEARS OF TRAINING
FOR ONE CLIMBING
TRIP, A SOLO LINKUP
OF EL CAP AND
HALF DOME IN LESS
THAN 24 HOURS, OR
WRITING A BOOK ABOUT
CRACK TECHNIQUE.

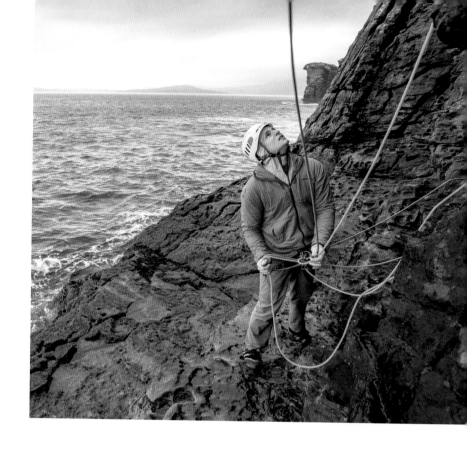

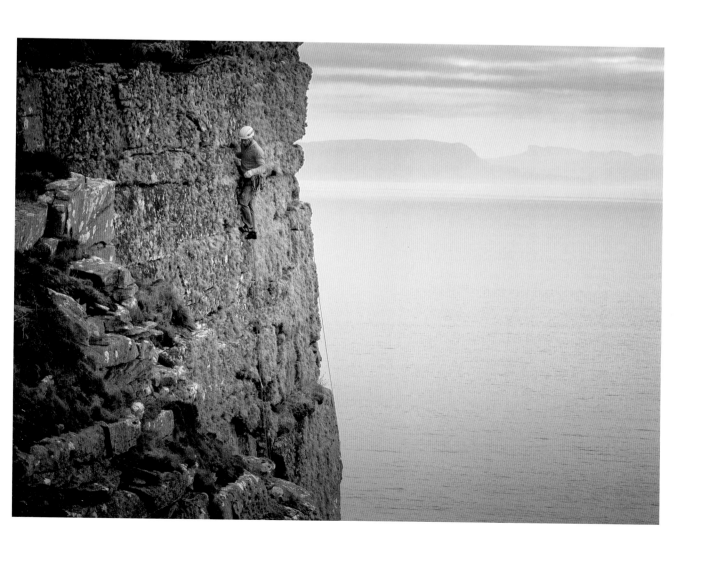

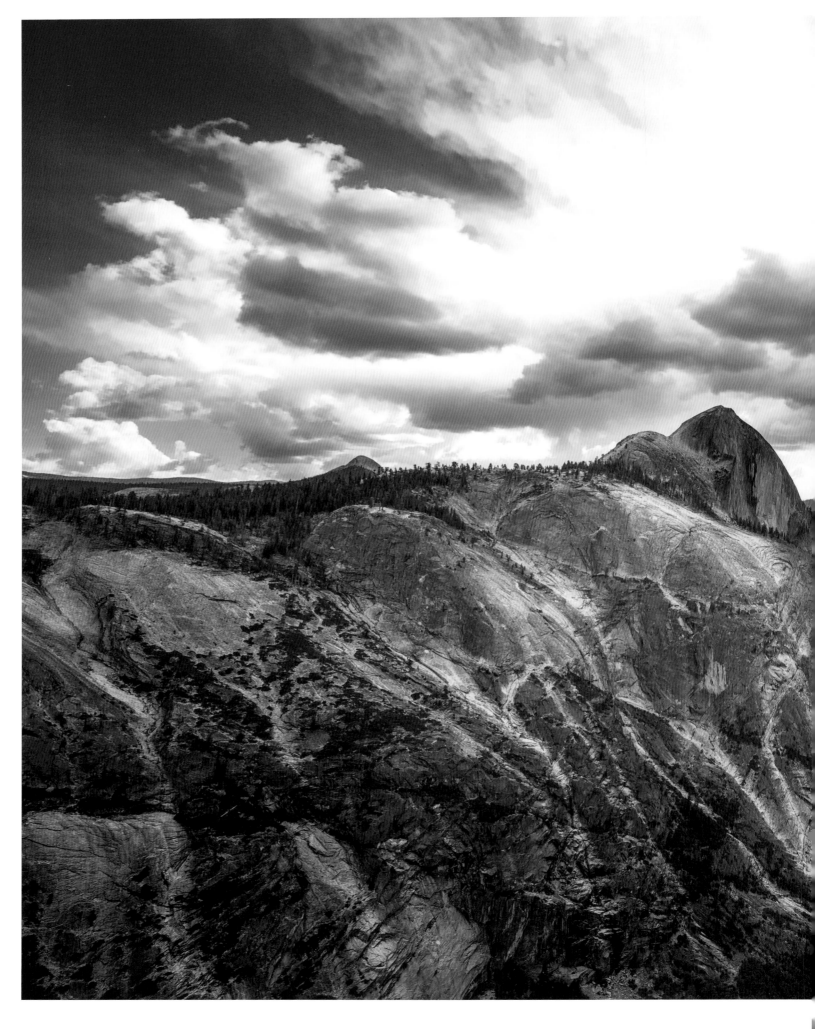

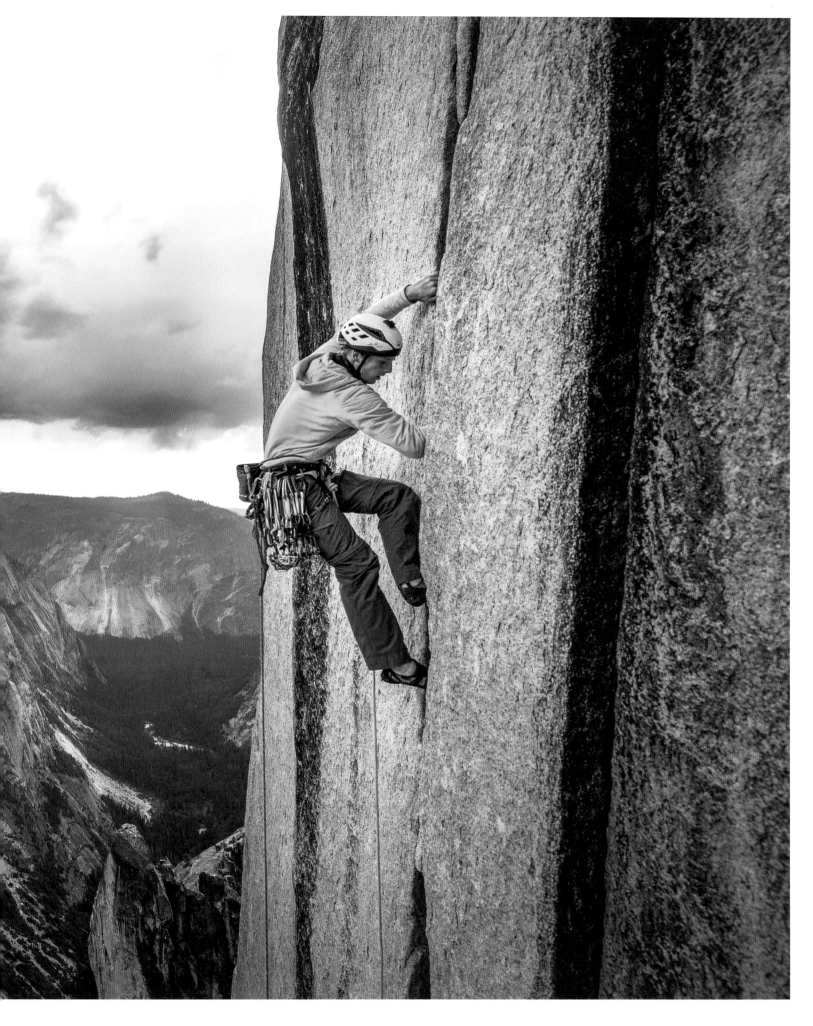

A CLIMBER'S GUIDE TO VAN LIFE

Climbers have become part of a bigger movement to embrace
a non-traditional lifestyle of living on the road—sometimes working, sometimes not—
in order to spend less money, travel more, and climb as much as they can.

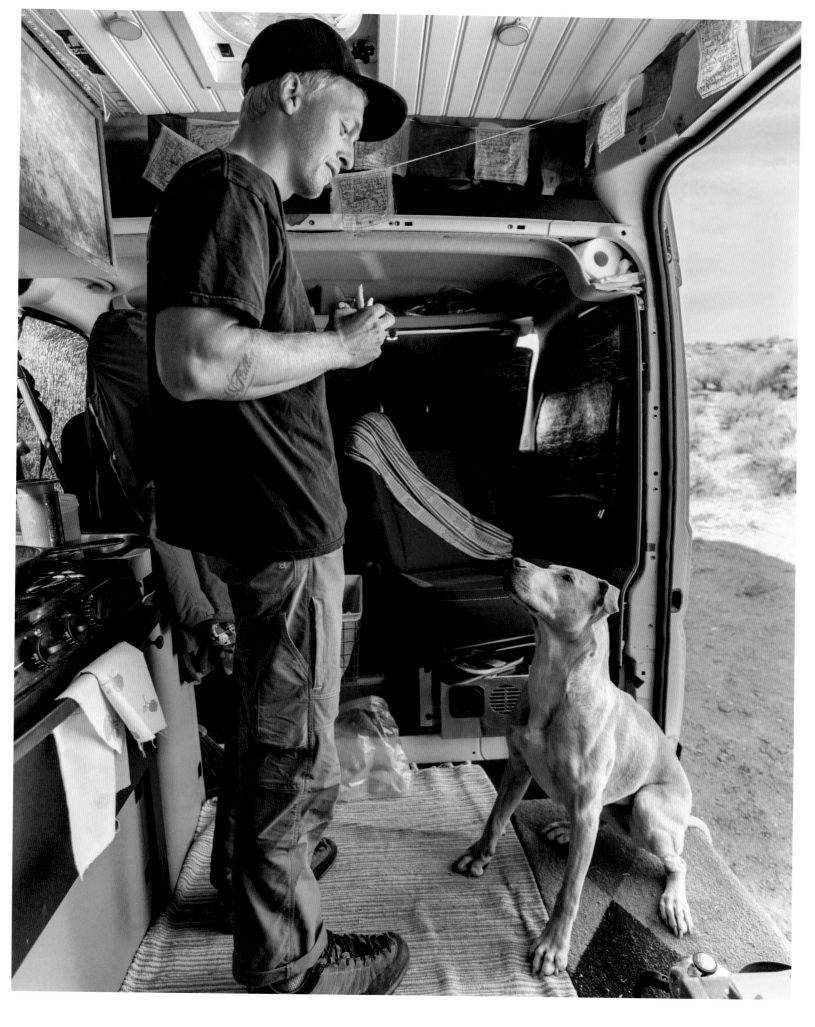

Imagine waking up in your own bed, making some coffee, and opening your door to a view of the ocean, the sound of waves crashing, and the warm, salty breeze filling your home. The next morning, you wake up in that same bed, make coffee, and open your door to a view of the mountains, the sound of birds chirping, and the cool, clear air filling your home. Now repeat this scene in the desert, the forest, a city. This is not a mental exercise for a quick money-making pyramid scheme, or a page from a billionaire's biography. This is the idealized concept behind Van Life, a growing subculture of transient individuals who choose to live in their vehicle. The movement values living a non-traditional life, one that emphasizes minimalism and experiences over materialism and routine. For climbers, it is a way to visit a world-class climbing area, spend an entire season there, and then move on to the next one.

Living in your car is not a new concept, but typically the car dwellers were forced into it because of their economic situation. Others might have done it as an act of protest against society, or the person is older and retired and chooses to spend her time traveling. The idea of van life is not much different, but the demographic has shifted. Modern van lifers come from all different backgrounds, but one commonality is that they are young adults on the cusp of entering the "real world." Some might have just graduated from university and must decide what to do with their lives, while others might have spent a few years working on their chosen career path and are feeling jaded by the monotony or pointlessness of it. They are not on board with one of the guiding principles of modern society: work hard to make money so you can have all the trappings of a comfortable life, such as a big house, nice car, and fun vacations. Many van lifers do it as a way to reject that way of life, to choose a more simple, balanced lifestyle in its stead. The idea is that without rent or a mortgage, utilities, a car payment, and other normal expenses, you can spend less time working and more time traveling and climbing. The small living space also forces you to pare your belongings down to the absolute essentials.

Although "van life" became the popularized term, it really means living in any type of automobile, whether it is a station wagon, pickup truck, or Smart car. The rigs can vary from old conversion vans that cost a few hundred dollars to vintage Volkswagen buses to brand-new, tricked-out Mercedes Sprinters. Many climbers go with any rig that offers high clearance and four-wheel drive for off-roading capabilities so they can get to hard-to-reach climbing areas. Some setups have simple two-burner propane stoves that can be easily moved outside to a campsite's picnic table, and others have three-burner oven ranges for baking fresh cookies or roasting a whole chicken. There are vans whose buildouts are centered around the storage for gear and toys—mountain bikes, kayaks, climbing equipment—and others that favor livability, with a nice couch, comfy bed, and a table. You can choose to buy a vehicle and build it out yourself, or you can hire someone else to do it. With the popularity of this movement, there are now custom van builders all over the world who will convert your vehicle to whatever specifications you can dream up (and afford). Some of these rigs have full plumbing setups, with running water, a shower, and gray water storage, and solar power systems that provide electricity for lights, fans, computers, and a refrigerator.

"Where do you go to the bathroom?" might be the most common question asked to van lifers. The response will vary, but typically van lifers go to the bathroom wherever one might go while on a climbing road trip: gas stations, rest stops, campgrounds, trailheads, restaurants, coffee shops, large grocery stores, and big-box stores. Some vans might have a composting toilet that is on wheels and compact enough to be rolled away under a bed or in a cabinet when not in use. Most van lifers, males and females, have some sort of pee jar or pee bottle for going number 1 in the middle of the night. If you are someone who has a constitutional every morning right on schedule, it helps to put some forethought into where you park for the night. That way a flushable toilet is just minutes away when you wake up and *gotta go*. The real crux of the bathroom situation is when you must do some "urban camping." It is not glamorous, but it is a necessary element to living on the road. The reality of van life is not all beautiful mountain views and oceanside parking spots. If you decide to move around a lot, you will inevitably end up spending many nights in more populated areas, parking on the side of a street in a big city or staying overnight in a large parking lot where you will not be noticed. You can't exactly wander off, dig a hole, and poop surrounded by trees and forest animals, and you definitely cannot just empty your pee bottle by throwing it into the dirt outside your van. Instead, you have to be strategic about where you park. Most businesses are not thrilled at the idea of a bunch of van-dwelling transients living outside their establishments, so people must be cognizant of where they can and cannot park. Most van folks have had at least one experience where they got a loud knock in the middle of the night, were told they could not stay there, and had to move.

"How do you make money?" might be the second-most common question asked of van lifers. The response varies much more in this case, as is also the case with people who do not live in a car. Some people save up as much money as they can before they begin van life, treating it as a temporary situation where they will be spending money but not making it, much like a long vacation. Others will go into it thinking it is temporary, really enjoy it, and have to figure out a way to make money on the road to keep it going. Then a third group might already have a job that allows them to work remotely, as many companies are now offering that option to their employees. Seasonal work (commercial fisherman, wildland firefighter, camp counselor), creative freelance gigs (writing, photography, videography), self-employment (marketing, business consulting, coding), and careers like travel nurse and computer programmer are popular in the van life community. Some van lifers find a way to make money off living in a van itself, by partnering with companies and brands, writing blogs and books about van life, and building large social media followings.

Getting sick, running out of water, not finding a place to park, and having your van break down are all crappy parts of van life. If done solo, living on the road can feel quite lonely and frustrating at times. If it is hot outside, it is probably hot in your van. When it is cold, it is cold. You must often go days or weeks without a shower, and you must battle a constant flow of dirt into your home on wheels. You might go crazy in such a small space, or yearn for the comforts of a real house. Every mundane task takes longer when living in a van—cooking, cleaning, dealing with hygiene—and there are specific van life chores that will eat up any extra time: filling water, emptying gray water, finding places to park, putting everything away any time you need to drive, pulling those same things out again, keeping everything organized. But if you can stand all that, van life can be the most rewarding experience. You will get to travel as much as you want, meet new people, and see new places. You can climb every day, and leave one crag for the next as soon as the weather turns. Van life has become a community in itself, with regular meetups and organized groups, and it is now a way to meet people in climbing area parking lots around the world.

THE MOVEMENT VALUES LIVING A
NON-TRADITIONAL LIFE, ONE THAT
EMPHASIZES MINIMALISM AND
EXPERIENCES OVER MATERIALISM AND
ROUTINE. FOR CLIMBERS, IT IS A WAY
TO VISIT A WORLD-CLASS CLIMBING AREA,
SPEND AN ENTIRE SEASON THERE, AND
THEN MOVE ON TO THE NEXT ONE.

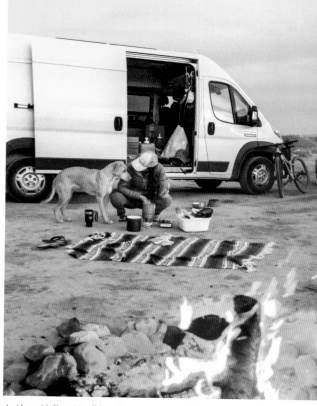

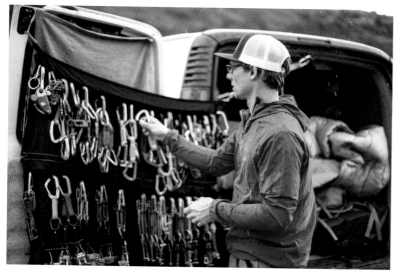

↑ *Above* Melissa McGibbon has a moment with Lizzie while van camping in southwest Colorado. ← *Left* Alton Richardson keeps his gear organized out the back of his van named Bertha. ↓ *Below* Van life is all about community, where traditional neighbors are replaced by fellow van dwellers who park together.

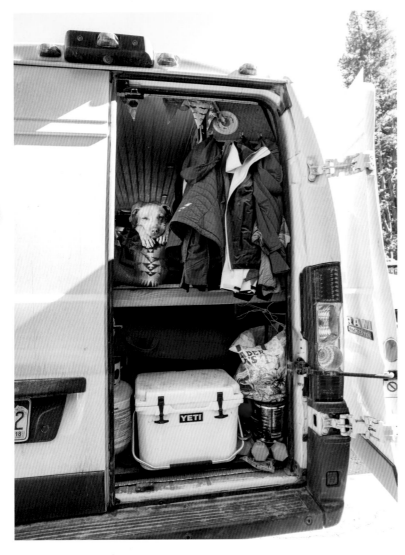

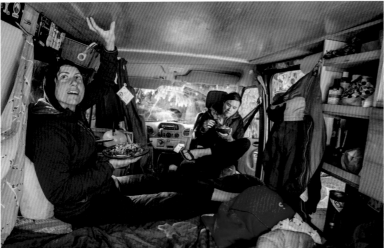

↑ *Top* Fitting all your gear inside is a huge component of picking what type of van will work for your lifestyle. ↑ *Above* Couples who live in vans might experience different types of relationships stressors! → *Right* Being able to work less frees up more time to enjoy the simple things in life, like this swimming hole in Tuolumne Meadows, California.

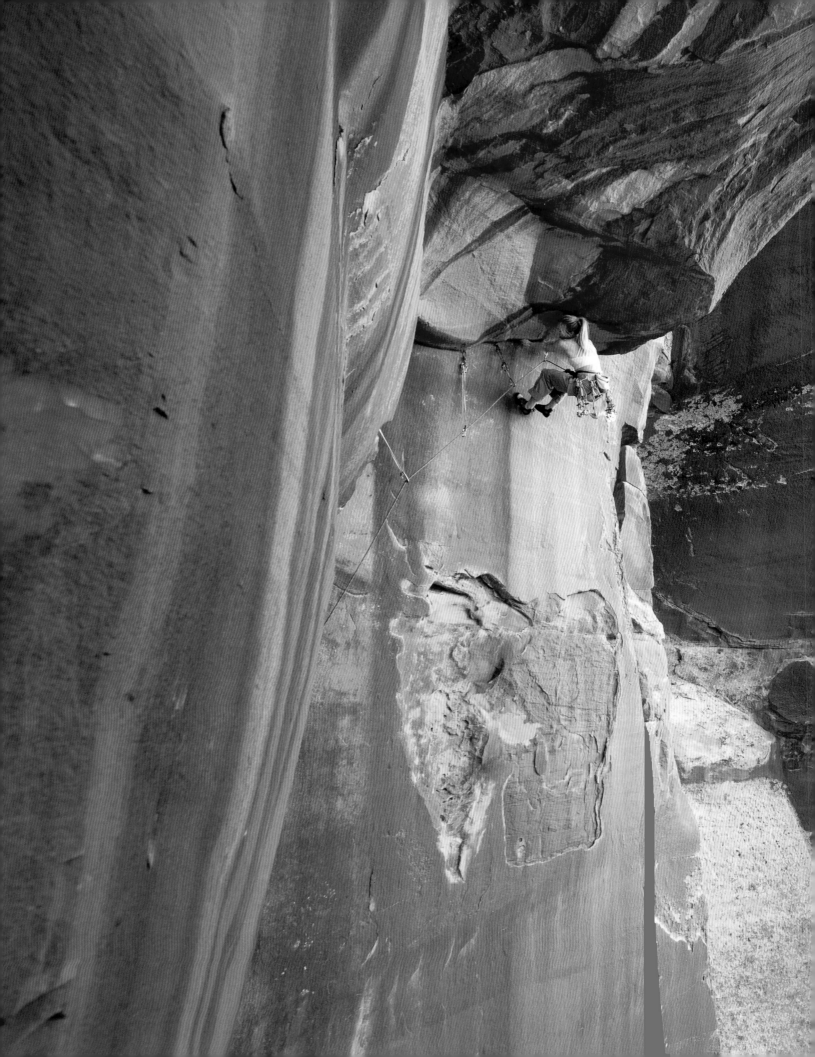

INDIAN CREEK

Utah · USA

Utah's sandstone mecca, where single-pitch
cracks of every size offer a physical and
mental beatdown that might result in some
of the happiest days of your life.

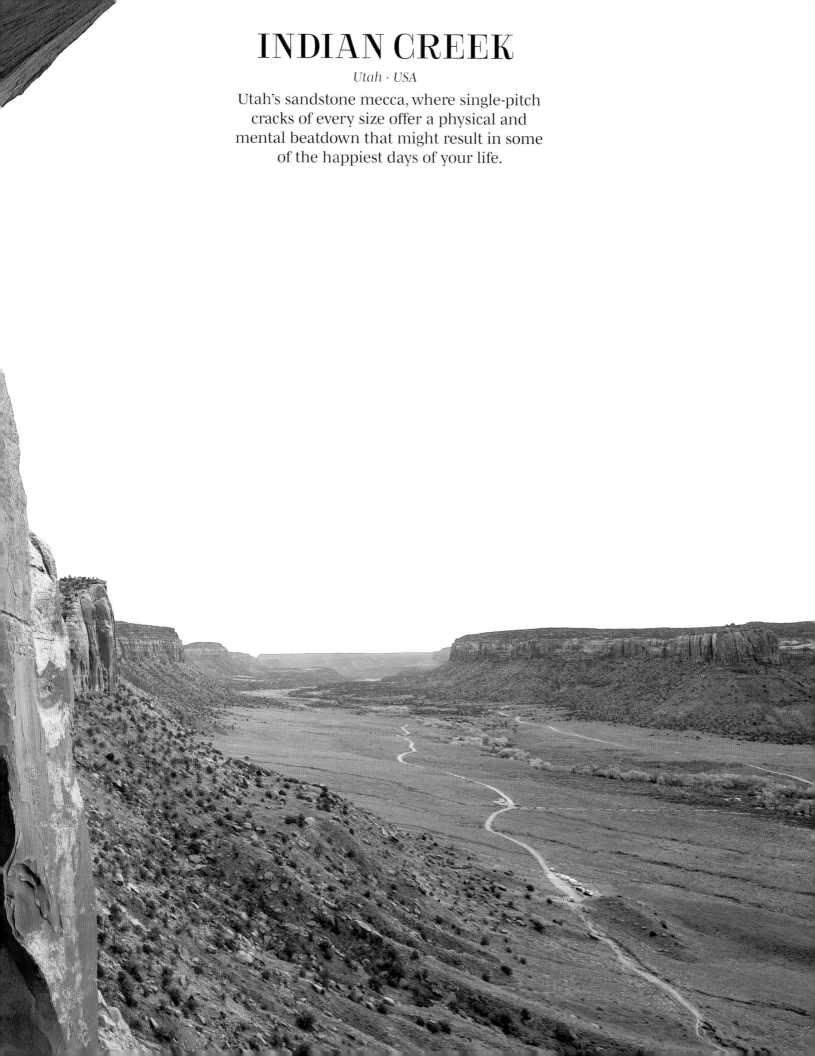

Indian Creek will get you prepared for almost any other climbing area in the world, but no other climbing area in the world will get you prepared for Indian Creek. These are the words many climbers hear before their first trip to the Creek, when they are fledgling trad climbers looking for advice wherever they can find it. Before you go, you might not know exactly what the adage means, but the ominous overtones can be intimidating. Indian Creek has a fabled reputation for being hard, particularly because the very specific style can be so physically and mentally demanding. You will want to be as prepared as possible, but apparently only going to the Creek itself can do that.

So you must go. The absolute uniqueness of Indian Creek is what makes it special. It is singular in nature—there's no other place on Earth like it, at least from a climbing perspective. With thousands of routes spread over almost 100 areas, the Creek is infamous for crack climbing. This is where climbers use specialized technique to put their hands and feet into cracks in the rock, instead of pulling on holds that protrude from the rock. Many of the cracks are parallel sided and uniform in size for long periods, so you find yourself doing the same move—and placing the same piece—over and over on one pitch. Crack sizes range from too small for a toddler's fingertips to so large that André the Giant could fit inside with room to spare. How "easy" a certain crack size feels is fully dependent on your finger, hand, and foot size. A route where your hand slots perfectly will feel harder for someone with bigger or smaller hands. The grades in Indian Creek are based almost solely off the first ascensionist's opinion, meaning the grade depends heavily on his or her hand size. Read: grades in Indian Creek do not mean much.

Crack climbing technique is specific, and to do it for entire rope lengths is unusual in the climbing world. By virtue of rock type, most other climbing areas only have short stretches of discontinuous cracks, maybe a few body lengths, which tend to fluctuate in size. This means you can employ a variety of movement techniques to get to the top. At Indian Creek, a crack can be the same size for 115 feet (35 meters). The repetitive movement, which varies entirely based on the size of the crack, is hard to master and physically exhausting. Not to mention that having to jam your fingertips, hands, toes, and feet into cracks is quite painful. On top of that, the rock will ravage every inch of exposed skin (creating sores that climbers have dubbed "gobies"), then scrape your clothes right off your body and destroy the skin underneath. Most climbers make tape gloves out of white climbing tape to cover and protect the backs of their hands, the area most susceptible to gobies.

It is trad climbing, so you are placing your own gear, and cams reign supreme. The cracks are mostly parallel, sans the constrictions necessitated for nuts and passive protection. Because of the uniform size from top to bottom, you might need 10 or 12 pieces of protection, all the same size. Most climbers only own three, maybe four, of a particular cam. Thus the "Indian Creek rack" is distinctive because you will need all the cams you have access to, from friends and friends of friends and friends of friends of friends. This aspect of community is yet another special feature of Indian Creek. Watching fellow climbers push their limits, try hard, get bruised and battered while you do the same thing, and then sharing a cold

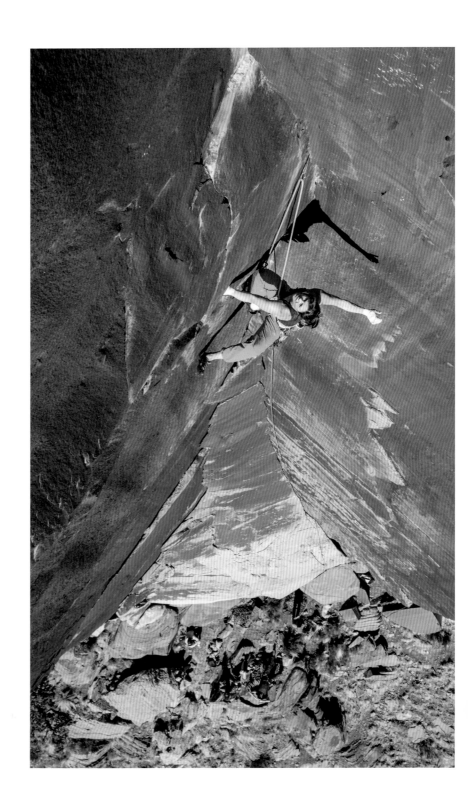

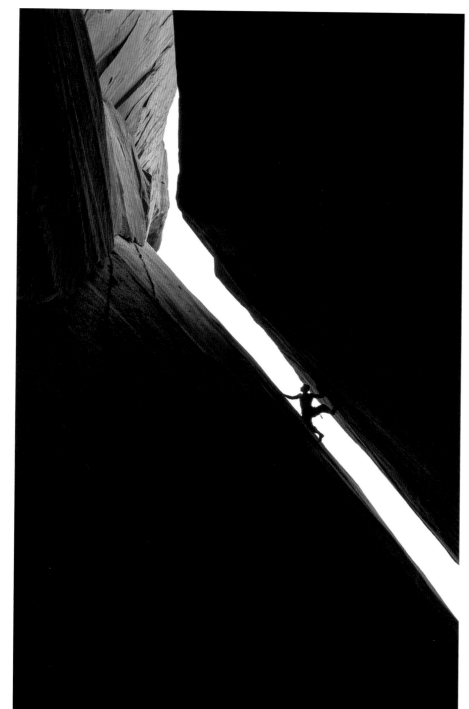

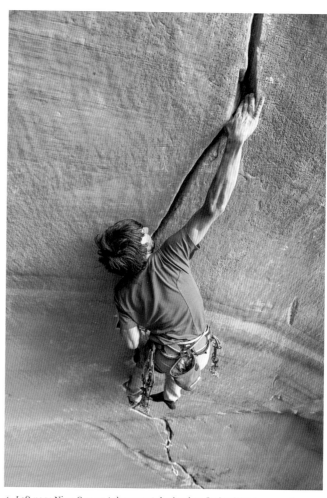

← *Left page* Nina Caprez takes a rest during her flash (climbing a route on the first attempt) of *Desert Shield* (7a+/5.12a). ← *Left* Ben Hanna climbing up *Closed Course* in Indian Creek, Utah. ↑ *Above* Finding a fingerlock on *Annunaki*, a classic 7a+/5.12a in Indian Creek. →→ *Following spread* Venturing up a crack route. →→ *Page 216 The Cave Route* in Indian Creek is a photographer's dream—the best images can be taken right from the ground.

beer at the end of the day while the sun sets in the west unifies anyone who visits Indian Creek. Climbing these angular fractures is physically and mentally taxing, and it requires the boldness of bigger trad objectives, despite the fact that you are not usually more than 130 feet (40 meters) off the ground. The climbing and the setting of Indian Creek are one of a kind, but the feeling of being there is what is perhaps most remarkable.

The sandstone cliff lines stretch for dozens of miles in the southeast corner of the American state of Utah, near the Colorado border. On both sides of a flat valley, large mesas undulate to and from the center of the rift. The basin was so lush that hunter-gatherers started visiting the area 10,000 years ago, and much later, in the last 2,000 years, Native Americans inhabited the area year-round, growing corn, beans, and squash. On each side of the valley is a continuous cliff that oscillates between prows of red-brown sandstone and deep canyons, where the rock face arcs away from the valley's middle but maintains a sustained height. These uninterrupted cliffs are broken only by thousands of vertical cracks, affectionately called splitters because the fractures are so uniform. Each cliff comprises 330 feet (100 meters) or more of loose scree and 100 to 130 feet (30 to 40 meters) of solid rock with geometric fractures, topped by more shrub-covered layers of loose rock. This middle section is what makes this little valley in the middle of nowhere a mecca for climbers from all over the world.

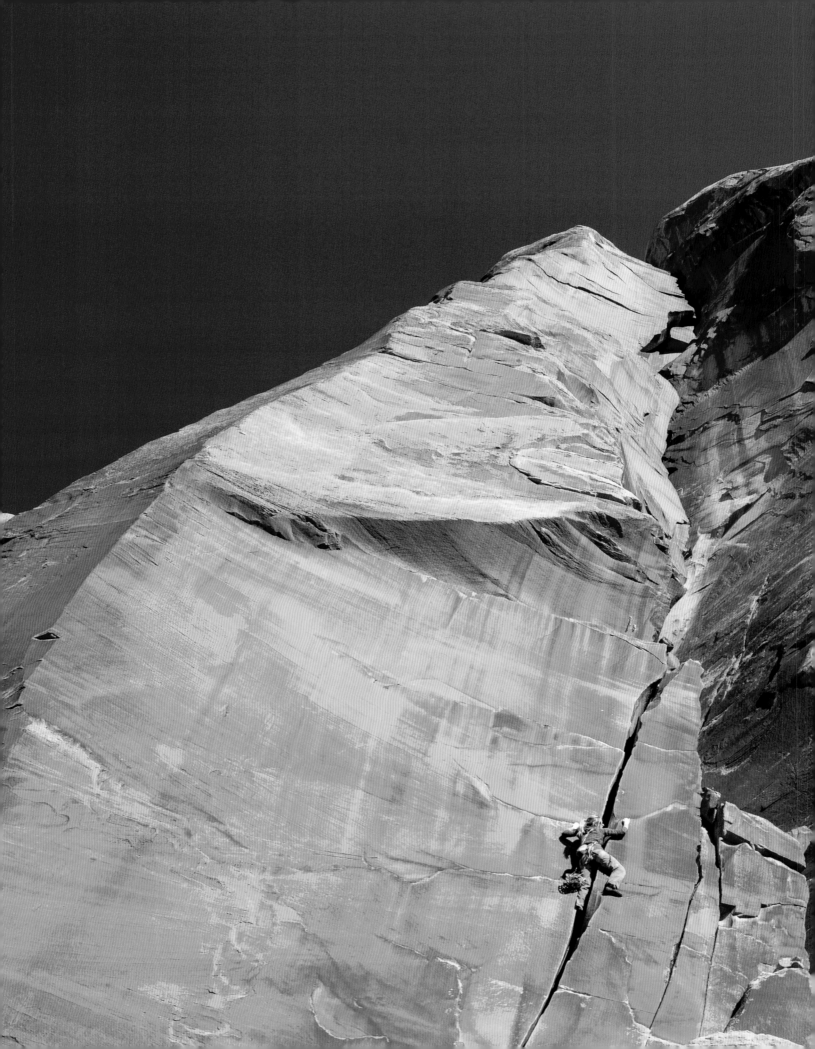

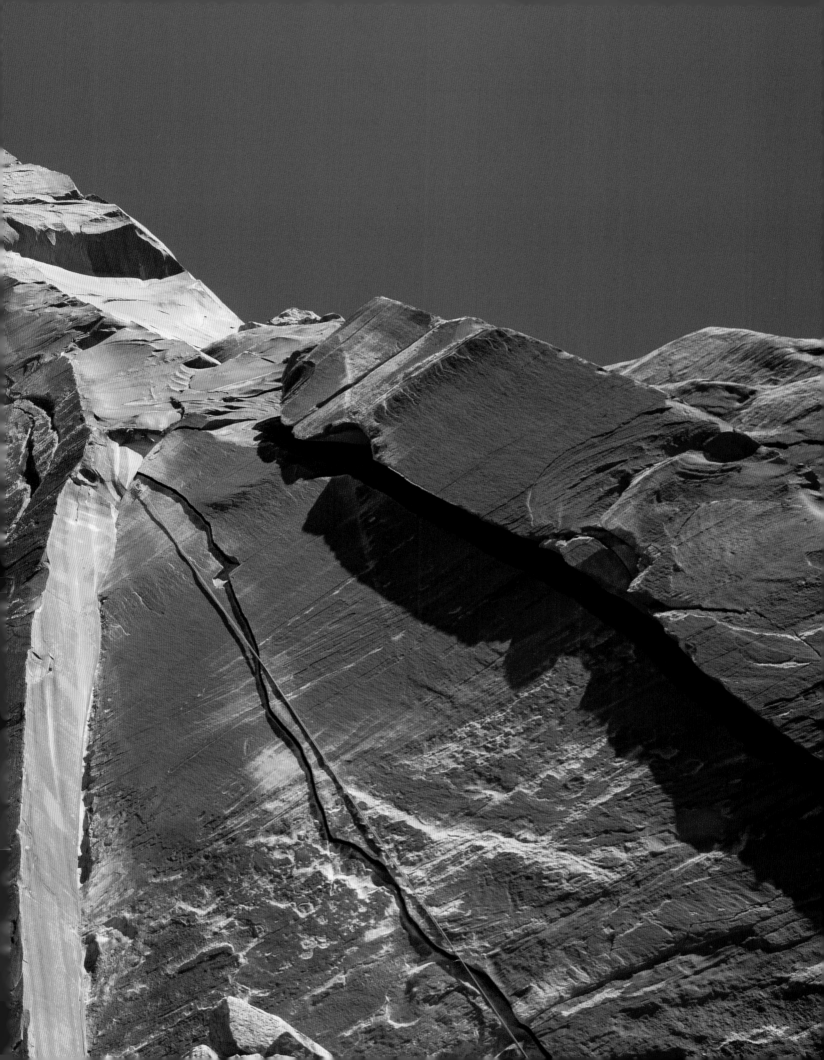

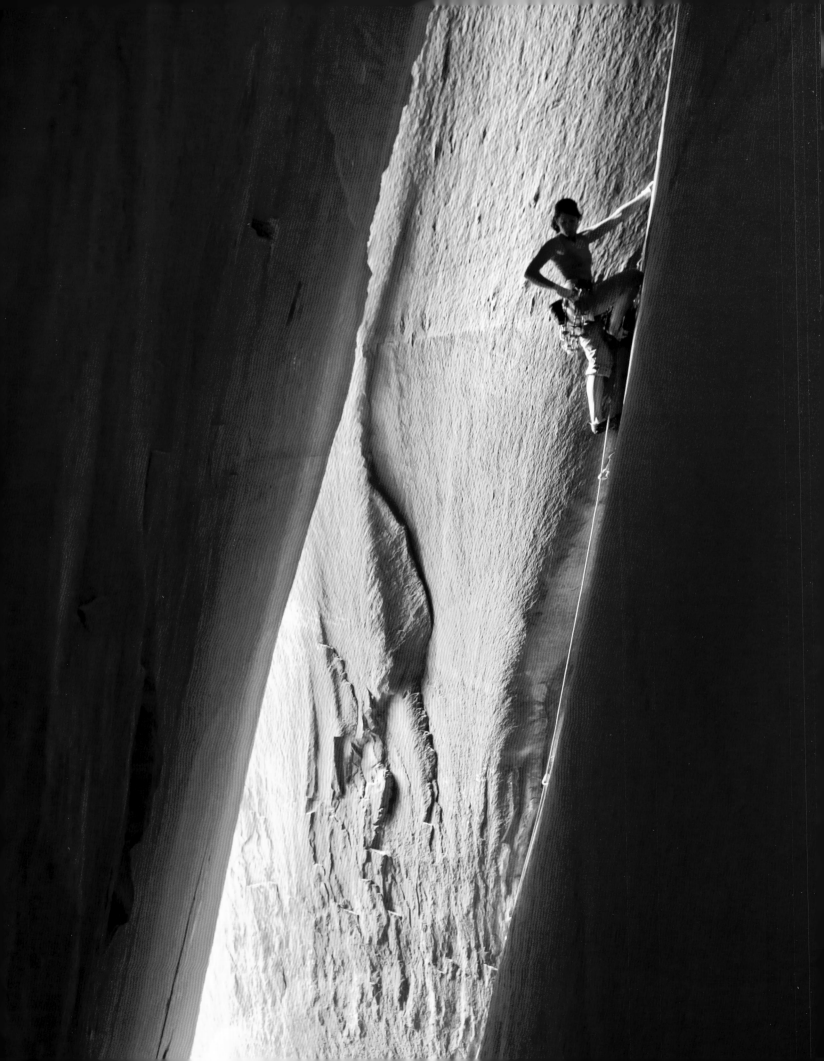

INDIAN CREEK

in a Nutshell

CLIMBING TYPE

Trad

PROTECTION

Trad rack

SEASON

Spring, fall, and winter (can be very snowy and cold!)

WHERE TO STAY

Camp in the area's campgrounds for a small fee

ONE MORE THING

The sandstone is very fragile, so do not climb when it is wet. After rain or snow, wait at least 24 hours to climb and make sure the rock is completely dry. A good guideline to follow is this: "Mud on your feet? Retreat! Shoes dry? Go try!"

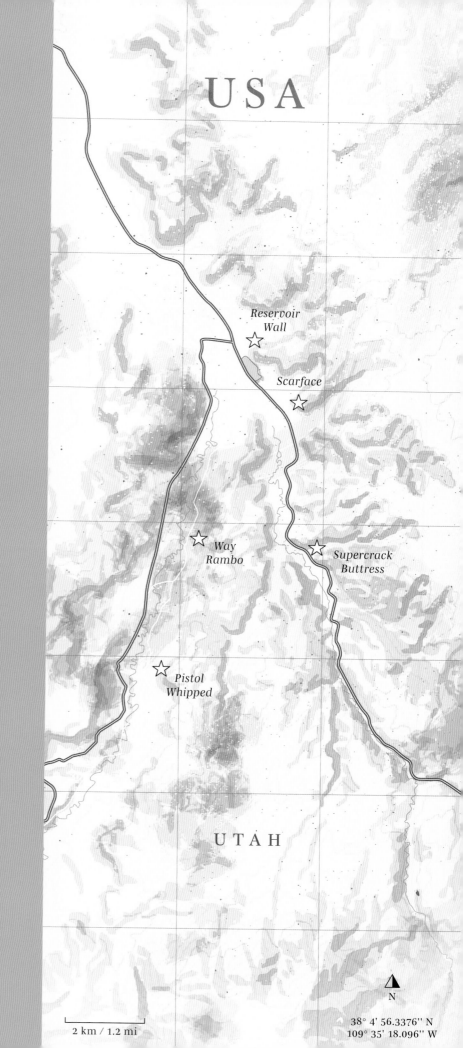

USA

Reservoir Wall ☆

Scarface ☆

☆ Way Rambo

☆ Supercrack Buttress

☆ Pistol Whipped

UTAH

N

2 km / 1.2 mi

38° 4' 56.3376'' N
109° 35' 18.096'' W

JACOPO LARCHER

BIG WALLS, TRAD ROUTES, SPORT CLIMBS,
FIRST ASCENTS, PHOTOGRAPHY,
ROUTE-SETTING—THIS ITALIAN CLIMBER DOES
IT ALL, BUT HE WOULD NOT BE THE ONE
TO TELL YOU ABOUT IT.

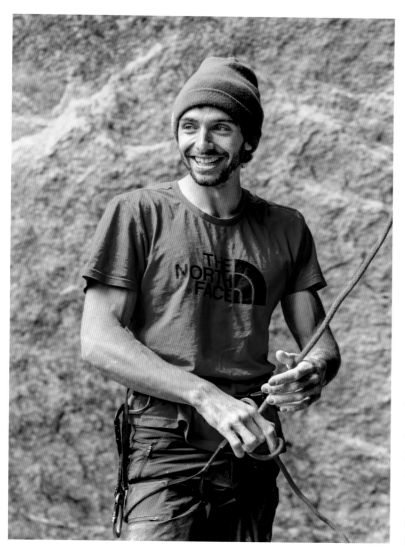

Standing among the pinyon pines above Bishop, California's Owens River Gorge, a group of climbers stood around their respective vans one evening in June 2019, chatting about the only thing climbers know how to talk about. They discussed how their climbing days went, the routes they were working on, the upcoming weather forecast, and what they planned to climb the next day. Italian climber Jacopo Larcher was among them, tall and lanky, with black curly hair and big, blue eyes. Leaning against the door of a friend's van, he mostly asked about everyone else's projects, not saying much about his own, which at the time was *Everything is Karate*, an 8c+/9a (5.14c/d) in nearby Pine Creek Canyon.

"How many ascents does that thing have anyway? Like five?" one of the climbers asked Jacopo.

"Yeah, something like that," he said as he nodded slightly and looked down. His climbing partner and girlfriend, Barbara "Babsi" Zangerl, gave him a nudge with her elbow.

"Well, six now," she said quietly while looking at Jacopo, who smiled almost imperceptibly and stared at his shoes. The other climbers erupted in surprise.

"What?! You sent *Everything is Karate*?! That's sick!" one of them said.

"You weren't even going to say anything, or even count your own ascent?!" another exclaimed. Jacopo grinned sheepishly at the attention, happy that he sent but uncomfortable in the spotlight.

The climber from Bolzano, Italy, now living in Bludenz, Austria, is nothing if not humble—and strong. He has sport climbed up to 9a+/5.15a, trad climbed a possible 9a+/5.15a (which was also a first ascent), free climbed 8b+/5.14a big →

→ walls, and bouldered up to 8B/8B+ (V13/14). Growing up in South Tyrol near the Dolomites, Jacopo spent his childhood playing outside with his cousin and friends. His parents loved to be in the mountains, and they would go hiking or skiing every weekend. As a shy kid, none of the team sports like soccer, baseball, or tennis appealed to him. He took a climbing course for kids at the local gym when he was 10. "It was love at first sight!" he says. "I loved the feeling of freedom I got while climbing." When that course ended, he immediately signed up for the next one—at one point he was attending three different courses on the same day. Eventually his dad started going with him, and then he tried competition climbing. As a member of the Italian Youth team and then the Italian National team, he won several national competitions and started traveling internationally. After 10 years of focusing on competition climbing, he decided to stop doing competitions in order to explore other aspects of climbing.

"I couldn't stand anymore the fact of traveling so much without having the opportunity to see more of those places, but just climbing gyms," he says. "I wanted to discover more, and I was looking for different challenges in climbing." Jacopo's fitness and strength from competition climbing made the shift from climbing indoors to bouldering and sport climbing outside quite easy, but he found his personal motivations changing, too. As a kid, he cared about the difficulty, but as a young adult now seeking routes in nature, he was attracted to the beauty of the line and its movement. After focusing on sport climbing for a few years, he started to try trad climbing. On his first crack climbing trip to the trad climbing mecca of Indian Creek in America, He had to project climbs rated 5b/5.9, a significantly lower difficulty level. A few days earlier in the Red River Gorge, he had been sport climbing 8c/5.14b.

"The process of shifting from sport to trad and big wall climbing was—and it still is—very long," he says. "I basically had to restart from zero. That Indian Creek trip was very humbling and at the same time very motivating. I liked the fact that after so many years of climbing I could feel like a beginner again. That feeling motivated me to invest more time and energy in learning something that was new to me." In addition to being a sponsored climber, Jacopo also works as a professional route-setter, traveling around Europe, Austria in particular, to set for commercial gyms and competitions. The route-setting job balances out his climbing life; he calls the setting gig "Plan B." He says, "This allows me to feel less financially dependent on my sponsors, and I get to enjoy climbing without any 'commercial' pressure. It's also nice to have some work duties every month; this makes me use my free time better. You get more motivated when you have less time!" Jacopo is a talented photographer and takes striking images on his numerous climbing trips around the world. He says he feels the same satisfaction from sending a route and taking a good photo.

Jacopo lists Caderese, Italy, as one of his favorite climbing areas because it is a place he likes to spend time and where he feels at home. Short granite cliffs jut out of the green forests of far northwest Italy—so far up there it is

↑ *Above* Trying the crux moves of *Cobra Crack*, an infamous 8c/5.14b trad route in Squamish. ↓ *Below* Jacopo Larcher on his masterpiece, *Tribe*, a 100-foot (30-meter) climb that could be the hardest trad route in the world, at 9a+/5.15a (although Larcher declined to grade it). → *Right page top + bottom* During the free ascent of *Odyssee* (5.13c/8a+, 800 m) on the north face of the Eiger. Summer 2018. →→ *Following spread, left* Getting into the steep section of *Dreamcatcher* in Squamish, British Columbia, Canada. →→ *Following spread, right* Jacopo Larcher on his proudest first ascent to date: *Tribe*, in Cadarese, Italy, in March 2019.

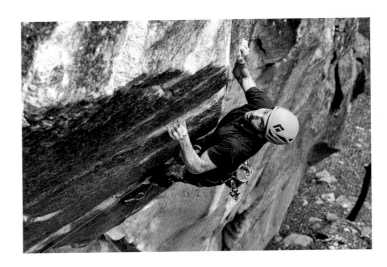

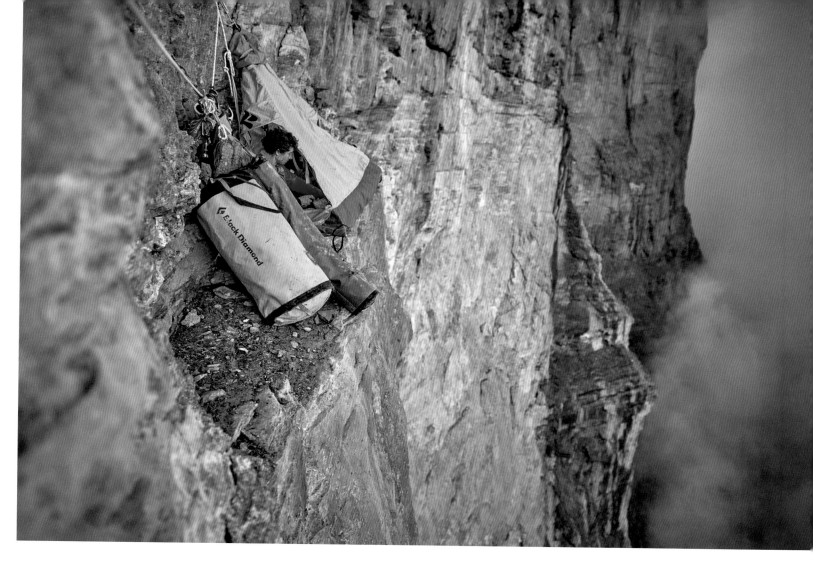

practically Switzerland. "I love to hang out there with my van, meet my friends, and enjoy the quietness of the valley. It's the place where I started to trad climb and that has witnessed my evolution as a trad climber. It offers a big potential for new lines—it's a big playground!" That evolution came full circle in March 2019 when Jacopo sent his project of six years, doing the first ascent of *Tribe*, a 100-foot (30-meter) trad route. While he declined to grade it, he said in an interview after the ascent, "Everyone is wondering how hard it is, but all I know is that for me personally, it's the hardest thing I've done." Since his hardest route before *Tribe* was *La Rambla*, a 9a+/5.15a in Siurana, Spain, there was consensus in the climbing community that the new route was potentially the same grade.

"It's very hard to describe how it felt to finish *Tribe*," he says. "I was simply very, very happy. I was thankful for having believed in myself and for not giving up, for the support I received from the community, my friends, and Babsi. At the same time, I also realized that something beautiful and very demanding just came to an end. It's always a weird feeling when you end a big project. You're happy, but at the same time you know you're gonna miss it!"

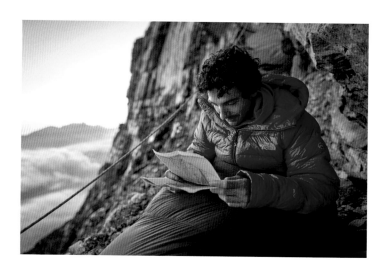

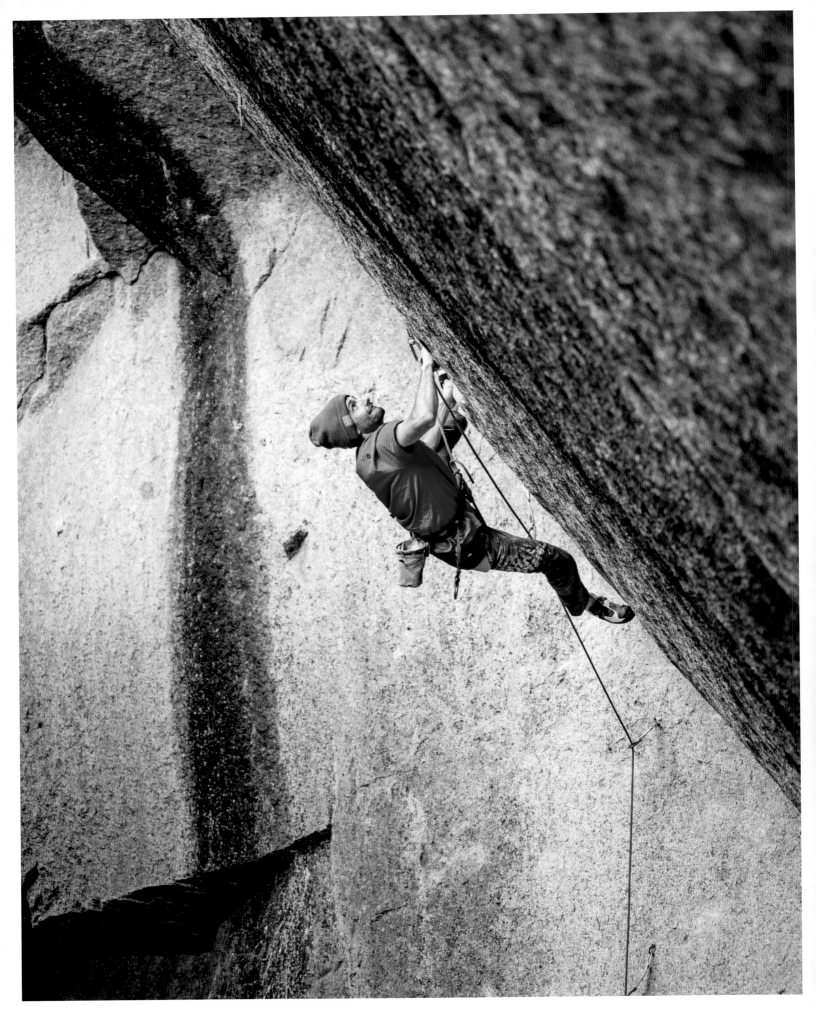

JACOPO LARCHER

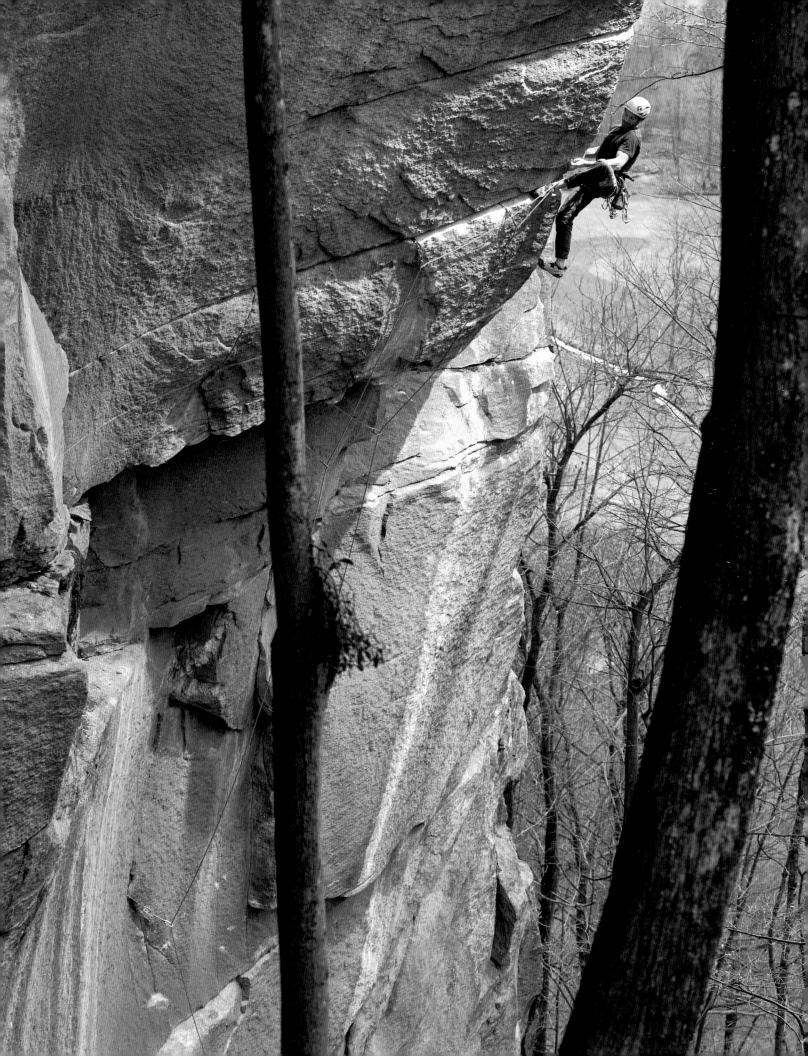

BEHIND THE SCENES OF BIG WALL CLIMBING

As a type of "vertical camping," this overnight adventure means climbing thousands of feet, sleeping on the side of a wall, and yes, even using the bathroom up there.

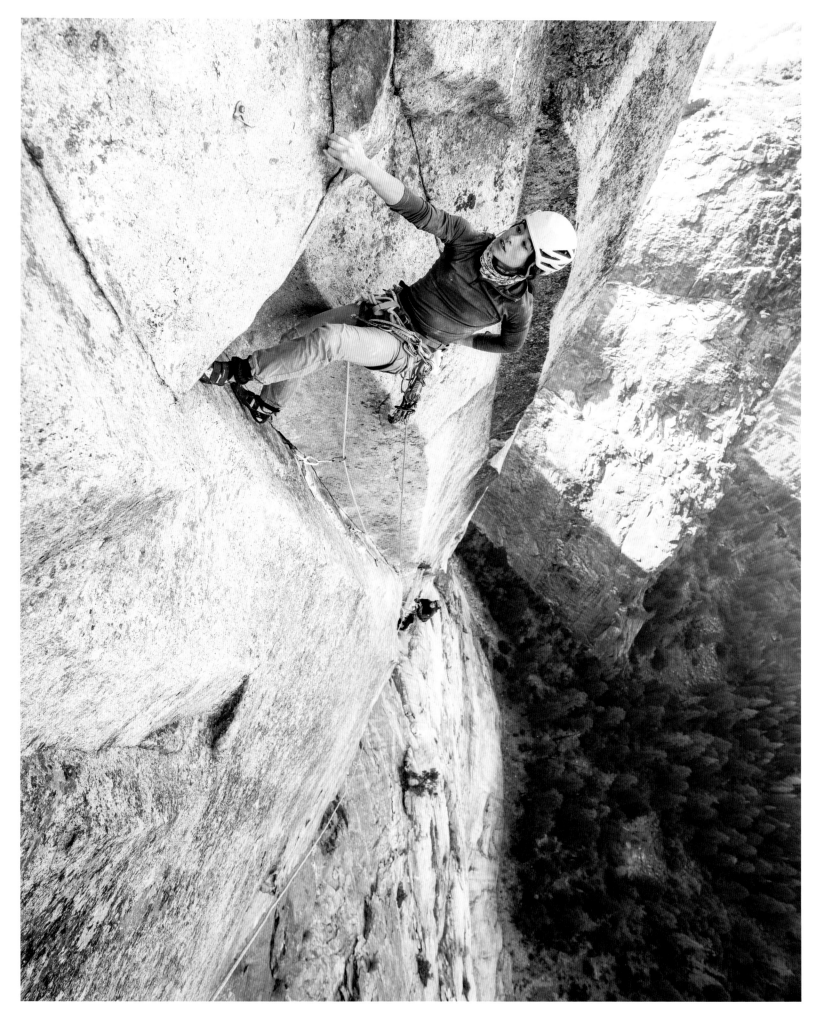

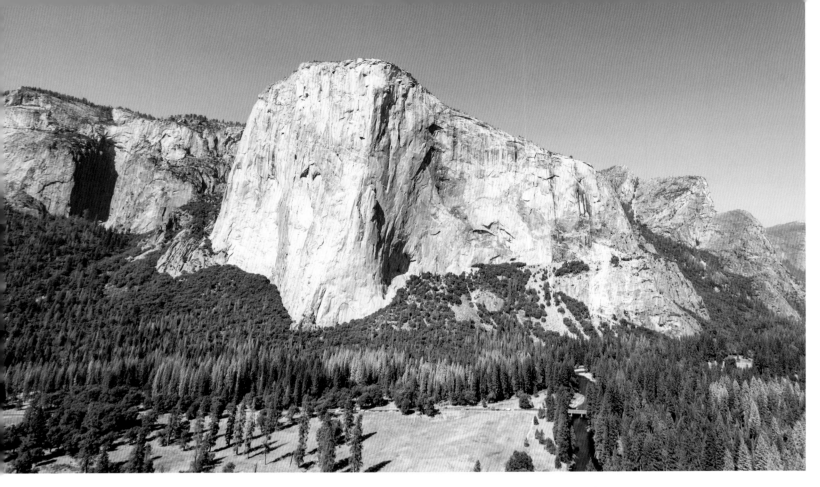

BIG WALLING IS A COMPLEX DISCIPLINE THAT COMBINES THE TECHNICAL SYSTEMS, FEAR MANAGEMENT, AND MOVEMENT TECHNIQUES OF ALL THE OTHER DISCIPLINES INTO ONE MEGA-CHALLENGE.

↑ *Above* Yosemite's El Capitan, aka the Big Stone, is the most popular big wall formation in the world. ← *Left* Big walling involves lots of complex technical skills and systems. ↓ *Below* Going on a big wall for five or six days means bringing all your gear, food, water, and clothes up there with you. It can get really heavy, really fast. →→ *Following spread, left* Katie Lambert leads off the bivy ledge, the spot where the climbers spent the night in their portaledge. →→ *Following spread, right* Sometimes climbers will move ahead on the wall, tick certain pitches, and then retreat lower to their portaledge for the night.

I magine waking up in that classic early-morning daze, not quite sure of where you are. When you first open your eyes, you see pale-blue sky through the small face hole in your down sleeping bag. The first sun rays are hitting the tops of the dramatic granite peaks towering above you. The sun's warmth will not hit you for another hour, so you nestle deeper into your bag, enjoying that cozy feeling that comes with being able to go back to sleep in such a comfortable setting. The breeze blows gently all around you, and your brain starts to register that you are sleeping outside. It is beautiful and quiet and you are surrounded by nature—you must be camping. Rolling over on your side, you go for one last look at the peaceful backdrop before you drift off to sleep, when—bam! Your stomach drops and your heart starts racing when you realize that instead of reliable and horizontal terra firma underneath you, there is a steep rock face that sweeps 1,650 feet (500 meters) to the valley floor below. It is nothing but air all around you.

Big wall climbing is one of the most extreme forms of the sport, where the routes are so long that they require spending one or more nights on the wall itself. Living on the wall is an involved process that requires a lot of gear. In addition to climbing gear, climbers must bring specialized camping equipment, personal items, food, cooking essentials, and water for however many days they will be on the wall. It all adds up to extremely heavy loads that are dragged up the wall alongside the climbers in a process called hauling. This is a physically exhausting operation where the climbers put a pulley or other mechanical advantage on the anchor, and then use their body weight to haul the loaded bags up to them. These haul bags drag over rock slabs, through cracks, and around roofs, so in addition to the sheer weight of the gear, the climbers must fight against an incalculable force of friction. This must be repeated for every single pitch of the climb, which adds up in time and energy. Each pitch of a big wall must be climbed by the leader, then followed and cleaned by the seconding climber, and then the gear must be hauled (usually by the follower, so the leader saves energy for climbing).

While sport climbing and bouldering can be distilled down to the fitness and grace of movement, big wall climbing is more like manual labor on a construction site. There are extremely heavy loads,

you are dealing with a ton of complicated rope systems, and every daily task, from making coffee to brushing your teeth to peeing, becomes much more difficult when you are hanging off the side of a mountain. It is a lot of work, but that is part of the fun.

Big walling is a complex discipline that combines the technical systems, fear management, and movement techniques of all the other disciplines into one mega-challenge. Climbers bring multiple ropes: at minimum one for climbing, one for hauling, and often a backup climbing rope. They must be proficient at placing gear, building anchors, and moving fast over tons of rock terrain. Most climbers do not start out with big wall climbing. They might start with sport or trad climbing, then get into longer multipitch routes, and after they have gained some knowledge and experience, they might have a go at big wall climbing.

Ascending hundreds of feet might be intimidating to any climber, but "big wall climbing" encompasses a wide range of styles, difficulty, and locations. There are big walls for every skill level. Some big walls are climbed completely free, some are climbed via aid, but most big walls are a mix of free climbing and aid climbing. The idea is that the leaders climb the easy parts free, and then begin to aid (pull on their own gear) when it is more difficult. Because they have so much vertical to cover, moving quickly and efficiently is the priority. To that end, often the followers on a pitch will not climb at all; they will simply ascend a rope that the leader has fixed at the anchor above. This is called jumaring, or jugging, because the equipment to ascend the rope, or ascenders, are called jumars. This mix of free and aid climbing on a big wall is common, unless the team is trying to free the entire route, or perhaps one climber is trying to free the route.

A notable example of a big wall free climb is Tommy Caldwell's seven-year project to free the *Dawn Wall* on El Capitan in Yosemite. In January 2015, Caldwell and partner Kevin Jorgeson both free climbed all 32 pitches of the route after 19 continuous days on the wall. At 9a / 5.14d, the *Dawn Wall* is considered the hardest big wall free climb in the world. Impressively, Adam Ondra freed the same route in November 2016 in eight days, while his climbing partner jumared behind him. While Yosemite might be considered the big wall mecca thanks to soaring granite walls that are practically roadside, a place

like Baffin Island provides similar sheer granite walls that are a bit more remote and much harder to get to. Straddling the Arctic Circle, Baffin lies between mainland Canada and Greenland and requires weeks of travel via hiking, snowmobile, or dog-pulled sled just to get to the base of the walls. Climbers must battle dangerous polar bears, numbing winds, and ice-covered rock, but they can be rewarded with 24-hour sunlight and more than half a mile of granite climbing. Needless to say, Baffin is reserved for the most adventurous big wallers.

As grades were pushed across climbing disciplines, the same has gone for big walling over the years, as well as the style and speed with which these ascents are done. *The Nose* on El Capitan is arguably the most famous big wall in the world and an indicator of the evolution of big wall climbing. Ignoring the steep, hard prow for years, Warren Harding finally started the climb in July 1957 and did not finish until November 1958, teaming up with a few different partners. The first ascent of *The Nose* took 45 days, using a combination of free and aid. In 1975, John Long, Billy Westbay, and Jim Bridwell managed to climb it in less than 24 hours in the same style. Lynn Hill free climbed *The Nose* in 1993 in four days, and then came back to free climb it in 1994 in less than 24 hours. In June 2018, Caldwell and Alex Honnold nabbed the speed record on *The Nose*, ascending the route via free and aid techniques in 1 hour, 58 minutes, 7 seconds. (While these sub-24 hour ascents do not include spending the night on the wall, which is the standard marker of a "big wall," these ascents are still considered big walls because of the length of the route and overnight style most climbers typically employ.)

Big wall ascents are also done in a rope-solo style, meaning the climber climbs without a partner, but he still uses a rope and safety gear to protect him if he falls. Many rope soloists use aid techniques, but in November 2016, Briton Pete Whittaker was the first person to rope-solo *Freerider* (7c+ / 5.13a) on El Capitan in less than 24 hours. Seven months later, in June 2017, Honnold free soloed the same route—meaning no rope, no partner, no aid climbing—in 3 hours, 56 minutes. A fall from anywhere on the 33-pitch route would have been fatal. Honnold's ascent was the first-ever free solo of El Capitan, and potentially the most impressive achievement in the history of rock climbing.

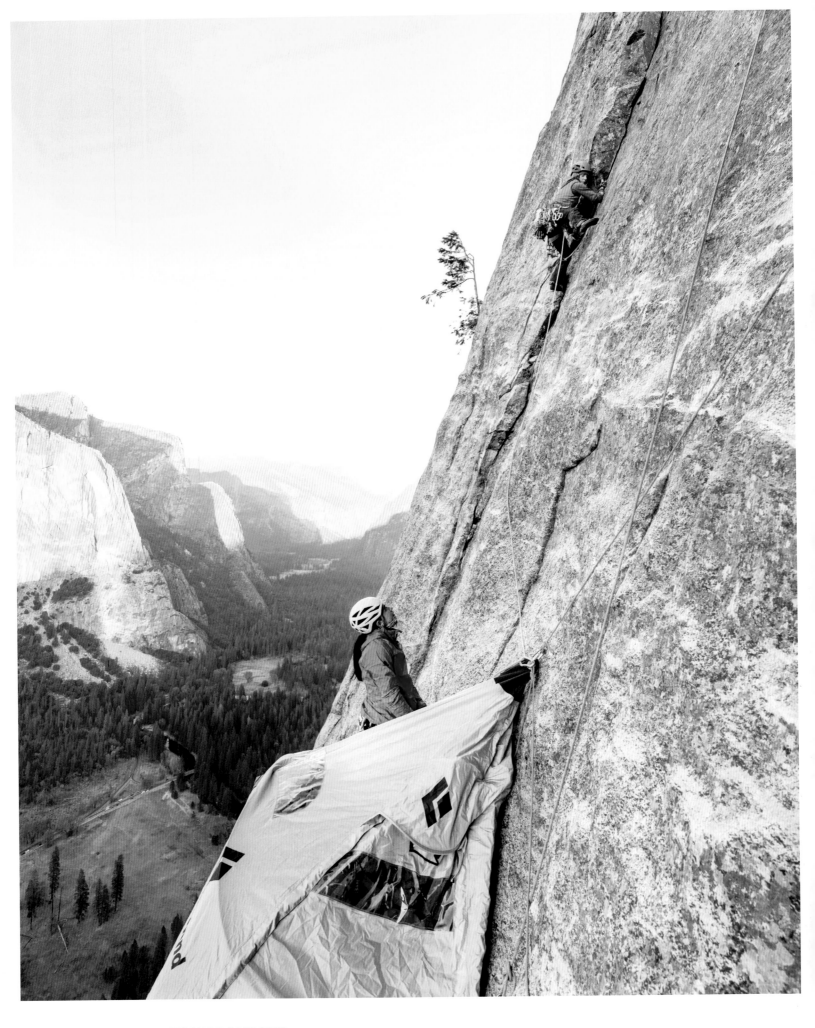

BEHIND THE SCENES OF BIG WALL CLIMBING

WADI RUM

Aqaba · Jordan

Jordan's sandstone mountains offer an adventurous style
of rock climbing, combining the commitment and unknowns
of the alpine with the hot, dry climate of the desert.

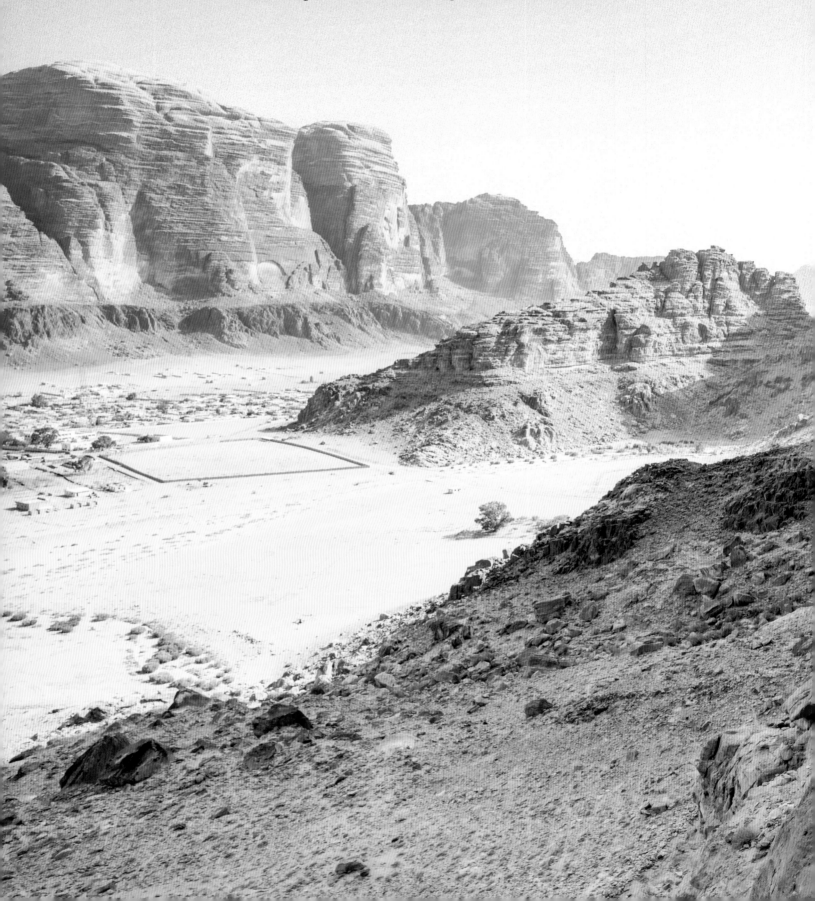

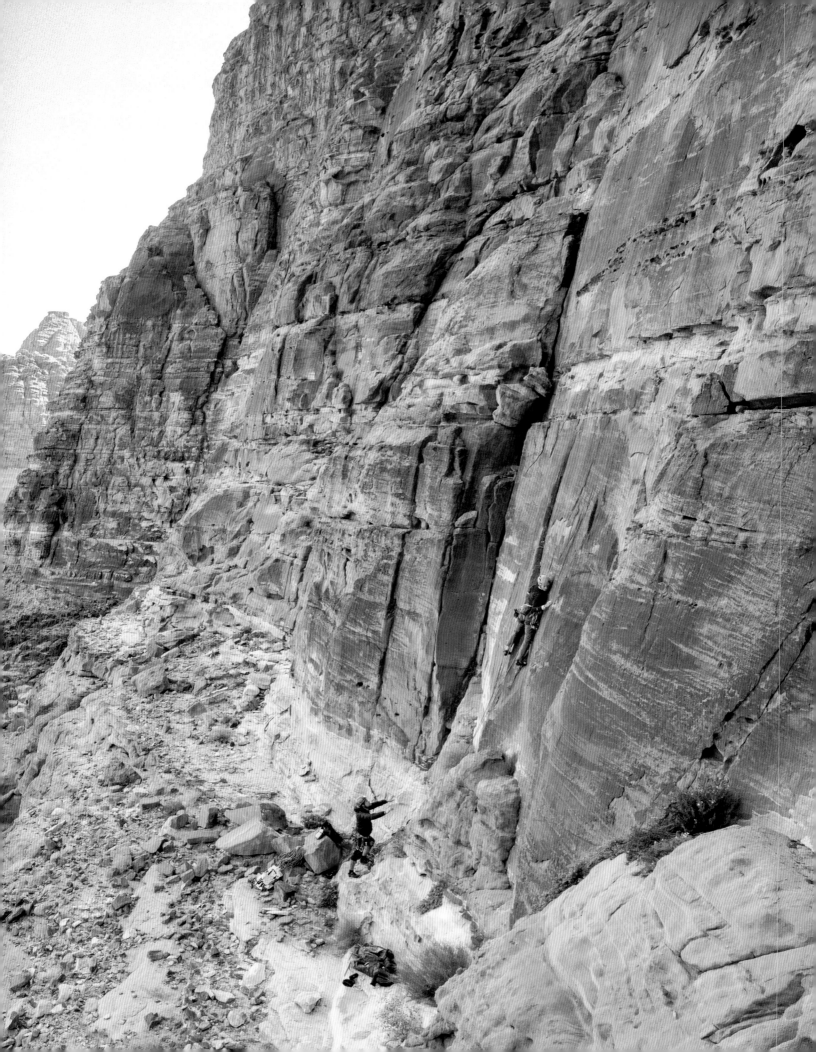

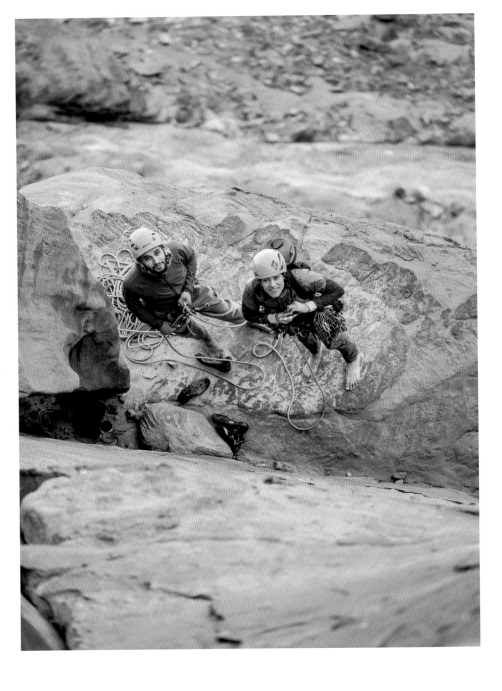

easier. *Pillar* embodies every aspect of a Wadi Rum route: a wide variety of climbing, from slabs to faces to cracks; unprotectable terrain; thoughtful gear placements; and rock that goes from perfect to horrifying in a matter of feet. In one word: adventure. Visiting climbers can study the route description from British climber Tony Howard's 2010 guidebook to the area, but the few sentences that relate the descent are vague at best. It can lull you into a false sense of security, assuming it will be a mellow walk-off, not the complicated maze of basins, cliffs, and slot canyons it actually entails. Once you stand on the summit and take in the grandiose view, reveling in your accomplishment, it's time to search for the way down. You'll go up and climb down countless small formations, hitting dead ends every which way. With only headlamps to light the way and dwindling food and water, you might just have to surrender to your fate of bivvying on top of Jebel Rum. Dozens of other climbers have. As the light fades over the small village of Rum below, you can watch the recently installed streetlights illuminate the quiet streets.

Despite the accidental nature of this night under the stars, it can be quite comfortable thanks to a sandy basin, an all-night fire, and a stash of sleeping pads and blankets found inside a bush. The Bedouins, the area's nomadic desert dwellers, put these little stockpiles everywhere so they can camp and hunt in the complex mountains without carrying gear. The Bedouins are adept at climbing these formations, and without any technical training or gear, they easily scramble fourth- and low fifth-class terrain. The traditional Bedouin routes are still very popular with modern climbers, prizing mountaineering and route-finding over technical movement. While the Bedouin have been inhabiting the area and climbing here for centuries, Wadi Rum was introduced to the Western world by the 1963 movie *Lawrence of Arabia,* a film adaptation of T. E. Lawrence's book *Seven Pillars of Wisdom.* More than 20 years later, a group of British climbers, including guidebook author Howard, saw the film and became determined to climb there. After getting permission from various foreign ambassadors and authorities, they traveled there to climb in 1984.

On that first trip, Howard experienced a few of his own unplanned bivvies while repeating the sandbagged Bedouin routes, and he and his team put up several new routes as well. Now Wadi Rum is home

The "shiver bivy" is ubiquitous in the alpine climbing world. You mess up the route-finding, move too slowly, or experience an out-of-nowhere storm that is typical of the big mountains, and thus are forced to spend the night somewhere you did not intend to. You and your partner find a ledge or nook somewhere that is as sheltered as possible, and then you settle in for the night. Maybe you can both lie down with the one puffy coat you have spread across your tired bodies, or maybe one of you must sit upright while the other curls up into the fetal position. With only so many hours in a day, a long route is easily made even longer by one of the many unknowns inherent to the alpine landscape. With its lower altitude and stable weather, desert climbing does not usually conjure up the same notions, but not only is it possible in Wadi Rum, it's almost likely to find yourself unintentionally spending the night on top of a mountain.

One of the most well-known and accessible routes in Wadi Rum is *Pillar of Wisdom,* a 1,080-foot (330-meter) 6a+ / 5.10b on the east face of Jebel Rum, the second-highest summit in Jordan. If you look at just the grade, the route sounds moderate, almost easy. Once you get on it, it will go fast because much of the climbing is graded lower and the movement is technically

to routes as easy as 2/5.4 and as hard as 8b+/14a, mostly multipitch trad climbs with little fixed protection. There are harder routes with bolts, but most of these lines are mixed, requiring trad gear as well. The area grows in popularity each year, and with it the infrastructure progresses, too. It is a short flight from almost anywhere in Europe, and Americans can travel there thanks to the strong relations between Jordan and the United States.

While traveling to such an area is safe, the climbing here is the opposite. The biggest danger is the rock itself, which is very loose and soft in places, meaning it can easily break, and blocks can dislodge.

A lot of the walls in Wadi Rum are on the edge of town, but the area is far from any big city, which makes it feel just as remote as many alpine climbing areas. There is no search-and-rescue team, and with a population of about 1,000 people, Rum village does not have a hospital. Climbers here must be experienced and self-reliant, and even then, things can go south. There have been countless accidents because of the soft sandstone, which is particularly dangerous when it is wet after a rainstorm. Anchors have failed, and people have died. Legs and collarbones have broken, and shoulders dislocated. All because rock crumbled and the climbers fell.

Back on top of Jebel Rum, the pre-dawn light will rouse tired climbers from their fitful slumbers. As you start to gather your things for the next day of finding the descent, your mind focuses solely on getting down the mountain. Your stomach grumbles and your mouth is dry, and you dread the upcoming task. But right as you start to feel grumpy and discouraged, the town's call to prayer comes in loud and clear, gaining volume each time it bounces off the massive sandstone walls on either side of the village. You pause for a moment of peace, grateful for your safety, and for such a unique experience that could only happen in Wadi Rum.

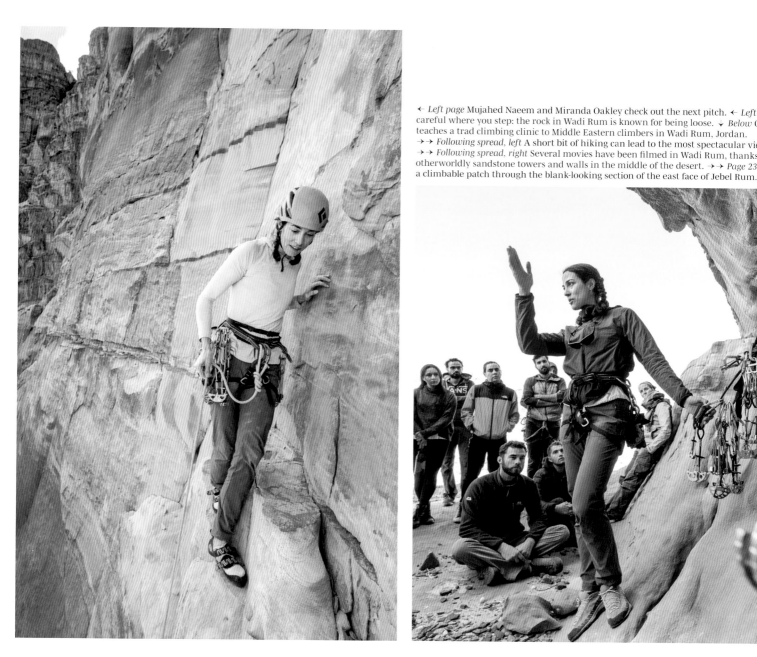

← *Left page* Mujahed Naeem and Miranda Oakley check out the next pitch. ← *Left* Be careful where you step: the rock in Wadi Rum is known for being loose. ↓ *Below* Oakley teaches a trad climbing clinic to Middle Eastern climbers in Wadi Rum, Jordan.
→→ *Following spread, left* A short bit of hiking can lead to the most spectacular views.
→→ *Following spread, right* Several movies have been filmed in Wadi Rum, thanks to its otherworldly sandstone towers and walls in the middle of the desert. →→ *Page 236* Finding a climbable patch through the blank-looking section of the east face of Jebel Rum.

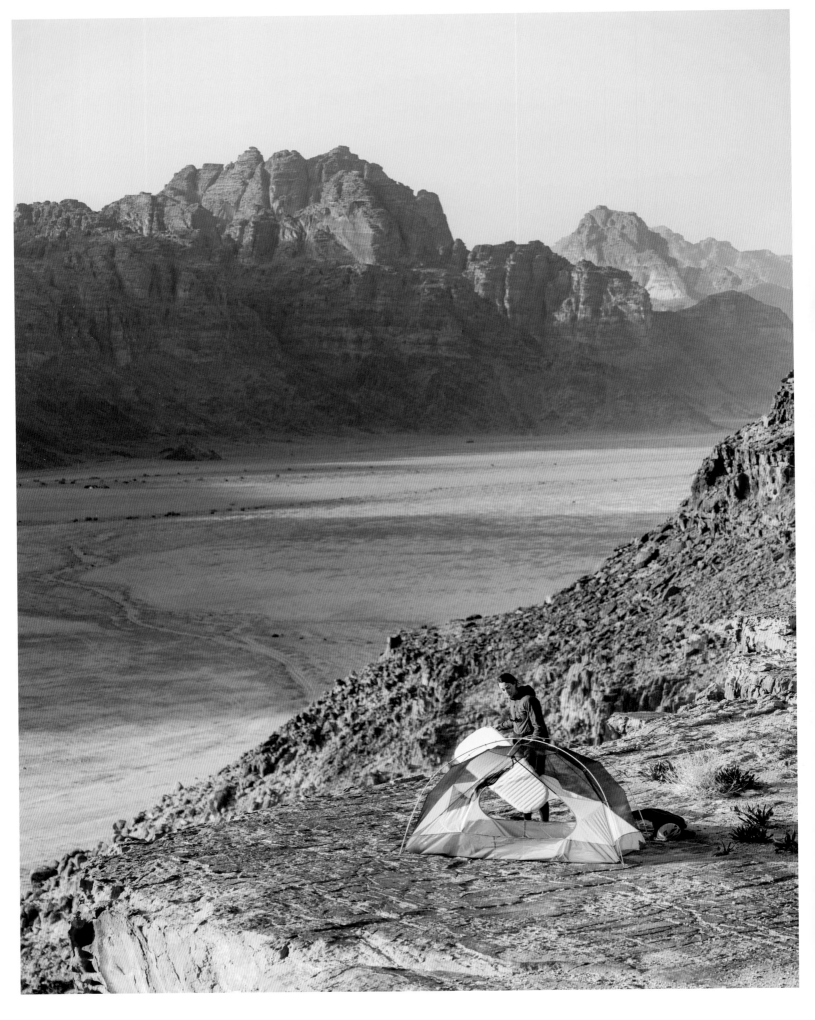

WADI RUM

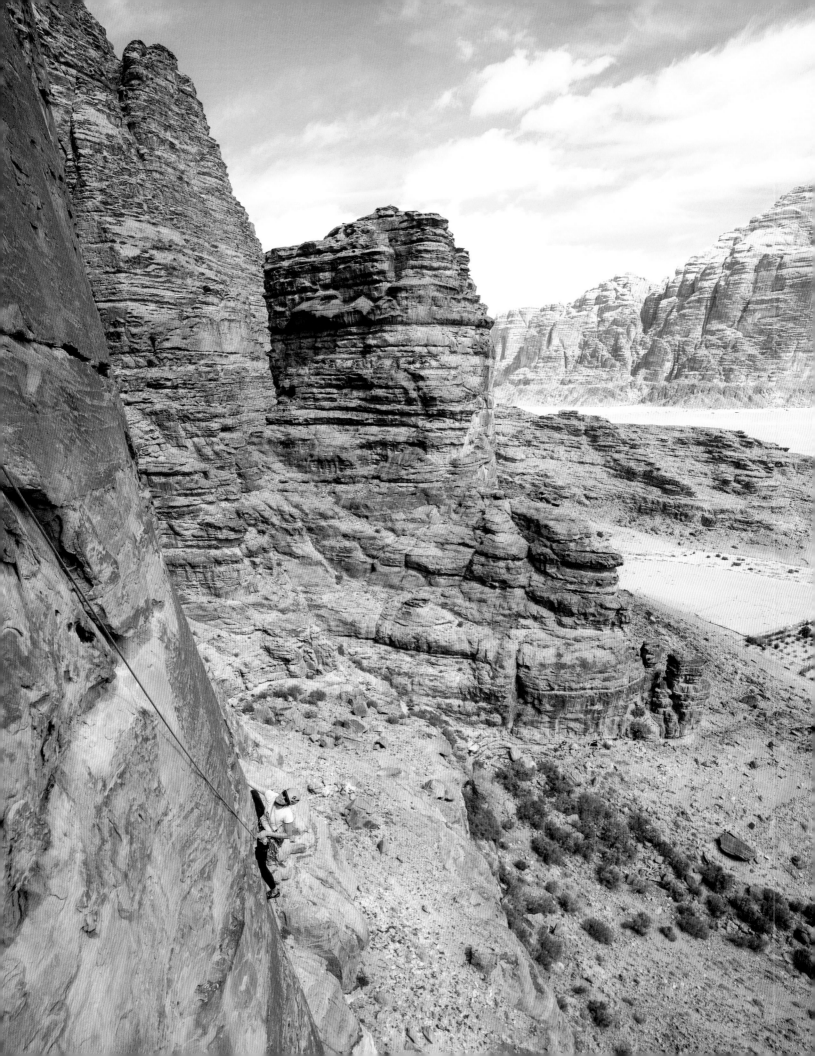

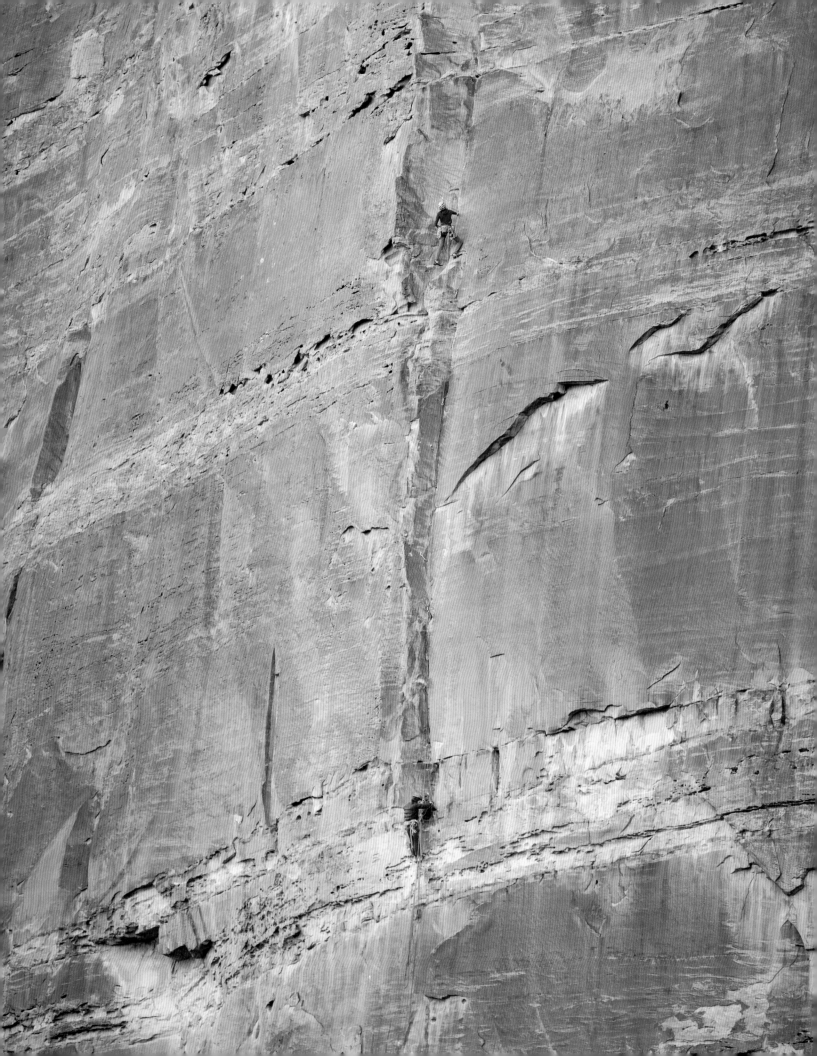

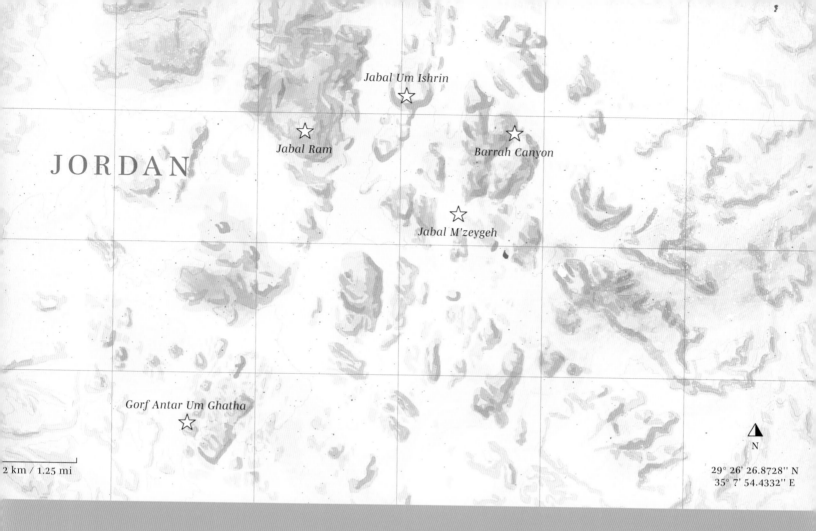

JORDAN

Jabal Um Ishrin ☆

Jabal Ram ☆

Barrah Canyon ☆

Jabal M'zeygeh ☆

Gorf Antar Um Ghatha ☆

2 km / 1.25 mi

N

29° 26' 26.8728'' N
35° 7' 54.4332'' E

WADI RUM

in a Nutshell

CLIMBING TYPE

Trad, some sport, but more
a mix of both

PROTECTION

Trad rack, quickdraws

SEASON

Spring and fall; winter
is decent but rainy

WHERE TO STAY

Locals in the small town of
Rum offer up their homes
for a small fee, and usually
include breakfast and dinner.
This is an excellent way to
support the economy, which
is shifting toward a focus
on adventure tourism. Search
online for Bedouin climbing
guides in Wadi Rum or
Rum village.

ONE MORE THING

Whether you agree with it or
not, be respectful of the
conservative Muslim culture in
the area. Wear modest clothing,
do not drink alcohol (or do it in
covert moderation), and read
up about other guidelines for
traveling in a religious country.
Jordan also offers tons of
cool tourist and sightseeing
opportunities like the Dead Sea,
the ancient buildings of Petra,
and various adventure activities
like camel riding, snorkeling,
and hiking. It is easy to travel to
Jordan, and the Jordan Tourism
Board can be very helpful in
helping you plan a longer trip.

MOUNTAINEERING & ALPINISM

CLIMBING MOUNTAINS HAS COME FULL CIRCLE—IT IS NOT ONLY THE FOUNDATION OF ALL OTHER TYPES OF CLIMBING, BUT THE ULTIMATE GOAL FOR MANY MULTITALENTED CLIMBERS

Humans have certainly been climbing mountains since first starting to walk upright several million years ago. While the earliest ascents came out of necessity, hunting food or moving nomadically through whatever terrain presented itself, the reason for modern mountaineering is best summed up in three words: "Because it's there." The infamous quote came from British mountaineer George Mallory in 1923, when he was asked by a reporter for the *New York Times* about why he wanted to climb Mount Everest. After unsuccessful attempts on the world's highest mountain in 1921 and 1922, Mallory returned for a third expedition in 1924, where he died with his partner, Andrew Irvine, trying to make a first ascent of the 29,028-foot (8,848-meter) peak. It is unknown whether Mallory and Irvine successfully summited since they died on the attempt. Almost 30 years later, Nepalese Sherpa Tenzing Norgay and New Zealand mountaineer Sir Edmund Hillary made the first official ascent of Everest in May 1953.

Many consider the first ascent of Mont Blanc in the Alps to be the advent of mountaineering. In 1786, the achievement was claimed by Jacques Balmat and Michel-Gabriel Paccard, who were both from Chamonix, a town that lies in the valley below the 15,778-foot (4,809-meter) peak. In the more than two centuries since this first ascent, the gear, safety techniques, fitness, and information available to modern alpinists has evolved so drastically that most of the world's major peaks, which were previously thought impossible to climb, have been summited. Today, climbing Mont Blanc is considered relatively easy by alpine standards, with a lot of physical fitness required but not a lot of technical climbing skills. About 20,000 mountaineers summit Mont Blanc every year.

The 19th century saw many of the alpine peaks of Europe conquered. The Golden Age of Alpinism—about a decade of mountaineering where many of the Alps saw ascents, many of them firsts—occurred mid-century. From British climber Alfred Willis climbing the Wetterhorn in 1854 to fellow Brit Edward Whymper's climb of the great Matterhorn in 1865, many of these expeditions had a scientific focus in addition to athletic achievement. By the end of the 19th century, with many of the European summits climbed, these accomplished mountaineers looked to other great mountain ranges: the Andes in South America, peaks in Alaska, and the Himalaya of central Asia. The next 50 years focused on the Himalaya, and by 1964, all 14 of the 8,000-meter (26,247-foot) peaks had been summited.

Many of these expeditions were logistically complex and required supplemental oxygen for breathing at high altitude, hundreds of porters to carry food and equipment, and massive basecamps set up for months at a time. Enter Reinhold Messner, a German-speaking Italian mountaineer, who pioneered an alpine style that was fast and light, without the use of porters, extraneous gear, and supplemental oxygen. For Messner, fitness, speed, and technical climbing skill were paramount. In 1970, Messner ticked the unclimbed and difficult Rupal Face on Nanga Parbat, Manaslu in 1972, and Gasherbrum I in 1975, all without oxygen. By 1986, Messner had completed all 8,000-meter peaks in this approach, including the first ascent of Everest without supplemental oxygen with Peter Habeler (1978) and the first solo ascent of Everest (1980, also without oxygen and while establishing a new route on the North Face).

Before Messner's era, mountaineers focused on ascending snow and glaciers, more or less "walking up" to a summit. With the evolution of modern techniques in rock climbing, a new generation of alpinists was able to combine skills gained from aid climbing, free climbing, glacier travel, vertical ice climbing, and big wall climbing to ascend the most vertical and technically difficult faces of ice and rock. Some of the most impressive faces and summits in Alaska and Patagonia were now within the capabilities of experienced alpine climbers. The goal was no longer just about getting to the tallest point of a mountain; the goal was now about finding a challenging and creative way to get there.

In 1992, the French magazine *Montagnes* and the Groupe de Haute Montagne, a French mountaineering organization, created an annual award for feats in mountaineering called the Piolet d'Or (French for Golden Ice Axe). The award criteria value commitment, a high technical level, an original objective, respect for the mountains, and an innovative nature of the ascent. As gear continued to progress, particularly cold-weather camping equipment and apparel, the boundaries of what was possible evolved in parallel. The objectives were deeper in the mountains, with longer routes, harder climbing, worse weather, and less information available.

In 2004, Americans Kelly Cordes and Josh Wharton established a route on the southwest ridge of Great Trango Tower in the Karakoram range of Pakistan, calling it the →

↑ *Above* Ines Papert deals with the spray of ice while ice climbing.
↓ *Below* A snowy ridge in Chamonix, France, which is widely considered the birthplace of mountaineering.

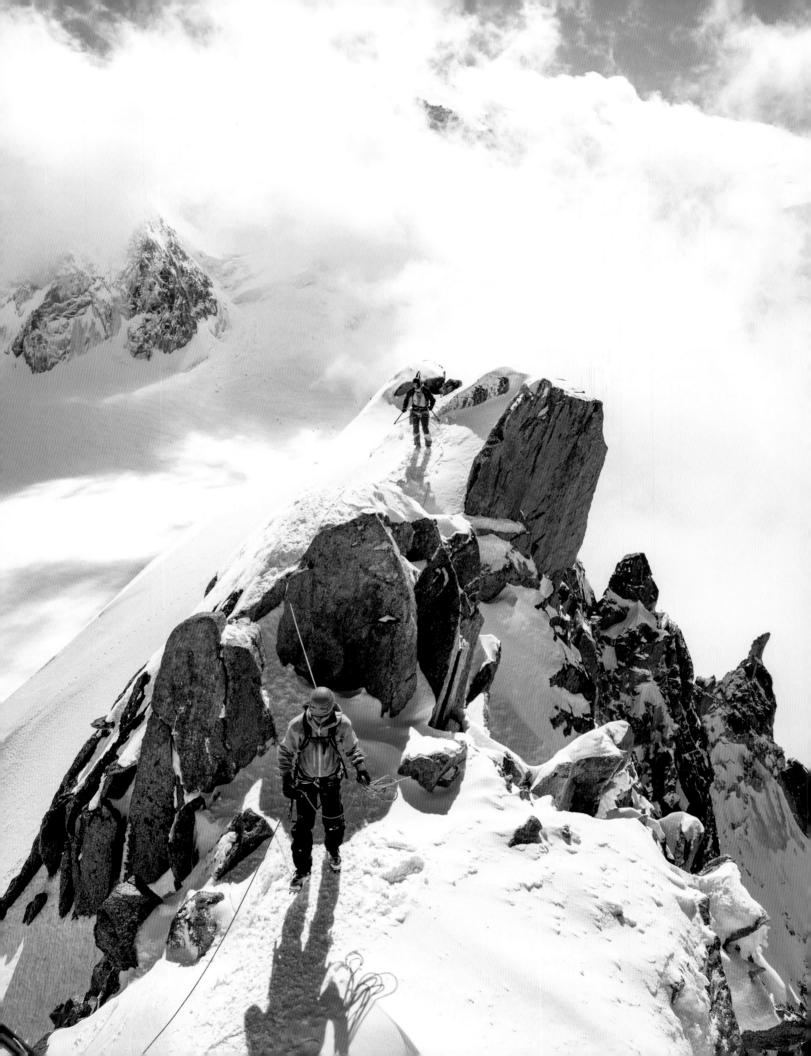

→ Azeem Ridge. It required a 50-mile (80-kilometer) hike to get to the base and more than 7,283 vertical feet (2,220 meters) of climbing done in 4.5 days. Four years later, Argentinian Rolando Garibotti and American Colin Haley traversed the entire Cerro Torre massif in Patagonia, establishing the Torre Traverse, with 7,220 feet (2,200 meters) of vertical gain spread out over four major summits. With differing strengths within climbing disciplines, Haley led the pitches of pure ice and rime (unstable, soft ice common to Patagonia) up to a difficulty of WI6, and Garibotti led the dry-rock pitches and rime-covered rock pitches up to a difficulty of 5.11 free climbing and A1 aid climbing.

These ascents are just two of dozens that demonstrate the crossover of all climbing disciplines being applied in big mountains. Combining elements of aid, free, trad, ice, big wall, and mountaineering into massive multiday efforts, these climbers often get their start by trad or sport climbing. Mountaineering is the foundation of all types of modern climbing: sport, trad, bouldering, and big walls. But now, those newer disciplines are the bricks with which modern alpinists build their own foundation. Even gym climbing, which Balmat and Paccard could never have dreamed a possibility, is a necessity for modern alpinism. Mountain climbing is the starting point and the end game. →

COMBINING ELEMENTS OF AID, FREE, TRAD, ICE, BIG WALL, AND MOUNTAINEERING INTO MASSIVE MULTIDAY EFFORTS, THESE CLIMBERS OFTEN GET THEIR START BY TRAD OR SPORT CLIMBING.

← *Left page* Perhaps one of the most well-known alpine routes in the world: *Arête des Cosmiques* in Chamonix, France. ↑ *Top* Chris Cox heads toward the big mountains in Patagonia. ↑ *Above* Ines Papert on the approach to an alpine climb in Norway.

↑ *Above* The very cold and punishing discipline of ice climbing requires many clothing layers and lots of mental fortitude. → *Right page* Climbers take the hard way up an alpine route in the Alps while a bird takes the express route. →→ *Following spread, left* Climbing the 463-foot (141-meter) Helmcken Falls in British Columbia, Canada. →→ *Following spread, right* Sam Elias ice climbing a column outside Vail, Colorado.

→ The Seven Summits is a mountaineering objective that involves climbing the highest mountain on each continent. The technical skill required varies widely across the seven peaks, and some alpinists criticize the accomplishment, saying these peaks don't require that much climbing skill compared to others. For example, K2, the second-highest mountain in Asia behind Everest, is far more technically challenging than Everest and has a high death-to-summit ratio at one to four. There are also variations on some of the lists, depending on if one of the summits is considered to be on mainland Australia or the tallest peak in all of Oceania, which would include Indonesia.

Messner reached six of the Seven Summits by 1978, suggesting Puncak Jaya in Indonesia should be on the list because it requires an expedition and technical climbing. →

MOUNTAINEERING IS THE ROOT OF ALL OTHER TYPES OF CLIMBING—EVERY OTHER DISCIPLINE IS AN OFFSHOOT OF IT. GENERALLY IT INVOLVES GETTING TO A SUMMIT, AND WITH THE EVOLUTION IN GEAR AND SKILLS, THE STYLE AND ROUTE OF HOW A CLIMBER GETS THERE HAS ALSO BECOME IMPORTANT.

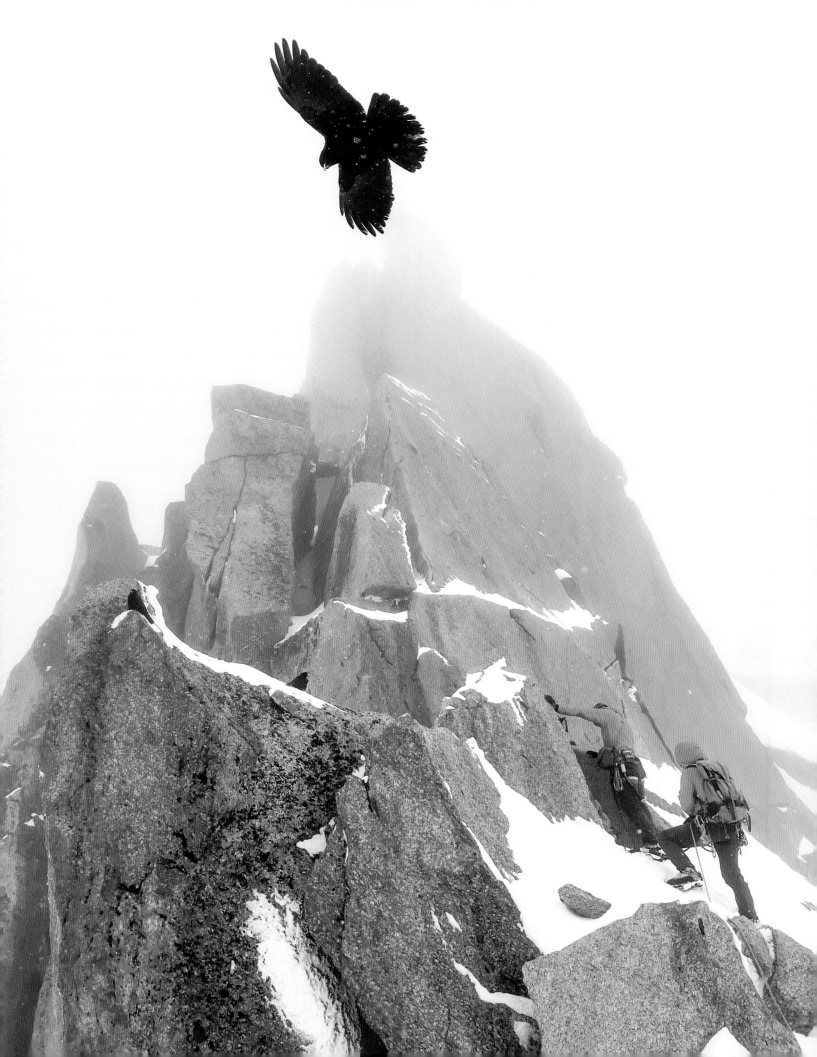

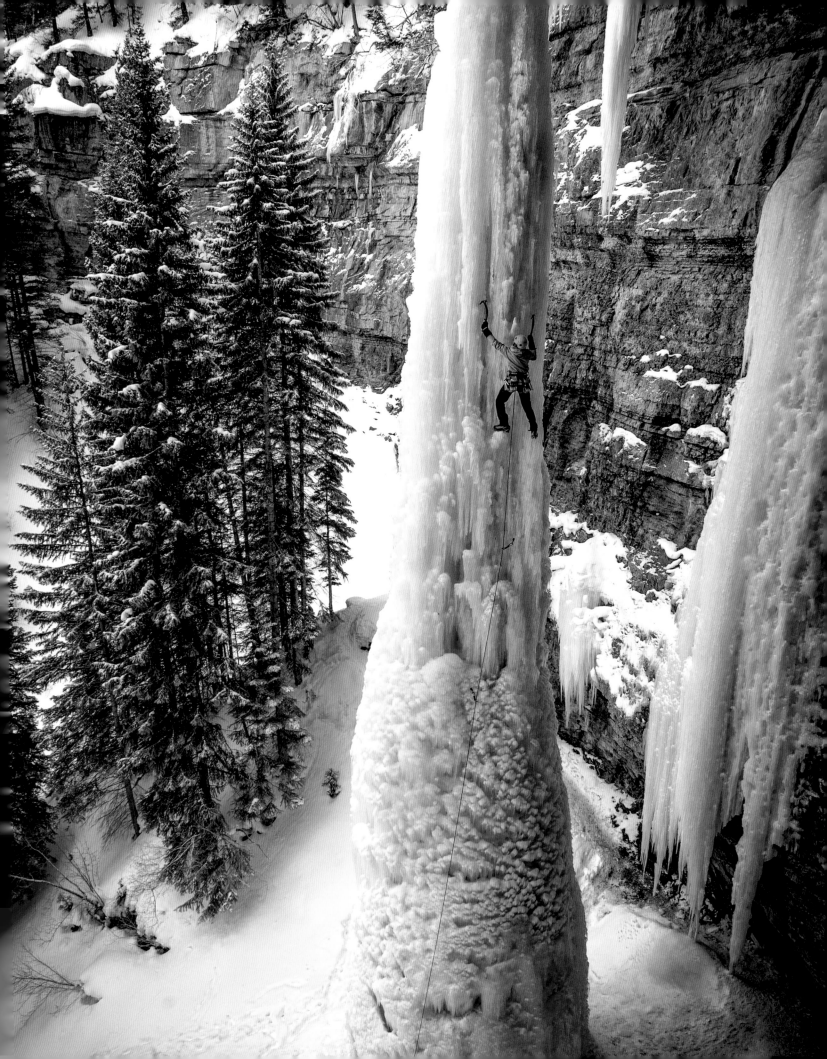

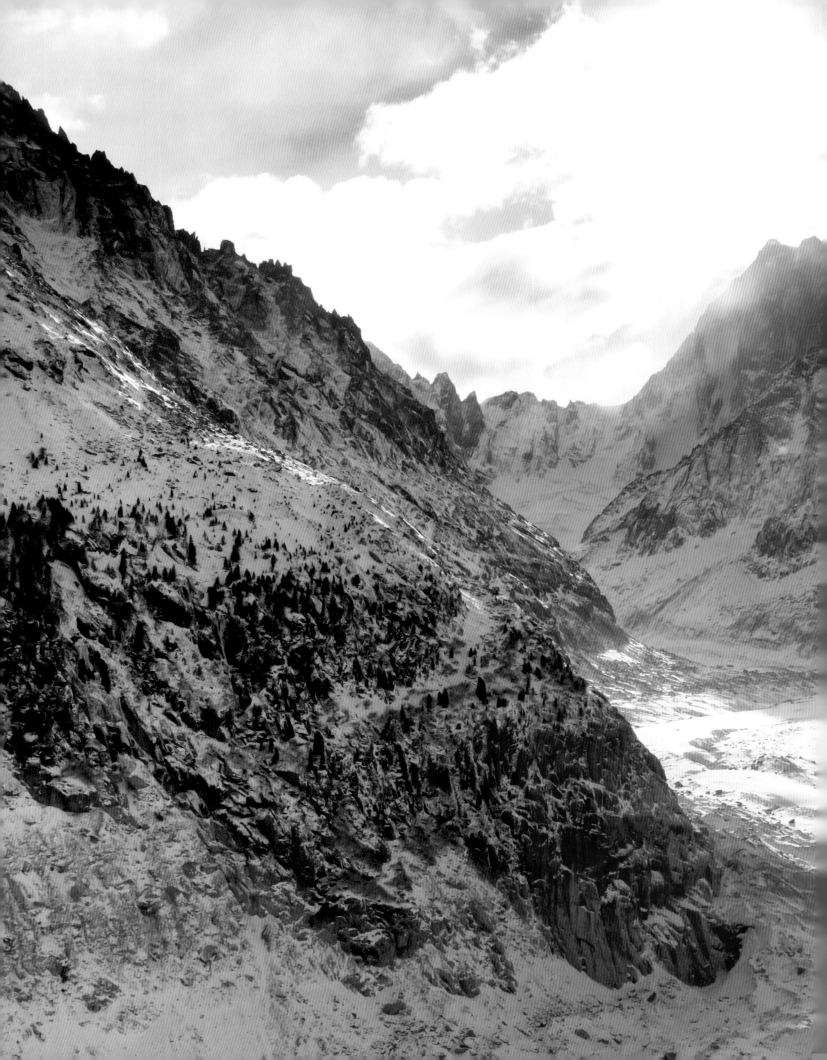

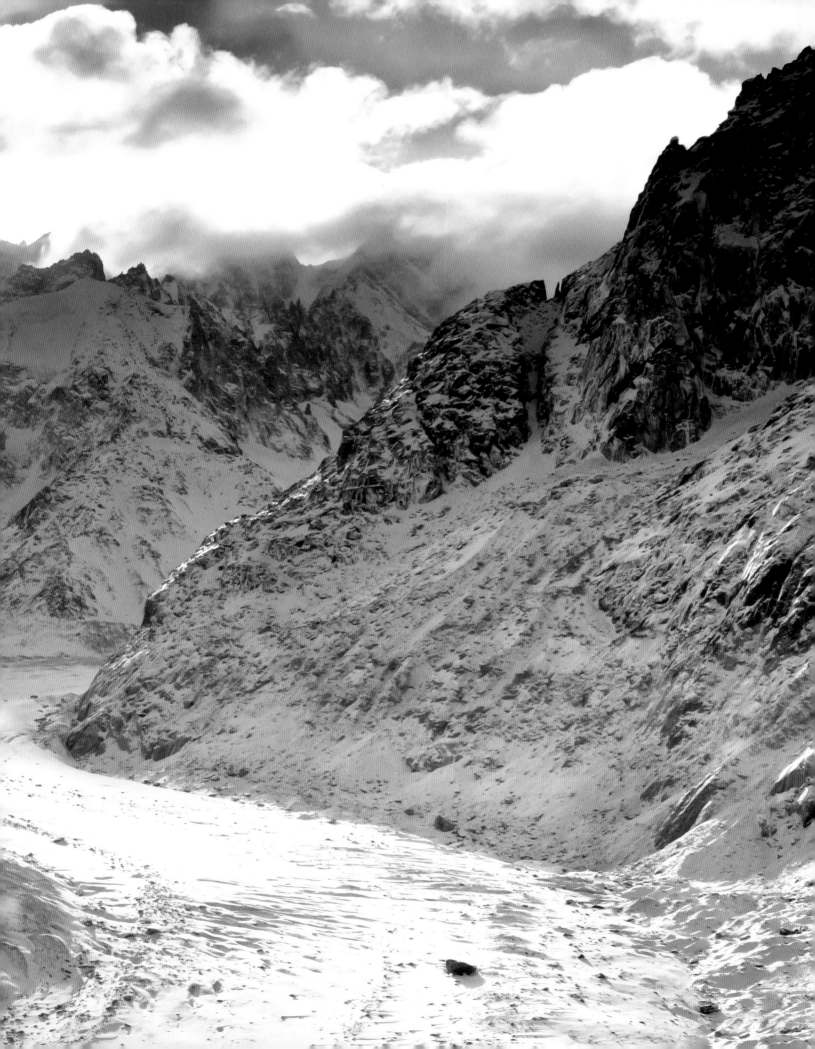

←← *Previous spread* The Mer de Glace glacier in Chamonix, France, is like a river of ice. ↑ *Above* Climbing away from the shrouded sun on Pico de Orizaba, Mexico. ↓ *Below* Climbing in sideways freezing rain and snow can result in a thin layer of ice on anything that's exposed.
→ *Right page* Sometimes your partners in the alpine might have four legs and a furry coat—and still be a better climber than you!

→ In 1983, Messner climbed Australia's Mount Kosciuszko, which is an easy walk-up, to satisfy the other geographic possibility of the list, but the first man to reach the Seven Summits was American Richard Bass (via Kosciuszko), climbing six peaks in 1983 and finishing with Everest in 1985. Messner didn't climb Mount Vinson until 1986. Junko Tabei, who was the first woman to climb Everest in 1975, summited Puncak Jaya in 1992, becoming the first woman to complete the feat. In October 2006, American skier and climber Kit DesLauriers became the first person to ski the Seven Summits (Kosciuszko). In January 2007, Swedish climbers Olof Sundström and Martin Letzter skied Puncak Jaya, now having skied the entirety of both lists. Below are the eight peaks that comprise the two variations of the Seven Summits.

Mount Everest, Asia, 29,029 feet (8,848 meters)
Aconcagua, South America, 22,829 feet (6,961 meters)
Denali, North America, 20,308 feet (6,190 meters)
Mount Kilimanjaro, Africa, 19,341 feet (5,895 meters)
Mount Elbrus, Europe, 18,510 feet (5,642 meters)
Mount Vinson, Antarctica, 16,050 feet (4,892 meters)
Puncak Jaya, Oceania / Australia, 16,024 feet (4,884 meters)
Mount Kosciuszko, mainland Australia, 7,310 feet (2,228 meters)

MOUNTAINEERING & ALPINISM

Good to Know

WHAT SETS IT APART

Mountaineering is the root of all other types of climbing—every other discipline is an offshoot of it. Generally it involves getting to a summit, and with the evolution in gear and skills, the style and route of how a climber gets there has also become important. Mountaineering is more about snow and glacier travel; alpinism is vertical rock and ice, as well as steep snow.

NECESSARY SKILLS

Cold-weather camping and climbing, vertical ice climbing, aid climbing, multipitch climbing, rock climbing, anchor building and gear placement for rock/snow/ice, self-rescue systems, rappelling, and a willingness to suffer

FITNESS FOCUS

Full-body strength and endurance, as well as mental fortitude

ICONIC LOCATIONS

Chamonix, France; Patagonia; the Dolomites, Italy; the Himalaya; the Alaska Range, U.S.; the Bugaboos, Canada; the Alps; the Andes

RATING SYSTEM

Since many alpine routes combine rock, snow, and ice climbing, which all have their own rating systems, most climbs get several grades. These can indicate the technical climbing required (Yosemite Decimal System, French, Austrian, mixed climbing, water ice grades, etc.), the overall seriousness (French alpine system), aid climbing (A0, A1, etc.), and commitment grades denoting overall challenges (using Roman numerals I through VII). Some regions also have their own grade systems, like Scottish Winter Grades and the Alaska Range.

NOTABLE FIRSTS

1786 First ascent of Mont Blanc, considered the advent of modern mountaineering.

1808 First ascent of Mont Blanc by a woman, Marie Paradis.

1854–1865 The Golden Age of Alpinism, from the ascent of the Wetterhorn to the first ascent of the Matterhorn.

1953 First ascent of Everest.

1964 First ascent of Shishapangma, the final 8,000-meter peak to be climbed.

1975 Reinhold Messner climbs Gasherbrum I for a second ascent, the first 8,000-meter peak to be successfully summited using alpine-style techniques.

1975 Junko Tabei becomes the first woman to climb Everest.

2005, 2009, 2011 & 2016 Simone Moro makes the first winter ascents of Shishapangma, Makalu, Gasherbrum II, and Nanga Parbat, respectively.

2014 Tommy Caldwell and Alex Honnold complete the first ascent of the Fitz Traverse in Patagonia, the ridgeline of Fitz Roy and surrounding peaks.

EQUIPMENT: MOUNTAINEERING & ALPINISM

The fast-changing weather and diverse terrain of the mountains demand the right tools for the job, from the apparel you wear to the gadgets you bring. Each alpine mission is gear-intensive, and climbers must carry everything on their backs. Every ounce matters, along with function, performance, durability, and weatherproofness. A climb in the mountains can involve long walks uphill with a heavy pack, technical climbs on rock and ice, and frigid temperatures during an unplanned bivouac, so preparedness is the name of the game. While the whole kit can be quite pricey, having the right equipment for the high country is more than important—your life depends on it.

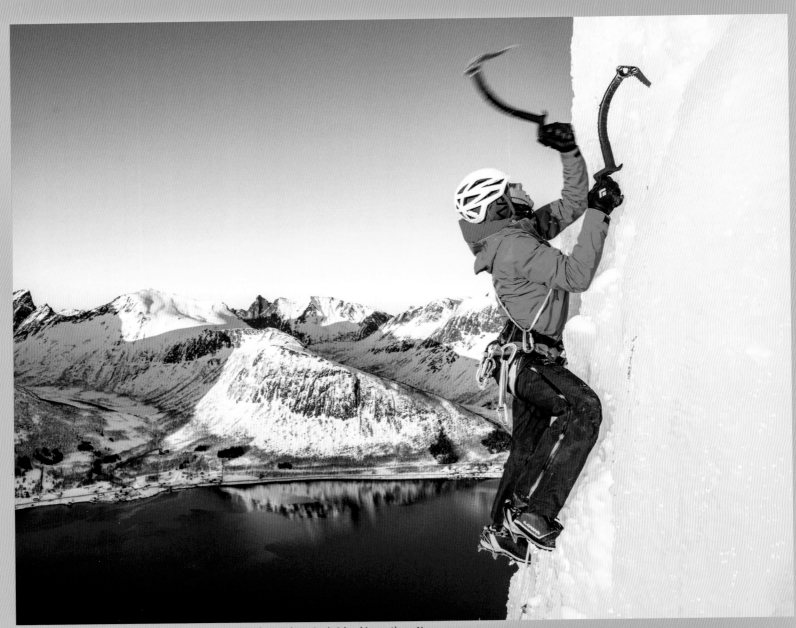

↑ *Above* Ines Papert climbs ice high above a fjord in the Arctic on Senja Island in northern Norway.

ICE AXE & ICE TOOL

Both of these implements evolved from the medieval *alpenstock,* a long alpine walking stick with a metal spike on the bottom. Modern ice axes are not quite as long—usually 22 to 31 inches (55 to 80 centimeters) depending on the climber's height—but they still have a spike for sticking down in the snow while walking. Mountaineering axes have a pick on top for swinging into steeper snow or ice. On the other side of the pick is usually a hammer or adze. The main difference is the mountaineering ice axe is longer and has a straight shaft, mostly for purchase while walking on snow. The ice tool has a curved shaft with a hand grip on the bottom for swinging overhead into steep ice and snow.

BACKPACK

An alpine pack can range from about 30 liters to 55 liters or more. The former is best suited for "fast and light" missions where speed equals safety, and the latter is better for overnight objectives or trips that revolve around a basecamp. The pack must be comfortable to carry all day, be lightweight, and have all the right bells and whistles. Important features include straps for carrying a rope, ice tools, and crampons on the outside of the pack.

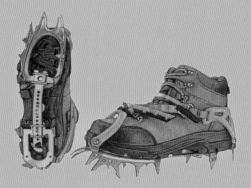

MOUNTAINEERING CRAMPONS & VERTICAL ICE CRAMPONS

These shoe spikes might look like some kind of weaponry, but crampons provide purchase in snow and ice so climbers can move up terrain covered in frozen water quickly and efficiently. There are two main types for different angles of terrain. Mountaineering crampons usually have 10 or 12 points that are less aggressive for walking up lower-angle snow and glaciers. Vertical ice crampons are lighter, with specialized spikes on the toe that stick straight out (single, called monopoint, or double) for technical ice climbing and ascending steep snow.

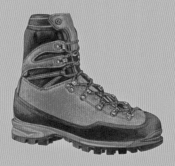

MOUNTAINEERING BOOTS

Potentially the most important piece of an alpinist's quiver, mountain boots are a lesson in contrasts. They must be flexible for long hiking approaches, but stiff for climbing rock and ice. They must be waterproof and warm for sub-freezing temperatures, but breathable so your feet do not sweat and then freeze. They must be burly enough to offer support for 18-hour days on your feet, but light enough not to feel like you are carrying an extra few pounds on each leg. With hundreds of quality boots on the market, the best way to choose is to find kicks that are customized for the type of alpine climbing you do most, whether it is multiday rock ridges or moderate snow couloirs.

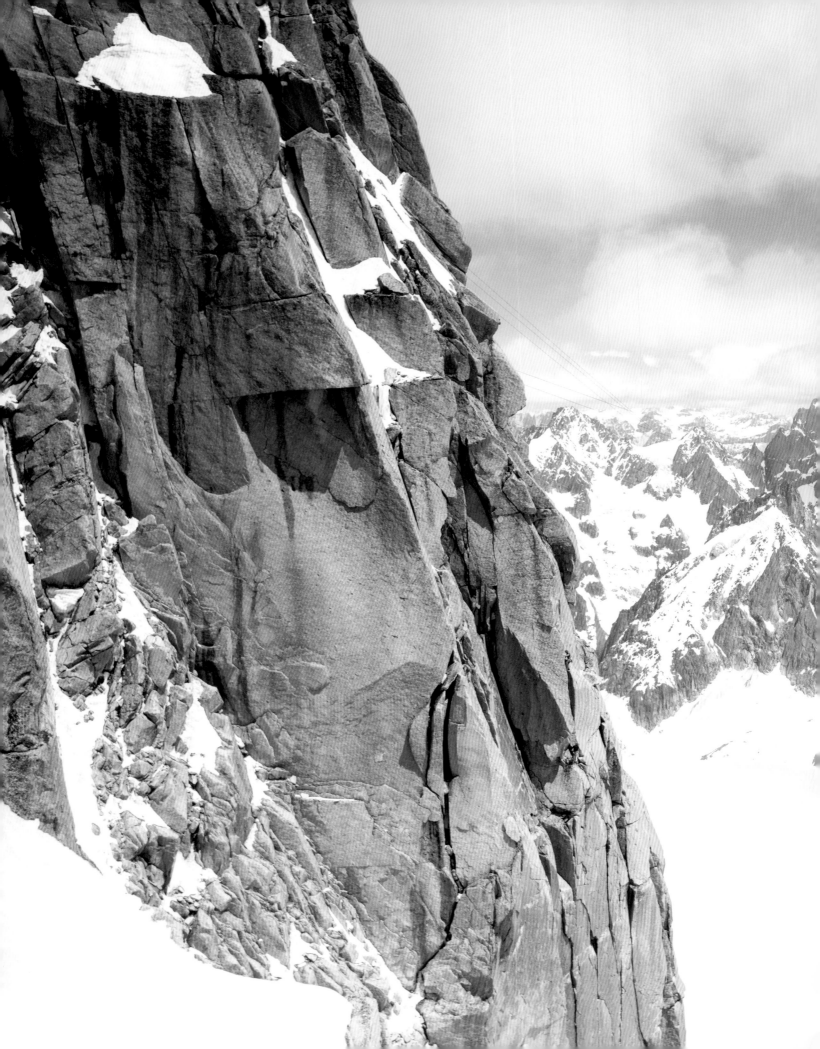

CHAMONIX

Auvergne-Rhône-Alpes · France

In the birthplace of mountaineering, first-time
mountaineers and experienced alpinists can summit
a historic peak and be back to town for lunch.

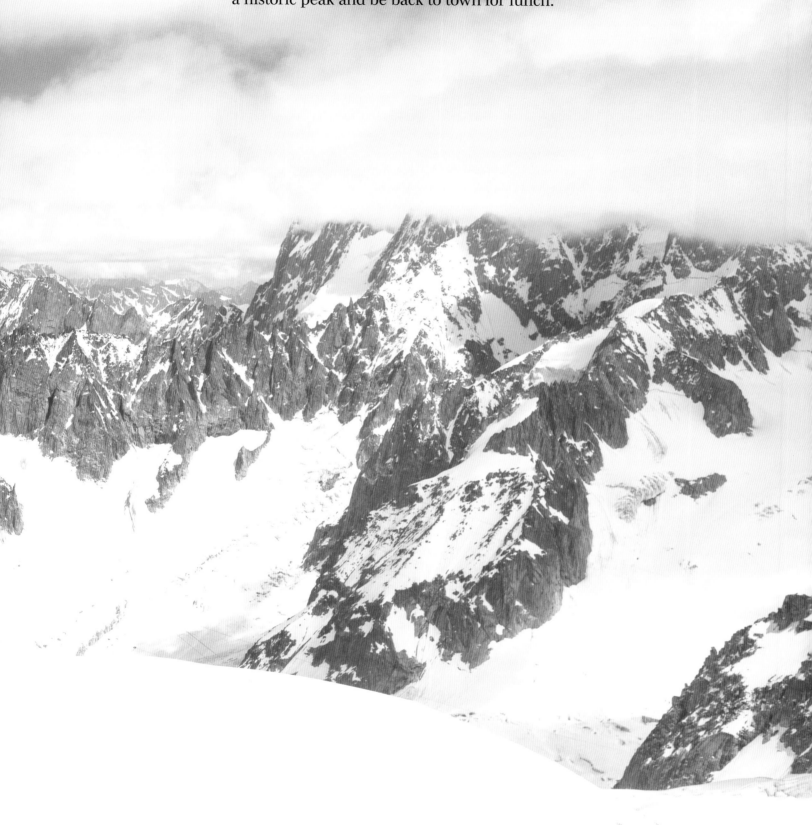

Stepping off the gondola into near-whiteout conditions, one would be happy to be covered in multiple layers of insulation and waterproof Gore-Tex. On any given day, three dozen people will stream out of the cable car at one time, their heavy mountaineering boots making them sound like a herd of elephants clomping along the wooden deck. When the sideways snow clears for a minute, you might view a young Chinese (or British or Russian or Brazilian) tourist about 30 feet (10 meters) away wearing flip-flops, fitted jeans, and a light sweater, holding a phone up to take a photo of a friend, who is similarly clad. Normally that spot offered a quintessential view of the mountains: jagged rock spires and ridgelines protruding out of swelling snowfields, with steep, icy couloirs resembling a network of veins running up and down the mountains. The duo might squeal with delight and perhaps discomfort, quickly taking a few photos before scurrying

back toward one of the metal doors fixed right into the rock.

This is just one slice of the interesting dichotomy of Chamonix, France, a high-country playground in the heart of the French Alps. While many big mountain ranges require massive treks that can take days to arrive at the climb's base, Chamonix, or Cham, has a cable car that takes you from the center of town, at 3,395 feet (1,035 meters), to the Aiguille du Midi peak at 12,605 feet (3,842 meters). The Téléphérique de l'Aiguille du Midi rises 9,209 feet (2,807 meters) from the valley floor in about 20 minutes. This is the starting point for mountaineers and tourists alike, offering super-fast access to very high mountains to anyone willing to pay the 60 euros. This is very convenient—and dangerous. The physical fitness and technical skills demanded by mountaineering force most climbers to gain experience slowly and hold off on the major alpine objectives for a while. But the Midi cable car drops tons of

climbers and skiers in serious alpine terrain, with crevasses, fast-changing weather, and miles of challenging snow, rock, and ice climbing. The Peloton de Gendarmerie de Haute Montagne, Chamonix's search-and-rescue team, performs more than 1,000 rescues per year—the busiest SAR team in the world.

Minutes before being on top of the mountain, you can be sitting outside a café on the cobblestone street that runs through town, enjoying an espresso and a croissant. With colorful flowers and quaint houses, it is like a scene from *The Sound of Music*. Chamonix is home to mountaineering objectives for everyone. On a first trip to the area, you might want to traverse the Vallée Blanche in the Mont Blanc Massif, a huge, glaciated blanket of snow and ice. This valley is surrounded by all the well-known peaks of the region, a craggy spine that includes Mont Blanc, Grandes Jorasses, Les Droites, Les Drus, Aiguille du Grépon,

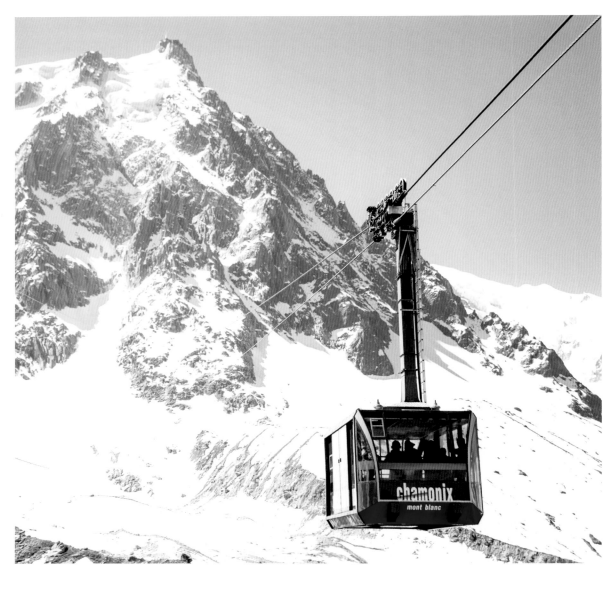

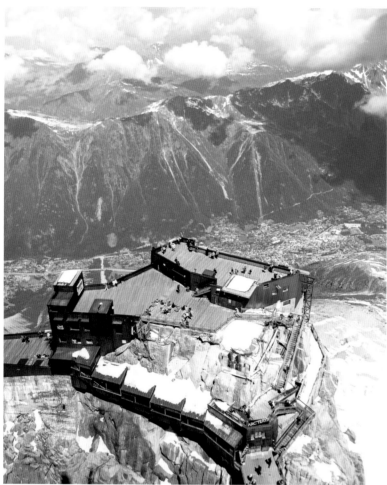

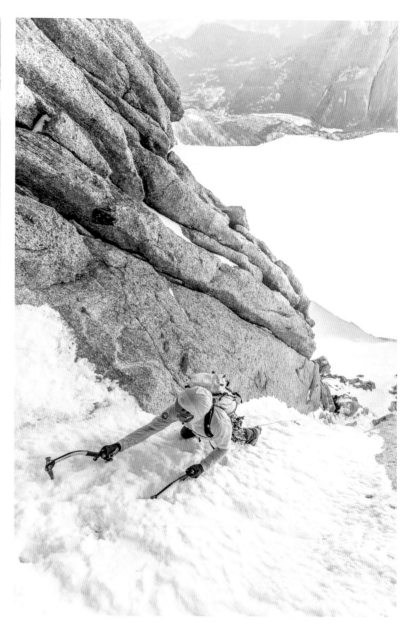

← *Left page* The cable car system in Chamonix takes tourists and climbers from town to summit in a few minutes. ↑ *Above* The viewing platforms offer everyone the chance to see panoramic sights, no climbing required. → *Right* Climbing snow and ice less than an hour's approach from the cable car. →→ *Following spread, left* A classic Chamonix scene: rock spires erupting from blankets of snow. →→ *Following spread, right* The layers and textures of the Alps. →→ *Page 258* Climbers often travel in rope teams on the glaciated terrain of Cham.

and many others. Walking across the glacier is like walking through a living museum of mountaineering. The first ascent of Mont Blanc in August 1786 is considered the advent of modern mountaineering. This area was also the scene of much of the Golden Age of Alpinism, a period from 1854 to 1865 when many of the notable peaks of the Alps were summited for the first time. The traverse goes from the Midi to Pointe Helbronner, a cable car station in Italy. Then you can reverse the three-mile (five-kilometer) route in less than 30 minutes via the Panoramic Vallée Blanche cable car.

Chamonix is an impressive feat of engineering. The Midi tram delivers you directly to restaurants, gift shops, viewing platforms, and a glass skywalk, all

constructed at the literal top of a mountain. The Montenvers–Mer de Glace train travels almost 3 miles (5 kilometers) to a station for the Mer de Glace, a 4.7-mile-long (7.5-kilometer-long) glacier on the north side of Mont Blanc, and then a long set of stairs bolted right into the granite goes down to the glacier itself. The Tunnel du Mont Blanc is a highway tunnel that goes 7.2 miles (11.6 kilometers) from Chamonix, underneath Mont Blanc, and ends at Courmayeur, Italy. Then there is the Grands Montets gondola that goes more than 6,500 feet (2,000 meters) up from the small village of Argentière, north of Cham, to a warming hut. Perched on the summits and ridges throughout the mountains, these refuges provide shelter for climbers mid-route, offer warm meals to anyone passing

through, and can become overnight camps if necessary. After summiting Petite Aiguille Verte via the Couloir Chevalier in waist-deep snow, 16 mph (25 kmph) winds, and ice and mixed climbing, you can have a hot croque monsieur sandwich while waiting for the ride back down.

Cham's most classic route allows the climber to combine all her skills in one objective: the *Arête des Cosmiques*. It is more than 980 vertical feet (300 meters) of snowy couloirs, moderate ice, and technical rock climbing. Start at the Midi station, descend down to a refuge, and then go up the varied terrain with ice axes and crampons via several short pitches. The final pitch is ultimate Cham-style: a metal ladder that tops out on a viewing deck at the Midi Station.

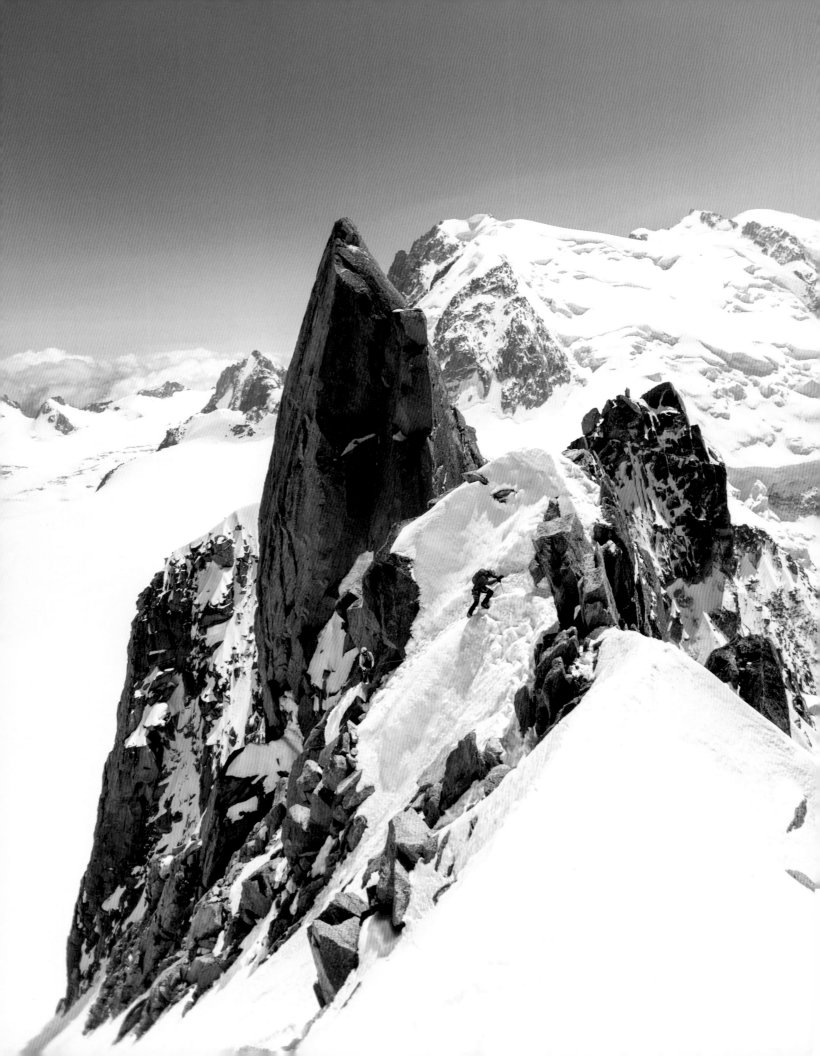

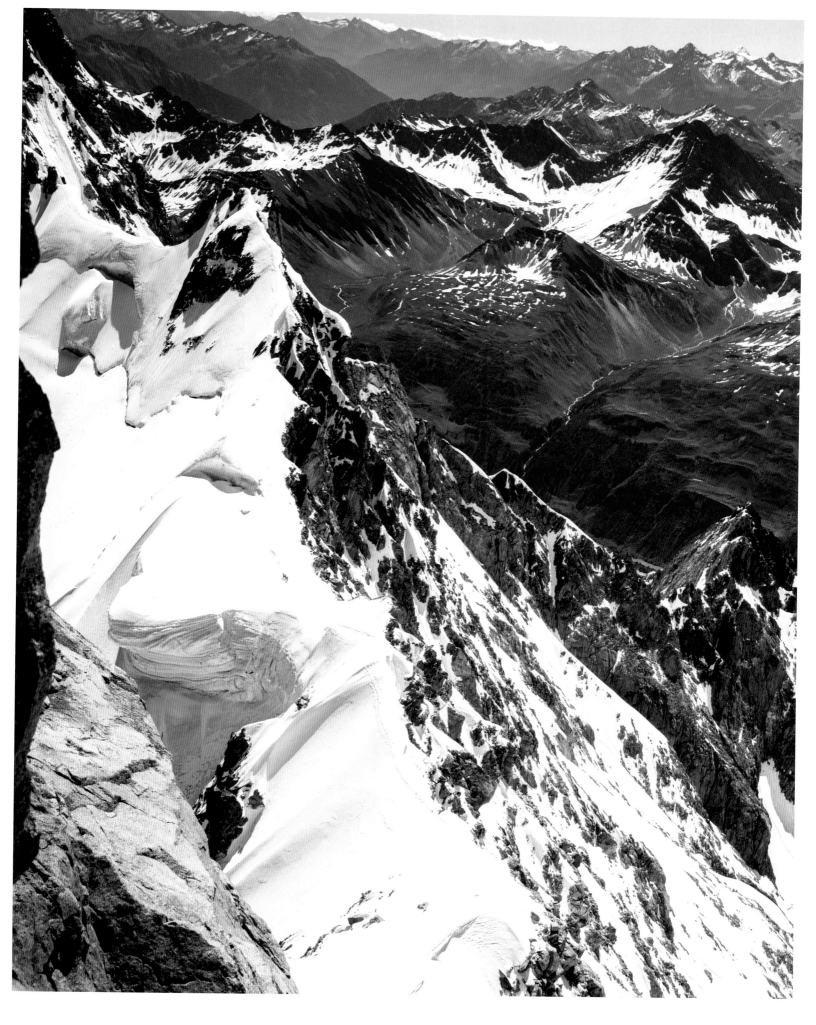

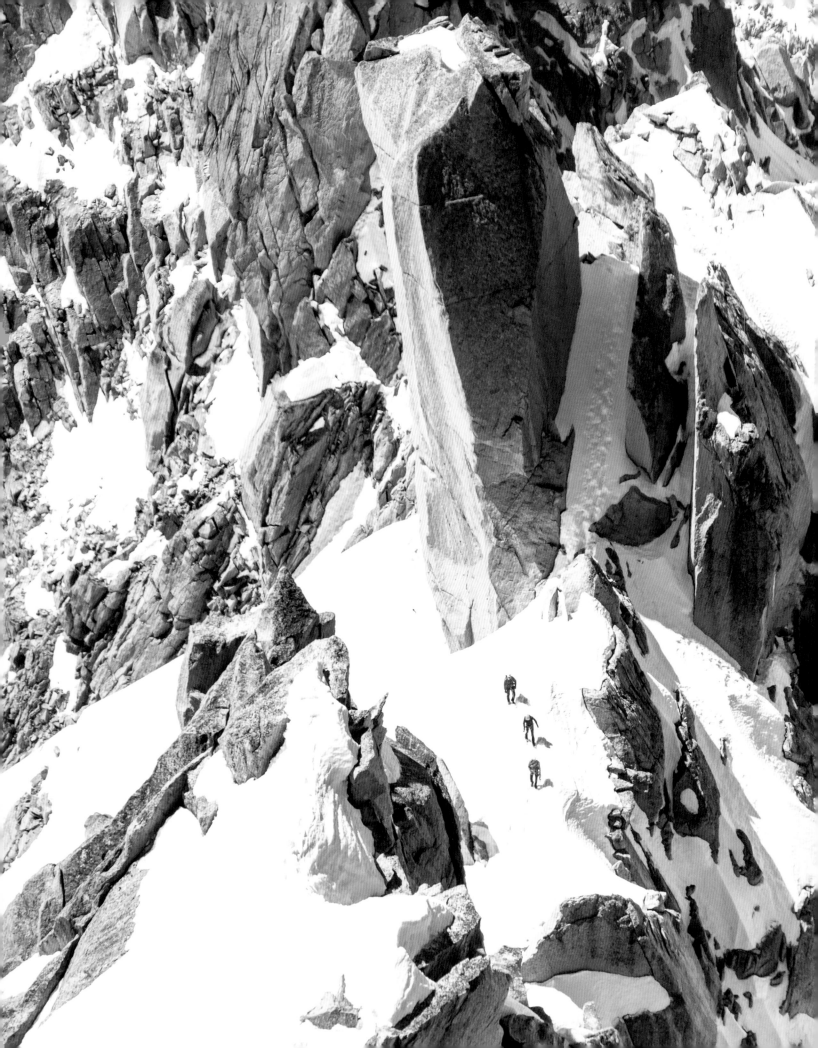

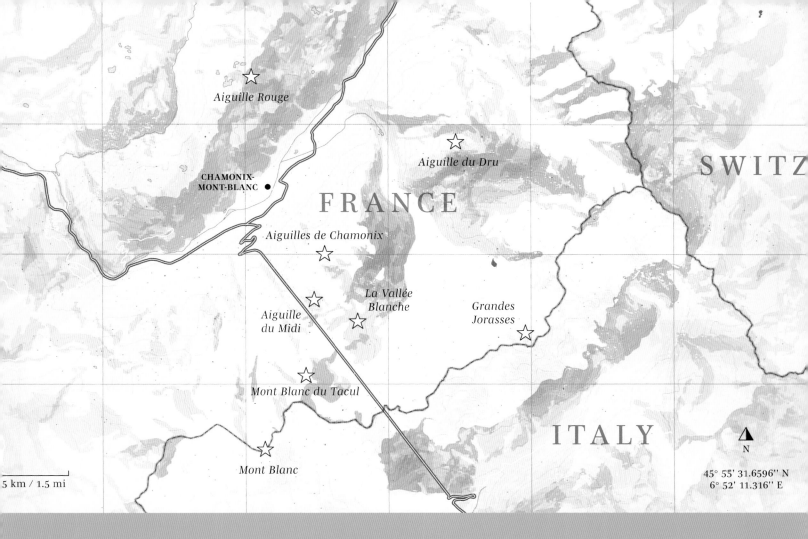

CHAMONIX

in a Nutshell

CLIMBING TYPE

Alpine rock, ice, snow, glacier

PROTECTION

Depends on your objective, but
a mix of trad rack, quickdraws,
snow pickets, ice screws, and
anything you might take into
the alpine.

SEASON

Spring, summer, and fall
(winter for skiing)

WHERE TO STAY

Rent an Airbnb or apartment
in town; there are plenty of
hotel options as well.

ONE MORE THING

Alpine is the name of the game
in Cham, but there are plenty
of cragging and mellow rock
climbing areas nearby, too.
For long limestone multipitches
(bolted, but some trad gear
is recommended), check out
the Vallée de l'Arve between
Cluses and St. Gervais.

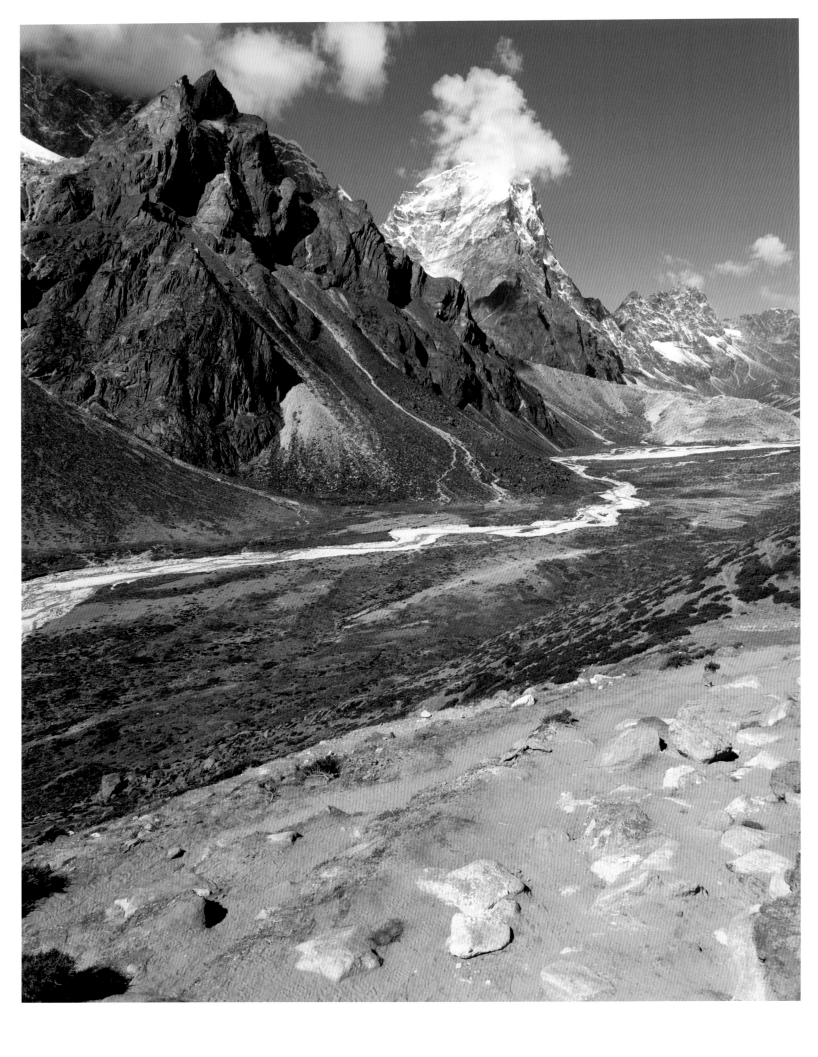

DAWA YANGZUM SHERPA

THIS NEPALI WOMAN FLOUTED THE CULTURAL NORMS OF HER REMOTE VILLAGE TO BECOME AN INTERNATIONALLY CERTIFIED GUIDE AND ONE OF THE MOST ACCOMPLISHED ALPINISTS OF HER GENERATION.

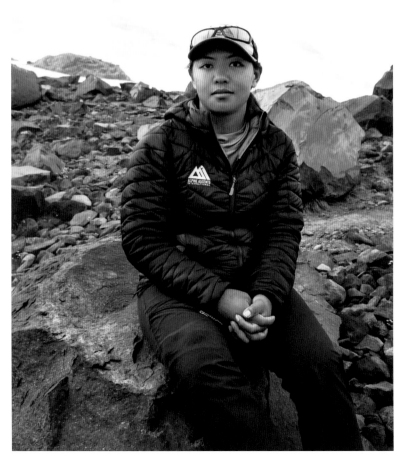

Growing up in a village of 50 houses in Rolwaling Valley, Nepal, Dawa Yangzum Sherpa spent all of her childhood outside. Her parents, three brothers, and two sisters would spend most of the year in a village at 13,800 feet (4,200 meters), then move down the valley to a lower elevation for the winter. Despite being surrounded by Himalayan peaks sought after by mountaineers the world over—including Everest—they did not have outdoorsy sports like skiing and climbing. With no roads to their village and the next-nearest town a few days' walk over a mountain pass, they did a lot of high-altitude walking to get everywhere, but it was not considered hiking. Dawa Yangzum's formal education ended at age 11, and she spent her free time playing outside in the rocks, and in the snow during wintertime. To the people of the Rolwaling Valley, carrying huge buckets of water to and from the river and ferrying heavy loads up and over mountain passes was not hiking or climbing—it was just life.

Every spring, Dawa Yangzum would watch dozens of men from her village leave their home to go work on climbing expeditions throughout the Himalaya and beyond. They would work as porters and guides for mostly Western expeditions, earning several times the average yearly income for other Nepalese households in just a few months. "Every house in my village has two to three people who have summited Mount Everest," Dawa Yangzum says. "I would hear on the radio about them getting money and getting famous." In her community, climbing mountains was a job, not a sport, and only men were encouraged to pursue it. Women were supposed to stay home, have kids, work in the fields, and take care of the family—a life that Dawa considered dull compared to the climbers who would return from expeditions with cool →

→ equipment and impressive stories. Dawa Yangzum wanted become the first woman from her village to climb Everest.

In 2003, Dawa Yangzum was 13 years old and ready for something different. She had a bad relationship with her father, she was not in school, and she had no reason to stay in the valley. So when a trekking group came into town looking for porters, she jumped at the opportunity. Without telling anyone, Dawa Yangzum left Rolwaling Valley. She and five other girls, who were all 18, were hired to carry heavy loads for six days through the snow to a neighboring town. When the other porters headed back to the valley, Dawa Yangzum kept going, all the way to Kathmandu. She lived there for the next five years with various family members: an uncle, cousins, her brothers. At 18, Dawa Yangzum's older brother, who worked as a guide on Everest and other peaks, hired her as a trekking guide. She enjoyed the work, but realized it paled in comparison to her biggest dreams of summiting Everest. In 2010, she took a free climbing course at the Khumbu Climbing Center (KCC), a nonprofit school started by American climbers Conrad Anker and Jenni Lowe-Anker designed to teach Nepalese climbers the technical skills required to do their jobs safely on expeditions. When instructors noticed her proficiency with knots, rescue systems, and climbing technique, they asked her to come back the next year as an instructor.

"One of the big, big things is that I was in KCC, which really helped me," Dawa Yangzum says. "When you go to climbing school, you just go there with your clothing and then you get harnesses, crampons, a helmet. Everything's there and you just go climb and then give the gear back. If you rent it out, it's expensive, and it's not the good stuff. The KCC really helps you in the beginning." Dawa Yangzum spent the next two years gaining experience by climbing 23,000-foot (7,000-meter) Himalayan peaks and taking more intensive mountaineering classes. After teaching at KCC in 2011, Dawa Yangzum was invited by Anker to join a 2012 Everest expedition sponsored by *National Geographic* and The North Face, a climbing gear manufacturer. She was excited, but also nervous about how tough it would be. And it was, hauling dozens of heavy loads between the various camps and climbing hundreds of vertical meters at high altitude day after day. But when she stood on top of the 29,029-foot (8,848-meter) peak on May 25, 2012, it was all worth it.

Summiting Everest was not only the realization of a lifelong dream, it was also a major turning point for Dawa Yangzum's career. She wanted to lead the climbing expedition instead of just running support for it, so she decided to pursue guiding. What followed was several years of rigorous training courses, exams, and ticking big personal climbing objectives. She started spending summers on mountains in the United States, mostly Mount Baker and Mount Rainier in Washington, then spring, fall, and winter back in Nepal. She summited Island Peak (20,305 feet [6,189 meters]) and Ama Dablam (22,349 feet [6,812 meters]), and got a first ascent on Mount Chekigo (20,532 feet [6,812 meters]). In 2014, Dawa Yangzum and her climbing partners, Pasang Lhamu Sherpa Akita and guide Maya Sherpa, stood atop K2, the second-tallest mountain

↑ *Top* At the trailhead to Mount Baker in Washington. ↑ *Above* Being a guide means carrying a much heavier pack than the clients. ↓ *Below* The tools of her trade as a mountain guide. → *Right page* Dawa Yangzum teaches climbing school on Mount Baker in Washington.

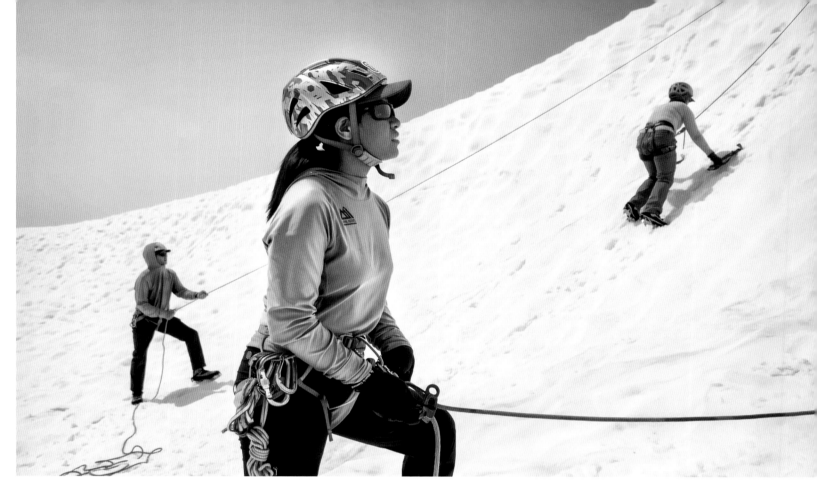

IN 2014, DAWA YANGZUM AND HER CLIMBING PARTNERS,
PASANG LHAMA SHERPA AKITA AND GUIDE MAYA SHERPA,
STOOD ATOP K2, THE SECOND-TALLEST MOUNTAIN IN
THE WORLD AT 28,251 FEET (8,611 METERS). THEY BECAME
THE FIRST ALL-FEMALE NEPALI TEAM TO SUMMIT THE
"SAVAGE MOUNTAIN."

in the world at 28,251 feet (8,611 meters). They became the first all-female Nepali team to summit the "Savage Mountain." In 2017, Dawa Yangzum earned her International Federation of Mountain Guides Associations (IFMGA) certification, making her the first Nepali woman ever to do so, and the next year she climbed the highest peak in North America: 20,310-foot (6,190-meter) Denali. Shortly after becoming a sponsored athlete by The North Face, Dawa Yangzum summited the fifth-highest mountain in the world, Makalu (27,825 feet [8,481 meters]), climbing from Advanced Base Camp to the summit in 21 hours.

While her climbing career and guide certification process has been filled with ups and downs, including times when she was depressed and wanted to quit, Dawa Yangzum is very happy with her lifestyle and decision to see it through. She splits time between Rainier and Boulder, Colorado, when she is in the United States, and Kathmandu when she is in

Nepal, working as a guide in both countries. Her family and friends want her to slow down and stay put somewhere, but she is not stopping anytime soon. Future objectives include a winter ascent of an 8,000-meter peak, climbing Everest without oxygen, and putting new routes up in Rolwaling Valley. In the first 10 years of her climbing career, Dawa Yangzum was the only woman from her village who was climbing. Then one year three girls from the Rolwaling Valley started climbing peaks.

"I'm considered not a good girl 'cause I'm too much outwards, too much rough, and too much climbing," Dawa Yangzum says. "My friends and family don't understand me, they say, 'Oh, you have so many things, you have fame, you have so much going on, still why do you keep climbing?' I keep telling them, 'I think climbing is the thing that brought me here; mountains and climbing made me who I am today. I should climb.'"

THE LIFE OF MOUNTAIN GUIDE ERIN SMART

Climbing and skiing in the mountains every day sounds like a dream job to most, but dangerous conditions, lengthy training, and seasonal employment can be major drawbacks. Erin Smart shares her life and career as a mountain guide.

"I STILL VIVIDLY REMEMBER MY FIRST TIME DOWN THE ARÊTE OF
THE AIGUILLE DU MIDI WITH MY SKIS, LOOKING OUT AT THE ALPS.
IT WAS A MAJOR AHA MOMENT FOR ME, IN THAT I KNEW THE
MOUNTAINS WERE EXTREMELY IMPORTANT TO ME AND SOON
AFTER BECAME THE CENTER OF MY LIFE."

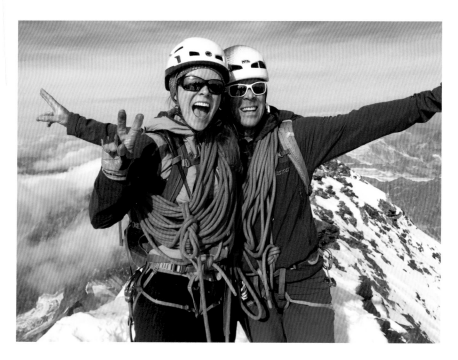

↑ *Top* A beautiful finger crack section on the *West Face* route on
North Early Winters Spire, an alpine climb in the Cascades of
Washington. ← *Left* Erin on the summit of the Matterhorn with her
brother, Miles, who is also a guide and an inspiration for her
becoming a guide. ↑ *Above* Ski guiding clients in La Grave, France,
in the Couloir Olympique, a beautiful south-facing couloir that
descends into the Vallon de la Selle.

Watching the shadow of the mountain rise in the early morning light, right before the sun comes up. Fresh powder tracks in hidden couloirs. The perfect hand jam high on an alpine peak. Sharing these experiences with amazing people. While this might sound like the brochure for an outdoor lover's dream vacation, it is the way Erin Smart describes her job. As a mountain guide living in La Grave, France, Erin takes clients climbing and skiing almost every day in the summer and winter—and gets paid for it.

If ever a person was born to do something, Erin Smart was born to be a mountain guide. Growing up in Seattle, Washington, her family had a small cabin near Stevens Pass in the Cascade Mountains. As a kid, she was exposed to the culture, music, and city life of Seattle during the week, then spent every weekend skiing at the cabin. There she was forced to keep up with her brothers in the mountains. "They pushed me to be like them, to keep up," she says. "My stride became long, and my complaints kept to a minimum, for fear of being the little sister left behind." At 15, she visited her older brother, Miles, in Chamonix, France, to ski and alpine climb. At the time, Miles was training for his own career in guiding. That same year he had started guiding in Jackson, Wyoming, with Exum Mountain Guides. Three years later, Miles would become the youngest American to get internationally certified at the age of 24. The trip to Cham was Erin's first introduction to the French Alps, and a major turning point in her life.

"I still vividly remember my first time down the arête of the Aiguille du Midi with my skis, looking out at the Alps peeking out through the blanket of clouds," she says. "It was a major aha moment for me, in that I knew the mountains were extremely important to me and soon after became the center of my life." When she got home, she came up with a plan to graduate from high school a year early, save money from her summer job lifeguarding, and spend what would have been her senior year skiing in La Grave, where her brother was working as an Aspirant Guide. She assisted him throughout the winter and became a part of the community of American, Swedish, and French mountain guides who worked there. The next year, she went to college at Western Washington University and spent winters ski patrolling at Mount Baker Ski Area. After graduating, she went back for another ski season in La Grave and realized she wanted to pursue guiding as a career. Soon after, she took her first trip guiding real clients to climb Washington's Mount Baker.

"It was instant satisfaction," she says. "Bringing clients to that first summit filled me with such joy, even with the patience of walking oh-so-slowly to the top and back down again. Their smiles and joy of sharing the mountains and an incredible summit stuck with me. I was so elated after that first trip. I also remember a strong feeling of accomplishment when all the clients were so impressed with this small girl carrying a pack twice as big as theirs and with energy to spare."

Since Erin wanted to guide internationally, particularly in France, she needed an IFMGA certification (International Federation of Mountain Guides Associations), which is an expensive process that can take years. Guides must take courses in rock climbing, skiing, and alpine climbing, then take exams, as well as keep up with personal objectives in rock, ski, and alpine. It took Erin six years, starting in February 2010 and finishing in September 2016. "When I began the program, it was a near-impossible dream. But when I accomplished it, nothing felt sweeter. There was a time in the middle, when I was living month to month and had to move back in with my parents to afford guiding, going through the expensive training program and unpaid personal training, that I thought about giving up on the program. I began to think about changing careers entirely, to make some money and a living. But my brother convinced me to stick with it because I was so close to the end. I'm so glad I did!"

Besides the fulfilling and often fun aspect of getting into the mountains for work, the seasonal nature of guiding is one of its biggest draws. In a typical year, Erin will work in the summer and winter, alpine climbing and skiing, respectively, then take spring and fall off for personal skiing and climbing expeditions. "The year begins in La Grave, where I spend almost every day skiing. The majority of days are working with clients coming for the freeride and couloir skiing in the area—winter is my biggest work season. Most of my clients are excellent skiers, which allows us to ski some of the better lines in the neighborhood, so my office isn't too bad!" Springtime means a personal ski trip with her partner, Benjamin Ribeyre (who is also a guide), often in France, Alaska, or the Cascades. Work picks up again in the summer for alpine climbing in Les Écrins, Chamonix, and Zermatt, Switzerland. She and her partner are off again in the fall, when they head off to climb in spots like Liming, China, or the Himalaya. Then in December she will dust off her skis again and teach a few avalanche education courses while the snow accumulates.

In January, the clients show up in La Grave, and she starts the cycle all over again.

She has had a few close calls with broken ski bindings and falling rocks, but the most notable was heli-skiing in Italy. "As I was skiing with my group and another guide, there was a helicopter crash above us on the same mountain. There was a deep, persistent weak layer, and the helicopter crash triggered an avalanche deep in the snowpack. Within an instant, the mountain was falling down above us. The other ski guide and I were able to straight-line out of the fall line and miraculously, there was a small ridge feature that we reached. The three clients were swept into the avalanche. Two were on the surface because of their airbag packs that they were able to inflate, and the third was buried—she was knocked out by the force of the avalanche and was unable to pull the airbag trigger. We got to her quickly and unburied her from the snow and she was fine. Everyone survived the avalanche, as well as everyone in the helicopter crash survived. That was a crazy day."

With a life and career so deeply embedded in the mountains, one might think that getting outside every day might get repetitive, but Erin "just can't and doesn't want to stop." She says, "I feel the most myself in the mountains, and when I'm away for too long I feel off. My passion has become a huge part of my identity, and I would lose a piece of myself if I stayed away for too long." She does have other interests—the ocean, writing, live music, movies, surfing—but she loves her job. "When guiding, you get to have people at their best. They are on vacation, they've chosen to come to you, and they have put trust in you that you will pick the best outing for their trip. I get to gain a lot of faith in humanity within my job," she says. The hardest part for her is being so reliant on the weather and conditions. Wanting to provide excellent trips for her guests, she gets frustrated and stressed when the conditions make it difficult or impossible to climb or ski certain lines. With climate change affecting the very state of the mountains she relies on for work, Erin recently passed the French mountain bike guide exam to diversify her options and adapt her career as the conditions permanently change. Despite those difficulties, Erin loves her winter work and looks forward to the potential evolution of her summer work. It is building strong relationships with clients, climbing and skiing bigger routes with more confidence in each other, that keeps her coming back. No matter what happens, Erin says, guiding and working in the mountains will always be a part of her life.

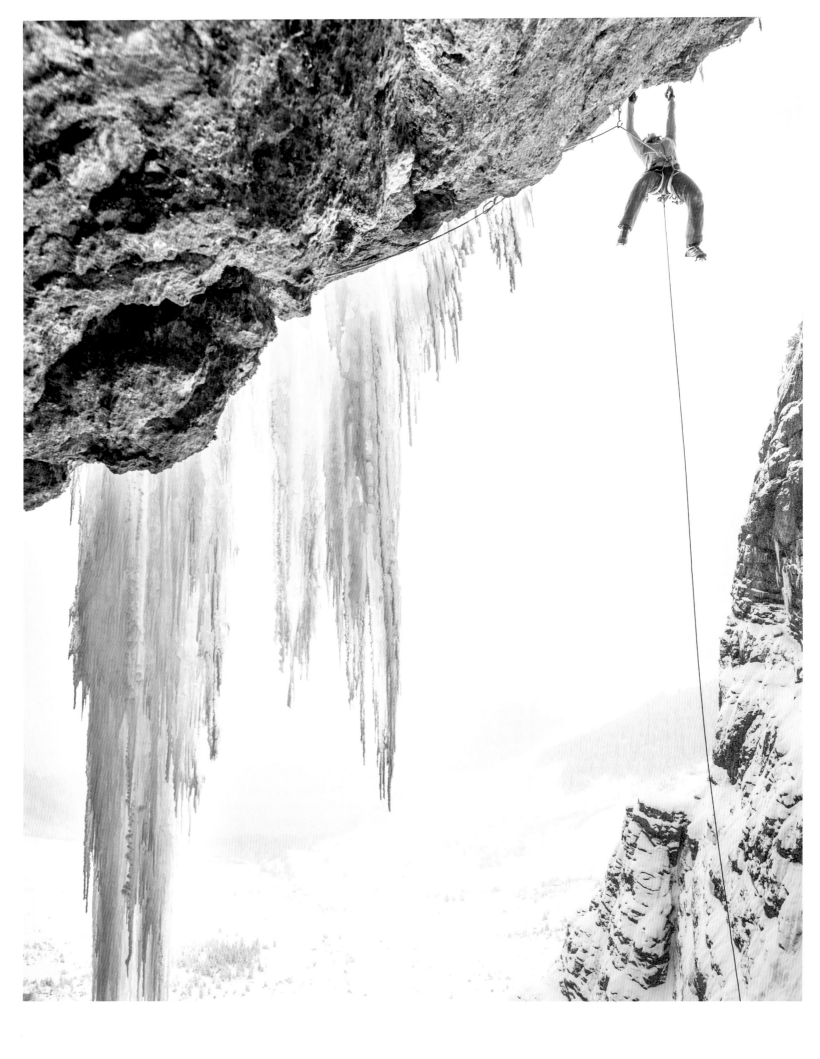

INES PAPERT

AFTER A CHILDHOOD SPENT IN SOVIET-RULED
EAST GERMANY, THIS CLIMBER MOVED
TO THE MOUNTAINS AND QUICKLY BECAME A WORLD
CHAMPION ICE CLIMBER AND A CUTTING-EDGE ALPINIST—
ALL WHILE BEING A SINGLE MOTHER.

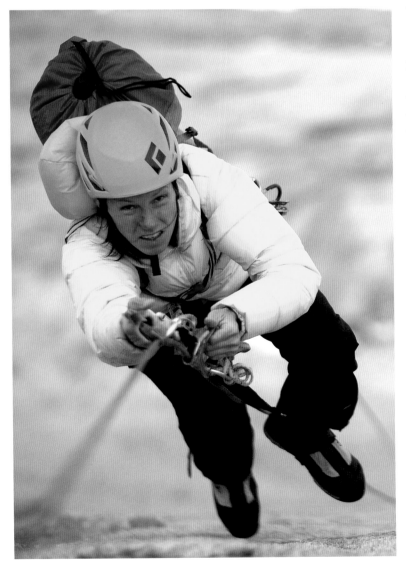

Waking up to a gray and cloudy morning, three climbers hang off the side of a mountain in the Canadian Rockies. It is *very* cold—as in, "a few minutes of exposure could lead to frostbite." At about 10,800 feet (3,300 meters) above sea level, the mountains in the Valley of the Ten Peaks near Canmore are not the tallest in the world, but they offer obscenely cold temperatures, unpredictable weather, and highly variable conditions that add up to dangerous situations up high. The climbers are actually thankful for the bone-crushing cold, because that means more stability in the terrain and a lower chance of avalanches. The trio is settled on a narrow snow ledge, clipped into the wall to keep them from tumbling several thousand feet to the valley floor below. They wear every layer they have, share sleeping bags for warmth, and melt snow for water. They only got a few hours of restless sleep after a long day of climbing. As they move up, the pitches get steeper, the rock looser, and the route-finding harder as the three climbers move delicately over the rock, snow, and ice. A few hours later, a snowstorm hits.

This was the scene right before Ines Papert, Brette Harrington, and Luka Lindič topped out the first ascent of *The Sound of Silence* (WI5, M8; the mixed climbing difficulty is WI5, and the ice climbing difficulty is M8) a 3,600-foot (1,100-meter) alpine route on Mount Fay (10,610 feet [3,234 meters]), and it is a scene that has played out hundreds of times in Ines Papert's life. The climber has been at the cutting edge of alpinism since the early 2000s, having climbed some of the hardest mountain routes in the world, many of them first ascents. She specializes in a style that combines rock, ice, snow, and mixed climbing in bad weather on unfriendly peaks in faraway locations. (Mixed climbing is a discipline that involves using ice tools, →

→ which are usually reserved for ascending ice, on rock, which is sometimes dry and sometimes covered in ice or snow.)

Her accomplishments are almost too vast to put on a short list, but here are a few: She has sent mixed climbs up to the difficulty of M13, one of the hardest grades in the discipline. She nabbed a solo first ascent of Likhu Chuli I in Nepal—meaning no one had ever stood on the summit— via the 22,043-foot (6,719-meter) mountain's north face. She made a first ascent of the route *Azazar,* a nine-pitch rock route in Morocco graded 8a/5.13b. Over the course of two weeks, Papert made a fifth ascent of *Riders on the Storm,* a 4,265-foot (1,300-meter) route (5.12d/7c, A3), in Torres del Paine, Patagonia. Her proudest ascent happened in October 2016, when she and Lindič put up a new route on the southeast face of Kyrgyzstan's Kyzyl Asker (19,167 feet [5,842 meters]) that was 4,000 feet (1,200 meters) long and graded WI5, M6. Papert had failed on two other expeditions to this mountain, but when she topped out in 2016, she says she was the happiest person on the planet. "There are many ascents that I feel proud about, but on this one, we were a great team," she says. "One reason is that I invested more in this than in any other project. The other reason is that I found the partner of my life." The couple have had incredible successes together, including the north faces of Piz Badile and Grandes Jorasses, but they have also experienced intense near-misses. When attempting a new route on Nyanang Ri (23,200 feet [7,071 meters]) in May 2018, the climbers got caught in a massive avalanche the day before their summit push.

Papert also excelled in ice climbing competitions from 2000 to 2008, winning more than 20 World Cup events, multiple Ouray Ice Festivals (including winning first place overall in 2005, meaning she won both the men's and women's divisions), and a European Championship. She had a quick rise to success in competition ice climbing, thanks in part to how much she loved the community of climbers. "I never had the feeling we climb against each other," she says. "This way I never felt any pressure. Soon we were all friends, and I was so proud being a part of the international climbing community." Papert liked competitions, but climbing plastic got boring after a while. She decided to retire from competitions and refocus her efforts on climbing new routes in the mountains and doing expeditions.

And what motivated her in the mountains in the beginning is what motivates her now. "Seeing an eye-catching line that drives me has always been the start of it," she says. "Of course, the difficulty has always been part of it since I am a human being who wants to explore my own possibilities and boundaries. I also look more for unclimbed lines, since over the years I learned how adventurous a new route is. No one can tell if it's even possible."

Despite a seemingly natural talent, Papert grew up in a very flat part of East Germany, "called Saxonia, behind the Iron Curtain." During a time of oppressive Soviet rule, Papert and her sister explored the forest surrounding their house, but not much farther. Her parents worked hard to provide them a nice life, including getting into the nearby mountains for

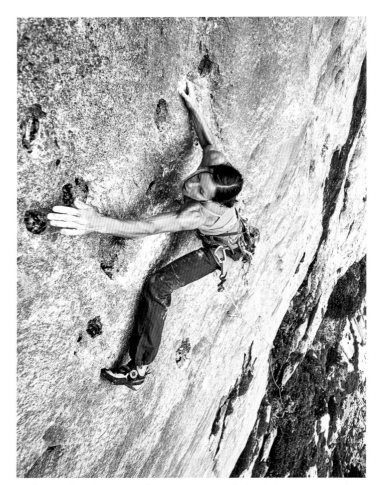

↑ *Above* During a free ascent of the route *Scaramouche* (5.13b/8a) in Berchtesgaden am Hohen Göll. ↓ *Below* Bivying 3,000 feet (1,000 meters) above the ground on the southeast wall of Kyzyl Asker, Kyrgyzstan, on the first ascent of *Lost in China* with her partner in climbing and life, Luka Lindič (rechts). → *Right page* Climbing the frozen waterfall Finnkona on the island of Senja, in Norway. →→ *Following spread* Ice climbing in Rjukan, Norway, in a gorge that offers numerous possibilities in almost all levels of difficulty.

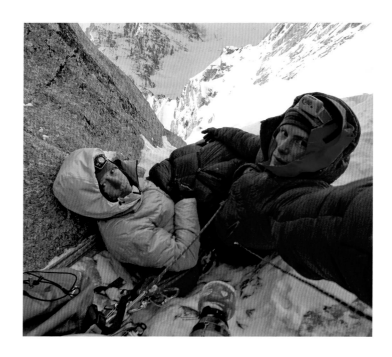

skiing and hiking a few times a year. "They were very active, progressive, and revolutionary, trying to change the communist system," she says. When the Berlin Wall came down in 1989, Papert was 16 and itching to travel and explore the Alps. Two years later, she moved to Bayerisch Gmain near Berchtesgaden, where she still lives to this day, to hike, bike, ski, and climb. She found friends to take her out and teach her the necessary skills, and she could not get enough. "During some earlier trips to Yosemite and South America, I fell in love with the exploration part of climbing," she says. "For me it soon became a lifestyle, more than just a sport. All year round I explored the mountains, no matter if by ski, bike, or while climbing. But apparently I was somehow talented for climbing and the exposure did not bother me at all." Right when she was rapidly progressing, Papert found out she was pregnant.

This did not stop her thinking about climbing, and it was not until after her son, Emanuel, was born in 2000 that climbing became her career. "I kept competing, won pretty much everything you can win in ice climbing, and managed more and more to make my and my son's living out of that," she says. "Plus I was able to travel more than ever before." Her son (she calls him "Manu") does enjoy climbing, but more on the dry-rock side of things with sport climbing and bouldering. "When it comes to sport climbing, we have pretty much the same level, but I will never convince him to do more alpine climbing," Papert says. As Manu gets older, Papert notices more and more that he does not want to follow in her big-mountain and alpine footsteps exactly. "But that's more than OK," she says, "I am happy to plant the seed in him, having the same feeling and appreciation for the mountains."

"DURING SOME EARLIER TRIPS TO YOSEMITE AND SOUTH AMERICA, I FELL IN LOVE WITH THE EXPLORATION PART OF CLIMBING. FOR ME IT SOON BECAME A LIFESTYLE, MORE THAN JUST A SPORT."

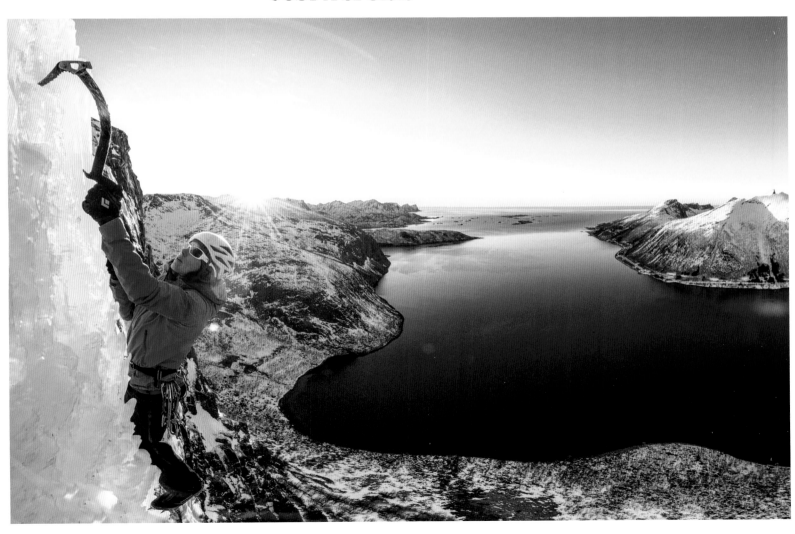

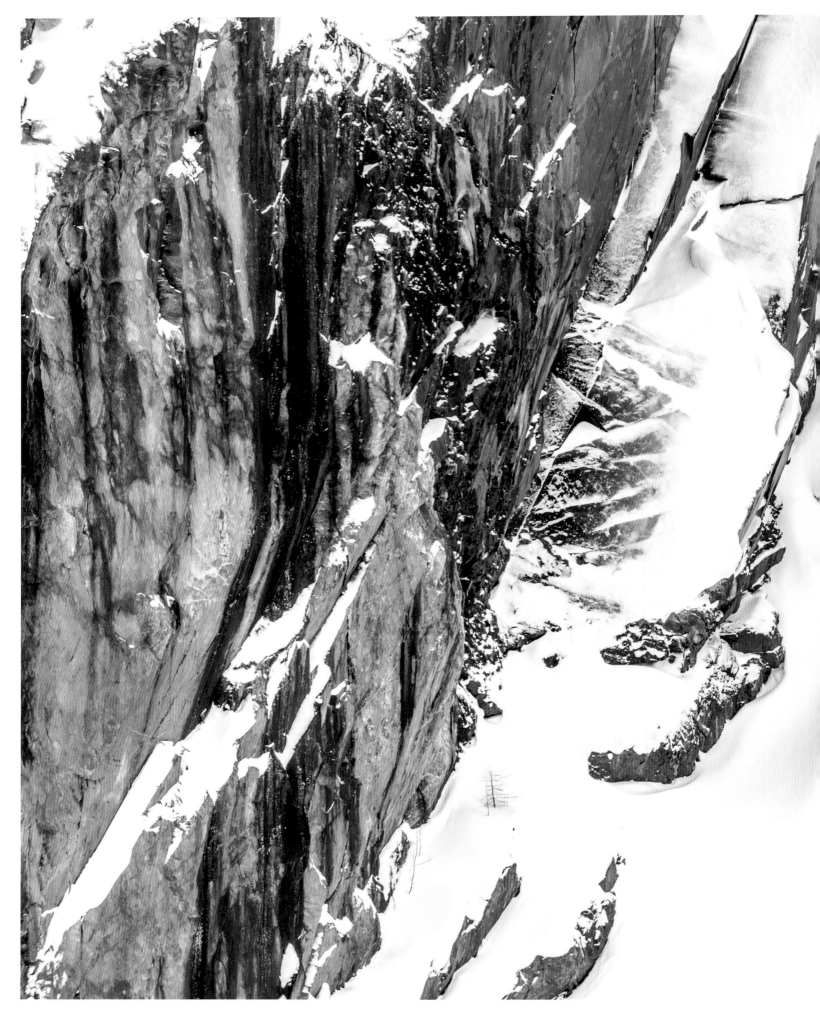

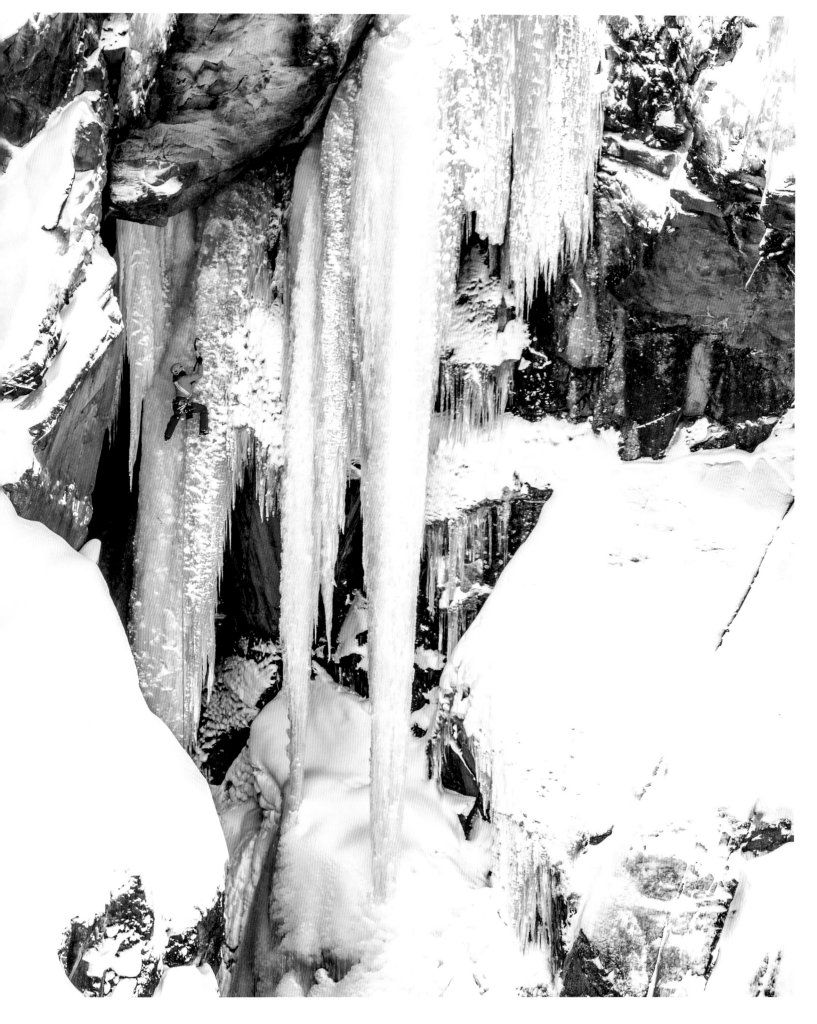

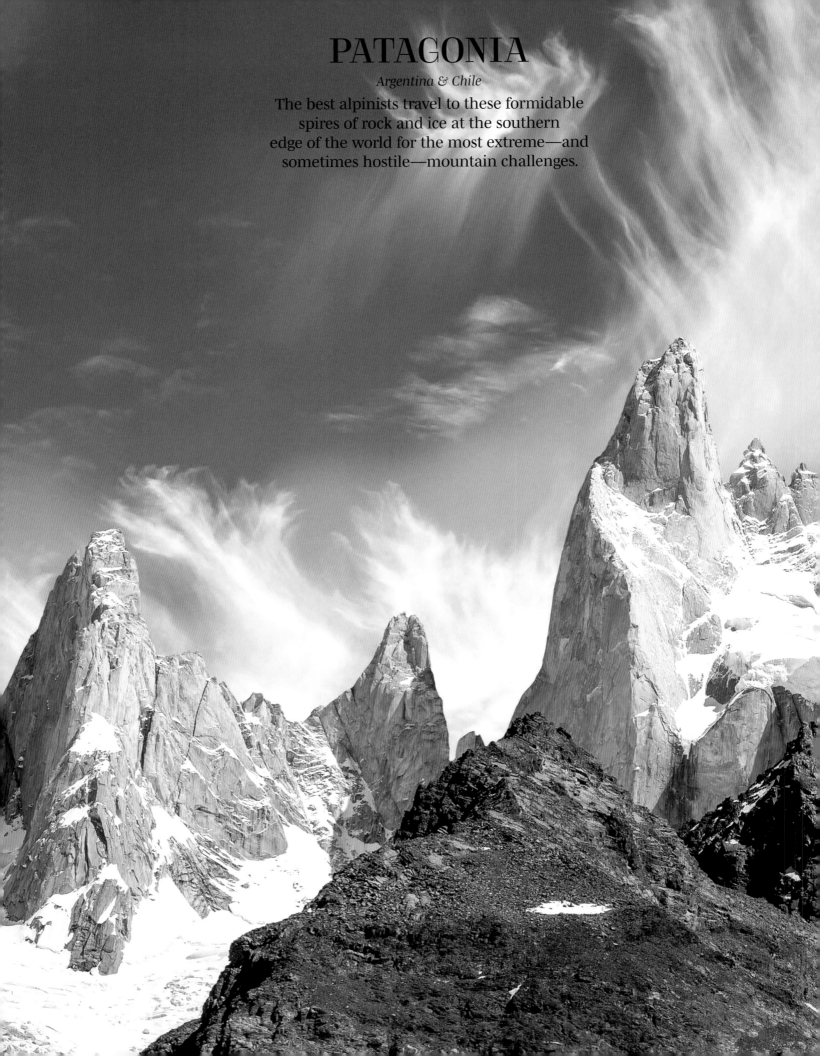

PATAGONIA

Argentina & Chile

The best alpinists travel to these formidable
spires of rock and ice at the southern
edge of the world for the most extreme—and
sometimes hostile—mountain challenges.

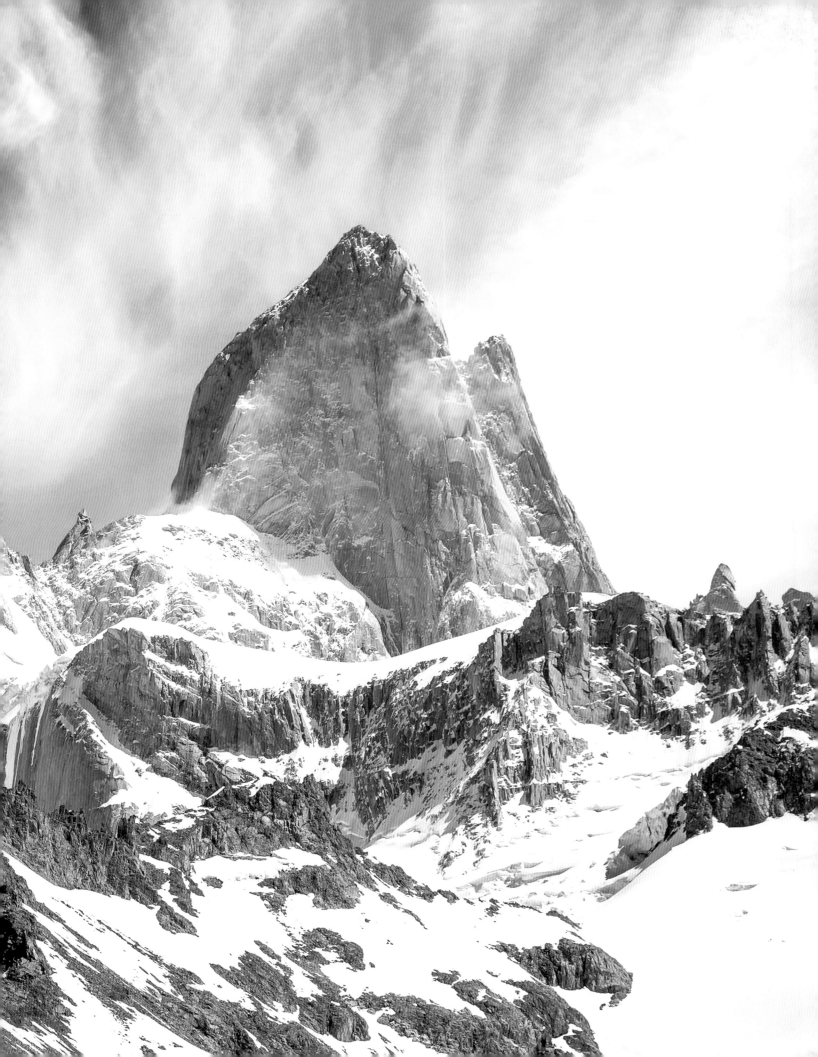

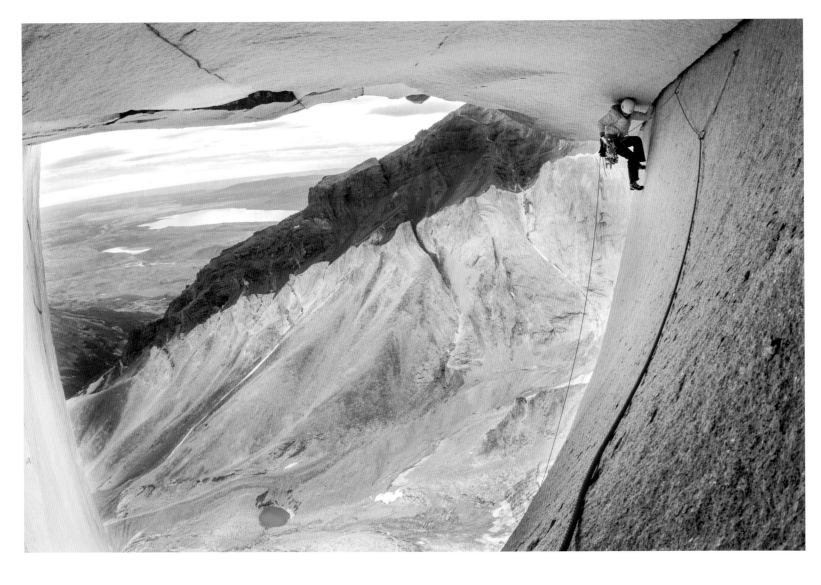

At the very bottom of the Andes Mountains, the Patagonia region covers more than 386,000 square miles (1 million square kilometers) in Chile and Argentina. With an awe-inspiring landscape, Patagonia encompasses multiple ecosystems and is bordered by three oceans. While the massive zone is a favorite destination for all types of nature enthusiasts, climbers are drawn to the southern end, where the famed peaks Fitz Roy and Cerro Torre dominate the skyline. The sheer granite towers that seem to explode out of the Southern Patagonia Ice Field, a 217-mile (350-kilometer) ice mass that feeds dozens of the area's glaciers, are intimidating—and rightfully so. The holy trinity of alpine climbing— heinous weather; hard ice, snow, and rock climbing; and the utter length of the routes—makes any Patagonia outing a serious alpine endeavor.

"World's Worst Weather" reads the wooden plaque outside Rolando Garibotti's cabin in El Chaltén, Argentina. At almost 50° south, this small town, with a year-round population of a few hundred residents, is the gateway for hikers and climbers in the area. Climbers will watch the weather forecast for weeks, waiting for short windows of decent conditions. Even with the rapid advancement of weather forecasting, the real-time situation can change in an instant, blasting climbers with 62 mph (100 kmph) winds, driving snow, and whiteout visibility. If Chaltén is the gateway, then Garibotti, known as Rolo, is the gatekeeper. He's the man behind Pataclimb.com and has authored a guidebook with Dörte Pietron, *Patagonia Vertical: Chaltén Massif.* Born in Italy and raised in Bariloche, Argentina, 1,056 miles (1,700 kilometers) north, a 10-year-old Rolo first visited El Chaltén in 1982 as a tourist. Five years later he came

back as a climber, and over the next three decades built a résumé that has earned him the title as one of the world's greatest alpinists. (He is also technically a knight. Italy made him a Cavaliere dell'Ordine della Stella della Solidarietà Italiana in 2009 for his international climbing achievements.)

Patagonia is one of the most remote places in the world, with no search-and-rescue team and no helicopter; the only form of retreat is self-rescue. Although many of the grades seem moderate at the 6a+/5.10 level, the alpine nature, often ice-covered rock, technical ice climbing, snow spindrifts, bad weather, and length of the routes have a multiplier effect on the difficulty. Climbers get in over their heads all the time, so much so that Rolo provided a preliminary questionnaire for climbers heading into the mountains. He writes:

"The huge number of accidents that have been happening in comparison to the

number of users is worrisome. The experience of some of the climbers relative to the objectives they choose is concerning. Each good weather window there is at least one serious accident. Because the rescues are done on a volunteer and good Samaritan basis, at this pace the pressure on the local community is unsustainable."

There are 50 questions that require climbers to ask themselves: "Do we have group, cultural, or personal pressure? Do we feel compelled to have a certain result? Are we aware that half of the climbing deaths in this area have occurred while descending? Are we able to put our partners on our backs and rappel multiple times until we reach the ground? Have we practiced this enough to be able to do it under stress?"

Rolo's career highlights include the first ascent of the Torre Traverse, first ascent of 10,262-foot (3,128-meter) Cerro Torre

from the north, and the first complete ascent of Fitz Roy's north face. Rolo became one of the first climbers to champion an "alpine style" of climbing, foregoing fixed ropes and big expeditions for a fast-and-light approach: two people, each with a backpack, go climbing. The older expedition style required a lot of time and human power, setting up fixed lines, large group sizes, and weeks or months spent trying to climb one route. One of the most controversial examples of this was when Italian mountaineer Cesare Maestri and his crew attempted the southeast ridge of Cerro Torre in 1970. They fixed thousands of meters of ropes and dragged a gas-powered compressor and bolt gun up the mountain to drill more than 400 bolts. This massive bolt ladder required little technical skill to climb and drew criticism from climbers worldwide. In 2012, American Hayden Kennedy

and Canadian Jason Kruk climbed the dubiously named *Compressor Route* by "fair means," bypassing the bolt ladder, placing natural protection, and only clipping into two of Maestri's bolted anchors, which they considered a reasonable use. On the descent, the North American duo removed approximately 125 of the original bolts, a controversial act that stirred much debate in the international climbing community. (There are many more parts to this complex Cerro Torre story, and the whole saga is documented in Kelly Cordes's *The Tower*.)

In an essay about Maestri's bolts on Pataclimb.com, Rolo writes, "Like most things in life, the why relates to the how. …There is something deeply contradictory about such an overwhelmingly manufactured pathway, on such a fantastic peak, existing merely so people can stand on top."

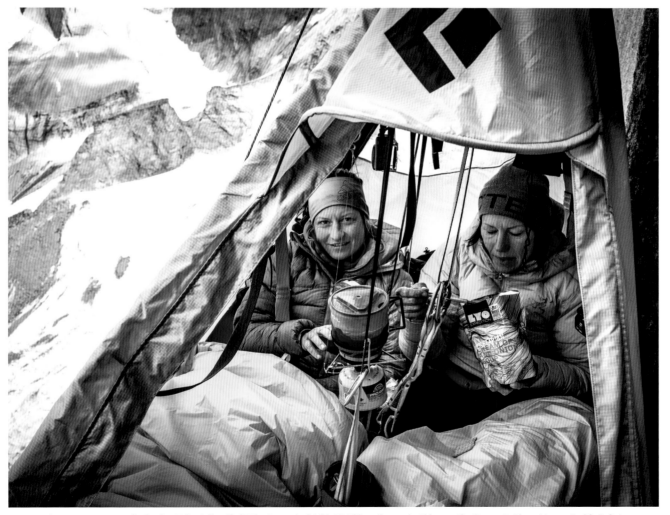

← *Left page* Ines Papert climbs the 27th pitch called "The Rosendach" (7b/5.12b) on the route *Riders on the Storm.* ↖ *Above* Mayan Smith-Gobat (left) and Ines Papert enjoy a little respite from the wind and cold temperatures in their portaledge on *Riders on the Storm* in Torres del Paine. →→ *Following page* Mayan Smith-Gobat climbs one of the key pitches (7C/V10) of *Riders on the Storm* in Patagonia.

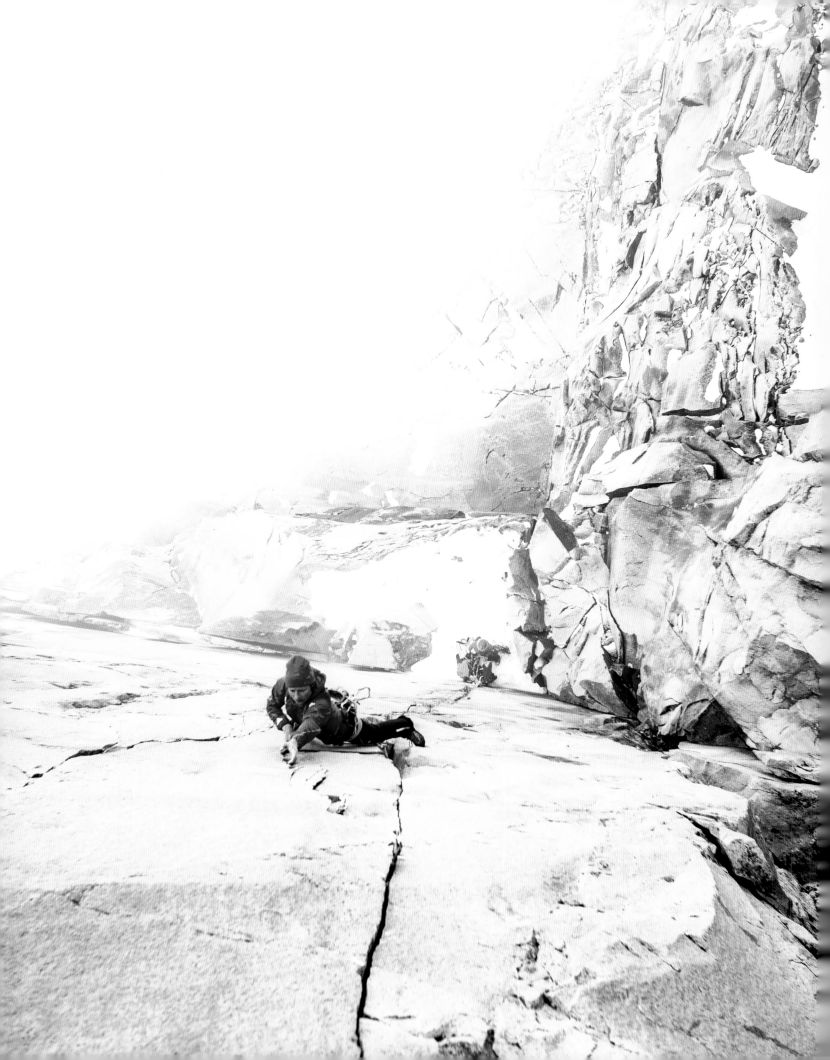

PATAGONIA

in a Nutshell

CLIMBING TYPE

Trad, alpine, mixed
(rock, ice, snow)

PROTECTION

Trad rack, ice screws,
snow pickets

SEASON

Winter (Southern
Hemisphere summer)

WHERE TO STAY

Camp at one of the
numerous campgrounds,
or book a hostel.

ONE MORE THING

While the Cerro Torre / Fitz Roy
massifs involve big, high-
commitment climbs, there is
plenty of climbing in Patagonia
for a moderate ability level. For
alpine routes, there's Torres del
Paine, south of El Chaltén; for
sport climbing and bouldering,
there's plenty right outside the
town of El Chaltén, or try Piedra
Parada, south of Bariloche.

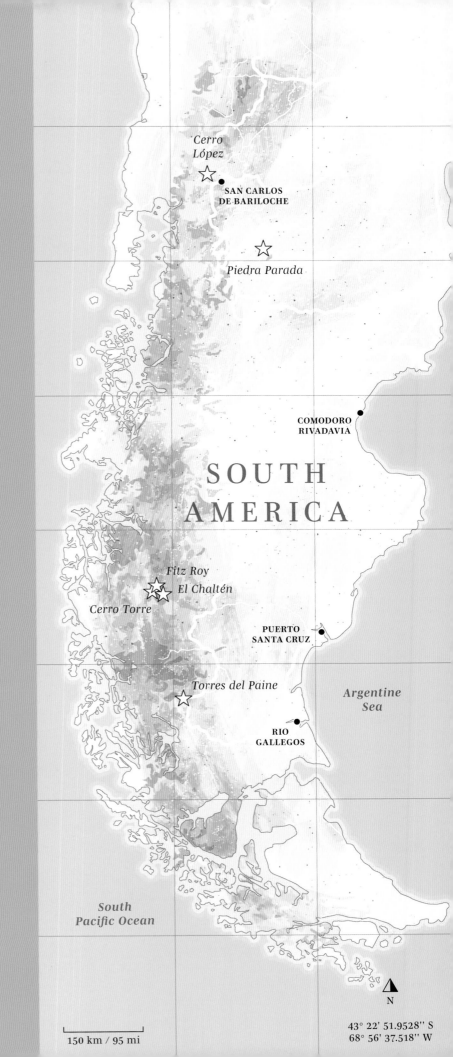

Cerro
López

SAN CARLOS
DE BARILOCHE

Piedra Parada

COMODORO
RIVADAVIA

SOUTH
AMERICA

Fitz Roy
El Chaltén
Cerro Torre

PUERTO
SANTA CRUZ

Torres del Paine

*Argentine
Sea*

RIO
GALLEGOS

*South
Pacific Ocean*

N

150 km / 95 mi

43° 22' 51.9528'' S
68° 56' 37.518'' W

THE CLIMBING WORLD TOUR OF CHARLOTTE DURIF & JOSH LARSON

This pro climber couple went on their dream climbing trip,
traveling to six continents over the course of a year, putting up new routes,
meeting new people, and having the experience of a lifetime.

IN THE MIDST OF WRITING HER PHD THESIS IN MATERIAL SCIENCE FOR NUCLEAR CHEMISTRY AND WATER FILTRATION, AND JOSH TRAVELING BETWEEN FRANCE AND THE UNITED STATES, THEY STARTED TO ORGANIZE THEIR PLAN: SPEND MORE THAN A YEAR TRAVELING THE WORLD TO CLIMB.

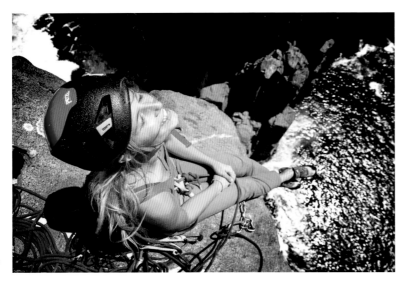

↑ *Above* A night under the stars on Mount Cook, New Zealand.
← *Left* Enjoying the summit on one of the many climbable towers in Tasmania. ↓ *Below* Climbing around the world in a year means weeks of travel. →→ *Following spread* Climbing on a foggy day in Little Babylon, New Zealand.

Traveling the world can be an incredible, life-changing experience, and climbing is a great excuse to visit far-away countries. Exploring new areas is half the reason some people climb in the first place. Meeting other climbers, experiencing different cultures, eating exotic dishes, climbing fresh routes—it is a special treat that many climbers will only get to experience a few times in their lives, if at all. In 2016, when Charlotte Durif was getting close to finishing her PhD in her home country of France, she and her boyfriend, Josh Larson, who had been working as a route-setter in Boston, Massachusetts, started talking about what they wanted to do when she was done with academia.

Climbing had always been a central part of their lives—she started at 9 and he started at 14, and they had both accomplished a lot in competitions and outside on real rock. They knew that whatever they did, it would be centered around climbing. "Amongst the realistic ideas, we said, 'Let's travel the world,' thinking right away, 'Yeah right, we can't do that,'" Charlotte says. "We don't have the money, not possible for our careers." A few weeks later, the idea stuck with them, so they looked into it and realized it would be totally possible. In the midst of writing her PhD thesis in material science for nuclear chemistry and water filtration, and Josh traveling between France and the United States, they started to organize their plan: spend more than a year traveling the world to climb.

Charlotte and Josh had met three years earlier when she headed to Boston, where Josh was working as a route-setter at the MetroRock climbing gym, to do an internship at MIT through her engineering studies. She was still involved in climbing competitions, so her coach contacted the head route-setter of the biggest gym in Boston so she could have good routes to train on. "I met this person on my first day across the ocean, and it happened to be Josh, who I got a crush for right away," she says.

"I received an email from the coach of the French National Team about a 'girl' coming to Boston and needing HARD routes to train on," Josh says. "He asked for grades up to 8c/5.14b, and well, our gym never sets that hard, so I had to find out who this French rock star was. I was nervous when I met her, so I knew—things were about to get crazy."

They spent a year organizing their trip, each one picking 10 to 15 places they wanted to climb or develop climbing, and they kept the disciplines broad. "Mountains, routes, bouldering, trad, and deep-water soloing were all in the cards," Josh says. "Even some tourist destinations unrelated to climbing. We narrowed them down to 18 places total by choosing a theme of 'less-traveled places' for climbing." Then they reached out to friends and friends of friends for ideas, information, and travel tips. Then they drew it all out on a map, planned the best weather windows, and gathered as much detail as possible.

Extended travel was nothing new for the pair, as they had spent 100 days traveling across America in an RV a few years earlier, stopping at 10 climbing destinations for a project called "Lost in North America." They had taken the trip early on in their relationship, so they knew that while the world trip would be hard, they could do it. During the RV trip, they had formed a production company called Cold House Media, and through that created a sponsored video series about the journey. For the world trip, they decided to do the same thing, working with climbing brands to create videos, a blog, social media content, and other media surrounding their journey, which they dubbed "A World Less Traveled."

The basic plan was to visit Europe, Asia, Oceania, Africa, South America, and North America, spending anywhere from one to five months on each continent. The list of countries included Greece, Serbia, Japan, Tasmania, Madagascar, Namibia, Peru, and Brazil. A few of the places on the list were already popular climbing areas, but many had some established climbing with the potential to develop even more routes. They bolted routes in Kyparissi, Greece; Pitumarca, Peru; Piedra Blanca in Puerto Rico; and Manang, Nepal, among other places. "We don't go to random places and just throw bolts in the wall," Charlotte says. "Always we are in contact with local climbers to see if they need help to develop new places, or if they think of some new places that they never get the chance to develop. We always make sure that the local communities accept the practice and allow us to bolt, and we always check to see what the local ethics are. It's been an important part to us, but also one of the best ways to really experience the places we've been to, by working closely with the communities."

While they planned their trip out meticulously beforehand, with a set amount of time they would spend in each place, they got used to changing plans on the fly based on weather and motivation. They left a few places early because of the heat, Brazil and Australia in particular. By the time they got to Brazil, they were six months into the trip. "Somehow we were hot all the time," Charlotte says. "Brazil was SO hot I couldn't handle it anymore." The opposite happened for Alaska on the very last leg of the trip in May 2018, where there was too much snow for them to do what they wanted, so they extended their stay in Pitumarca, southeast of Cusco. They had fallen in love with the place, so it was an easy decision. "Endless walls to be developed and climbed, and even mountains and boulders too," Josh says. (They loved Pitumarca so much that they returned in September 2019 to put up more routes.)

With so much travel in planes, trains, and cars, there were plenty of small hiccups along the way, like delayed flights and a stolen passport, and they each had small injuries and illnesses that put them down for a few weeks at different times. Then there was the 660 dollars (600 euros) bag fee on their way to Madagascar. "Luggage was always a bit of a problem with some airlines. Crash pads, ropes, bolting gear, alpine gear, trad gear, camera gear, and then add all the normal things one travels with! Then, we took it all to crazy-remote locations in countries we didn't know much about and where we didn't speak the language! We got lucky, I'd say, with the bad luck," Josh says.

Josh and Charlotte both point to the people they met and the larger climbing community as the best part about their global climbing trip. "Climbing has taken me to all corners of the globe, and at the same time feeling like I'm right at home in a community so passionate and supportive of the outdoors," Josh says. Some of their favorite moments of the trip included bolting sport climbs in Greece "in a near-perfect fishing village, staying in villas and eating lamb and Greek salads every day." In New Zealand, they were in a rented SUV for 45 days, traveling to tourist attractions, climbing Mount Aspiring, sport climbing in the remote fjords of Milford Sound, and bouldering in iconic Flock Hill. In Africa, they went on safaris and had elephants just feet from the car, climbed massive, 2,000-foot (600-meter) peaks, and slept on big walls. Asia was the last leg, where they lived in China, bought a moped, and climbed every day with old and new friends. In Nepal, they trekked to Mount Everest base-camp for 12 days and bolted new routes with local climbers in the Annapurna Range.

Charlotte says supporting each other and listening to each other's motivations and needs, as well as adapting plans if they felt like it, was key to handling the stress of such a big undertaking as a couple. In the end, they had to let things happen and not force anything.

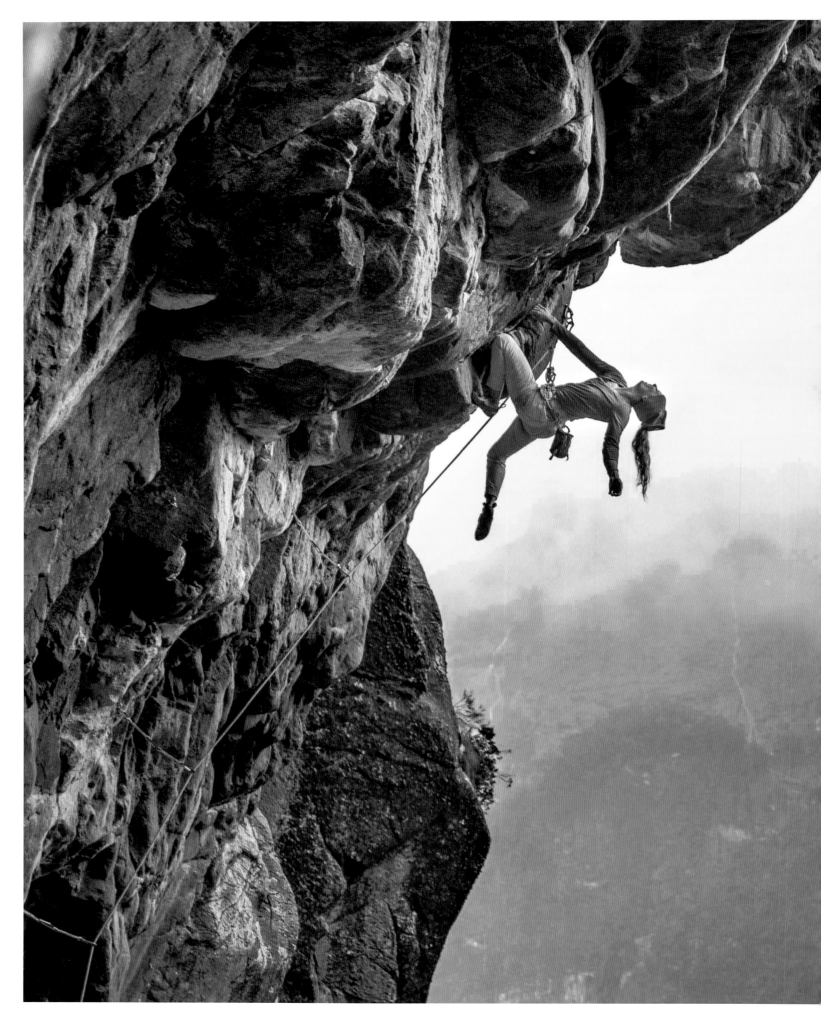

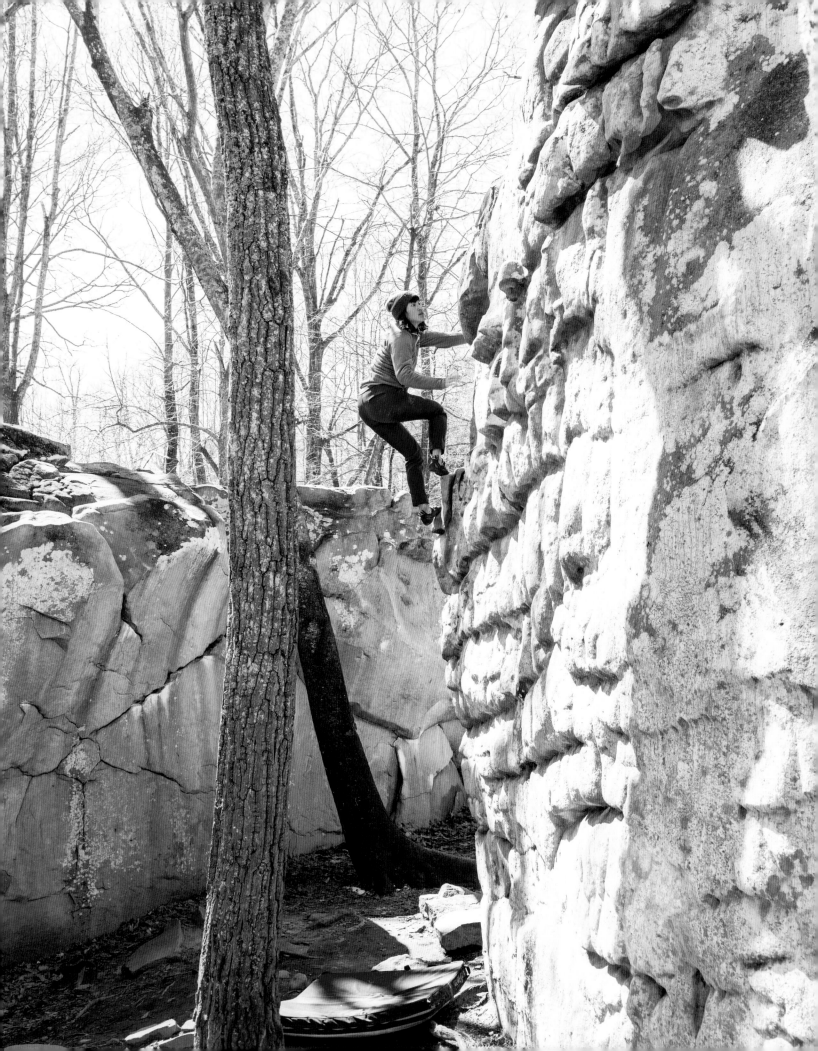

PHOTO CREDITS

CLIFFHANGER

New Climbing Culture
& Adventures

This book was conceived, edited, and designed by gestalten.

Edited by Robert Klanten *and* Andrea Servert
Co-Editor: Julie Ellison

Text and preface by Julie Ellison

Editorial Management by Eszter Kalmár

Photo Aquisition by Eszter Kalmár *and* Mario Udzenija

Design, layout, and cover by Stefan Morgner

Illustrations by Oriana Fenwick

Maps by Bureau Rabensteiner, Innsbruck

Typefaces: Mencken *by* Jean François Porchez * *and* Solide Mirage *by* Jérémy Landes

Cover photography by Reinhard Fichtinger
Back cover photography by Alton Richardson
Endpaper photography by Julie Ellison *and* Keith Ladzinski

Printed by Gutenberg Beuys Feindruckerei, Langenhagen, Made in Germany

Published by gestalten, Berlin 2020
ISBN 978-3-89955-996-5

For more information, and to order books, please visit www.gestalten.com

Bibliographic information published by the Deutsche Nationalbibliothek. The Deutsche Nationalbibliothek lists this publication in the Deutsche National- bibliografie; detailed bibliographic data is available online at www.dnb.de

None of the content in this book was published in exchange for payment by commercial parties or designers; gestalten selected all included work based solely on its artistic merit.

This book was printed on paper certified according to the standards of the FSC®.

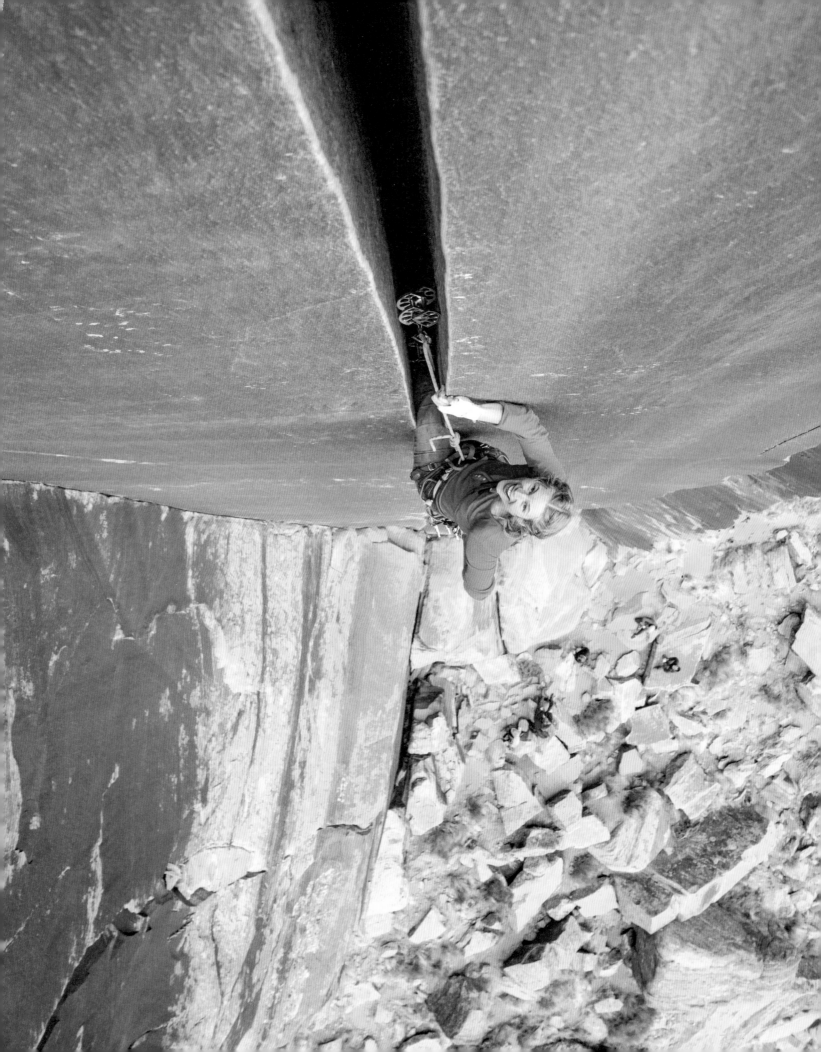

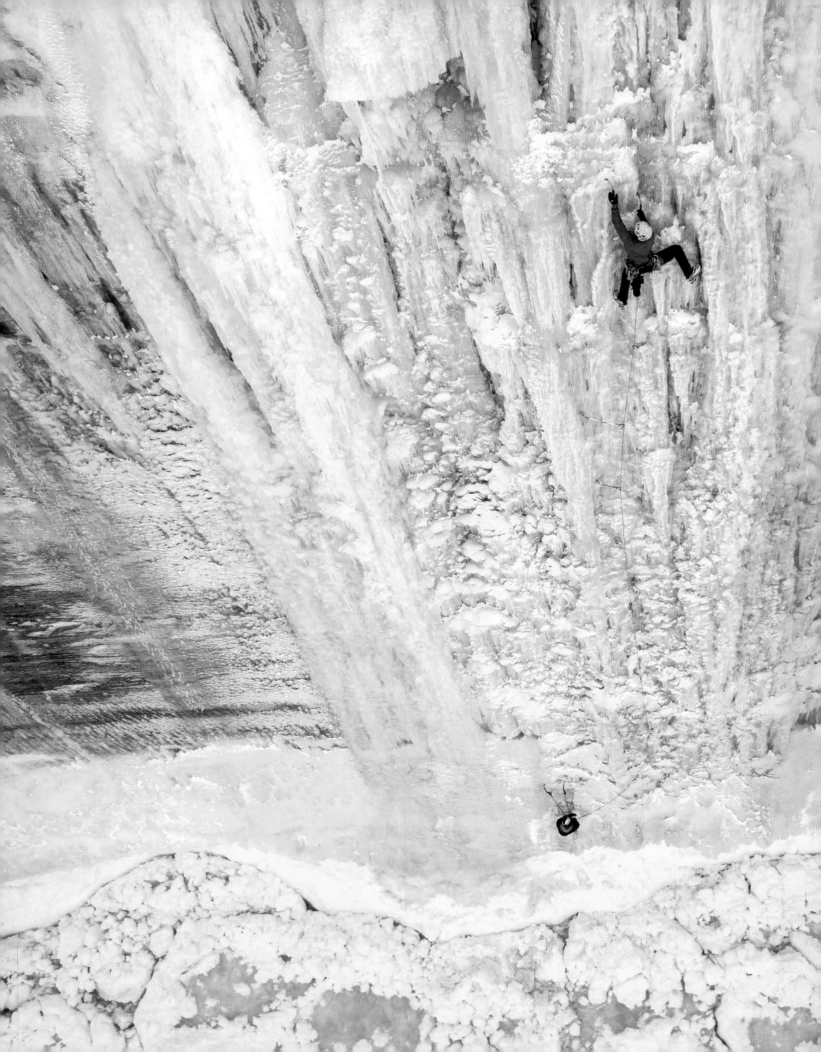